A Vision of the Future

STAR TREK®
VOYAGER™

Stephen Edward Poe

P O C K E T B O O K S

New York London Toronto Sydney Tokyo Singapore

For Fran

because this is a forever deal

An *Original* Publication of POCKET BOOKS

POCKET BOOKS, a division of Simon & Schuster Inc.
1230 Avenue of the Americas, New York, NY 10020

ISBN: 0-671-53481-5

First Pocket Books trade paperback printing April 1998

10 9 8 7 6 5 4 3 2 1

POCKET and colophon are registered trademarks of Simon & Schuster Inc.

Book design by Richard Oriolo

Printed in the U.S.A.

CONTENTS

Introduction iv

Acknowledgments ix

PART ONE – DECEMBER 5, 1994

1 The Company 3

2 "Eye of the Needle" 16

3 The Lot 31

4 The Franchise 47

5 The Art Department 59

6 The Stages 73

7 The Shoot 92

PART TWO – THE BACKSTORY

8 Endogenesis 111

9 The Vision 125

10 The Owners of the Game 137

PART THREE – THE MISSION

11 The Secret Meetings 155

12 The Mirror 166

13 The Creative Process 181

14 The Bible 194

15 State of Flux 209

16 The Pressure Cooker 223

17 Something Old, Something New 237

18 The System 250

19 Show & Tell 265

20 T Minus Ten 281

PART FOUR – SHOW TIME

21 False Start 299

22 Rolling! 310

23 Warp Six 331

24 Mythos 346

25 Starflight 353

Appendices

Appendix 1 - Crew List 362

Appendix 2 – Transfers & New
 Assignments 371

INTRODUCTION

THE STORY OF *VOYAGER* IS FAR LARGER THAN THE story of the emergence of a new *Star Trek* television series. One of the central themes of this book is the impact that the *Star Trek* universe has had on several generations of television viewers. It also attempts to explore the questions, "Why? What is it about *Star Trek* that has made it such an enduring phenomenon?"

This is more than some passing fad, more than just a group of fans who dress up in costumes on weekends and speak Klingon. *Star Trek* is about this incredible voyage that

Gene launched all of us on—a voyage that has in some ways altered many things that we do today. And it has altered the way some of us perceive the world around us, and our role in that world.

In attempting to present some answers, I have tried to tell the story of *Voyager*, while at the same time exploring a much wider view—culturally, socially, psychologically, personally. Because each affects the others. Everything is connected to everything.

I have tried to tell a balanced story, which means I have talked about some positives and some negatives. It is very difficult to do this. However, I do not think that it is realistic to discuss only the niceties of television life, nor do I think the reader would be interested in reading a lengthy press release.

So while I have told a story that I believe is the way it "really" is, I have also tried to be careful that the story is *constructive* rather than *destructive*—especially in terms of human beings. That is my own personal and professional responsibility to my craft as a writer, and to the *Star Trek* universe.

In some ways my experience of working on this book was quite different, and rather a bit more difficult, than it was when I researched and wrote *The Making of Star Trek* in 1966–1968 (under the name Stephen E. Whitfield), which was all about *The Original Series*. When I first met Gene Roddenberry in 1966, I was an outsider to episodic television production. My only knowledge of the industry was through my efforts in licensing/merchandising. Moreover, there was nothing on television to compare *Star Trek* with at the time—the whole concept was so new. I was fresh to the industry, and *Star Trek* was fresh to television. I suppose it was a good combination.

In any event, the role that I played as a researcher, writer, and chronicler of *Star Trek*, of its emergence, was a unique one. I was not quite a participant, but I was not a completely detached observer either—partly, I suppose, because Gene and I became very close friends. He was in some ways my mentor as well. We co-owned a thirty-six-foot sloop (yes, named *Star Trek*), and spent a lot of time together, sailing off the California coast. I am proud of the fact that I was somewhat instrumental in getting Gene to the altar with Majel. And it warms my heart to know that I played some role in their life together. My link to *Star Trek* is forever linked to Gene and Majel as well.

I reveal this personal connection with Gene because I want the reader to know that what I have said about Gene in this book is based on the fact that I knew him quite well, and loved him in spite of his humanness, and also because of it. I can only hope to be so fortunate, where people who know me are concerned.

To a certain extent my role has been the same with the *Voyager* book as it was with

my book about *The Original Series*, although my perspective now is different. I am no longer new to television production. And I have had the benefit of thirty years of observing the expanding *Star Trek* universe. It is from this different perspective that this book chronicles *Voyager's* creation—the why, something of the how, and a measure of the when. Most of all, this book is about the people who create each episode, and the price each one of them pays, to bring viewers their favorite television show each week.

What has also emerged is an exploration of the universe that Gene created, and at the same time, an exploration of the response people have had to that universe—the impact on people's lives—using *Voyager* as the explanatory vehicle.

The complexity of the *Star Trek* production group (as an entity, it is commonly referred to as "the company") is several orders of magnitude above that of Norway Productions in 1966. Norway was a small family. The company is familial, but in numbers is more like a tribe. Fifty versus five hundred, so to speak. And that is just the production group itself. Those numbers do not include anyone at Paramount or elsewhere whose jobs are related in any way to *Star Trek*.

So to begin with, there were a whole lot more people for me to talk with and get to know. While doing that, I gathered enough material for at least two or three more books. This made it somewhat difficult to decide what to include and what to leave out. There is so much that I think should and needs to be said. Also, along the way, I was sidetracked by other matters, which added unavoidable delays to my completing this project.

The writing has definitely been a labor of love, heavily laced with nostalgia. When I came back on the lot for the first time, to start the research on *Voyager*, it had been a number of years since my last visit. Then, it was to have lunch with Gene. My first impression was the overwhelming feeling, "I'm coming home." I had spent a significant portion of my life on the old Stages 9 and 10 (now renumbered to 31 and 32), in and around the sets of the original *Enterprise*, and on the Paramount lot. I felt that same sense of familiarity again, as I walked around Stages 8 and 9, going through the new *Voyager* sets for the first time.

And yes, while on the bridge I sat in "the chair." I closed my eyes and felt the starship shudder as it passed into warp drive. It was thrilling, and exhilarating, and breathtaking. I don't know why. It's not as if I haven't been on a starship before. I only know that it was.

So as I walked around the lot that day, I was excited about writing a new *Star Trek* book, but underlying that excitement was the pure joy I felt at coming home.

In fact, my experience that first day was very Zen: Everything's the same, but different.

Some months earlier, when I first heard about *Voyager* I thought, "Hot dog! A woman

starship captain, and her own series!" I feel passionately that the human race has been operating with only half its brain for far too long as it is. So I personally was thrilled with the idea. What made it even better was that a woman was involved in its creation. I couldn't wait to get started.

I've met a lot of wonderful, dedicated, caring human beings on this journey of mine through the *Star Trek* universe. Some, it turns out, I had met before, a long time ago, in a different lifetime. Jim Van Over and I met in 1968 at a science-fiction convention in Oakland, California. I was signing books, and he wanted me to sign his copy. Doug Drexler was running a Federation Starship Store in New York City in 1969. Gene and I were in town for a convention, and I stopped in at Doug's store for a visit. I sat on the counter and we talked *Trek*.

It was fun. And it still is.

I would like to say a little about what this book is not.

There are no "juicy" stories in these pages. No racy laundry aired. And very few "warts," as Gene would say. Not that there aren't plenty of warts to be seen. Everybody is human. It's difficult to live day by day with any group of people and not become aware of personal traits, situations, relationships, and so forth that the persons concerned would prefer not be held up to public scrutiny.

There are no such tales to be found in this book. This will probably disappoint some readers. I cannot in good conscience write such a book. My guiding principle all the way through the research and writing has been to help, not hurt.

This is not a detailed history of *Star Trek*. A number of books already exist that, collectively, address *Star Trek* history quite thoroughly. Nor is this book a detailed recitation of every aspect of the production process. Much has already been written about that subject, including my own first book. Revisiting the production process in depth would be redundant and, no doubt, boring. It's also unlikely that it would be widely read.

I should also like to add a caveat.

The observations I have made are mine and mine alone. If I have erred anywhere in the writing of this book then the fault is mine, and not that of any of the exceptional people who so generously and continuously shared with me the information on which this book is based. The men and women who create and produce *Star Trek: Voyager* are extraordinary in so many ways. Most do not think so. But I do.

It is at least a measure of Rick Berman's patience and tolerance that he agreed to "open the doors" and let another writer in to look around. Having looked, it is now my personal conviction that there is no one else who could or would do what he does. I do

not agree with all his decisions (he probably won't agree with everything I've written, either). But then, I don't have to, and he sure won't lose any sleep at night because of my opinion.

Nevertheless, I admire greatly his willingness to be the man riding the horse. Whatever they pay him, it isn't enough. I hope he stays firmly in the saddle for a long, long time.

My life, somewhere along this road of happy destiny, somehow became intertwined with *Star Trek*. That was never my intention. I just wanted to write a book. Looking back, I can say I am supremely grateful for the influence. Gene and *Star Trek* both have impacted my life in a very profound and personal way. It has been exciting, exhilarating, frustrating, and enlightening. I believe I am the better for it. I am proud to have had the opportunity to have been a stowaway on this journey through the stars.

It has been wonderful.

It has been magical.

And it has been laced with sadness.

I miss my friend.

Stephen E. Poe
Reno, Nevada
June 1997

A C K N O W L E D G M E N T S

I NEVER USED TO READ THIS PART OF A BOOK. UNTIL I wrote my first one and discovered that while the actual, physical aspect of the project sooner or later comes down to a one-on-one with the computer (actually, it was a typewriter at the time) books are not written alone. To do the research, to breathe life into the creation, to see it through to completion…that requires the active assistance of quite a few people. Once I understood how it works, I've always made it a point to read an author's acknowledgments. These are not just names on a page. These are flesh-and-blood people who have significantly aided the author's ability to write the book.

These are, in short, important people. They mean something to the author, and to the existence of the book.

I would like to formally acknowledge Rick Berman's acquiescence to my request for permission to roam around the Paramount lot, asking questions of everyone in sight. Without his agreement, I would not be writing this acknowledgment. He doesn't need his name in another book, so I don't really know why he said "Yes." But I'm glad that he did. I tried very hard to stay out of his hair, and that of everyone else, while doing the research. To my knowledge I only stepped on his toes once.

I would also like to say a few special words about Jeri Taylor. She is a wonderful lady, enormously creative, and never once denied my requests to share her time and insights with me. She helped me struggle through some rather dark moments, and for that I am truly grateful.

There are others in the *Voyager* production group who have been especially helpful to me, including Merri Howard, Wendy Neuss, Michael Piller, Brannon Braga, Dan Curry, Michael Westmore, and Richard James. Their support was augmented in numerous ways

by Dave Rossi, Lolita Fatjo, Janet Nemecek, Sandra Sena, Karen Ragan, and Zayra Cabot.

It was my great pleasure to become well acquainted with the shooting crew. Among them are a number of people who went out of their way to assist my efforts, and gave me their friendship in the process—Marvin Rush, Bill Peets, Randy Burgess, Dick Brownfield, Alan Bernard, Cosmo Genovese, Adele Simmons, Charlie Russo, Alan Sims, Suzan Bagdadi, Arlene Fukai, Michael DeMeritt, and Jim Garrett.

And I must acknowledge the many contributions and insights of Ed Herrera and L.Z. Ward. Two finer men never walked the earth. They both are tremendous assets to *Star Trek*. I treasure their friendship.

There is another group to whom I owe a great deal, and about whom I wish I could say volumes—Rick Sternbach, Michael and Denise Okuda, Doug Drexler, and Jim Van Over. They accepted me without hesitation (well, maybe just a teeny bit at first), and will always have a special place in my heart. None more so than Michael and Denise, who welcomed me into their lives and their home as well. At the eleventh hour it was Michael who, while pressed to the limit with his own deadlines, nevertheless took time to read the manuscript and give me a (long) list of technical corrections and suggestions. I cannot thank him enough for his keen eye, sharp wit, and loving support.

Now comes the place where the author usually says something about the people "without whom this book," etc., etc. No doubt what the author says is Mostly True. Which is not the same as All True. Which is not the same as Way True. In my case, there is a group of people without whose help I absolutely could not have written this book. That is Way True. I refer to the doctors, nurses, and staff of the Bone Marrow Transplant Unit at Stanford Medical Center. They literally saved my life. After which I wrote this book.

I am particularly indebted to Robert S. Negrin, M.D.—who was the prime mover in my being at Stanford in the first place, and has been steadfastly supportive of my treatment and recovery ever since—along with Drs. Karl Blume, Gwynn D. Long, Stephen Hall, Maureen Ross, Christine Hoyle, Wendy Hu, and Joe Alvernaz.

And I have to say, I was superbly looked after by Jan Petree, RN, who is hands down *the best* nurse I could have ever asked for. She was wonderfully backed by nurses Donna Healy, Sandy Burgess, Angela Johns, Kelly Gould, Adrienne Van Beckhoven, Kate Tierney, Barbara Carr, and Norine Mugler. Nor can I omit Carole Graham, for her soothing, healing touch. The entire staff—especially Irish Jackman, Tara Coughlin, and Nirmala Singh—were incredible.

I am also indebted to my own oncologist, Dr. John Shields. I definitely would not be on the planet to write this were it not for John. No patient could ask for a better partner.

His associate, Dr. Steven Schiff, continues to be a bulwark, as do Willee Coyle, Leslie Girsch, Darlene Hart, Eileen Gianola, Miki Powell, Judy Willoughby, Belayne Gibson, Irene Sandell, and the rest of the staff at Alpine Hematology.

Nor can I fail to acknowledge the unstinting care and attention afforded me by Dr. William Povolny. His physician's eye, and personal friendship, have been more beneficial to me than he will ever know. And last, but absolutely by no means least, is W. John Diamond, M.D., for the unceasing application of both his friendship and his homeopathic skills. Barbara Diamond, Judy Joslin, Patty Pia, Cathy Chamberlain, and Judith McKay at Triad Medical Center also are just exceptional. Way True.

There are others I need to recognize. Judith and Garfield Reeves-Stevens, who were the first to show me, in a way I could not deny, that my original *Star Trek* book had actually meant something to someone. Teresa Love, Clark Reil, and Melinda, Dave, Cameron, and Derek Sexton, for their encouragement and support, and their willingness to help me experience what it truly means to be a part of a family. Dave, particularly, who helped me through the early and difficult process at Stanford. Teresa, especially, for providing me with access to information sources it would have been impossible for me to reach otherwise.

My long-time friend David Berlatsky, for his insights and timely logistical support. Tony and Carla Drake, who gladly stepped in at just the right times and did for me what I could not possibly have done for myself. Karl and Barbara Kaplan, for being a part of my family, and for providing the perfect advise when (each time) I really needed it. Len and Eileen Savage, for much-appreciated assistance along certain lines. Alice Epstein, for her singular inspiration and validation of my ideas on recovery. Yat Ki Lai, for his incredible skill as a Chinese herbalist. And Stephen J. Healy and John Lambert, Esqs., for their sage counsel, convivial lunches, and enduring friendship.

I definitely want to thank Kevin Ryan (wherever you are) for starting me on this project, and Margaret Clark for her patience in seeing it through to the end with me, and not complaining nearly as much as she would have been justified in doing. I have grown to admire and respect her editor's eye, and know only too well that this book is definitely better because of her suggestions and influence. I trust her guidance, and her instincts.

Last, and most of all, my prodigious and copious thanks to my wife, Fran—my kindred spirit and soul mate—who assisted with the transcribing, made innumerable editorial suggestions (most of them I used), literally never stopped supporting me in this work, and has never ceased being my biggest fan, and my best friend. While I danced among the words, she toiled among the vineyards. No man could possibly be more blessed than I.

Life is a game.

The fire...the passion...

the exhilaration...

is not in the stands.

It's in the arena.

PART

ONE

DECEMBER 5, 1994

ONE

THE COMPANY

I learned Gene's vision directly from Gene. It wasn't my vision of the future, but it was at the

foundation of *Star Trek*. It was like learning a foreign language. I studied it, and I know

it quite well. We bend it a little bit, but we try not to break it.

Rick Berman
Executive Producer
Star Trek: Voyager

BRAD YACOBIAN SLOWLY WALKED UP THE STAIRS, deliberately lifting the left foot up to the next riser, shifting his weight, pushing his body upwards, lifting the right foot...over and over...repeating the motions, his body on autopilot. Sixteen-hour days were starting to wear on him, and the first season was not even on the air yet. It was almost 2:00 P.M. People would already be gathering, ready to enact a ritual that took place every seven working days. The pattern was

always the same. A preproduction meeting one week before an episode shoots, then a production meeting two days prior to shooting.

Brad's body was in the stairwell, making its way up to the second floor, but his mind was still back in the sickbay set, on Stage 9.

It was a small mix-up that should not have escalated, but did. Tempers flared. Phone calls were made. Brad had arrived to play mediator. Some conversation, a misunderstanding explained away. Some pacifying, some emotional hand-holding. No more problem. Just part of the job. The unit production manager wore a lot of hats. Mediator was only one of them.

At the top of the stairs, Yacobian turned left and made his way down the hallway past his office to a smallish meeting room on the top floor of the Gary Cooper Building, on the Paramount Studios lot in Los Angeles, California. The room he walked into was long, narrow, and high-ceilinged, with bare, vaguely green walls that gave the appearance of a cold, military-style briefing room left over from some World War II army base.

The austere atmosphere was reinforced by the 1940's-era steel casement windows on the far wall, opposite the entrance. The floor covering was an unrecognizable something, probably carpeting, long since napless and lifeless, trampled flatter than flat by thousands of feet for who knows how many decades. Whatever it once was, it had expired a long time ago.

The room's barren appearance was exaggerated by the Spartan decor. Scarred, worn, and badly abused long wooden folding tables formed a rectangle-within-a-rectangle, conforming to the shape of the room. Around the tables were forlorn-looking brown metal folding chairs, scratched and showing years of heavy use. All looked like refugees from a thrift shop sale. Five armchairs, upholstered in faded maroon something-or-other—no doubt passing for padded comfort—were at the far end of the room, veritable thrones in contrast to the folding chairs. The arrangement was cramped, leaving barely enough room for people to squeeze by between the chairs and the walls.

Some twenty people began arriving by ones and twos. They did not care about the furniture or the walls or the dead carpeting. More important matters were on their minds.

Most production meetings are lengthy, at times contentious, and almost universally disliked by those required to attend them. Today's meeting would not be much different, except that it would be mercifully short.

As the group crowded into the room they greeted one another, took seats—not the upholstered ones—and began informally discussing today's episode: "Eye of the Needle." The sixth episode of the new *Voyager* series, "Eye of the Needle" was scheduled to start

shooting on Wednesday, just two days away. As usual, there were a number of issues remaining to be resolved.

Dick Brownfield, the series' veteran mechanical special effects coordinator, arrived. Special effects are those that take place on the set during filming. (*Voyager* is shot in 35mm film, then transferred to videotape for all postproduction work and final distribution.) Visual effects are those created later, during postproduction. He dropped wearily into a seat next to big Al Smutko. Al is the only head of construction for any television series who can boast his own fan club. The two men have known each other for decades, and fell into an easy conversation typical of long-time friends.

Dick Brownfield and Al Smutko are rarities in the *Star Trek* production world; both worked on *The Original Series* —Smutko as a young carpenter just starting in the business, Brownfield as an apprentice electrician. Both are graying warriors seasoned by countless feature and television productions, most of whose names, stars, plotlines, and production problems have long since blurred into a kind of untroubled vagueness.

Though few would admit it, Brownfield and Smutko are envied by some of the younger, less experienced crew members. In a mythological sense, they have both been "out there" and returned. They know. Just as the Zen Master knows. The way they carry themselves says so: a kind of quiet grace that comes from within, born of the scars and afflictions only the production process can bestow. They do not seem to rattle easily in a notoriously stressful, pressure-cooker business. There are many men and women like them in episodic television production.

Technically speaking, there are approximately three hundred people directly employed by the production group referred to as "the company." It is the company that oversees all production activities from start to finish, on both *Star Trek: Deep Space Nine* and *Voyager*. A small core group of thirty-five to forty people work simultaneously on both series. The remaining personnel are divided pretty evenly between the two productions— about 130 each. In *Voyager's* case, only forty or so of these are actually on the set during filming. This smaller group, which includes the cast and crew, is collectively known as the shooting company.

Star Trek's employment impact at Paramount Studios is far wider, though, than just the direct production company employees. Scattered among various departments of Paramount Television, United Paramount Network, Paramount Pictures, and Viacom are hundreds more…all of whom are directly or indirectly involved with some type of *Star Trek*-related effort. Most of these people rarely—if ever—visit a set during filming.

There are a number of reasons why this is so.

First, the sets are closed. Access is automatically denied anyone without express permission from the producers. Second, those who do have a legitimate reason to visit the sets tend to show up only when they have time—which is not often. As is true in most corporations in any other type of business, at Paramount employees are always scrambling, trying to get too much work done in too little available time. There is not much opportunity for curiosity-seeking on the sets.

And lastly, for most of those who have worked in the business for some period of years, there is no longer a sense of wonder about what goes on during filming—unless something extraordinary is occurring, in which case people show up in droves.

The majority of the production company personnel have worked together for at least the last five years, a factor accounting for the sense of "family" that most experience. Many go back to the final three or four seasons of *Star Trek: The Next Generation*. Some can even say they were there when that series first began in 1987. Everybody knows everybody very well. The way members of a close-knit family know each other. Even to the outside observer, it shows. There is a relaxed, familiar camaraderie in the room, forged from years of working together through brutally long hours, impossible deadlines, and high creative achievement.

> Rick Berman: One of the benefits of having a group that's stayed together for
> so long is that feeling of belonging to a family. Usually in this business you're
> dealing with people who are assembled for short periods of time. Here, most
> of the people I work with, I've worked with for three, four, five, some of them
> eight, nine years. And a lot of them are people we have promoted up through
> the ranks. You get a much greater sense of family when people feel they've got
> a job here for a while…not just "let's see how many episodes we get to work
> on this season"—which is the way episodic television usually is.

For everyone there is also enormous satisfaction and pride in the knowledge—no, the fact—that no other television series in history has been as enduring, envied, or emulated as *Star Trek*.

Side by side at the table, Dick Brownfield and Al Smutko were a study in contrasts. Brownfield is medium height, stout, perpetually muscular, with thick wiry hair; he could easily pass for a stevedore. Smutko, on the other hand, is more the grandfatherly type (he is one)—warm, portly, with thinning gray hair and a ready smile.

But Brownfield's mind was not on his conversation with Al Smutko. He was preoccupied with smoke. Specifically, the amount of smoke he might have to use for a scene in "The Cloud," episode number five in the new series. Today was Day Six in "The Cloud"'s seven-day shooting schedule. While people gathered for this afternoon's production meeting, others were busy light-years away in our galaxy's Delta Quadrant, shooting in the *Voyager* sickbay on Stage 9.

Tomorrow (Tuesday) the script called for smoke to be used in Chez Sandrine, a holodeck set on Stage 16. A more or less typical Parisian bar complete with pool table, hustlers, and other assorted patrons, it was also supposed to look…well…smoky, like most bars.

And therein lay the rub for Dick Brownfield. He was worried that the episode's director, David Livingston—who was also *Voyager's* supervising producer—would want to go overboard with smoke. An excellent director, Livingston has the reputation for being meticulous…often to the point of wanting "more" of something—props, extras, effects. It happens with some directors.

Smoke is Brownfield's responsibility. He takes a lot of heat from the cast and crew when it is used excessively. Everyone complains about smoke. It is hard to see through, hard to breathe in, and most actors do not like it. No one performs well in it. That slows down production. Slow productions run over time and over budget. That makes the producers and the studio executives nervous.

Brownfield did not want the finger of blame pointed at him.

He was not alone.

No one wants to be blamed for shooting late. Everyone worries about it. Almost anyone among the cast and crew can, if they are not on their toes, end up being the cause of running over. In the end, it does not really matter. It is the director who gets the blame when a shooting day runs late. He is supposed to direct. Everything. He is in charge on the stage. He has the power. What he wants, he usually gets. Even if he does not like the results and decides to reshoot the scene a different way (a common occurrence).

There is a downside, though. Being in charge can be hazardous to a director's employment health if he or she consistently runs late and over budget.

Tomorrow was the last shooting day of "The Cloud." Normally, all episodes are shot in seven days, and all episodes shoot "back-to-back." There is no break in between. "Eye of the Needle" was due to start the cycle all over again on Wednesday morning at 7:30 A.M. If "The Cloud" shot late Tuesday evening, it would push back the start of shooting on "Eye of the Needle" Wednesday morning.

There are rules about such things.

For the actors and production crew, a normal shooting day begins Monday morning at 7:00 A.M., on the set, ready for the first shot. Everyone breaks for an hour from 1:00 to 2:00 P.M., then returns and shoots for another six hours. The meal break is euphemistically called "lunch," even though it rarely occurs at noon. This means a normal day's filming can last until 8:00 P.M., or twelve hours. Not included is the time spent by crew members who must arrive earlier than 7:00 A.M. to get ready for the start of filming. Also not included is the time the cast is required to spend in makeup before arriving on the set for the first shot. This can be as much as three hours earlier, or 4:00 A.M.

If a shooting day runs longer than twelve hours, Screen Actors Guild contracts require cast members be given twelve hours rest before they can be called in again. IATSE, which represents most of the production crew, has slightly different requirements. Some members are guaranteed twelve hours; lesser-ranked members—such as lamp operators and scenic artists—get only eight. If the day's shooting ends at 10:00 P.M., for example, cast and crew cannot be called to the set the next day until 10:00 A.M. or later. Although directors try hard to avoid it, a typical day's shooting will generally run over the twelve-hour stipulation, often by several hours or more.

This creates an expensive domino effect, triggering financial fallout: penalties payable to cast regulars, overtime charges for crew members, and a second meal brought in for everyone. Making matters worse, the start of the next day's shooting is even further delayed, adding to the cumulative effect of what quickly becomes a vicious circle. Shooting can start on schedule first thing Monday morning, but by Friday things might not get started until noon, maybe later. This happens a lot.

One of the typical problems resulting from this domino effect is that it tends to destroy the weekend for both cast and crew. If shooting begins on Friday at noon, for example, the last shot might not wrap (finish) until 2:00 A.M. Saturday. By the time the crew puts everything away, clears the lot, and arrives home, it could be 3:30 or 4:00 A.M. The actors have it worse because they have makeup and/or appliances to remove, which delays their departure even longer.

To recover, most people sleep through the bulk of Saturday. Before they know it, Sunday rolls around. Time to take care of laundry, maybe go on a date, say hello to the wife or husband, play with the kids, and do a few other chores. Then try to get to bed early Sunday evening in order to get up early Monday morning and start the routine all over again. And again. Week after week.

Brutal is an apt description of the pace.

A VISION OF THE FUTURE

There is a way to get the schedule back on track—calling in the cast and crew with less than twelve hours rest (known as "forcing" a call). But again, Screen Actors Guild and union contracts make this financially painful. It is meant to be, to protect the actors and crew. The aim is to encourage producers and directors to ask for quick turnarounds only when absolutely necessary. Generally speaking, casts and crews do not mind a quick turn-around once in a while. Habitual quick turnarounds are another matter.

With significant penalty payments to the cast and double overtime for the crew, the impact on the budget can quickly become serious. This puts the producers in the position of "damned if you do, damned if you don't." Either way, the cost consequences are sub-stantial.

Some of this financial impact is anticipated, and budgeted for accordingly. In plan-ning each production, the script is analyzed, and determinations are made as to which shooting days will likely run longer—simply because there are too many scenes to shoot within the allotted twelve hours that day. Calculations are made and additional money is budgeted to cover the late shooting days. While everyone knows going in that there will be overages, every effort is made to keep the extra time under control.

When a shooting day runs late, everyone is affected. No one likes it. Nevertheless, sixteen-to eighteen-hour days are common for cast and crew.

Rick Berman: Most people who aren't working in Hollywood look at this business as being very glamorous…until they actually get here, are working here, and see the kinds of hours we have to put in…the tediousness it takes in order to do something. Many of our people come in at four or five o'clock in the morning and don't go home until nine or ten at night. You're lucky to get a weekend off, you can't go out to eat lunch…there are so many personal things you can't take care of.

Despite Brownfield's apprehensions "The Cloud" *would* shoot late anyway—until a stupefying half-past midnight—but for reasons having nothing to do with the smoke. Mercifully, Livingston decided to use the smoke only minimally.

Winrich "Rick" Kolbe arrived, worked his way through the cramped space along the wall, and took a seat in one of the upholstered chairs. Kolbe would be directing "Eye of the Needle." Slender, mustachioed, handsome in a Teutonic sense (he's Prussian), Kolbe

looked the part of the dapper director. He was casually but impeccably dressed in a brown sweater and slacks, and seemed completely at ease with the environment and the people around him.

With good reason.

In the world of *Star Trek* production, Rick Kolbe is a seasoned, master director.

Over the last nine years Kolbe has directed more than two dozen *Star Trek* episodes, covering both *The Next Generation* and *Deep Space Nine*. He was picked by Rick Berman to direct the new series' pilot, "Caretaker." By the start of the "Eye of the Needle" production meeting, Kolbe had already directed *Voyager's* episode number four, "Phage."

As he took his seat, Kolbe was immediately drawn into an animated discussion with Dan Curry, *Voyager's* Emmy Award–winning visual effects producer. The subject was a Second Unit blue screen sequence that Dan would later be directing for a scene in "Eye of the Needle." The scene involved a character named Lord Burleigh, and it took place in a holodeck set which re-created a drawing room in an English Lord's nineteenth-century manor. Fond of bestowing nicknames on virtually everything, the crew had already dubbed this set "the Jane Eyre set."

According to the script, this scene—and "Eye of the Needle"—would introduce viewers to the "holonovel." Although the concept of holodeck technology, and novellike stories, had been firmly established in *The Next Generation* series, the idea of a fully interactive holonovel was new to *Voyager*.

On the surface, the idea seemed filled with potential.

For centuries people everywhere have routinely read written words on paper, in the form of nonfiction books or novels. Depending on how well they like the book, readers often become totally engrossed in the story. An extension of this pastime is the "audio book"—books marketed on audiocassette. These have become quite popular for many people, including those with reading difficulties and those who like an alternative to radio or music on a long drive in the car.

The writers wanted to extend that idea and combine it with the holodeck technology. The result: holonovels—highly sophisticated computer programs accessible and activated only on the holodeck, and entirely three-dimensionally interactive. Sort of the ultimate virtual reality experience; it does not just *seem* as though you are there, you actually *are* there.

In the twenty-fourth century of *Voyager's* time, the ship's holodeck would allow crew members to participate in their own personally designed holonovels. Far from having a passive adventure, the ship's crew members could experience total, physical immersion in the story, with a full spectrum of sensations in every way.

The concept would provide endless additional story possibilities, new ways for crew members to learn, to periodically escape from shipboard routine, to do research, to relax, to be their own heroes in self-directed sagas, or even to use the stories as a safe and acceptable means of releasing pent-up emotions.

Not a bad idea for the twentieth century, either.

Like others aboard ship, Captain Janeway would have her own personal holonovel, parts of which would be incorporated from time to time in some of the episodes. Gradually this "story within a story" would unfold for viewers, as *Voyager* steadily made its way back to the Alpha Quadrant. "Eye of the Needle's" teaser would be the start of Captain Janeway's personal holonovel.

When Jeri Taylor wrote the first draft of the teaser, she constructed a scenario in which Janeway was a pioneer woman in a covered wagon, headed out West. She had a husband and children. Day to day living was at a very simple level, often requiring her to do things for which she was quite unprepared and untrained—such as building a campfire. In short, nothing remotely like her job as a starship captain. Taylor thought it was a great metaphor for the captain's predicament in the Delta Quadrant, and would also provide a unique method of developing and enhancing Janeway's character.

Only two small problems. First, Taylor discovered that Kate Mulgrew was not exactly thrilled with the idea of working with horses. Try dead set against it. Second, after looking at departmental cost estimates, Suzie Shimizu ran the budget numbers and discovered that the cost per episode could run as high as $100,000 additional—per day. Even though the pattern budget per episode was $1.8 million, this would still be a heavy hit. It was a pretty good bet that any episode would automatically be over budget every time Janeway yelled "giddyup!"

Jeri Taylor: Money rears its ugly head constantly. We were over budget in some of our early shows because we wanted to give a lot of production pizazz to them. We realized that if we locked ourselves into this Western program for the holonovel, we probably would be saying over and over again, "We can't afford that this week, we're going to have to do something else."

Because it means going on location, it means horses, it means wranglers, it means a lot of things that are complicated. We're also well into the time of year when the days are shortest. You don't get many pages shot when you go outside. All in all it seemed not a prudent decision.

What they decided to do instead was to make Janeway's holonovel a Gothic mystery. Which is how the Jane Eyre set came into being. It was an expensive set, but it could be reused again and again. Assuming the set was used fairly often, the cost could be amortized over quite a few episodes during the run of the series. On that basis it would definitely be more cost-effective than a covered wagon lumbering along the countryside on location.

The holonovel concept—especially Janeway's Gothic mystery—ended up being a case of "sounded good in theory, but it didn't work out in practice." Almost everyone grew to dislike the concept, and it was abandoned.

But on this December day, no one knew that yet, so people were naturally proceeding "as if."

A true craftsman, Dan Curry wanted to make sure Kolbe's projected camera angles would match the ones he intended to shoot separately for the blue-screen footage. The script called for the drawing room to disappear and the standard holodeck image to appear in its place. Kolbe would be directing the drawing-room scene; Curry would separately direct the actor—in this case, Kate Mulgrew—for the blue-screen shots. Later, in post-production, Curry would optically combine the two pieces of film, making the holodeck "appear," with Mulgrew in the foreground. It was a visual effect Dan Curry and Rick Kolbe had done dozens of times together.

Still, Curry wanted to make sure the shots were set up to match perfectly.

Dan Curry's influence on the *Star Trek* universe has ranged far beyond his role as visual effects producer. He frequently provides ship-design input to the art departments, particularly in regard to the placement of mounting brackets for the scale models used in motion-control photography. Since twentieth-century science does not yet have antigravity devices, something has to hold the scale model ships suspended in midair during filming. Thus the need for mounting brackets.

The trick is to place them in such a way as to be unnoticeable by the all-seeing eye of the camera. Curry is quite inventive in suggesting surface features and concepts to hide the brackets. His ideas often result in a wider choice and greater flexibility of camera angles.

Curry's contributions have influenced *Star Trek* in other, more visible, ways as well. It was Dan Curry who designed the now-famous Klingon fighting weapon known as a *bat'leth*, for use by Michael Dorn, the actor who plays the role of the Klingon Starfleet officer, Lieutenant Commander Worf. The Klingons are a fierce warrior race of aliens with a high code of honor and loyalty. The *bat'leth* is known within the Klingon culture as the

"sword of honor," and is shrouded in a mythological origin not unlike that of another famous weapon, King Arthur's *Excalibur*.

Curry is a martial arts expert in his own right. He lived in Asia for some twenty years, studying various forms and styles including T'ai Chi. Having designed the *bat'leth* for Michael Dorn, Curry then created a fighting style complete with intricate T'ai Chi–like movements for the actor to use with the weapon. The *bat'leth* has become a true *Star Trek* icon.

In 1995, when Dorn's character Worf joined the cast of *Deep Space Nine*, Curry and Dorn teamed a second time, creating an entirely new weapon, the *mek'leth*, loosely based on a Northern Tibetan cavalry sword. Having designed the ergonomics for Michael's body mass and hand size, the two again worked out a fighting style to go with the new weapon.

> Dan Curry: The people who work on the show see it as being as much of a calling as it is something to do for a paycheck. It's *Star Trek*. It's not just another show. So people go home, they think about it. They think about it on their way back and forth to work. They think about it on weekends. People will come up with and volunteer ideas for somebody else's department. There's no nine-to-five mentality here. And everybody, despite the immense hours we put in…the really hard work…the normal grumbling about such circumstances…everybody gives it a lot more than what they would give for just a paycheck.

Part of Dan's value is the fact that he takes nothing for granted. His careful planning and willingness to attend to detail has earned him a reputation as one of the outstanding visual-effects men in television. Both technically and creatively, Dan Curry has few peers in television or feature-film production.

More people straggled in, packing the room. Extra chairs were brought in and squeezed into the corners. Jim Mees, *Voyager's* set decorator, slipped into a metal folding chair beside *Voyager's* visionary Emmy Award–winning production designer, Richard James. Mees was in a testy mood and complained about the production meeting interfering with his work.

Apparently that was okay; nobody seemed to care what he was saying. Richard merely laughed. A few people glanced at Mees; most simply continued their conversations. Everybody knew it was just "Jimmy's way." In truth, the series was fortunate to have him; Jim Mees is a highly regarded, talented set decorator.

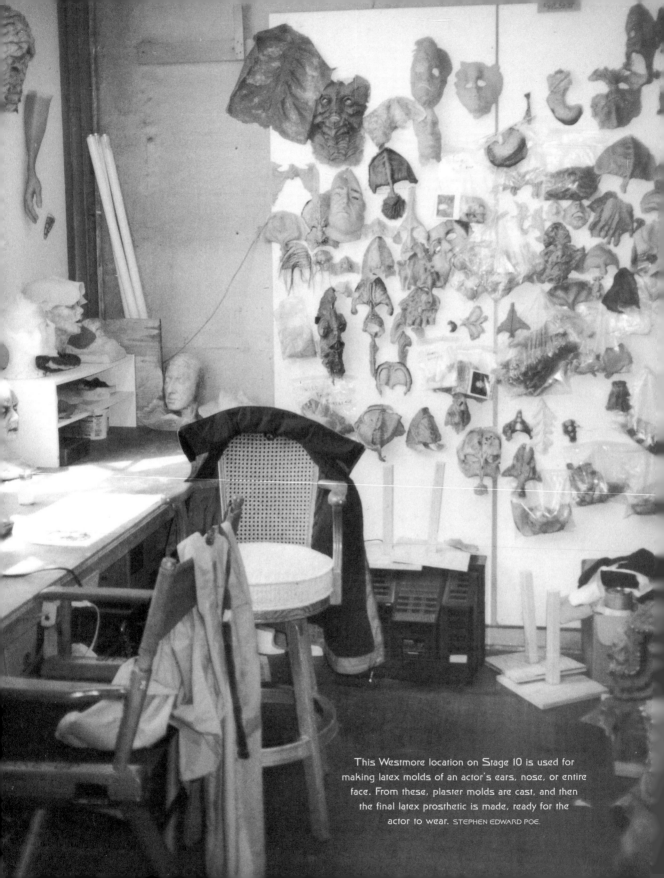

This Westmore location on Stage 10 is used for making latex molds of an actor's ears, nose, or entire face. From these, plaster molds are cast, and then the final latex prosthetic is made, ready for the actor to wear. STEPHEN EDWARD POE.

One person not present was Michael Westmore, *Star Trek*'s Emmy and Academy Award–winning makeup artist. Normally Michael was present for production meetings, but not today. "Eye of the Needle" did not involve any special makeup requirements, alien or otherwise—except for a Romulan, and Romulan makeup had been well established for many years.

Rick Berman: Michael Westmore has done an exceptional job, given the inordinate constraints of television production. An example of Michael's brilliance is the way he designs alien races. He makes them identifiable as a particular race, but they're all different from individual to individual. He's such a genius at that. Look at the Ferengi. They're a separate distinctive alien race with easily recognizable racial features. But each Ferengi is also identifiable as a unique individual. That's extraordinary.

The metal folding chairs were now filled. Conversations, greetings, and good-natured banter permeated the room, generating a cacophony of sounds. Listening outside the doorway, it would have been difficult to separate out any individual exchange. Abruptly, the noise ceased, falling away as if some unseen hand had turned down an invisible volume control.

All eyes shifted to the doorway, marking the arrival of the series' co-creators and executive producers, Rick Berman, Michael Piller, and Jeri Taylor. Line Producer Merri Howard was close behind.

"EYE OF THE NEEDLE"

They don't pay me to save them money in the budget. They pay me to put the story on the

screen. If I don't do that, nobody's gonna watch it anyway.

Rick Kolbe
Director

THE FOUR PRODUCERS TOOK THEIR PLACES IN THE upholstered chairs on either side of Rick Kolbe. The new arrivals were trailed by Kristine Fernandes and Dave Rossi, personal assistants (PA's) for Rick Berman and Merri Howard. It was 2:16 P.M., and the room was packed. The meeting officially got under way.

Jeri Taylor introduced the new Writer's Guild of America (WGA) trainee, Tom

Nibbley, made a few announcements, and then settled back in her chair. That was the cue for Brad Yacobian to begin.

Tall, lanky, and perpetually dressed in a white sweatshirt, Levi's, and sneakers, Brad was ideally suited to his role as *Voyager*'s unit production manager. He is well liked by everyone, has a good sense of humor, is absolutely tireless, and takes his job very seriously. A large part of his work involves managing the actual hands-on budgeting and scheduling of each episode. He is Merri Howard's strong right arm, and a key person in *Voyager*'s production.

It is said you can always tell when an episode is in trouble: Brad Yacobian shows up on the set. By whatever means, he will try to hurry things along, get the production back on schedule, and preserve the budget if at all possible. Budget damage control. If a director gets behind schedule, Brad will try to make suggestions to help the director catch up. Ultimately, he can pull the plug on a day's shooting if need be, rather than incur more over-budget costs for the day.

By the end of the week either Brad or Merri will show up on the set, and stay there until wrap (the last shot of the day). Friday shootings tend to run late into the evening, so Brad and Merri alternate "set duty" on Friday nights in an attempt to minimize the impact on their own personal lives.

> Merri Howard: It's not just about trying to control the costs. You have to take care of people too, down to just the simple things, like bringing in food. When you have a crew that went to lunch at four o'clock in the afternoon, and they're working 'til midnight, you bring in food…a lot of other companies don't do that. We do, because this is our family…when you're not going home to your children, your husband, your wife, your boyfriend, your girlfriend, or to your animals until probably fifteen hours after you start work in the morning…this becomes your family…so you really have to care.

Brad immediately began reading aloud the script for "Eye of the Needle" scene by scene, beginning with the episode's teaser. He read the scene description only, skipping over the dialogue, stopping each time someone interrupted with a question, raised a point, or voiced a concern. Each person followed along with his or her own script, keeping pace with Brad's reading.

Rick Berman sat quietly at the head of the table, under the windows. For a while he

was silent, but his eyes followed the discussion from person to person. He missed nothing.

Brad reached the bottom of the first page. "The tea...is pouring...page two...." Rick Kolbe interrupted, his Germanic accent rolling pleasantly through the room. "Let's talk about the tea for a moment. How do they make tea in England? How did they make tea in that time? Do they just pour the stuff in the pot and pour the water on top of it?"

Alan Sims, *Voyager*'s innovative property master, spoke up. "The tea is already in the pot, so...."

Kolbe abruptly interrupted again, saying the script seemed to go on for several pages while the tea is being poured. He said he thought that was too long, and not very interesting. A jumble of comments ensued as everyone focused on how to pour tea. Sims, cut off by Kolbe, fell silent.

A short, easygoing yet energetic man, Sims is popular with the crew. He is responsible for all props used on the set. Food, utensils, phasers...any object carried or picked up and used by an actor. Where possible, Alan will use an existing object, always trying to place it in an out-of-context setting, in a manner unfamiliar—or unexpected—to the viewer. It is an odd aspect of human nature (but true) that when humans view a familiar object made for one purpose but used for an entirely different (unfamiliar) purpose, we often fail to recognize the object at all.

Alan Sims: For one show I went to a gourmet kitchen store and bought this really great-looking potato peeler. Cost like three bucks or something. It had a large cylindrical white handle with little black accent ribs. I took it back to my shop, removed the cutting blade and replaced it with a long thin little light bulb. I hid a battery in the handle. Bob Picardo uses it as a micro-cellular scanner that he passes over the patient's body. It came out really neat.

Although props must frequently be custom-made, the teapot under discussion was not one of them. It fit the nineteenth-century period because it was a genuine nineteenth-century antique. Alan sat quietly, not because he didn't care, but because the discussion did not concern him. His job was to supply the teapot, not determine how the tea should be poured.

Finally Rick Berman asked, "What time period are we talking about here?" Everyone looked at Jeri Taylor. "Eighteen-forties to eighteen-fifties," she quickly replied.

Kolbe wanted to solve the problem and move on. "Okay. So we better find out how

they did it then." Brad continued reading the scene description. The sound of rustling pages filled the room as people kept pace with Brad's reading.

The business with the tea illustrates a thirty-year-old concept inherent in *Star Trek*, known as the "believability factor." First established by Gene Roddenberry in *The Original Series*, it means the goal has always been to strive for accuracy and believability whenever possible. The concept gets bent fairly often because of the needs of dramatic storytelling, entertainment, or budgetary limitations. Still, *Star Trek* prides itself on adhering to the believability factor when it can.

That is why the way tea is poured in the 1840s was an important issue. Probably most viewers would never give 1840s-era tea-pouring practices a moment's thought. But *Star Trek* does. Kolbe's insistence that "we better find out" also reflects the way Rick Berman approaches any *Star Trek* production. Philosophically, he sets the pace, maintaining Gene's original vision, expanding and embellishing, and everybody else follows.

Rick Berman: Science fiction to me, by definition, is an ability to take something that is very human…a quality, a characteristic, a prejudice even…and kind of turn it around on its ear a little bit and look at it from another perspective. And that's what we often try to do. We don't *always* try to do it, but we *often* try to do it. Of the times we *try* to do it we often succeed. Letting people, in a not very abstract fashion, watch a show and think about it, and think what it means, and discuss it with their family.

At page 3 Brad read "…it's the brushing of branches against the window when it BURSTS open with the force of the wind…."

Kolbe interrupted again. "Let me talk about the trees. Weeping willows? That kind?" Another discussion ensued. Was it winter or summer? Would the trees have leaves or not? If so, what kind? Kolbe liked weeping willows, thought they looked "kind of romantic." They decided to go with weeping willows.

Brad resumed reading but was immediately interrupted again by Kolbe. This time he had a question about the windows. There were two along one wall of the set. He wanted to know if it mattered which one was used. He had just come from Stage 16, had surveyed the as-yet-unfinished drawing-room set, and had some concerns. The window on the left would cause him difficulty with certain camera angles; therefore he preferred to use the one on the right.

Dick Brownfield asked, "Does it blow open and stay open or do you want it to flap?"

Kolbe pondered this for a moment. "Well, I…"

Brownfield pressed the point. "Because there's gonna be a lot of rain and wind comin' through."

That decided it for Kolbe. "Well, it shouldn't flap. Once it's inside I think it will stay. Because there's nothing inside that causes it to flap back." They talked back and forth for a few more minutes, with Merri Howard and Al Smutko joining in. Kolbe settled the issue, saying he would use the window on the right.

Still, they were not finished with the window.

The scene description called for the momentary reflection of a woman's face in the glass pane, as Janeway was closing the window. Dick Brownfield questioned how much rainwater would be coming through the window as Janeway is trying to close it. Merri Howard said it wouldn't matter; Janeway's cloak would keep her from getting wet. Jeri Taylor diplomatically pointed out that Janeway had by that point removed her cloak.

Kolbe's frustration began to show. "Yes, yes. I'm not talking about…we're having a few drops on that thing [the window]. I don't think I want to make a big issue out of this action here. The point of this particular element as far as I'm concerned is to see the woman's face reflected in it. I don't want to make a big deal out of this window. She goes there, she sees the face in there. That's about it." He looked around the room. Silence.

Brad continued reading. There were minor interruptions, small points here and there. Scene 3, page 5. "The drawing room disappears and is replaced by…the holodeck. Janeway is still dressed in her nineteenth-century garb, which looks strangely out of place now."

Rick Kolbe again interrupted. "Now let me ask you something. Raindrops…on her gown…in the [holodeck] program. Will they be on her gown after the program disappears?"

Michael Piller clarified the point. "No, they will be gone."

"Okay." Kolbe was satisfied. They moved on.

And so the meeting went. Details, details, details. The smallest detail was examined, discussed, weighed. This level of scrutiny has always been typical of *Star Trek* productions. The window scene that Kolbe was so concerned about, for example, would have consumed mere seconds on screen. Yet the production meeting devoted a considerable amount of time to working out its details. In this case, even though the scene was filmed, it was never shown. The entire sequence on the Jane Eyre set was later cut from "Eye of the Needle" and replaced with what Berman believed was a more exciting shipboard teaser.

Scene 4, page 7. "Janeway sees an Okudagram which shows a blinking point of light in space…."

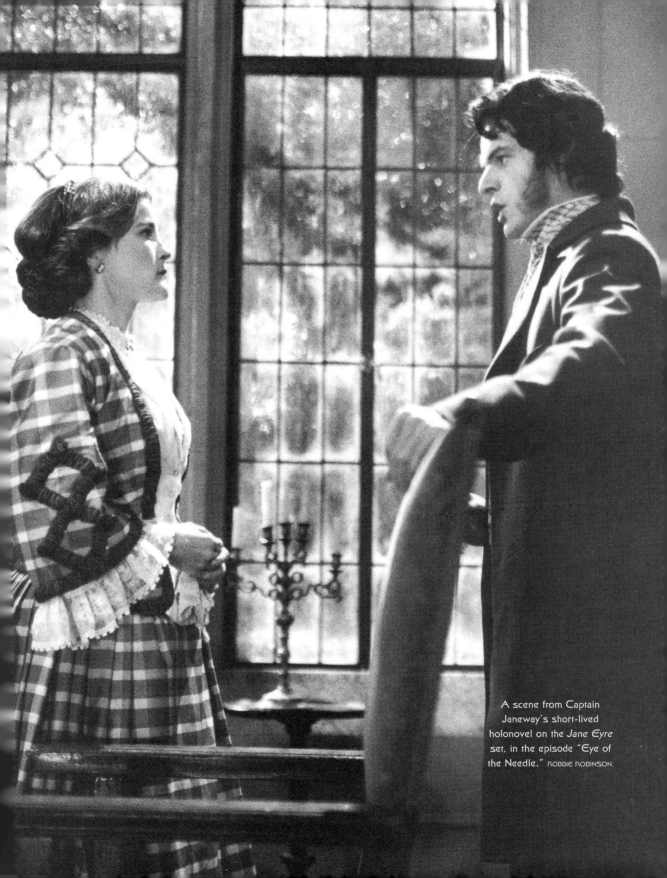

A scene from Captain Janeway's short-lived holonovel on the *Jane Eyre* set, in the episode "*Eye of the Needle*." ROBBIE ROBINSON.

"Okudagram" is a generic reference to a drawing or piece of animation developed by *Voyager*'s art department, under Richard James's direction. Okudagrams can be seen in every episode of every *Star Trek* series except *The Original Series*. Each is a work of art in itself. Scriptwriters now use the term generically, to indicate a certain type or category of graphic they have in mind, without having to describe the graphic in detail. The artists and illustrators will attend to that.

This *Star Trek* colloquialism has evolved over the years as a result of the influence of Michael Okuda, *Voyager*'s brilliant scenic arts supervisor. In 1987, at the beginning of *The Next Generation*, it was Okuda who designed the look of the graphics and the feel of the animation on the reborn *Star Trek* television series. Michael is one of two unofficial keepers of the grail. *Star Trek* grail, that is.

The other grail keeper is Rick Sternbach, *Voyager*'s gifted Emmy Award–winning senior illustrator, a man who has probably designed and illustrated more spaceships for television and motion pictures than anyone else on the planet. Both men are also technical consultants to both *Star Trek* series and feature productions.

History does have an odd way of repeating itself. "Okudagram" is now firmly entrenched in the *Star Trek* lexicon, in much the same way that "The Jefferies tube"—named after *The Original Series*'s art director Matt Jefferies—became part of *Star Trek*'s Federation starship set designs. Every Federation starship has a Jefferies tube, a lasting tribute to the guiding genius of Matt Jefferies.

There are other examples. The wrist-mounted flashlights worn by *Voyager* away teams are called "Sims beacons," after Alan Sims. "Mees panels," for Jim Mees, are the gadget-laden interior wall panels that *Voyager*'s crew members often make repairs to, whenever certain ship systems malfunction.

The concept of paying homage to an individual is not new to the *Star Trek* universe. From the very beginning, those who have had a powerful effect—directly or indirectly—on its evolution and philosophy have always been honored in one fashion or another. Some are famous, and some are less well known. Some have been recognized in obvious ways, such as by using their name or likeness, others by an indirect or subtle reference.

People like physicist Stephen Hawking, model maker Greg Jein, astronaut Mae Jemison, aviator Amelia Earhart, President Abraham Lincoln, author Ray Bradbury, playwright William Shakespeare, *Original Series* producer Robert H. Justman, explorer Jacques Cousteau, American Revolutionary War patriot Thomas Paine, poet/philosopher Alfred Lord Tennyson…more are added every year.

Perhaps the most poignant tribute to date can be seen on the official Starfleet commissioning plaque mounted on the wall of *Voyager*'s bridge. The plaque lists the names and

Starfleet departments for the principal production company members who were involved in developing and launching the *Voyager* series. The final entry on the list, set apart from the rest: Chief of Staff, Gene Roddenberry.

Brad was now at page 13, Scene 9. The scene description called for a starfield to appear on the main viewscreen, and then to be magnified several times in succession. It was a visual effect Dan Curry would produce. The problem was, no one could agree what to call it.

David Stipes broke in with a question. Stipes worked for Dan Curry as one of *Voyager*'s three visual effects supervisors (Ronald B. Moore and Bob Bailey are the other two). Each was assigned to alternate episodes. Stipes would be Curry's second-in-command on this episode, and would be responsible for supervising (under Dan Curry's direction) the actual postproduction work to create the visual effects for "Eye of the Needle."

Stipes was plainly suffering. Eyes bleary, nose running, racked by paroxysms of coughing, he had just begun a bout of Klingon flu (or something equally nasty) that would dog his every step for the next three weeks. But he was there at the meeting, gamely pressing on.

"Is this a magnification of the image that's on there, or is it a switching to higher magnification, as in when you switch lenses?" Stipes wanted to make sure that what he created would end up matching what Jeri Taylor had in mind when she wrote the script. The question precipitated a variety of responses—all different—from half a dozen participants. Berman silently watched, taking it all in, but saying nothing.

The point may seem small and unimportant, but actually is quite serious. In a production as complex as a *Star Trek* episode it is imperative that everyone speak the same language. Words, terms, references, and definitions absolutely must mean the same thing to one and all. *Star Trek* does not need a Tower of Babel.

The odd thing about this discussion was that the effect called for was not new. Over the last thirty years, countless visual effects have been created for the hundreds of episodes produced to date. Each one has a name, a category, a type. Many of these names have become standard jargon in the realm of *Star Trek* production. This one seemed to have escaped the process.

Finally Berman settled the issue. The effect would be called a "zoom effect," as in "zoom lens." This told Stipes what he needed to know in order to design the effect. Kleenex-to-nose, he sat back in his chair and relaxed.

Brad Yacobian continued reading scene descriptions, pausing frequently for discussions. At page 18 they finished Act One and moved to Act Two. Here Rick Berman pointed out the obvious: the script, as presently formatted, contained a teaser and five acts. He

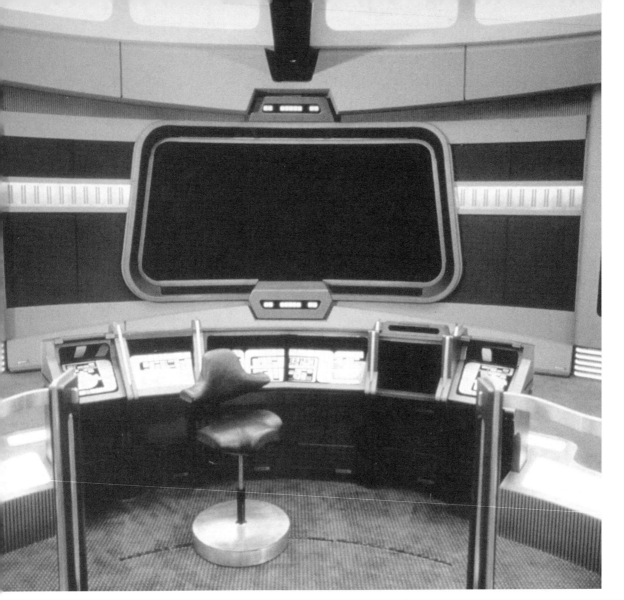

The view from the captain's chair.

then announced a new episode format: a teaser and four acts. There was barely a ripple of comment as everyone took this information more or less in stride.

The lack of reaction was surprising, considering the potential ramifications for "Eye of the Needle."

The four episodes already shot were not a problem. They would simply be recut to reflect the new format. With filming completed on these episodes, there was no other

choice. But "Eye of the Needle" was different—filming was about to start. As a result, many of those in the room would be affected by the format change.

Each act is designed to close on a "cliff-hanger" or other dramatic element, so viewers will not switch channels during the commercial breaks. Changing from five acts to four meant each act would probably end in different places, or scenes—ones that were not necessarily designed to be suspenseful moments as the script currently stood. There was only one solution: rewrite the endings for Acts One, Two, and Three. That could mean restructuring portions of important scenes. Dialogue would undoubtedly change. Some scenes would likely change. Schedules on and off the set could be affected. So many variables were involved, it was hard to predict the impact.

One thing was sure: people would have to adjust to, and make, whatever changes might be required. In fewer than forty-eight hours. Shooting on the set was to begin Wednesday morning, and it was already Monday afternoon.

There was no overt reaction in the room. Yet there was an undercurrent of surreptitious activity as people began scribbling on notepads, consulting electronic notebooks and laptop computers, checking work schedules.

Smutko frowned with concern about overtime costs that would one more time threaten to massacre his budget. He knew his construction crews would have to work through at least one full night, maybe two, just to shift set-construction schedules. His crews always worked based on which sets were slated to shoot each day of the seven-day schedule. With new act endings, some sets would probably shoot earlier than anticipated. Completion of those sets would have to be accelerated.

Richard James was equally concerned about the potential impact on Smutko's construction budget. Al's "pattern budget" per episode was set at a predetermined figure. Each of the previous four episodes had run well beyond the allotted amount, which put him way over for the season—and the series wasn't on the air yet. Making matters worse, the Jane Eyre set, counting Jim Mees's set-decorating needs, had by itself already annihilated Smutko's budget for the entire episode.

The move from five acts to four was an interesting one. The most obvious result would be fewer commercial breaks on air. This could not be good news for Paramount's new start-up venture, the United Paramount Network, which would syndicate the series. Fewer commercials meant fewer distribution profits. Good for viewers, who often complained about too many commercials as it was, but bad for income, for the studio as well as the television stations. Many people believed that this was one decision destined to be reversed.

Berman's announcement plunged Jim Mees's life into chaos. Efficient as ever, Mees had the set decorating all planned out for each of the seven days, with set dressings scheduled for delivery to the sets according to the announced shooting days. Some of his carefully laid plans, like everyone else's, were suddenly in the proverbial toilet.

Rick Sternbach and Wendy Drapanas just smiled, looked at each other, and shrugged, as if to say, "Well, what else is new?" Wendy is a scenic artist in *Voyager*'s art department. Both, like everyone else in the room, were well accustomed to sudden changes in plans. It went with the territory. They all knew it, accepted it, even if they did not like it. The answer was always the same: Just do it. People sitting next to each other began whispered, abbreviated discussions, trying to adjust and coordinate changes as quickly as possible.

Rick Kolbe was at least as affected as the others, in some ways more so. He had spent days walking the sets, blocking every scene, every shot in the script, setting up each camera move and angle for maximum dramatic effect. Some of his well-planned efforts could now be trashed. He too would have to rethink his ideas for certain shots. He would also have to plan for new ones…ones he knew had not as yet been written. He gave Jeri Taylor a questioning look, as if to ask when she would have new scenes written for the ends of each act. She gave him a reassuring smile. The new pages, she whispered, would be delivered to his home that evening.

Those in the room were not the only ones who had to scramble. As fast as Jeri Taylor could rewrite the act endings, the new pages would have to be formatted, printed, and distributed to the entire company. This task would fall to Lolita Fatjo and Janet Nemecek. Lolita is *Voyager*'s preproduction script coordinator; Janet is the assistant script coordinator. Time was truly their enemy. They could not start their work until Jeri Taylor wrote the words.

In actual fact, the reformatting process was already well under way. Jeri Taylor had known about the change in formats when she arrived at her office in the Hart Building at 7:00 A.M. She had spent the morning rewriting the new act endings, and given the changes to Lolita before coming across the street to the Cooper Building for the production meeting. Even so, it would take hours before the new pages were actually ready for distribution—certainly not before people headed home at the end of the day. It would be hours more before the new pages were in the hands of all concerned. The messenger service would be busy all over Southern California that night.

Jeri Taylor: Syndication traditionally has five acts…probably because they can get more commercials in that way and stations need to make their money by

selling commercial time. Because this is now part of the UPN Network, the network was anxious for *Voyager* to look like a network show and not a syndicated show. The traditional structure for one-hour dramas on networks is four acts. We had our choice. It was presented to us, and we decided that we would go to the more traditional network structure and…try to act like the big guys.

Brad began reading again. "Kes is preparing vegetables for Neelix; he's busily chopping them with a massive knife. Neelix is…"

Rick Berman interrupted. "What kind of vegetables are these?"

Vegetables were props. Props were Alan Sims's responsibility. Alan began enthusiastically describing the ones he had in mind for this scene, trying—as always—to sell his ideas.

"I've got some really great items picked out…fruits and vegetables…teardrop tomatoes, yucca root, Asian pears, habaneros, jicama, daikon, ginseng, feijoas, bananas, starfruit, prickly pear, and kiwanos. They'll really look terrific!"

Merri Howard stepped in. "Maybe we should lose the bananas?" Her question was directed to Rick Berman. He nodded in agreement. "Yes, definitely. They look too Earthlike." He added that the other vegetables were okay.

Alan Sims relaxed in satisfaction. Sometimes it was tough selling his ideas to the producers, especially Rick Berman. Sims is definitely not alone in this respect; virtually everyone experiences the same difficulty. Doubtless more than one person in the room believed the bananas had served their purpose.

Brad resumed reading again. There were no further significant comments until Act Three, page 36. "Zimmerman appears." Although originally created as "Doc Zimmerman," the holographic doctor had yet to get a formal name. Through common usage he has become well established as simply "the Doctor."

David Stipes interjected a question. "When the Doctor appears…does he appear…doing what he was doing when they deactivated him the last time…or…how does that work?" The seemingly innocuous question was in reality rather important.

First, because the answer could well create continuity problems from scene to scene unless great care was taken to avoid such conflicts. For example, what the doctor was doing previously might have no relevance whatever to what he was being activated for the next time. This could get sticky, from episode to episode. People began looking at Berman, who for the moment remained silent.

Second, this was a "blue-screen shot," which meant Dan Curry would direct a Second Unit filming of the Doctor against a blue screen, and then combine that footage with footage in sickbay, which Kolbe would shoot. What the Doctor was doing in Curry's footage must match what Kolbe had in mind when he composed his shot in sickbay at the moment the Doctor materialized there.

The third reason was more philosophical, but fraught with far-reaching ramifications. The answer to Stipes's question would establish precisely how the Doctor's holographic program began. Once established, it would always have to begin the same way, for the life of the series—expected by everyone in the room to be seven years. *Star Trek* is a stickler for adhering to a detail once that detail has been established. But Stipes also knew what everyone else in the room knew: viewers were generally computer literate. Most people knew computer programs always started the same way. *Star Trek* would have to forever live with that bit of reality—one more example of adhering to the believability factor.

So Stipes's question about what the holographic Doctor looked like—what he was doing—when he first appeared, as an image, was a rather important point to establish. The question provoked a lot of discussion. At length Rick Berman decided the Doctor should appear near whomever summoned or needed him. "I would think that if it's a patient, he appears near the patient. If you come in to see him about something he appears near you. If it's Janeway calling from the bridge, he appears center stage in sickbay, and then delivers his introductory line…'Please state the nature of the medical emergency.'"

What this discussion clearly indicated was the still-developing nature of the new series. They were still trying to define terms, flesh out characters, and determine the limits of *Voyager* technology—to solidly establish the *Voyager* universe, and who and what would be in it. Despite the fact that more than a year and a half had already been spent developing *Voyager* as a series, there remained an incredible wealth of detail that was still not known, established, or understood. Each succeeding episode would fill in more blanks. But the process of honing, fine-tuning, and fleshing out the ship and crew would continue well into the third and fourth seasons.

The reading continued, at last moving along at a rapid pace. Brad made it to Scene 25, page 48 before being interrupted again. "B'Elanna EXITS on the run, leaving Janeway to reflect upon this unexpected gift. She turns to the picture of Mark and the dog…picks it up and looks at it."

Merri Howard asked if they have the picture of Mark with his dog. Alan Sims replied that they did. Rick Berman smiled and said, "I don't think we should always have Mark with his dog." A chorus of chuckles and comments greeted this statement. They were near

the end of the script—and the production meeting. People were in a lighter mood. So was Rick Berman.

"Let's get a shot and crop the dog out," suggested J.P. Farrell, *Voyager*'s supervising film editor.

"What does it cost us to get the actor back?" Berman's question was directed at Merri Howard.

She hesitated.... "I don't know....I'll have to check."

"We didn't take any pictures of him without the dog?" Kolbe asked.

"No. I don't think so."

Alan Sims repeated J.P. Farrell's suggestion. "Well, J.P. said he could crop and enlarge...to get around that."

"Crop and enlarge," Berman agreed. He paused. Then with a grin, rephrased his statement. "Optically remove the dog." More laughter.

Brad resumed reading scene descriptions. "Page 53...Scene 28. Interior transporter room. Optical. B'Elanna and Kim are at the controls; on the transporter pad sits a metal cylinder."

Rick Berman interrupted. He wanted to see the cylinder. Alan Sims, sitting at the far end of the room, held it aloft. Berman had seen it before. He personally approves the evolution of each new prop, style of alien makeup, costume—any significant item to be used in any episode. Any item is a significant item.

> Rick Berman: I'm very hands-on. I tend to get involved with everything...the initial stages of coming up with story ideas, writing and polishing the scripts, casting, alien makeup, props, fine-tuning the editing of each show, the scoring [music] of each show, the dubbing of the shows with all of the visual effects work. So...my job almost has a contradictory definition to it.
>
> There is a part of me that is involved in fine-tuning every aspect of each show. And then there is a part of me that is involved in the overall overseeing of all of it. It's the two extremes. Sometimes I feel like I'm the guy who has to oversee this whole big piano factory. But I'm also the guy who tunes the pianos.

Berman's comments are easily the understatement of the century. He is probably the most hands-on producer in episodic television today. In learning the "language" of *Star Trek*,

Berman did not also need to learn Roddenberry's search for perfection. Rick Berman already had that quality down cold. He accepts nothing less from those who work for him. To some, he seems to be a tough taskmaster, but the results show.

Part of the price he pays for his insistence on quality is that he lives with *Star Trek* seemingly twenty-four hours a day. He generally arrives at his office by 7:30 A.M. and plunges immediately into the day's details. His work schedule in fact is so crammed, minute by minute, that people needing to see him about something would have better luck getting an audience with the Pope.

It is not that Berman is totally inaccessible. He is just mostly inaccessible. At least it seems that way to others around him because Berman's pace is nonstop, all day long, well into the evening. A common sight is this solitary man, walking along the sidewalk late at night from the Cooper Building, toward his car, a briefcase full of scripts and notes in each hand. Even when he is going home he is, in a sense, not leaving *Star Trek*.

At the moment, Berman's eye for detail was fastened firmly on the object Alan Sims held in his hand. This was the third generation of the "metal cylinder"—a device about twelve inches long and six inches in diameter. The prop would get a lot of attention on camera because it figured prominently in the episode's story line. Berman was concerned that, to the viewer, it look like something special, something that indeed might just actually be a device capable of doing what the story called for.

During the preceding week when Sims had shown each of the previous versions to Berman, Rick had requested additional modifications. The current model reflected those changes.

Rick was still not satisfied. He wanted it to look more complex, more "high tech," with blinking lights and "things happening." Alan Sims tried to salvage the model, saying he had already spent money on the device and it was practically finished. Berman replied that it did not look finished at all. More discussion. More suggestions by Berman on what to add to the cylinder to make it look more complex. Finally, they moved on.

Brad was now at page 60, Act Five. He continued reading. No more comments through the last five pages. The meeting ended at 2:45 P.M.

T H R E E

THE LOT

When they smile, we want to see the mask smile. They can eat, laugh, cry, kiss, pick their

nose...they can do anything a human can do.

Michael Westmore
Makeup Artist

ICK BERMAN STOOD UP, SIGNALING THE END OF the meeting. People immediately gathered up their things and began crowding toward the door. Al Smutko leaned against a wall, talking briefly with Richard James and James's art director, Michael Mayer. Both Richard and Michael were worried. These last-minute changes in act endings were an unwanted problem. The ripple effect could become serious.

A portion of Richard James's office in the Dreier Building, above Stage 8. From here, near the entrance to the art department, *Voyager*'s art director has ready access to his staff, the standing sets, and the mill. STEPHEN EDWARD POE.

First, because as production designer, James not only must design the visual theme, or "look," for each episode, he must then carry that theme into each new set needed for that show. Next, Michael Mayer, as art director, has to translate James's vision into working drawings and, ultimately, into actual set-construction blueprints. Like those in all other departments, James and Mayer schedule staff workloads based on when they think certain sets will work (be available for shooting).

If the shooting schedule changed, that might mean the construction crews would need certain set blueprints earlier than planned. In all likelihood, those would be ones that had not been started yet. This, in turn, would alter Al Smutko's set-construction schedule. His men could not start work without blueprints.

Listening to James, Al was relaxed, a smile tugging at the corners of his mouth. He had been there before. So had James. Not to worry, he reassured Richard. Wait and see what the revised Call Sheets looked like. Maybe things would not be as bad as Richard thought. If the schedule was really bad, his construction crews would work through the night if they had to—more than one, if necessary—but the sets would be ready.

Richard James: It's a hard enough schedule as it is…under what we laughingly call a "normal schedule." The construction people come in at 5:00 A.M., and normally work only a ten-hour day. They work Saturday and Sunday so much

we really don't want to work them more than ten-hour days. We do twelve-hour days sometimes but it's just too much.

As it is, they go weeks and weeks without a day off. The guys work so much overtime that their life away from here is a very brief one. I think all they have time for is to go home, say hello, have some dinner, and go to bed.

Despite Al's reassurances, James was still worried. Ordinarily the five-act-to-four announcement would be nothing more than a minor annoyance. But coming as it did, when all his resources were stretched to the limit with the "Caretaker" reshoot, this could send everyone into complete overwhelm.

Scheduled for Monday and Tuesday of the following week, the reshoot was a massive undertaking, requiring the complete rebuilding of huge sets that had been built, filmed, and torn down two months earlier. People were scrambling in every department, trying to get ready for Monday morning. For most, there would be no weekend at all. They were facing at least fourteen more days without a day off. And now, unexpectedly, there was a potential problem with "Eye of the Needle," an episode everyone thought would be a breeze, since it took place entirely aboard ship.

No wonder Richard James was worried.

Edging towards the door, Dan Curry and David Stipes discussed Stipes's ongoing sessions with Image G, a motion-control studio located north of Hollywood, in the San Fernando Valley. Image G was where much of the motion-control filming was being done with scale model miniatures of the Deep Space 9 station along with the *Voyager*, the Maquis raider, and other vessels used in the series' pilot, "Caretaker." Some of the film would also end up as stock (off-the-shelf) footage for use in subsequent *Voyager* episodes. As part of his job, Stipes was generally present during the motion-control filming, to supervise the efforts of Image G.

Unfortunately, Stipes was also the designated visual effects supervisor for "Eye of the Needle." Ron B. Moore was currently assigned to "The Cloud," and Bob Bailey was still tied up in postproduction work on *Voyager*'s third episode, "Time and Again." This required Stipes to be on the set during the filming of any scene in which visual effects were planned. It was a simple matter of insurance.

Visual effects are generally produced (created) weeks after an episode has been filmed. If the visual effect called for does not fit into the scene as it was shot weeks earlier on the set, the logistical and financial consequences can be disastrous. It is almost impossible to go back and reshoot the scene (although Rick Berman had already decided to do exactly that, for some major scenes in "Caretaker").

The Maquis ship model at Image G, being prepped for a motion pass, or flyby, toward the camera.
STEPHEN EDWARD POE.

Curry's concern was that the change in scene scheduling, which would undoubtedly result from Berman's five-act-to-four announcement, might interfere with David Stipes's Image G sessions. Nose buried in a mountain of Kleenex, eyes watering, Stipes nodded his concerned agreement. He understood the dilemma all too well. They had both been in this situation many times. Curry knew Stipes could not be in two places at once. He also knew that Stipes would have to do it anyway. There really was no adequate solution to this type of problem. People just lived with it, and did the best they could.

Behind Curry and Stipes, Rick Kolbe and Jeri Taylor were deep in conversation. Kolbe had more questions regarding the drawing-room scenes.

Across the room, still seated at their table, Rick Sternbach and Wendy Drapanas were engaged in an animated discussion with Denise Okuda* over when a particular

*Denise and Michael Okuda are married (to each other).

A VISION OF THE FUTURE

Okudagram would be ready. The graphic, being created by Wendy, was slated for use on a monitor at Tuvok's station on the bridge. Once finished, the graphic would be handed off to Jim Van Over, *Voyager*'s (and *Deep Space Nine*'s) scenic artist assistant and resident computer animation guru, who would integrate the graphic with an animation sequence he was creating.

The completed sequence…an Okudagram…would then be transferred to 3/4" videocassette and given to video playback operator Ben Betts, ready to be fed to Tuvok's monitor on the day that set was scheduled to work.

Under normal circumstances Van Over does not get involved with graphics that do not move—Wendy Drapanas creates most of those. Occasionally, however, there is a requirement for static graphics and animation to be combined (the case here). In such instances Van Over is a participant in the process.

The three-way discussion between Sternbach, Drapanas, and Okuda typified the suddenly changed circumstances for "Eye of the Needle." Denise found herself in the same boat with Kolbe, James, and everyone else. Any lead time they all thought they had now seemed in danger of evaporating. How to get everything done (or redone) in time for the start of shooting Wednesday morning could be a problem.

But that was not the only brushfire that suddenly needed to be put out.

Compounding the intensity of the pressure was the "Caretaker" reshoot, seven scant days away. The entire production company, including Rick Kolbe, was already under the gun to recreate some major scenes previously shot for the pilot. Everyone was scrambling to get ready, as it was. Now, to top it all off, there was the change in act formatting.

Understandably, Denise wanted reassurance that the graphic would be ready in time to meet Van Over's schedule. She was as nervous as everyone else about getting things done on time.

As *Voyager*'s video supervisor, Denise Okuda is responsible for the selection and timely availability of the images actually displayed on any monitor during filming on *Voyager*'s sets. She wears the same hat for *Deep Space Nine*. Her concern reflects a constant theme throughout the production process: timing is everything. When the camera rolls on the bridge, the monitors have to be ready to display the animation sequences called for in the script.

> Denise Okuda: On the Voyager bridge there are six twenty-inch monitors, four nine-inch monitors, and one thirteen-inch monitor. My main task is to go through each script and decide what graphic or animation piece should be on which monitor screen during each scene. If we're at Red Alert, we should be seeing graphics that reflect that condition. If a crew member says, "We're scan-

Denise Okuda's workstation in the *Deep Space Nine* art department. There is barely enough room for her mouse. STEPHEN EDWARD POE.

ning the planet," lo and behold, on one of the screens we see the planet. It helps make the instrumentation come alive.

So many elements created by so many different people must always—every day, every week, every month, all year long—come together at precisely the right time and in precisely the right way. No one thinks about the complexity of it all (that is the stuff their private nightmares are made of). They cannot afford the dubious luxury of indulging in those kinds of thoughts. *Stay focused...don't think about what's next...don't think about the time...don't think about when...don't think about home...don't think about the fact that this is the eighteenth time you've had to rework it...change it again, put it back the way it was the first time, start over...stay focused...just do it.*

There are a thousand different reasons why the process should not work. But it does.

Rick Berman: The attention to detail is part of our success. The viewers respond to that. The fact that we are at the same time doing something thought provoking...it's not necessarily provocative but certainly thought provoking...is terrific. There's not a whole lot on television you can say that about. One of the things that I am most proud of is the fact that this show *means* something to people.

People can watch *Seinfeld*, or any one of a dozen really fine television shows. They watch it to be entertained, to laugh, to cry. But it doesn't necessarily stay with them. It doesn't necessarily act as a catalyst for them to think about themselves and about their community. The fact that our show *does* is something I take a great deal of pride in.

What these after-the-meeting discussions underscore is a fact of life in television series production: no one operates in a vacuum. Rarely is someone affected as an isolated individual by something that happens in a production meeting. The television production business is a team business, if nothing else. What affects one affects many, sometimes all. Few departments would escape the ripple effect of the format change.

It is just like the environment; everything is connected to everything.

In the corridor outside, Adele Simmons headed for her office just down the hall. Adele was the first assistant director (first AD) assigned to "Eye of the Needle." There are two; Jerry Fleck is the other. At the moment, Jerry was on Stage 9 with David Livingston, filming "The Cloud." Each first AD is assigned to an episode on an alternating basis. The seven days in between allow each of them time—probably not nearly enough—to prepare for their next episode.

One of Adele's duties was to prepare a production board based on the script. The production board is a visual representation of a script. It displays the major elements needed for each scene, groups all like scenes together—all scenes on the bridge, for example—and tells what days those groups of scenes will be shot. This is the reason why an episode's scenes are not filmed sequentially, from the beginning of the show to the end. When finished, copies of the boards are distributed to all departments involved in the production.

Adele Simmons: We try to shoot out a set because our goal is to shoot as economically and as efficiently as possible. The common wisdom is you go into a set and you stay there until you've shot everything you need in that particular set. Sometimes we're not able to do that, so we have to do what's called "go in and out of sets"…maybe an actor isn't available, which means we have to come back later…or maybe what we planned to shoot in one day turns out to be too much to do, so we'll have to split a set up. But overall, we organize and schedule an episode in a manageable fashion, literally shot by shot.

As a teenager, Adele had been an avid fan of *The Original Series*, and was completely entranced by the cast and all the high adventure with Captain Kirk and the *Enterprise*. Her heroes were Kirk, Spock, Uhura, and the others. She later studied television production and started her career working on *Hill Street Blues*. When Adele was hired as an assistant director trainee in 1987, while the pilot for *The Next Generation* was being prepped, she was in seventh heaven.

During her first day on the job she went into a deserted Stage 9, wandering into the engineering set. Everything was dark and quiet. Unable to resist the impulse, Adele entered the transporter room. She looked around. There was no one there. She stepped up on a transporter pad and said in a commanding voice, "Beam me up, Scotty!" Unbeknownst to Adele, Dick Brownfield was working behind the set and heard her. He promptly activated the transporter room lights.

> Adele Simmons: On this totally dark set, all of a sudden the lights went on, and I said, "I'm really here! I'm really on this ship!" I was so excited. Then, later, when I started spending twelve to sixteen hours every day on those sets, it was like, "Oh God, I really *am* living on this ship!"

New endings for Acts One, Two, and Three automatically meant a revised production board. Once Adele received her copy of the revised script she could go to work on the new boards. It would be another late night. A sigh of resignation passed her lips. She set her jaw with an air of determination; in the meantime, she reminded herself, there were still other details demanding her attention.

Production boards help determine an episode's daily shooting schedule, but they also form the basis for each day's Call Sheet, a sort of master plan for that day's shooting. Call Sheets contain a wealth of information, including what scenes/sets will be shot, which cast and crew members will be needed that day, what time filming starts, what props will be used, the exact time cast members need to report for wardrobe and make-up, advance shooting notes for the next two days, plus any special notes or information people need to know—such as scheduled press interviews and publicity photos.

When Adele finished the revised production boards later that evening, the work still would not be finished. She would give the revisions to Arlene Fukai, the second assistant director (second AD), so Arlene could use the information to revise the Call Sheets and distribute them. Anyone having anything to do with the production gets a copy. People and events are so interconnected it would literally be impossible to operate without Call Sheets.

A copy of the boards would also end up on Suzie Shimizu's desk, across the hall from Adele's office. Suzie is the highly efficient and long-suffering head estimator for both *Voyager* and *Deep Space Nine*, whose task it would be to try to readjust the budget to reflect any added, and unexpected, costs.

TELEVISION CALL SHEET

Production Number 011-40841-723 ; W.A. No.

Production Name "STAR TREK: VOYAGER" Day MONDAY Date DEC. 12th, 1994

Episode "CARETAKER" Re-SHOOTS Crew Call 6A RPT TO Location L.A. CONVENTION CENTER

Exec. Producer BERMAN/PILLER/TAYLOR SUNRISE: 6:49A SUNSET: 4:44P Shooting Call 7:15A 1 Day out of 2 RE-SHOOT Days

Director RICK KOLBE SCHEDULE LUNCH: 12N

SET # SET	SCENES	CAST	D/N	PAGES	LOCATION
					L.A. CONVENTION CENTER
INT. OCAMPA COURTYARD (3RD LEVEL - UPPER CORRIDOR)	R - 131 pt	1-3-4 - A	N/A	1 9/8	
INT. OCAMPA COURTYARD (LEVEL 2 TO LEVEL 3) ESCALATOR	R - 128 pt.	1-2-3-4-7-A	N/A	2/8	
INT. OCAMPA COURTYARD (NEXT TO FOOD COURT)	R - 130	1-2-3-4-7-8-23 ATMOS	N/A	7/8	
INT. OCAMPA COURTYARD (LOBBY LEVEL - LONG LENS)	R - 134, 136	1-3-4 - A	N/A	3/8	

Total Pages - 2 4/8

✳ = ND Breakfast
K = Minors under 18

TALENT

CAST AND DAY PLAYERS	ROLE	MAKE-UP/LEAVE	SET CALL	REMARKS
1/ KATE MULGREW	JANEWAY	✳ 5A	7A	REPORT TO LOCATION
2/ ROBERT D. McNEIL	PARIS	7:15A	8:30A	
3/ ROBERT BELTRAN	CHAKOTAY	K 5:45A	7A	
4/ TIM RUSS	TUVOK	✳ 5:15A	7A	
7/ ETHAN PHILLIPS	NEELIX	✳ 5:45A	6:30A	
8/ JENNIFER LIEN	KES	7A	10A	
23. ERIC DAVID JOHNSON (N)	DAGGIN (OCAMPA)	7A	10A	

➡ IF YOU WOULD LIKE TO HAVE BREAKFAST, PLEASE COME BEFORE YOUR CALL TIME.

➤ NOTES: 1) BECK-OLA WILL BE SHOOTING PERMANENT SETS ON STAGES 8 & 9 ✳ ON TUES - Dec 13th
 2) ACCESS SHAFT WILL SHOOT FIRST ON TUES - Dec 13th ✦

NOTES: 1) ALL CALLS SUBJECT TO CHANGE BY AD. 2) NO FORCED CALLS W/O AD/UPM APPROVAL. 3) CLOSED SET - NO VISITORS W/O CLEARANCE FROM RICK BERMAN'S OFFICE. 4) NO SMOKING, FOOD OR DRINKS ON SET. 5) NO LEANING ON OR TOUCHING WALLS ON SET. 6) PLEASE READ SAFETY BULLETINS POSTED AT STAGE 8/9 ENTRANCE.

ATMOSPHERE AND STANDINS		SPECIAL INSTRUCTIONS
3 STANDINS SUE, SY, LEMUEL	6A	PROPS- PHASERS TRICORDERS (JANEWAY, PARIS
2 STANDINS JERRY, SIMON	8A	TUVOK)
2 STANDINS JENNIFER, RICHARD	9:30A	GRIPS - 200' DOLLY TRACK
4 DAGGIN OCAMPA - H. FERGUSON (F)	6A	CAMERA - 300 mm & 500 mm LENS, 2 CAMERAS
M. BLANCHARD (F), P. ESPINOSA (M)	6A	SHAKES - Scs. 131pt, 130, 134, 136
E. WHITMORE (M)	6A	
10 OCAMPA (M) - I. ROSS, C. CHAMBERS, S. BOLDOR,	4A	
J. FLANNIGAN, P. ALCAZAR, S. DEROY, L. SLAUGHTER,	2 @ 4A / 2 @ 5A	
J. RUBENSTEIN, R. BOSLEY, D. WILSON	5A	
8 OCAMPA (F) - P. FONG, D. LEE, S. CHASE, C. BOHLING,	4A	
B. DUNNER, A. GIULETTI, J. KARSON, M. RODERTS	5A	

SHOOTING DATE	PAGES	SET NAME	LOCATION	SCENE	CAST
TUESDAY 12/13/94 DAY 2 OF Re-SHOOTS	3 3/8	INT. ACCESS SHAFT LOWER & UPPER LEVELS	STAGE 16 move to	R - 140, 143, 145A, 148	1-3-4 1-2-3-4-7 1x - 3x - 4x
		INT. OCAMPA ENCLAVE	STAGE 18	R - 123	1-2-3-4-7-8-23 24-A
WEDNESDAY 12/14/94 DAY 4 OF #107	7 7/8	- COMPANY MOVE - INT. JANEWAY'S QTRS. INT. BRIEFING ROOM - COMPANY MOVE - INT. SICKBAY - OPTICAL INT. CORRIDOR ("72)	STAGE 8 ↓ STAGE 9	23 pt. 34 21 44	1, 11 (D.C.) 1, 2, 3, 4, 5, 6, 11, A 1, 9, A

Spvr Producer D. LIVINGSTON Phone		Producer M. HOWARD		Phone
Unit Production Manager B. YACOBIAN Phone		Assist. Director J. FLECK		Phone
Prod Dsgnr R. JAMES Phone		A. FUKAI/M. DeMERITT/M. RISNER/D. SHERMAN		
Art Director M. MAYER Phone		Set Director J. MEES		Phone

Issued by Operations: Date Time Approved by ___

FORM NO. PP-135 Rev. 1-93

The Call Sheet for the first day of the "Caretaker" reshoot. Please note the glamorous lifestyle of the television actors: the first makeup call is at 5:00 A.M.

TELEVISION CALL SHEET

Production Number 011-40841- 723 W.A. No.

Production Name "STAR TREK: VOYAGER"

- RPT TO LOC. SEE MAP. *

Day MONDAY Date DEC. 12TH, 1994

Episode "CARETAKER" Re-SHOOTS

PRODUCTION

NO	ITEM	TIME	CHARGE	REMARKS
1	1st Assistant Director	O.C.	705-03	FLECK
2	2nd Assistant Director	O.C./3:30A	705-04	FUKAI/DeMERITT
1	Script Supervisor	6A	705-06	GENOVESE
1	ADD'L 2ND AD	6A		P. SHERMAN
1	DGA Trainee	5A	705-09	RISNER

CAMERA

1	Cinematographer	6A	710-01	RUSH
1	Operator		710-02	CHESS
1	Assistant 1st		710-03	RAMIREZ
1	Assistant 2nd		710-04	STRADLING
2	Camera Pana		710-08	
1	Extra Operator		710-02	TBD
1	Extra Assistant		710-04	MIDDLETON
	Still Photographer		710/920	
1	FILM LOADER	✓		M. STRADLING

SET OPERATIONS

1	Key Grip	5:30A	725-01	SORDAL
1	2nd Grip		725-01	BURGESS
2	Extra Grips		725-02	MOORE/VITOLLA
4	Extra Grips		725-02	@ LOC.
1	Crab Dolly Grip	✓	725-03	SZILLINSKY
6	EXTRA GRIPS	8:30A		DEVLIN +5 AT
	Boom No.		725-06	STAGE 18
2	Craft Service	4:30A/6A	725-11	DJANRELIAN +1
1	CONSTRUCTION	6A		PER A. SMUTKO
1	Painter	6A	725-14	O'HEA
	Plumber		725-17	
1	SpecEfxPerson	6A	735-02	THOMS
3	Special Effects Person	O.C.	735-01/02	BROWNFIELD/ CHRONISTER/STIMSON
1	SpecEfxLaborer	✓	735-02	CARLUCCI
	Benches For People		725-25	
	Knock Down Sch. Rms.		725-23	
	Knock Down Dr. Rms.		725-23	
	Portable Dressing Rms.		725-23	LIT & READY
	Hook-Up Dr. Rooms		725-21	
	Schoolroom Trailers		725-24	
9	Dressing Rm. Trailers	—	725-24	

SOUND

1	Sound Mixer	6A	765-01	BERNARD, A.
1	Mike Operator	✓	765-02	AGALSOFF
	Sound Recorder		765-03	
1	Cable Person	6A	765-03	BERNARD, D.
	Extra Cable Person		765-04	
	P.A. System		765-06	
	Playback Mach. & Op.		765-07/05	
	Sound System		765	
15	Walkie Talkies	5A		@ LOC.

PROPERTY

1	Property Person	O.C.	750-01	SIMS
1	Set Prop Person	6A	750-01	RUSSO
1	Set Asst. Prop. Person		750-02	NESTEROWICZ
1	Set Dresser	O.C.	745-01	MEES
1	Lead Person		745-02	SEPULVEDA
3	Swing Gang Personnel		745-02	DE LA GARZA/
	Drapery Person	✓	725-18	D'ANGELO/RENICH
	ExtraSwingPrsn		745-02	
	Make-Up Tables		725-25	
	Hair Dressing Tables		725-25	
	Animals		750-06	
	Handlers		750-07	
	A.H.A. Representative		750-07	
	Wranglers		750-07	
	Wagons etc		750-08	

WARDROBE

1	Costumer Frprsn	O.C.	755-01	KUNZ
1	Costumer Dept		755-02	THOMPSON
1	Cost Dept	✓	755-03	SIEGEL
2	Set Costumers	5:30A	755-03	HOFFMAN/THOMAS
2	Extra Cost	4:30A	755-03	BERGGREN/ PALINSKI

MAKE-UP

NO	ITEM	TIME	CHARGE	REMARKS
2	Dept Head	OC/OC	760-01/01	WESTMORE/NORMAND
1	Make-Up Person	3:30A	760-01	KALLIONGIS
1	Makeup Person	4:30A	760-02	NELSON
1	Makeup Person	5:30A	760-02	WHEELER
1	Makeup Person	5A	760-02	SHOSTROM
9	Extra Makeup	3:30A	760-02	TBD
1	EXTRA M/U	4:30A		TBD
1	Hair Stylist	3:30A	760-05	MILLER
1	Hairstylist	3:30A	760-05	McKAY
1	Hairstylist	3:30A	760-05	ASANO-MYERS
7	Extra Hairstylist	3:30A	760-05	

ELECTRICAL

1	Chief Lighting Tech	5:30A	730-01	PEETS
1	A.C.L.T.		730-01	EY9LEE
4	Lamp Operator			CHRISTENBERRY/ SUZUKI/COOPER/BOURSE
3	Extra Lamp Op	5:30A		@ LOC.
5	EXTRA LAMP OP	8:30A	STG. 18	McKNIGHT +4
	Operations Phone		725-21	AT STAGE 18
	Portable Telephone		725-21	
	Wig Wag		725-21	
X	Work Lights and		725-21	
	MU Tables			
X	Gen 4 Oper	6A	730-02	@ LOC.

POLICE AND FIRE

	Fire Control Officer		725/775	STAGE
X	Fire Warden Loc.	PER LOC.	775	PER LOC. MGR
1	Set Security	3:30A	725	WARD
1	Set Security Person	5:30A	725	HERRERA
X	City Police	PER LOC.	775-02	PER LOC. MGR
	Studio Police		725-15	
	Motorcycle Police		775-02	
1	First Aid	6A	725/775	
1	LOC. MGR	3:30A		L. WHITE

MISCELLANEOUS

	Process Equipment		780	
	Process Camera Person		780-02	
	Process Asst. Cam. Per.		780-02	
	Process Grips		780-04	
	Process Electrical		780-04	
1	CostDsgnr	O.C.	755-04	BLACKMAN
1	VisEfxSpvr	—		
1	GraphicArtist	O.C.		OKUDA
1	Video Op	—	765-05	BETTS

MUSIC

	Piano		810-06	
	Sideline Orchestra		810-06	
	Singers		810-06	

CATERER

145	Hot Lunches	11:30A	12N	775/790	MICHELSONS -
X	HOT BREAKFAST RDY @ 4:30 AM		775/790	2 LINES	
	Dinners		775/790		
X	Gallons of Coffee	4:30AM	775/790	@ LOC	
	Gallons:				
X	Dozen Doughnuts	4:30 AM	775/790	@ LOC.	

TRANSPORTATION

1	TransCapt		770 775	SATTERFIELD
9	DRIVERS		770 775	
1	Camera Truck		770 775	
	Electric Truck		770 775	
3	StnWgns		770 775	
1	Grip Truck		770 775	
1	Property Truck		770 775	
1	Spec. Effects Truck		770 775	
	Set Dressing Truck		770 775	
2	Wardrobe Truck Trailer		770 775	
	Water Wagon		770 775	
1	Sanitary Unit - 8-RM		775	
2	MU Trlr		770 775	
1	Hair Trlr		770 775	
1	Maxi Van		770/775	w/Driver
5	CREW CABS			
3	3-RM TRLRS			
1	2-RM TRLR			

NOTE: ALL TRANS. CALLS PER SATTERFIELD

40

Merri Howard returned to her office, in the opposite direction from Adele's, following along behind Rick Berman, whose office occupied a corner of the second floor near hers, but on the other side.* In between, also on a corner, is David Livingston's office. The three offices form *Star Trek*'s production command center, and also define the perimeter of a large open area dominated by the desks of the PA's for each of the production executives.

An attractive brunette with a model's finely chiseled features, Merri Howard plays a central role in *Voyager* production, and is hands down one of the most loved members of the company. Time and again she has come to the aid of individual cast and crew members, helping solve both personal and work-related problems, and helping facilitate career moves for people who might not otherwise have been given the opportunity without her direct support or intervention. In a popularity contest, it would be a tough call between Merri Howard and Jeri Taylor. Both have done so much for so many.

One of the reasons Merri alternates Friday evening "set duty" with Brad Yacobian is that she wants both of them to have lives of their own. Merri has a fiancé, with whom she naturally wants to spend as much time as possible. Brad and his wife have three children. Merri does not want him to miss seeing them grow up. Howard has no children of her own, so the two alternate Friday evenings to give Brad a chance to participate a bit more in his children's lives. They also trade evenings off when shooting runs late and conflicts with personal activities. Brad, for example, likes to take his kids trick-or-treating at Halloween, so Merri works late if Halloween falls on a weekday. Likewise, Brad covers for Merri if she has a commitment of her own.

A veteran of *The Next Generation*, Merri Howard began her *Star Trek* career as a first assistant director during that series' second season. She was later promoted to unit production manager, and eventually to line producer. Now a full producer, she is an excellent example of Rick Berman's policy of always trying to promote from within. An apt title for her would be "Queen of Everything."

Merri Howard: I deal with everything that nobody else wants to do. I do the line-production work, which means I'm the focal point for everyone in the company, with the day-to-day operations. I oversee everything that happens on the set…making sure we're staying within budget…making sure we can meet

* During the third season Berman moved to larger offices at the other end of the Cooper Building.

our schedule. People bring their problems to me first. If there's a problem ordering equipment…a problem the actors have on the set, creatively with a line or a scene…or the director needs something, I can solve the problem or I can take it to David, Jeri, Michael, or Rick.

Everything publicity-wise goes through my office. Special projects, licensing matters, television ad support, outside conventions, charitable events, things like that. Between Brad Yacobian and me, we coordinate the efforts to make those things happen.

At Dave Rossi's desk, Merri stopped long enough to pick up her phone messages. Rossi was already back at work, on the phone while writing notes to himself. Superefficient, Rossi at times seems to be everywhere at once. Calm, deliberate, and very quick, he lives in the middle of a pressure cooker, but almost never shows it.

Merri glanced at her messages and smiled. One was an urgent call from David Livingston on Stage 9. He needed to talk with her "right away" about additional extras for a scene in Chez Sandrine the next afternoon. She smiled because she had been through this routine with David many times before. Livingston would press his case, Merri would listen patiently, and then she would, more often than not, diplomatically but firmly say "no."

It is an odd position for her to be in, since Livingston is her boss from day to day. But when he is working as a director, he has to answer to her in the same way any other director would. Merri Howard is an exceptional line producer, and one of the reasons is because she works hard at trying to keep each episode within budget. Some days, she is convinced it is a losing proposition.

There is a running joke about David Livingston. As *Voyager*'s supervising producer, Livingston plays a key role in keeping the day-to-day production business on track. He has been with *Star Trek* since the first season of *The Next Generation* and knows his craft very well. But it is no secret that David Livingston does not really want to be a producer. What he really wants to be is a director. Since he is quite good at it, Livingston will usually direct three or four *Voyager* and *Deep Space Nine* episodes each season. He has a passion for his work, shoots a lot of takes, and wants his episodes to be the best episodes ever directed by anyone.

In essence, David wears two hats. And with each, he is a different person. Which is where the joke comes in. When David is wearing his producer hat, operating from his executive office on the second floor of the Cooper Building, his attitude is "What? You want twelve extras? We don't have the budget! Can you do it with three?" When he is

wearing his director hat—as he was on Stage 9 that afternoon—his attitude is "What? I can only have fifty extras?"

Merri disappeared into her office. Rossi called after her. There was another request from the folks at Make-A-Wish Foundation. A young boy was dying of cancer and wanted to visit a *Star Trek* set. Merri okayed the request, instructing Rossi to make sure the boy will get whatever pictures he wants. Within the hour Rossi would generate memos alerting security, cast, and crew members of the upcoming visit.

Star Trek's production office has a long-standing policy of active cooperation with the Make-A-Wish Foundation. Every year terminally ill children are given the red carpet treatment with a tour of *Star Trek* sets. The policy was started by Berman during the years of *The Next Generation*, continued with the inception of *Deep Space Nine*, and now has since been expanded to include the *Voyager* series. Terminally ill kids and young adults are allowed on the sets during filming, are encouraged to talk with cast and crew members, and get their pictures taken with their favorite stars. Every effort is made to make them feel that this is their special dream come true.

The meeting room was half-empty now. Alan Sims stood at a table near the door, one foot propped up on the chair he had been sitting in minutes earlier. Oblivious to those elbowing past him, he was already talking on his cell phone to the model maker. The cylinder needed to be modified. Add blinkies. Yes, he knew blinkies needed batteries to run them. Yes, he was aware there was no room to hide the batteries. He instructed the model maker to hollow out the cylinder and hide the batteries inside the device.

"Blinkie" is a generic term for small blinking lights added to props, instrument panels, clothing, walls, or just about anything else that sits, walks, runs, or flies. True or not, the belief is widely held that adding blinking lights to something makes the item look more high tech. Blinkies are almost a standing joke in production because some people feel they are overused.

Before hanging up, Alan added that he needed the new version by Thursday. Then he rushed downstairs and out of the building, past the commissary, and hurried east along the studio's promenade.

The promenade is a wide pedestrian thoroughfare attractively paved with red bricks, tastefully landscaped with trees and large-potted shrubs, and sprinkled with benches and seating areas. It is an inviting and frequently used setting for relaxed lunchtime meetings, or a quiet cup of coffee between friends. The appearance is almost parklike—clean, attractive, contemporary—and gives the impression of a shaded walkway between ivy-covered buildings on a college campus somewhere, or perhaps the landscaping along the side of an upscale suburban mall.

It was a long walk back to his office in the Dreier Building above Stages 8 and 9. Sims checked his watch. Almost three o'clock. The day was late, and there was still a lot to do. "Eye of the Needle" would begin shooting in about forty hours. Sims again cast a nervous glance at his watch, something he would unconsciously do four more times before he reached his office.

Alan Sims paid little attention to the pedestrian traffic around him. There were few people about, unusual for a Monday afternoon. The length of several city blocks, the promenade serves as the main east-west thoroughfare for foot traffic between the executive offices of the motion picture division on the Van Ness Avenue (east) side, and offices of the television division, including *Star Trek* production and writing offices on the Gower Street (west) side.

In the middle lies a swath of parking lots, administrative buildings, production offices, soundstages, editing rooms, shops, mills, and support facilities running the entire length of the Paramount Studio property, from south to north.

Paramount has been home to *Star Trek* for some thirty years now, but not always under that name. As most fans of the series know, *Star Trek* began under the aegis of Desilu Studios, a venture created by Lucille Ball out of her purchase of the old RKO Pictures facility. That "lot," as such properties are known, was located at the corner of Gower Street and Melrose Avenue, stretching north along Gower for three or four city blocks. There it dead-ended up against a cemetery. The running jokes about this neighbor to the north have never ceased.

Immediately to the east, and smack up against the Desilu lot, was an intense competitor, Paramount Pictures. A wood and metal fence, in some places topped by barbed wire, separated the two rivals.

When Gene Roddenberry first pitched his science-fiction series idea to Herb Solow* in 1964, Desilu Studios was mostly a rental operation. Desilu's main claim to fame was the *I Love Lucy* show, shot before a live audience every week on one of the studio's ten soundstages. Everything else was rented out to independent production companies. Hollywood studios have a long history of renting at least some space to the independents; Desilu had more under rental than most.

In 1966 Desilu Studios was sold to Gulf & Western, an entertainment conglomerate that had also purchased Paramount Pictures. Eventually the fence was torn down and the two lots were combined into one sprawling facility covering roughly sixty acres.

* Herbert F. Solow, Desilu's executive in charge of production, and co-author (with Robert H. Justman, *Star Trek: The Original Series*'s co-producer) of *Inside Star Trek: The Real Story*, published by Pocket Books.

Today, Paramount Pictures is owned by Viacom Corporation (headed by Sumner Redstone)—which also owns other high-profile properties like Simon & Schuster, MTV, and Blockbuster Video. The owner may be new, but much of what came before remains. Most of the buildings date back to the twenties and thirties, their thick layers of paint attesting to decades of budget-minded, surface-only cosmetic care. Fifty years later the effect of the war years (WWII) is still visible, betrayed by an occasional corrugated tin roof or a decrepit-looking shed cobbled together with scavenged wood and metal, built during a time when new construction materials were all but nonexistent.

While some of the buildings have all the architectural style of an army recruit training base, the majority of them have names that evoke Hollywood history, glamour, romance, and legend: Dietrich, Valentino, DeMille, Von Sternberg, Zukor, Crosby, Ball, Fields, Wilder, Swanson. There's even a building named after the late great Carole Lombard, but it is tucked away in a corner of the lot and a bit hard to find.

There are several new buildings, to be sure. Back in the sixties when *The Original Series* was filming, there used to be an old auto mechanic's garage and some other dilapidated buildings on a site along Van Ness, near Gower. Over the years these structures were torn down and the property paved over for a parking lot. In 1993 a four-story building was erected and named the Marathon Building, which is what that part of the lot used be called before it was called the Paramount lot. It is this building that anchors the eastern end of the promenade.

The Marathon Building is home to executive offices for motion picture marketing, the digital entertainment division, licensing/merchandising (the preferred term is consumer products), and a host of other activities. History is nothing if not laden with irony. Today, a major portion of the fourth floor of the newest office building on the lot is devoted to the licensing and merchandising of products related to Paramount's film and television programs, the preeminent property being, of course, *Star Trek*. Yet, when *The Original Series* was struggling through its initial seasons, Desilu treated the whole idea of *Star Trek* licensing and merchandising with immense disdain. It was as if studio executives felt greatly annoyed at having to even discuss the subject at all.

Thirty years later it is still difficult to comprehend that attitude. In the late sixties, television series such as *Batman*, *The Munsters*, and others were making lots of money with licensed merchandise tied into those shows. It was not as if no one in Hollywood knew there was money to be made from licensing. *The Hollywood Reporter* and *Daily Variety* commonly reported on these earnings, often on the front page.

But when it came to *Star Trek*, something seemed to "click in"— some sort of corpo-

rate aberration—and licensed merchandise emerged only slowly and with, apparently, great reluctance. Certainly the evidence indicates there was no great push.

With the success of the *Star Trek* motion pictures, particularly *Star Trek IV: The Voyage Home*, and the growing popularity of *The Next Generation*, *Star Trek* merchandising began to be taken seriously—more so as the number of licensees grew and studio revenues grew with them.

Money makes believers. And changes attitudes.

Especially when the bottom line is affected.

Today *Star Trek* licensing and merchandising activities are the goose that laid the golden egg. So much for being an annoyance.

The golden goose generates more than just dollars. In 1990 a large three-story office structure was built near the middle of the lot, on the west-central side, and named the Roddenberry Building, after *Star Trek*'s creator.

It is no secret to those who knew him that Gene for many years felt he was a prophet without honor in his own house. His relationship with Paramount was stormy, contentious, almost never smooth. He did not trust the studio and, rightly or wrongly, allowed that distrust to motivate his dealings with studio executives. Human nature is such that negative actions and statements invariably provoke negative responses—witness the situation in the Middle East.

In retrospect, Roddenberry's association with Paramount was not unusual; many writer/producers have had similar relationships with other studios. Whatever their origins, these affairs seem to be a long-standing feature of the Hollywood landscape.

Though in failing health at the time, Gene was able to attend the dedication of the new Roddenberry Building, and for a while bask in the glow of studio recognition. While the tribute may have come late in his life, it must have been immensely gratifying to him. To some, the building itself is a constant reminder of "The House That Gene Built."

To the east, the Roddenberry Building overlooks a sunken parking lot that doubles as a giant water reservoir, flooded periodically to film ocean or lake scenes. Some of the most exciting naval battles in the history of cinema have been shot in this parking lot. It was here that Moses parted the Red Sea, under the direction of Cecil B. DeMille, and the castaways of *Gilligan's Island* cavorted every week. A number of *Star Trek* scenes have been filmed in this same parking lot, including the famous whale scene in *Star Trek IV: The Voyage Home*.

Immediately to the north, right behind the Roddenberry Building, is a well-known Hollywood landmark, the Paramount Studios water tower. It is easily the tallest structure on the lot, looming high above the entire operation.

THE FRANCHISE

An average week for us runs seventy to eighty hours, five days. You try to come in fresh, but it's very difficult. People don't realize what it takes to get five seconds of film in front of the camera. It's a very brutal pace.

Alan Bernard
Sound Mixer

RELIEVED THAT THE PRODUCTION MEETING WAS over so soon, Denise Okuda, Rick Sternbach, and Wendy Drapanas made their way back toward the *Voyager* art department at the far northeast corner of the lot. The trio headed north toward the Roddenberry Building, then cut east again along the edge of the parking lot/reservoir. The sunken lot was devoid of cars, temporary barricades surrounded the entire area. Workmen were beginning to drill a row of large holes through

the asphalt, along the top perimeter. Nearby were stacks of materials, including a sizable pile of telephone poles.

Rumor had it that the parking lot was slated for use as a replacement for an ocean set in a movie being shot by Universal Studios. It was said the original set, costing millions, had sunk somewhere in the South Pacific. According to what Denise had heard, the movie was already being labeled a financial disaster. Something called *Waterworld*, starring Kevin Costner, she thought. The construction forced the three to detour around the area.

Taken as a whole, the Paramount lot is a small city-state, complete with restaurants, theaters, a licensed merchandise outlet—named, appropriately enough, The Company Store—dry cleaners, barber shop, florist, gymnasium, credit union, postal facilities, lumber yard, phone company, and police and fire departments. There are numerous other support services as well, including a mill, machine shop, paint shop, library/archives, music recording studios (scoring), and carpet and drapery facilities.

In the last five years, there have been significant efforts to beautify the southern, Melrose, side of the lot—at least the part that visitors see first. The main entrance to the lot from the Melrose Avenue side is Windsor Gate, spruced up nicely from the nondescript, generic architectural style prevalent since the fifties and sixties. Nearby, the studio's original entrance, an old familiar wrought-iron-and-stucco arch, now accessible only to people who have already gained entrance to the lot, remains pretty much the same. Both drive-on and walk-on visitors pass through security points at the Windsor entrance, emerging into pleasantly landscaped parking areas flanked with shade trees.

Thirty yards or so further into the lot, visitors cross the wide, brick-paved pedestrian promenade, the centerpiece of the recent beautification process. Across the promenade and through the trees on the other side the illusion ends, as the bulk of the "real" buildings becomes visible. The contrast is conspicuous.

On any given day there are several thousand people "on the lot." Some are direct employees of Paramount—Studio, Motion Picture, Television, etc. Others are employed by Viacom, United Paramount Network, or the dozens of independent production companies and contractors who work on the lot. Paramount is the largest employer in Hollywood, and is now its sole remaining major studio.

A large percentage of the people who work on the Paramount lot carry pagers; many carry cell phones as well. When the camera is rolling (filming) on a set, the combined costs on that one set alone are in the tens of thousands of dollars per hour. If someone is needed immediately—to solve a problem, say—there had better be a way to find him or her fast.

Over the last thirty years, Gene Roddenberry's vision of the future has grown from Desilu's troublesome stepchild into Paramount's full-fledged entertainment giant. No. More than that. An entertainment phenomenon unprecedented in any medium.

This growth has certainly had an incredible impact on Paramount lot operations.

Consider: There are 32 stages on the lot, varying in size from the smallest, Stage 22, to the largest, Stage 16. The smaller ones are generally used for television shows; the seventeen larger ones can be used for either television shows or feature films. From a revenue-generating perspective, the largest stages are usually reserved for feature filming.

However, just to satisfy the weekly filming needs for *Voyager* and *Deep Space Nine*, *Star Trek* consumes six of the largest feature stages on the lot—permanently—plus the occasional use of two or three additional feature stages. As a commitment in plant facilities alone that represents a significant impact, not counting all the other ancillary offices and support facilities *Star Trek* consumes.

And there are a lot of them.

Voyager and *Deep Space Nine* both have their own separate casts and production crews. Writing staffs are different for each, as are the art departments, film crews, and editorial personnel. Whereas *Voyager* uses Stages 8, 9, and 16, *Deep Space Nine* uses Stages 4, 17, and 18. The same production and postproduction staffs oversee both series, and are headquartered in the Cooper Building.

The Hart Building—everybody refers to these buildings by a single name only, as in Hart, Cooper, Dreier—directly across the street from Cooper, houses the executive producers (except Rick Berman), a few producers, and the writing and preproduction staffs for both series.

In *Star Trek*'s case, the producers in Hart are all writers. The title "producer" is usually granted as a promotion, a reward to a writer after some tenure and performance. It is often negotiated between the studio and the writer, as a means of giving additional compensation and recognition. Brannon Braga, for example, is called a supervising producer, but he is exclusively a writer—although this would change significantly with *Voyager*'s fourth season.

Jeri Taylor is an exception to this practice. In addition to her writing duties she is also responsible for fielding all creative problems that arise on the set during filming: actors' requests for changes in dialogue (it happens), differences of opinion between a cast member and a director, questions regarding technical terms based on known real-world technology, the way a character is portrayed, and so forth. She is also involved in studio meetings, casting decisions, and addressing certain day-to-day operational matters including managing the writing staff.

From the outside, the four-story facility looks small. Once you are inside the entrance, the reason becomes clear: the Hart Building looks small because it is almost Lilliputian. Narrow musty corridors—they are too little to be called hallways—run down the center of each floor, giving access to mostly drab, closet-sized office spaces on either side. Producers of whatever rank generally rate offices somewhat larger than the closets.

Built in 1936, Hart has four floors. The first floor is assigned to *Voyager*. The second floor belongs to *Deep Space Nine*, with the third and fourth floors more or less split between the two.

Anyone who ventures above the first floor learns after a visit or two to take the stairs at the end of the corridors rather than chance the elevator. Aside from being of questionable reliability—it has a disturbing habit of stopping between floors—this ancient piece of machinery that pretends to be an elevator is not for the squeamish or the claustrophobic. Two people can barely squeeze inside. The interior is so cramped and confining that if a man and woman enter the elevator together, either one can file a sexual harassment suit against the other.

At one time, Gene Roddenberry had a small office on the third floor of Hart. He used to complain bitterly about the elevator, and would use it only as a last resort. Later, when his fortunes improved with the start-up of *The Next Generation*, Gene was moved to a larger office on the first floor—the very same office now occupied by Michael Piller. This particular office, along with its mirror-image twin across the hallway, has an interesting history. They were at one time occupied by Bob Hope and Bing Crosby.

In addition to assimilating both Cooper and Hart—Resistance is futile—the rest of the *Star Trek* production activities are scattered around the lot in a checkerboard of buildings and offices. The impact is so enormous, so pervasive, that it is not possible to spend any reasonable amount of time at Paramount and not be aware of *Star Trek*'s presence.

Many people—not just those directly associated with things *Star Trek*—often do not even refer to the phenomenon as a "show," or "series." The whole business—anything and everything related to *Star Trek*—has been lumped together under one all encompassing term: the franchise. And generally it is uttered with a touch of reverence in the voice of the speaker.

Not without reason. The franchise contributes so much money to Paramount coffers that it is easy to assume that the revenue pays for much of everything else at the studio...that *Star Trek* provides the financial matter-antimatter fuel that keeps Paramount running.

Michael Piller's office. A mirror image of Brannon Braga's, this office was once occupied by Gene Roddenberry during the early days of *Star Trek: The Next Generation*. STEPHEN EDWARD POE.

But to focus on revenue alone would be a mistake. Money does not define the franchise. Money is a by-product of the franchise.

There is something more at work here, something larger than currency, something more profound than a weekly television series. Never in the history of entertainment has there been anything like what has happened with the *Star Trek* universe.

Not even close.

One Paramount Television official who is acutely aware of the power, impact, and value of things *Star Trek* is Tom Mazza, Executive Vice President, Current Programs and Strategic Planning, Network Television. Practically speaking, Mazza is Rick Berman's immediate boss. In Hollywood, no one has absolute power. The system is a hierarchical chain. There is always someone sitting in a position of higher authority. Mazza reads every script, provides direct input on each episode, and exercises final approval on all major elements of both *Voyager* and *Deep Space Nine*. Technically, Kerry McCluggage—chairman of

Paramount's Television Group, and Mazza's boss—has the final say on everything. But it is Tom Mazza who is on the front lines of the day-to-day operations of *Star Trek* television.

This position of authority over Rick Berman and *Star Trek* manifests itself in some rather oblique ways. One of these is Hollywood's tendency to assign possession of projects to certain individuals. For example, if Rick Kolbe directs an episode, some people will later say, "Oh yes, 'Eye of the Needle'— that's a Rick Kolbe show." If Brannon Braga writes an episode, some people will later say, "'Parallax'? Yeah, that was a Brannon Braga episode." Similarly, certain entertainment industry executives will say, "Oh, *Voyager*…that's Tom Mazza's series."

> Tom Mazza: The franchise has a very theological umbrella hanging over it. One of the reasons viewers respond so well to it is it's a very uplifting franchise. It asks viewers to buy into a lot of belief systems…all positive ones. Not bad ones. We don't have a bad prediction for the future. Other science fiction shows don't have the uplifting, spiritual adventure that *Star Trek* has. People love to see interesting characters. They like to see them working together as a team. It's important. People want to have hope.

If indeed "the past is prologue," then there should be clues or useful comparisons, to help explore…explain…perhaps even understand…why and what it is about *Star Trek* that has produced the lasting popularity and the enduring nature of what has become known as the franchise. It turns out there are.

Throughout the history of broadcast television there have been attempts to resurrect a canceled series. These attempts have been singularly unsuccessful. *Bonanza* is a good case in point. Here was a series that was near-religion to millions of faithful for more than a decade. Its popularity was taken for granted, gaining the status of an American institution. Lorne Greene became the ultimate father figure, unseating the previous titleholder, Robert Young of *Father Knows Best* (later reprising his father-figure image as television's *Marcus Welby, MD*). American viewers love their father figures, but they are also fickle. Every so often they like to change idols. This is, after all, the age of the nuclear family.

And then the unthinkable happened…*Bonanza* was canceled. The anguished cries of heartbroken viewers were legion. Despite a massive outpouring of support, the decision was cast in stone. *Bonanza* stayed canceled. Time passed. Then in 1987 attempts were made to resurrect the series. The reasoning seemed sound enough. With millions of loyal view-

ers still out there—it was presumed they had not all died—the series looked like a sure thing. Yet, the effort failed miserably.

Not so with *Star Trek*. That same year Gene Roddenberry, Robert H. Justman, the late Eddie Milkis, and others were busy launching a reincarnation of their own. In an updated form and set one hundred years later, *Star Trek: The Next Generation* ran for seven seasons and became the highest-rated syndicated dramatic series of all time.

> Rick Berman: When I first got involved with *Star Trek: The Next Generation*, it already had at least two-and-a-half strikes against it. From the very start. It was a sequel, and sequels have never worked in television. It was a science-fiction show, and in 1986–87 there were no science-fiction shows on television that were successful…there hadn't been in a decade. And it was going to be syndicated! Unheard of! Unheard of! "It's not on a *network?*" "What network are you on?" "Well, we're on syndicated…" "Huh? What's that?" So here we had this syndicated science-fiction sequel.

Why would *Bonanza* fail, and *Star Trek: The Next Generation* succeed? Further, *Bonanza* is not an isolated case. Other defunct series have attempted a rebirth. None have done well. *Star Trek* still seems to be the lone exception. One recent example of an ongoing attempt at a resurrection is *Kung Fu: The Journey Continues*, but it just staggers along and abuses credibility unmercifully. What is it about *Star Trek*? Why should it live on while others remained in the television cemetery? Clearly, something else is afoot here.

This "something," whatever it is, has not gone unnoticed by rival Hollywood studios and producers. "If you can't beat 'em, copy 'em."

Broadcast television, more so than motion pictures, has taken mimicry to a high art. The rule of thumb seems to be "if their show is a hit, copy the idea and we'll have a hit." As a result, historically, successful motion pictures and television series are often soon besieged by clones and look-alikes, all eager (salivating?) to tap into a lucrative market. It is no surprise that Hollywood's interest in *Star Trek*'s phenomenal success has generated quite a few science-fiction television series, especially since 1987. Few have done well.

One recent example that failed to live up to expectations is *seaQuest DSV*.

From the outset *seaQuest* had a lot of things going for it. One who knows from firsthand experience is Ben Betts, *Voyager*'s personable and highly skilled video playback operator. According to Betts, who worked on *seaQuest* prior to joining *Voyager*, the premise was

good, and from a technical standpoint the show looked great. The cinematography was excellent; the special and visual effects were well created. In Betts's opinion, though, what was lacking was the vision that *Star Trek* expresses for the future of mankind.

> Ben Betts: They definitely wanted to have something like *Star Trek*. They wouldn't say that out loud, but that was what they were going for. They were trying to find *Star Trek* under water. Everything was there, except for the stories. They didn't have enough of a human element so they'd get caught up in the technology…kind of fall back on the technology to bail everybody out by the end of the episode. It was plain as day to people working on the show.
>
> Everything was right. They were spending the money to make the graphics look good, the CGI (computer-generated images) looked great, the sets were well lit, they had a pretty good cast…but it didn't work. It still wasn't *Star Trek*.

All the ingredients were there, on the surface. Yet *seaQuest* was not a hit.

Based on the evidence, entertainment-industry observers might well be asking themselves, "What do those people know," that everyone else in television production does not? The answer probably is "nothing." There are few secrets in the entertainment business. More likely, the answer rests in the way in which the franchise has evolved over the last thirty years. It seems to operate unaffected by whatever the rules are that govern clones.

Usually what happens is the clones fail to catch fire with the viewers and so get canceled rather quickly. Curiously, the show that spawned all the clones disappears soon thereafter. *Star Trek* is the notable exception. Copycats fall by the wayside, but *Star Trek* endures.

This reality must be enormously frustrating to more than one Hollywood studio. To oversee a production empire of one's own, and yet be able to look in your neighbor's backyard and see this untouchable and unduplicatable profit center—the franchise—basking on the *TV Guide* lounge chair, soaking up the glow of television viewership…the sight must drive many a rival studio executive crazy.

All the more so considering the fact that the franchise has succeeded in yet another, minefield-strewn sea of production—the spin-off.

Broadcast television is no different from motion picture production, in that everyone wants a hit. A megahit would be better. While some people have claimed to possess a crystal ball and can predict what will be a hit and what will not be, the reality is, it is still

a crapshoot. No one yet has invented a "surefire formula" for a hit show, let alone a megahit.

In the absence of such a formula, there is always the philosophy that says "if some is good, more is better." That is the mindset that generally launches spin-offs. On the surface, the idea has a certain logic to it: if a show is a hit, then take an element of that show, spin it off into a show of its own, and that show will be a hit also. Sounds like a good theory, but in historical fact it does not work very well at all. Seldom do spin-offs last more than a season or two. Those that do succeed are carried solely by the popularity of a single personality or star, such as the *Rhoda* series. But even with these, longevity ends up being tenuous.

Almost without exception, the spin-offs keep failing to win the loyalties of enough viewers to keep the spin-off spinning. *Star Trek*, on the other hand, keeps bucking the odds…and winning. With *The Next Generation* unbeatable in the syndication ratings, Paramount launched *Deep Space Nine*.

Suddenly Paramount found itself in the enviable position of having two successful series on the air simultaneously, one a spin-off of the other and the "other" being a sequel to the original! Could it last? Apparently so, because as *The Next Generation* began its seventh and final season, plans were already well under way for a second spin-off to the sequel, which became *Voyager*.

So here we have The-Franchise-Formerly-Known-As-*Star Trek* (*The Original Series*):

1. Resurrected from the dead to become a megahit;
2. A sequel to the original, sporting many of the familiar trappings of its forebear;
3. A science-fiction series;
4. A syndicated series; and
5. Spawning not one, but two successful prime-time spin-offs.

By now, even the most jaded Hollywood professional would have to agree that something extraordinary is going on here. Clearly, the viewers think so. But what is this "something"?

Whatever it is, the powerful appeal is not limited to broadcast television. This "something" has been carried over to the big screens of motion picture theaters in a string of eight full-length features. According to an article in the *Los Angeles Times*, merchandise from the four *Star Trek* television series and seven feature films "has generated nearly two billion dollars' worth of retail sales."

"Powerful appeal" may well be an understatement.

Now, it is true there have been successful television series in the past. Some have run a decade or more. There are at least a few highly rated television series on the air today. Too, there have been a few box-office megahit motion pictures that have gone on to generate highly popular (and sometimes critically acclaimed) sequels. *Star Wars* and the James Bond movies are stellar examples in the theatrical motion picture field.

But none has ever done both.

Repeatedly.

Except *Star Trek*.

The fact is, never in the history of any entertainment medium has there ever been a story, an idea, a situation, a set of characters, or a theme that has approached the magnitude or impact of *Star Trek*.

It would be a gross oversimplification to say that what is going on here is merely a handful of television series and a string of feature films. And that is probably the point of the term the franchise. The television shows and movies do not define the franchise any more than money does. They are merely expressions—offerings—from its wellspring.

Part of the reason for the growing scope and impact of the franchise is the fact that, like our own universe, the *Star Trek* universe has been steadily expanding also—for the past thirty-one years. Longer, if you count Gene Roddenberry's developmental ruminations before he made his pitch to Desilu's Herb Solow in 1964. In that time whole galaxies have been born. Men and women have journeyed beyond even the dreams of Roddenberry himself. A vast panoply of characters are alive today in the minds of an estimated thirty-five-to-forty million television viewers every week. Characters and alien races with names, families, and ancestries traceable back, in some cases, for thousands of years.

Complex technologies have evolved that at one time staggered the imagination, but no longer. Technologies previewed on *Star Trek* have been showing up on twentieth-century Earth from almost the very first airing of the very first episode in 1966—tricorders marketed by a company in Canada, flip-phone communicators (now called cell phones), personal access digital displays, electronic clipboards, and more.

References to *Star Trek* are now commonplace in our culture and throughout the English language. Bumper stickers proclaim "Beam me up, Scotty"; television and radio commercials tout products guaranteed to "take you where no ('X') has gone before"; a flight attendant for Southwest Airlines proudly announces "Captain Kirk has cleared us for takeoff"; Billy Crystal, in the movie *Forget Paris*, has a line of dialogue in which he says "His emotions were on warp speed"; etc., etc. etc. The jargon and references are everywhere.

All the more remarkable is the fact that no one bothers to explain where these terms or phrases originated.

It is assumed the listener already knows.

Culturally, that is staggering.

Clearly, *Star Trek* is far more than what meets the eye in movie theaters and on television. The impact on society is unlike anything ever experienced before in the history of entertainment. In fact, *Star Trek*'s lasting impression on all of us has been well documented in countless books, films, television specials, essays, articles, and lectures, and acknowledged as the source of inspiration for human endeavor in virtually every field imaginable. But there is more.

Unique alien races—species—have been created. Sentient beings that are easily identifiable, with unique characteristics of their own, each as uncommonly different from one another as human beings are from the aliens. Many of these alien races each have their own well-known, thoroughly established history, origin and evolution, culture, philosophy,* art, poetry, music, religion, social customs, martial arts, principles of business and finance, technologies, games…down to entirely new languages that are fully translatable into English!

In short, an entire universe so incredibly detailed, for both humans and aliens alike, that it might as well be real.

There simply is no precedent for what has happened. Small wonder the whole thing has been rolled up under the umbrella term, the franchise.

Small wonder Paramount takes a serious interest in protecting the franchise at all costs. And making it pay.

Nowhere is this more evident than in the realm of licensing and merchandising. Hundreds of consumer products are licensed each year for manufacture and sale by companies worldwide. Not to be outdone by Disney or Warner Brothers, Paramount has launched a merchandise retail store in Chicago devoted to Viacom products, the first in a projected chain of such outlets everywhere. Action figures, model kits, posters, books, computer games, clothing, mouse pads, commemorative china plates, coffee cups—the list of items seems endless. So does the queue of new suitors lined up outside the door, awaiting their chance for a piece of the twenty-fourth–century pie.

For vendors, an added bonus is the historical fact that, unlike anything else in entertainment, *Star Trek* has "legs"—staying power. Fads come and go. Television shows and movies are popular for a while, then fade away. *Star Trek* remains. And the merchandise continues, year after year.

According to Paramount's "Did You Know…" fact sheet, a lot gets turned out.

* For a truly superb example, see *The Klingon Way*, by Marc Okrand, published by Pocket Books.

STAR TREK® VOYAGER™

1995–96 SEASON

DID YOU KNOW...

• *Star Trek: Voyager* is the only television show in <u>TV Guide</u> history to be featured on the cover of the publication before editors could even see the show.

• *Star Trek* is seen in more than 100 countries and has been translated into dozens of languages.

• Every month, a classic *Star Trek* or *Star Trek: The Next Generation* novel is published by Pocket Books.

• 13 *Star Trek* books are sold every minute in the United States.

• More than 63 million *Star Trek* books are in print and have been translated into more than 15 languages including Chinese, Norwegian, Hungarian and Hebrew.

• Since July 1986, every new classic *Star Trek* novel published by Pocket Books has been a <u>New York Times</u> paperback best-seller. To date, the novels have sold close to 30 million copies, making it the best-selling series in publishing history.

• In addition to the novels, a variety of *Star Trek* books, including biographies and technical manuals, have landed on national best-seller lists more than 40 times.

• *Star Trek* conventions are held every weekend of every year, in at least four different U.S. cities attracting more than 300,000 fans and an estimated one million fans worldwide.

• "Trekkies," now called "Trekkers," are the only fans listed by name in the Oxford English Dictionary.

• The U.S. Space Shuttle, the "Enterprise," was given its name after NASA received 400,000 requests from *Star Trek* fans.

-more-

THE ART DEPARTMENT

Money is always a problem. It seems like we start out with designs for the Taj Mahal

and end up building Motel 6.

Richard James
Production Designer

THE VOYAGER ART DEPARTMENT OCCUPIES A
second-floor corner of the Dreier Building—a long, narrow, facadelike struc-
ture running the full width of Stage 8 and the adjoining Stage 9. If you did not
know it was officially a building, you would not recognize it as such. The building looks
like it was glued onto the front of both stages and, in fact, has been used as a set in such
motion pictures as *Sunset Boulevard*. The top floor is cut up into a series of small cubicles
that pass for offices. A narrow balcony/walkway runs the length of the second floor,

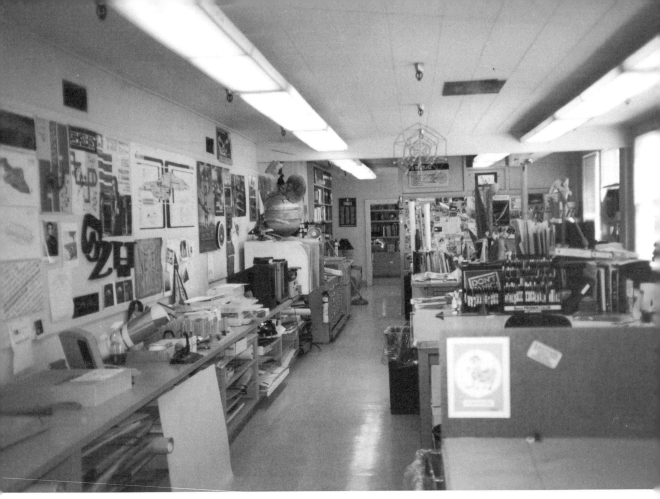

View from the opposite end of the *Voyager* art department. The door to Richard James's office can be seen in the far background. STEPHEN EDWARD POE.

giving entry to each cubicle. Rickety ancient wooden stairs at either end provide access from the street below.

The largest second-floor office by far is allocated to the *Voyager* art department; the other spaces provide shelter for people like Alan Sims, Jim Mees, Al Smutko, and makeup department head Michael Westmore. All but Westmore work for Richard James.

Altogether, James oversees a staff of some fifty to seventy people.

Richard James: It's not all about blueprints, and a few people making some quick drawings. Besides the ten people in the art department, I have a set decorator and his crew, a construction coordinator and supervisor, probably any-

where from ten to twenty carpenters—depending on the needs of each episode—the painters, property master and his crew...a lot of people.

Within the art department itself, James's staff includes Michael Mayer; Rick Sternbach; Michael Okuda; assistant scenic artists Wendy Drapanas and James Van Over; two senior set designers, Gary Speckman and Louise Dorton; and production assistant Tony Sears.

Physically missing from the *Voyager* art department is long-time science-fiction aficionado James Van Over. The computer animation guru is shoehorned into an office in the *Deep Space Nine* art department, sharing cramped quarters with Denise Okuda, Doug Drexler, and Anthony Fredrickson. Van Over's primary job is to create animation sequences for both series, using a Macintosh Quadra 950 computer—a function he performs brilliantly. He could actually work in either department, except for one small detail: when Jim was hired, the *Deep Space Nine* art department had the only spare workstation available. Having settled in, it would probably take an act of Q to get him to move.

Like Van Over and most of the other art department staff, Richard James has had a long-standing interest in science fiction.

As far back as junior high school in Texas, James was intrigued by science fiction, UFO's, and the idea of alien contact. It was only natural that he would begin gravitating to companies working in the burgeoning area of aerospace. While in college at Fort Worth, Texas, he majored in advertising art and design, to prepare for a career as an art director with an advertising agency. The possibility of working in show business never occurred to him. During the summer months and between semesters he worked for companies like General Dynamics and Bell Helicopter, doing technical illustrating.

After graduation, James stayed in Fort Worth because his father was ill with cancer. Instead of heading for New York City and Madison Avenue, he went to work full-time for General Dynamics. Over time, he got involved with Casa Mañana, a local theater-in-the-round. In the evenings he would show up as a volunteer, painting scenery for free. Eventually he was offered a part-time job. Show business began to grow on him, and he spoke to friends about his desire to move to New York.

Fortunately for *Star Trek*, his friends talked him out of it. Go to Los Angeles they advised. Get into films.

James heeded the advice, contacting North American Rockwell in Downey, California. The aerospace firm hired him, moved him to L. A., and assigned him to the art department. Later he was transferred to environmental engineering, where he created

3-D drawings on the interior of the Apollo capsule, to show the engineers what things looked like inside the craft. He soon realized his work was more important than he had initially thought, discovering that the slide-rule–oriented engineers could not visualize very well.

After several years of illustrating for engineers, James got so sick of what he was doing that he simply quit, to be free to look for a different job. He had by then decided he wanted to get into show business.

His friends thought he was crazy to give up the security of working in the aerospace industry.

But Richard forged ahead anyway, eventually landing a job in the scenic art department at NBC-TV. Three months later he was an assistant art director. Within the year he was promoted to art director. Over the years he worked on a number of shows, including *The Tonight Show* and *Battlestar Galactica*. It was his design influence on the latter series that brought him to the attention of Gene Roddenberry and production designer Herman Zimmerman when work on the pilot for *The Next Generation* was getting underway.

At the start of *The Next Generation*'s second season, Zimmerman shifted gears to work on the feature film *Star Trek V*, and James moved up to production designer on the series. Zimmerman subsequently became production designer for *Deep Space Nine*. When production on *The Next Generation* ended, Rick Berman asked James to assume the production-designer duties on *Voyager*.

For Richard James, it has been a long journey from Fort Worth, Texas. Along the way he developed an interest in collecting antique crystal inkwells and miniature lead military figures, as well as a passion for old cars. At the moment his pride and joy is a classic 1969 Mercedes 280 SE convertible. He is also a lover of antique English furniture—principally Chippendale and Queen Anne—and old-style musicals like *Oklahoma!* and *South Pacific*. Rare breeds of dogs are more than a passing interest as well; James owns two Australian terriers, named Grizzly and Spike.

The time to enjoy these interests is, unfortunately for James, all too short.

The physical layout of the *Voyager* art department is long and narrow. Just inside the entrance is Tony Sears's work area. It is not even an office—if visitors take too big a step as they enter, they will fall over his desk. James's office is immediately to the right. The rest of the space is arranged in an open room dominated by a single-file row of drafting tables, most of which are accompanied by Macintosh computer workstations. A cramped utility closet separates Tony's desk from the larger room. A row of windows runs along the street side; a long countertop with storage cabinets below runs the length of the opposite wall.

Lousie Dorton, at her drafting table in the *Voyager* art department. She was promoted to art director at the start of the fourth season and now has an office of her own. STEPHEN EDWARD POE.

The room is another world—part serious workspace, part study in the bizarre (example: two conical, tasseled breast covers glued to the side of Louise Dorton's file cabinet). On this December day in 1994 the room has been home to the *Voyager* art department for only about seven months, a familiar role since it was previously *TNG* art department, yet the space has already become fairly crowded. There are still open walk-way areas, but these are just as clearly being encroached upon by creeping art blight. Indeed, the room looks as if it cannot decide yet whether to be neat, clean, and orderly or just surrender to the process and ascend into chaos.

The countertop along the wall has begun to sprout piles of assorted materials: drawings; reference books; spaceship models in the making; spaceship models in the thinking; spaceship models as prototypes; just plain spaceship models; pieces of what used to be spaceship models; blown-up, Borged, Klingoned, Romulaned, or otherwise destroyed spaceship models; alien-planet-concept globes; a Uhura action doll; a vertical

artwork file bin labeled "Prelaunch Use Only"; a plastic alligator; a cast-off padd (personal access display device) from an old *Next Generation* episode—plus an assortment of miscellaneous useful items like a VCR, monitor, paper cutter, fax machine, and printer.

Here and there the few remaining open spaces on the countertop have been put on notice: the tide is inexorably rolling in.

The wall above is a repeat, in vertical form. While not completely covered yet, its days are definitely numbered. Most of the surface is now buried with an eclectic assortment of stuff like a scenic mural of Yosemite, various *Star Trek* posters, a *2001: A Space Odyssey* poster, line drawings of spaceship interiors, line drawings of spaceship exteriors, a large cutaway detail of the *Enterprise*-D, pictures of NASA astronauts, assorted posters and pictures adorned with irreverent comments, and colorful—if indecipherable—renderings of alien symbols. The effect is a cross between an art gallery and a berserk bulletin board.

Unquestionably, the product of warped minds.

Periodically Richard James, who is fastidious by nature, cannot stand it any longer and orders a clean sweep. For a while, work surfaces are actually visible. But, as one resigned to his fate, he knows it will not last. As soon as James walks away, the blight begins to creep back again, like mildew in a damp climate.

Not that everyone wants a messy work area—albeit the overall effect is an interesting, "arty" kind of environment, with a distinct appeal all its own. The real problem is that under normal circumstances there is barely enough time to get the day's work done, let alone be concerned with taking the time to put everything away.

Richard James: Time is always our enemy. From the time we get a script to the time it shoots…the first day of the seven-day schedule…I probably have, from start to finish, ten days on the average. That is reading the script, visualizing the sets, designing and budgeting them, getting them approved by Rick Berman, getting the construction blueprints drawn up and distributed to everybody, and then getting the sets built, painted, and dressed. That's not a lot of time.

The real killer episodes for us are the ones where the action takes place for the most part on the new sets—what we call the swing sets—those are built on Stage 16. If we get an episode with only one or two days shooting in the permanent sets on 8 and 9, and five days of shooting in the new sets on 16,

the impact on us is just a killer. It leaves us scrambling to get the new sets built on 16 for the next episode, because we can't start building those sets until we tear down the old ones. It's the kind of schedule I look at and say, "Oh, no."

Were it not for the pressure of getting ready for the "Caretaker" reshoots, James would have had a relatively easy schedule, prepping the sets for "Eye of the Needle." The episode took place entirely aboard *Voyager* —an episode known as a "ship show," or a "bottle show"—and called for only one other set besides the Jane Eyre set, the bridge of a Romulan ship. That set had been previously established in *The Next Generation*, so there was really nothing to design. But the change in act formatting for "Eye of the Needle," on top of the "Caretaker" workload, changed everything.

Tony Sears headed out the narrow door, suddenly changed his mind, and backtracked past his desk. Slender, medium height, quick to accept any task, Tony joined the *Voyager* art department in June, but at thirty-one has already spent most of his adult life in production, on both the East and West Coasts.

The reason for Sears's abrupt change of mind was a hunch. He rounded the corner past his desk and approached Michael Okuda, who was bent low over his drafting table, adding markings to an exterior drawing of *Voyager*'s shuttlecraft. The production drawing was destined for use by *Voyager*'s visual effects department, and Michael was adding a few technical updates to the shuttle's markings.

"Mike…I'm making a run to storage. Need anything?" Tony stood there expectantly, looking at the bent frame of the scenic art supervisor, who did not look up, but continued working on the drawing.

"Yes. Bring me back some photon torpedo letter bombs." This was not one of Okuda's better days. Yet the response was delivered quietly, without emotion or inflection.

"Okay," was Tony's cheerful reply, and he was gone.

At forty-three, Michael Okuda is an art department "old-timer," with roots going back to the feature *Star Trek IV: The Voyage Home*. He has a reputation for being both tireless and passionate in his devotion to helping maintain *Star Trek*'s accuracy, consistency, and inventiveness. His knowledge of *Star Trek* details—from *The Original Series* onward—is astonishing as well as legendary.

A native of Hawaii, Michael has maintained an ardent interest in *Star Trek* ever since he was hooked on *The Original Series* as a young boy. A career in "corporate graphics" held him in Honolulu for a number of years, but his heart belonged to the world of motion picture and television production in Hollywood.

In 1983 Michael heard that *Star Trek III: The Search for Spock* was going into production, and decided to try to get hired. He wrote a list—a sort of "Things I Would Do If I Worked On *Star Trek*"—and sent it to associate producer Ralph Winter, who was helping prep the new feature. Winter called Michael in Honolulu and regretfully said he was already into production and had no more openings. However, he was so impressed by Okuda's ideas that he used some of them, and said that if another feature were ever made he would call Michael. Two years later, Winter did exactly that.

Suddenly, with no background whatever in "the industry," Okuda was working on a *Star Trek* motion picture.

In January 1986, Michael began commuting from Honolulu to Paramount Studios, working on *Star Trek IV: The Voyage Home*. His work was noticed by Bob Justman and Herman Zimmerman, and when *The Next Generation* went into production, Zimmerman hired Okuda as a scenic artist. Still commuting from Honolulu, Michael was truly in seventh heaven. The only thing that could possibly be better than working on *The Next Generation* would be to have worked on *The Original Series*.

Eventually it became clear that the new *Star Trek* series would probably be around for awhile, so Michael moved to Los Angeles, and has lived there ever since. Denise is obviously happy he made the move—they met through mutual friends and have been married for nearly four years.

Okuda's response to Tony Sears's question was typical of his personality. His quiet reply was more like the Yoda character in *Star Wars*. He functions calmly—some say serenely—in the midst of a storm, and somehow seems to impart a quieting effect to those around him even when things are the most frenetic.

Out of the chaos of crisis, it is usually Michael who is the voice of reason, always balancing the good with the bad, always quick to point out the good aspects—especially where individuals are concerned, such as when someone else is complaining about a situation or a person. It is no surprise that he has an intensely loyal following.

Michael Okuda: I'm very uncomfortable in the role of supervisor. I'd much rather be the one doing the work. Ordinarily I would not have designed the new shuttlecraft's markings. It's just that it needed to get out, and it needed to get out now. We had to be working on other things. I find that on those occasions when I actually get to design something, I derive a great deal of satisfaction out of that. I don't get great satisfaction out of supervising someone. I do it because that's what my job requires me to do.

Like many others in the company, Michael Okuda wears two hats. He is the scenic arts supervisor for both *Voyager* and *Deep Space Nine*, after having held art department positions for all seven seasons with *The Next Generation*. He oversees separate staffs for both series, each located in a completely different building—necessitating a great deal of shuttling back and forth between the two.

On *Voyager*, Okuda is responsible for developing the graphics used on all sets. These include graphics and animation for the ship's control panels, signage, computer readout screens, alien written languages, and, of course, Okudagrams in general. On *Deep Space Nine*, Okuda has the same responsibilities, but works under the direction of Production Designer Herman Zimmerman.

Frequently these graphics appear in the background, as colorful displays that are meant to indicate some type of activity going on that is directly related to the scene. If the ship is orbiting a planet surface, for example, it helps to have graphic displays on monitors in the background that indicate the planet surface, statistical readings, atmospheric measurements, and so forth. The idea is to create visually exciting, meaningful graphics that help make a story point and enhance the scene, while maintaining Richard James's creative vision of the episode's overall artistic design.

People like Michael Okuda, Wendy Drapanas, Rick Sternbach, Louise Dorton, and the rest of the art department staff reflect the ability of Production Designer Richard James to bring together some of the most talented people in television. One measure: Okuda's work on *Star Trek* has been recognized with multiple Emmy nominations for Best Visual Effects.

The shuttlecraft drawing Okuda was working on represented one of those elements of the new series that was still evolving.

From the outset, Richard James believed the series needed a new shuttlecraft design. Trouble was, there was no money in the budget to design and build a new shuttlecraft—either a miniature or a full-blown set. The decision finally was to use the existing shuttlecraft miniature from *The Next Generation*'s *Enterprise*, along with the large sets left over from that series, but modify them slightly to make it appear *Voyager* had a newer version.

It was a poor compromise at best, further complicated by the decision to design and build new (different) interior sets for *Voyager*'s shuttle.

Design is often a case of "form follows function." The inherent danger of designing interiors without a clear notion of what the exterior would eventually look like is a bit like building the inside of one's house first, then later building the exterior of the house around

the interior. It might not be possible to make the two eventually fit together in any fashion believable to the viewer. The often-employed solution to this type of problem is simple: write an episode in which the shuttle is destroyed. End of problem.

Voyager has already used this technique several times in the first three seasons.

Still, no matter how Richard approached the problem, the answer from the executive producers was always the same: "We'd like to, but there's no money in this year's budget. You'll have to work with what you have."

And so he did. The very first episode following the pilot was "Parallax," which featured both interior and exterior views of the shuttlecraft. It worked, but James was still not happy about it. Neither was Michael Okuda, whose job it was to help James figure out how to limp along with what they had, while making things appear new and better. The hope was that the second season budget would allow money for a new full-size shuttle set (it didn't). Somehow the appearance of a new shuttle, which would have to have been aboard *Voyager* all along, would be explained away, and the series would finally have a new shuttlecraft. Such are the real-world vagaries of money and budgets.

The problem Michael Okuda wrestled with was not the shuttlecraft's design, since nothing could be done about it for the time being. Nor was the source of his irritation the shuttle's interior. Richard James had already established the look he wanted for the interior of the new shuttlecraft, and indeed the existing sets had already been modified for use in "Parallax." No, the problem Michael wrestled with was a name.

There are rules about such things.

All Starfleet ships, including shuttlecraft, have carefully chosen names, in keeping with a practice first established by Roddenberry in *The Original Series*. He decided to follow the same conventions used by the United States Navy, and so grouped Starfleet ships according to class—i.e., destroyers, frigates, battleships, and so forth.

In Starfleet, ships are similarly grouped by function. The first ship built in that class is given a name, which then becomes the name of that class. For example, the *Constitution* class of starships was named after the *Constitution*. Captain Kirk's *Enterprise* is a *Constitution*-class starship.

The names chosen by writers for the individual ships within each class follow the guidelines first set up by Roddenberry. For example, *Constitution*-class ships are named after famous vessels from history (even future history), i.e., *Farragut*, *Enterprise*, *Yorktown*, *Potemkin*, and *Lexington*.

Over the thirty-odd years since *The Original Series* first aired, quite a large number of ships' names have been used. To help the writers keep everything straight, an up-to-date

list of names is maintained. Otherwise, it is possible that a ship destroyed in one episode might magically reappear in a later episode. That would mess with consistency in an unacceptable way.*

The convention used by the writers in naming shuttlecraft is to choose the name of either an explorer or a scientist. At that point, every name Michael had proposed had been rejected by either Richard James or the producers. Time was running out. Visual effects couldn't wait forever. Frustrated by repeated failures to get the name issue resolved, Okuda had once again found himself back at square one.

With the pilot late and everyone scrambling to get ready for the reshoot the following week, and possible changes brewing in the work schedule for "Eye of the Needle" because of the act-format change, there was no time to waste on something as seemingly trivial as a shuttle name. Yet there was no choice. The drawings for visual effects could not be completed until a shuttle name was approved.

This type of problem frequently occurs, and is a direct reflection of Rick Berman's insistence on careful attention to detail. Even if such attention results in holding up progress on some aspect of production—which does happen at times. It is a "good news-bad news" sort of thing. The good news is, *Star Trek*'s consistency and accuracy has a better shot at being maintained. The bad news is, getting something done often takes longer than the task in question seems to warrant.

On the drawing board before Okuda was a new line drawing of *Voyager's* shuttle, onto which he had pasted lettering for the name the *Einstein*. But he really was not happy with it. Not that there was anything wrong with Albert. His reputation as a scientist was without peer. No, it was not the idea of Albert Einstein that bothered Michael Okuda. It was gender. What he really wanted was a woman explorer.

For the next few minutes he, Louise Dorton, and Rick Sternbach—who had by now returned from the production meeting and was back at work at his own drawing table three workstations away—tossed names back and forth like a verbal tennis match, first one, then another. Amelia Earhart…Mary Leakey…Madame Curie…Christa McAuliffe…Mae Jemison.

Back and forth, back and forth. Each name suggested was quickly discarded for one reason or another. Some had been used before. Others weren't appropriate, either out of

* For a complete list, see *The Star Trek Encyclopedia: A Reference Guide To the Future, Updated and Revised*, by Michael Okuda and Denise Okuda, published by Pocket Books.

deference to the woman's family members or due to some other equally compelling rationale.

Reinforcements arrived, in the persons of Richard James, Michael Mayer, and Wendy Drapanas, all of whom quickly joined in the discussion. Finally Richard looked at Michael and said, "Well, how about Valentina Tereshkova?" She was, of course, the Russian cosmonaut who became the first woman to go into space. Michael liked the idea right away. "Perfect," was his immediate response. He promptly printed out new type, pasted it in place, and stepped back in satisfaction.

Richard James disappeared into his office to, one more time, review his budget for "Eye of the Needle." Al Smutko would be coming in within the next hour or so with a revised budget estimate, based on the possible need to work some, if not all, of the construction crew additional overtime beyond what had already been anticipated. James also had to figure out how to balance the construction schedule requirements of the "Caretaker" reshoot, which were horrendous enough already, with this latest wrinkle on "Eye of the Needle." Why weren't there any "easy weeks" anymore?

Making matters worse, James thought ruefully, was the fact that he had not had time to even begin thinking about sending out Christmas cards yet. He dismissed the thought because there was nothing at the moment he could do about it. He knew this would probably end up being one more year in which he would be able to make only a cursory attempt at the custom.

Alas, the name *Valentina Tereshkova* did not stick. The name was never referred to in dialogue, although the shuttle itself was shown. By the time the second season episode "Non Sequitur" aired, *Voyager*'s shuttle was named *Drake*, presumably because the *Tereshkova* had been destroyed in an earlier episode.

Further into the second season, in the episode "Prototype," a third shuttle—now named *Cochrane* for Zefram Cochrane, the man who invented the warp drive in 2063—made its appearance. This shuttle would subsequently appear in later episodes but sport a different exterior design, suggesting yet a fourth shuttle. In *Voyager*'s third season the *Cochrane* shuttle(s)—both versions having been destroyed in previous episodes—would be replaced by a fifth shuttle named *Sacagewea*. Score one for women and Native Americans.

In yet a later third-season episode, Captain Janeway is communicating with members of an alien race who need help. She delivers a line of dialogue that includes the phrase, "…I'll send three of our shuttles…" suggesting *Voyager* carried at least eight shuttlecraft on board when the series began in January 1995.

This bothers some people and amuses others. The growing number of shuttles has

In the *Voyager* art department, Richard James (standing) talks with a former *Voyager* staffer, Jim Magdaleno. STEPHEN EDWARD POE.

become, predictably, a new source of jokes. "Hey, no problem! *Deep Space Nine* has a shape-shifter, *Voyager* has a shuttle-shifter." And…"In 2370 Starfleet developed the freeze-dried shuttle." Undoubtedly there will be more.

Does eight shuttlecraft aboard *Voyager* strain credulity? Absolutely. The *Intrepid*-class starship is not an aircraft carrier. Does this mean a lot of someones are not paying attention to detail? Absolutely not. It simply means the necessities of storytelling in the interests of entertainment often conflict with mathematics and reality—fictional reality or otherwise. It may also mean what some have suspected for a long time now: We live in an imperfect world.

Michael Okuda: Technical accuracy is important, but it can't drive the show. If the episode is enjoyable, if the story is meaningful in some way, the viewers

will forgive a lot. If they don't like the episode, it doesn't matter if the show is technically correct or not.

From names, the conversation turned to faces.

During the production meeting earlier that afternoon Merri Howard had asked about "the woman's face" momentarily reflected in the window of the drawing room. The script called for the source of the reflection to be a portrait hanging on the opposite wall. Merri wanted to know if clearances were needed.

Yes, there are rules about such things.

When a recognizable human face is shown on screen, such as the one in the portrait in the drawing room set, the face cannot be that of a real person unless permission, or clearance, has been obtained to use that person's likeness. Otherwise there could be lawsuits. On the other hand, clearances cost money. The pattern budget for each episode does not generally include money for clearances or lawsuits.

After considering various alternatives, Michael Mayer asked Wendy Drapanas to find an 1800's-style portrait of a woman, add a bonnet of some sort to her head, and further alter the face in some way to prevent it from being a recognizable person.

By the next afternoon.

SIX

THE STAGES

Do I think there's a message? Yeah, I do. I think the point of the show is twofold: to entertain,

and then to enlighten, or educate, or stimulate. Which is not always what most of

television is about, or even what most movies are about.

John de Lancie
Q

ED HERRERA STOOD WITH HIS BACK AGAINST THE wall of Stage 18, directly across the street from the entrance to Stages 8 and 9, one foot propped up behind him, in relaxed conversation with Greg Agalsoff, the shooting company's boom operator. The speaker/microphone clipped at Herrera's shoulder squawked intermittently with radio traffic between the assistant directors on Stage 9. Handsome, muscular, with an engaging, flashing smile, the thirty-three-year-old

security guard may have appeared relaxed, but in fact remained ever alert to his surroundings. Dedicated to his job, there was not much that escaped his attention.

At six foot three inches and 225 pounds, Herrera is an imposing figure. A passionate devotee of Sunday morning softball, his solid physique and professional demeanor effectively mask his love for pen-and-ink sketching, and his appreciation for artists like M.C. Escher and Frank Frazetta. The other love of his life is his bride of six months, Terri, who—coincidentally—works in the insurance office a few doors away from the entrance to 8 and 9, right under the *Voyager* art department. Just the day before, they had spent a fun-filled afternoon trying to get in some early Christmas shopping, but ended up mostly looking at baby clothes, toys, and furniture "just in case."

For the moment there was little for Herrera to do. The *TV Guide* group photo shoot (all nine cast members in the same shot) was finally getting underway on Stage 9, across the street from Ed's current position, necessitating a temporary halt in filming on "The Cloud." That gave most of the crew a welcome break, temporarily releasing Greg from his duties on the set.

During filming, Agalsoff's job is to hold a microphone above the actors' heads. The microphone is attached to a long boom, which he has to keep suspended just out of the camera's view, but close enough so that his boss Alan Bernard, the sound mixer, can record the dialogue of the actors. On long takes the boom gets heavy, requiring strong arms and a lot of silent suffering.

As the two men talked, Herrera visually swept the area across the street, in front of Stages 8 and 9, watching through mirrored sunglasses as people made their way past the twin rows of cast trailers permanently double-parked on the street in front of the large building, and disappeared inside. These two stages, sitting side by side and sharing a common wall and a common front entrance, house the permanent standing sets for *Starship Voyager*—the physical reality of what Production Designer Richard James envisioned for this newest *Star Trek* incarnation.

The main entrance to both 8 and 9 is in the center, midway underneath the second floor of Dreier. A large sign warns visitors and passersby that this is a closed set. No one is allowed to enter either stage without specific clearance from Rick Berman or one of the other producers. The rule is needed to keep unauthorized persons off the sets and away from cast members, and to minimize noise during filming.

Thus the need for Ed Herrera and his partner, L.Z. Ward. The two Paramount Studio security guards constantly patrol the exterior of 8 and 9 every working day, from first crew call—as early as 6:00 A.M.—to when the final shot "wraps," as late as 2:00 or 3:00

A.M. the next morning. An alley skirts both stages along the east, north, and west sides; a main thoroughfare runs along the southern side, the same street *Voyager*'s art department overlooks from above the front of Stage 8—and the street from across which Ed currently watches. Herrera and Ward alternate positions; with Herrera in place out front, L.Z. is on patrol in the alley on the opposite side of the building. Periodically, they switch.

Any time the camera is rolling on a set inside, red lights flash outside the building, above each of the six doors leading into the stage from all sides. More red lights are strung out to the edge of the street, mounted on four-foot-high tripods. The flashing red lights are hard to miss. Intentionally so. They are meant as a universal warning: Do Not Enter/No Noise!

To help keep the noise problem to a minimum, Herrera and Ward routinely stop drive-by traffic while the camera is rolling. When the red lights begin to flash, that is their cue to halt traffic. The streets on the Paramount lot are often choked with vehicles—everything from large delivery trucks and huge vanlike grip trucks going to or coming back from location, all the way down to the small electric runabouts (some people call them golf carts) constantly whirring about the lot like metallic dragonflies.

Ed Herrera: L.Z. and I are the first ones here, and we're the last ones to leave. We average about seventy hours a week. It's very difficult. It's not for everybody. What we do is more than just "being on guard." We see and hear everything, observe what's going on with the cast and crew, make sure everybody's okay, nobody's being harassed by visitors, lots of things. At times it's more PR work than anything else.

For L.Z. and me, it's great because everybody makes us feel like we're really a part of something. Kate Mulgrew gave me a big hug and a kiss, looked me square in the eye, patted my cheek, and said "good to see you." That's what makes it all worth it for me. I'm a part of something special. I go home and I feel good about myself. I'm not just a guy in a blue shirt telling people you can't go in there, kill that motor, don't bother the cast....

In addition to the cast trailers double-parked out front, there is also a directors' trailer, a trailer for guest stars, and two large vanlike trailers for hairstyling and makeup. It is to these latter two that cast members report every morning, and come back to at the

close of every day. The street along the front of 8 and 9 is clogged with trailers. Power cables and telephone lines run from the building to each, making foot traffic around them hazardous to anyone not paying attention.

Trailers are a common feature of the Paramount landscape. On virtually any street on the lot there are trailers double-parked outside a sound stage or other building. Some are more like the travel trailers used by *Voyager*'s cast and, like those trailers, are generally used by cast members of features or other series that are in production. Others are the large vanlike trailers similar to the one Dick Brownfield uses, and are typically occupied by wardrobe, makeup, or special effects persons working on one show or another. Each is home to someone.

A red flashing light on the wall above the main entrance to 8 and 9 warns when filming is in progress inside; when the camera stops, the red light goes out. An open doorway leads into a small six-by-eight-foot room with a thick, heavy wooden door at the opposite end. Here, too, a red light above the door warns when the camera is rolling. A tiny desk and chair offer small comfort to anyone getting stuck here, waiting to go inside. There is no choice but to wait until the light goes out and a loud buzzer sounds. In a pinch, prisoners can always pass the time by reading the bulletin board. Like the wall in *Voyager*'s art department, it can make for some interesting reading.

Opening this second door brings the visitor into a somewhat larger room, a sort of vestibule, perhaps ten by ten feet square. A thick, heavy door to the left leads into Stage 8; a similar door on the right leads into Stage 9. A red light is mounted above each of these doors as well. Getting stuck here is annoying, but not traumatizing. At least the room is large enough to make people feel they have room to breathe.

Once you are inside a stage, the ubiquitous red lights are quite literally behind you, having been wisely placed above each door on the inside of the stages as well. These lights are a visible reminder to anyone about to *leave* the stage. Exiting a sound stage during filming can be just as ruinous to a "take" as attempting to enter with the cameras rolling.

On first entrance, a sound stage can feel awesome, overwhelming. Even one like Stage 16, when half-filled, still seems cavernous. A small blimp could easily float in the interior. Stages 8 and 9 are almost as large as 16, and anything but empty.

The roof of each stage is some forty-five feet above the floor; the walls are 146 feet apart at their widest. The total floor space on Stage 8 alone is enough to hold eight medium-sized three-bedroom homes, with room to spare. Walls and ceilings are heavily padded with soundproofing materials held in place by stiff wire mesh. Even so, the massive inte-

riors are still subject to invasive sounds from outside. By far the biggest enemy of filming on a sound stage is noise.

Ed Herrera waved a greeting as Bob McLaughlin mounted the stairs to the upper floor of the Dreier Building. McLaughlin was a driver in the transportation department and had been working around *Star Trek* for nearly seven years. At the top of the stairs he doubled back along the walkway/balcony that ran the width of the stages, stopping in the middle. This placed him directly over the main entrance to the stages, with a commanding view of the street, the trailers, and surrounding areas below. It was a great place for people-watching. Characteristically, he lit a cigarette and settled into a leaning position against the railing, McLaughlin's typical pose when waiting for an assignment call from his boss, Transportation Captain Stewart Satterfield.

Herrera drew his attention back to the conversation with Agalsoff. They were good friends, having first met when Ed joined the shooting company in August. Among their common interests was physical fitness. Herrera worked out daily in the Paramount lot gym during his lunch hours. This mutual interest had given rise to shared (and self-appointed) nicknames. L.Z. Ward was "Beef One," Herrera was "Beef Two," and Agalsoff was "Sir Loin."

As they talked, the security guard noticed two young women slip through the main stage entrance. Not recognizing either one, he radioed a quick message. "L.Z.! Go to channel two." This would permit the two security guards to speak to each other in private. A moment's pause, then, "We've got a couple of bogeys." "Roger," came L.Z.'s quick reply. "Moving in." Herrera acknowledged his partner's response, excused himself from the conversation, and hurried across the street and through the stage door.

In a situation like this, L.Z. would automatically enter the back door of Stage 9 (since it was the one where shooting was currently taking place) and work his way through the sets, toward the front. Herrera would enter from the front, and work his way toward L.Z. All the while, they would be in continuous radio contact. When he spotted the two unknowns, Herrera would point them out to L.Z., so his partner could observe them from a distance. It was always possible that the visitors were known to one of the guards but not the other. Coordination could help avoid embarrassment all the way around. It also was good procedure for safety reasons. L.Z. and Ed were a close, tight-knit team, and took pride in the knowledge that they covered for one another and "watched each other's back."

Controlling access to the stages is sometimes difficult.

L.Z. Ward: We have three different sound stages we use. There are a lot of doors…a lot of different ways to get in. One of us is at either the front or back

of the stages. There's a possibility someone could go in, like when we're taking a ten-one hundred (restroom) break or something. So when we come back we take a walk around the stage and the sets and check everyone out.

We've worked with these guys long enough that we pretty much know who belongs here. If we see someone we don't know, we ask them are you working with *Voyager*? Are you here to see someone? If they don't belong at all, we escort them off the stage. If it's a real wacko or something we turn them over to the security office.

Entering Stage 8 is a visual assault on the senses as well as an interesting olfactory experience. With the first intake of breath inside, visitors are aware of a noticeably odd aroma permeating the interior. It is not an offensive odor; rather it is a bit pleasant, and faintly reminiscent of oil mixed with fine sawdust—the sort of compound widely used years ago when cleaning and dusting hardwood floors.

The visual onslaught begins with the first glimpse of the cavernlike enormity of the stage's interior. Stage 8 primarily houses the permanent (standing) sets for the bridge, conference room, ready room, wardroom/kitchen, and officers' quarters. High above the sets are a profusion of roof trusses, catwalks, rigging bars, cables, ropes, electrical conduits, wooden and iron braces, and lights of every size and description.

The eye is drawn everywhere at once; visual impressions are thrust on the brain faster than comprehension will allow. The moment passes quickly and is replaced by a series of individual images: a vast room with no apparent ceiling…darkness everywhere, broken by filtered lights here, pierced by brilliant lights there…in between, shapes…and in between the shapes, spaces. An interior wall is immediately to the left, covered with thick padding held in place by heavy wire mesh. The wall seems to go up forever, disappearing somewhere in the dim upper reaches of the structure.

In seconds the eyes adjust, and the interior begins to reveal itself. Directly in front of the entrance door is a wide, open pathway leading along the wall towards a series of tables, perhaps seventy-five feet further inside. Defining the pathway on the right are the walls of a fully enclosed lounge room known as the Green Room, set aside for use by the extras—or "day players," as they are sometimes known. Couches and chairs provide a place for them to relax, study their lines, read, sleep, or otherwise entertain themselves until they are needed for the next scene.

Actually, the Green Room is not green. But rooms like these are made available for

the extras throughout the television and theatrical communities, and are all commonly called the Green Room. Some Hollywood old-timers say the custom dates back many years, to an old theater whose operators painted its waiting area green because they happened to have a can of green paint handy.

Beyond the Green Room are the exterior walls of the conference room set. Here the pathway opens into a fairly spacious central area in front of the craft service (food) tables. A narrower pathway extends straight ahead, beyond this open area, past a soft-drink vending machine and other enclosed rooms to the opposite wall, some seventy-five feet from the center.

Immediately to the right is an open swath defining the middle cross section of the stage and separating two main groups of standing sets. On the right-hand side are the conference room, bridge, and ready room. To the left are the wardroom/kitchen, corridors, and Captain Janeway's quarters. The latter are sometimes "re-dressed" for use as quarters for Chakotay and Tuvok.

Dressing a set is the responsibility of Jim Mees, the set decorator. He selects and places all items including furniture, pictures, wall hangings, rugs, and accessories such as art objects, knick-knacks, and so forth. If an object stays where it is placed—on any surface, horizontal or otherwise—it is considered to be set decoration. If it is picked up or handled by a cast member it is classified as a prop, and therefore the purview of Alan Sims.

Re-dressing a set means removing most if not all of the set decorations and replacing them with entirely different items. The basic set remains the same, but with creative re-dressing the effect is a completely different set.

Richard James: Again, it's a matter of economics. I can get a lot more mileage, money-wise, out of a set that I can reuse by re-dressing it. I can get a one-hundred-thousand-dollar set for fifty-thousand-dollar…maybe less. It's one of the ways we try to save money in order to stay within budget, while giving the show as high a production value as possible. I'm just grateful the fans are forgiving enough to not gripe too much about this, because they must pick up on it from time to time. Hopefully, the story line is carrying the show well enough so that they're not watching the scenery all that much. We're in trouble if they're watching the scenery instead of being absorbed in the story.

The primary attraction on Stage 8 is unquestionably the bridge. *Voyager*'s bridge is larger than any Federation starship bridge to date, and certainly more impressive. It is

built on three levels, versus two for all its predecessors. The use of graphics is both strik-ing and exceptional. At the rear of the set, the eye is automatically drawn to a large, col-orful cross-section line drawing of the ship, designed by forty-one-year-old scenic artist Doug Drexler.

During *Voyager*'s long preproduction period, Doug, who normally works for Herman Zimmerman in the *Deep Space Nine* art department, was asked by Richard James to lend a hand with graphics. The cross-section drawing is one result of his efforts. After completing the design, Doug worked closely with Wendy Drapanas, who executed the final artwork.

Drexler is an Oscar-winning makeup artist for his work on the feature *Dick Tracy*. As a young boy, Doug had been thoroughly enthralled by *The Original Series*. But his parents would not allow him to watch television. So a school chum named Anthony Fredrickson—whose parents did allow him to watch television—would, the next day, describe in vivid detail, last night's thrilling episode. Doug's boyhood friend is the same Anthony Fredrickson who now also works in the *Deep Space Nine* art department. More proof that *Star Trek* changes lives.

In desperation, Drexler went on a begging campaign every day with his parents. All he wanted was one hour each week so he could watch *Star Trek*. Just one hour. Perhaps his sheer determination wore them down. In any event, they relented, and he was in heaven.

In addition to *Star Trek*, Doug also had an intense interest in graphic arts, aliens, and makeup. And although he was intent on a career in graphics, he found himself sidetracked by makeup.

> Doug Drexler: I found out that one of the greatest makeup artists of all time, Dick Smith (*The Exorcist, Amadeus, Little Big Man*), lived about fifteen miles north of my home in Brooklyn. I called him for advice on some *Planet of the Apes* makeup I was doing on my wife's Halloween costume, and we spent about an hour and a half on the phone. Three months later he called and asked if I was available to come work with him on *The Hunger*, a David Bowie film. I learned a lot about old-age makeup in that film. Then it was ten years straight for me, doing makeup.

But Drexler's passion for *Star Trek* would not go away. When *The Next Generation* went into production, he contacted Michael Westmore and struck up a friendship, visiting

Paramount several times from his home in New York. As the work on *Dick Tracy* came to an end, Doug became determined to work on *Star Trek*, and pressed Westmore to hire him.

> Doug Drexler: And he said, "What do you want to do that for? You're doing features!" And I said, "Yeah, but I wanta do *Star Trek*!" So eventually I started working for Michael Westmore. I became good friends with Michael Okuda because I thought what he was doing in graphics was revolutionary. I just naturally gravitated towards the art department.

Eventually Doug approached Michael Okuda about a job. Okuda could not believe that someone with Drexler's credentials would actually be willing to take a pay cut just to work in a *Star Trek* art department.

> Michael Okuda: At the time he first asked me we didn't have any openings. But I told him I'd keep him in mind. Then when I knew *Deep Space Nine* would be starting, I told him there was an opening after all. Doug bought a Mac and taught himself Adobe Illustrator, all on his own. The day he started work he told me, "Okay, I'm ready!" And he was. Now I'm amazed at what he can do. In fact, I don't know how he does some of the things he does!

Doug now shares a relationship with Dorothy Duder, his significant other of the last fourteen years ("If it ain't broke, don't fix it."), a Yorkie named Microbe, and a yellow-naped Amazon parrot named B'kr. (The spelling is Vulcan, but the bird is actually named after the Beaker character in *The Muppets*.)

As beautiful as the bridge may be, and it is, the set has also become a symbol of the grueling pace maintained by cast and crew. So much time is spent on this set that it is like a second home.

The standing sets are a striking study in construction contrasts. On the interior, all surfaces are carefully, meticulously finished—ceilings, floors, walls, chairs, crew stations, railings, everything. On the outside, where the camera never looks, the walls are unfinished stud-and-plywood construction with wires hanging off here and there, the backside of television monitors and electrical fixtures sticking through, support braces nailed to the floor, and so on.

It is not just the standing sets that get the careful attention to detail. Every set built specifically for each episode is also gone over in painstaking fashion. *Star Trek* has a history of exacting standards, and everyone, including James, tries to maintain them. The final scrutiny, however, will always come from Rick Berman.

Richard James: Berman is so fast. He picks up on things so quickly. He zeros in on something that maybe you hope he won't notice because we haven't had time to do more, or we've run out of money in the budget. And I think 'Wow! How did he pick that?' It's like he's standing on the edge of the Grand Canyon looking down and suddenly he asks, "Why is that one stone there?" He has a knack for details. Then he makes you make it better. He's just incredible.

Despite the open area in between the two groups of sets, the stage itself is remarkably crowded. In most areas around the perimeter of the stage, the sets are built right up to the interior walls, leaving barely enough room for a person to slip by.

Encroaching on the open spaces around and between the sets, and jammed up against the set walls themselves, are masses of lights and lamps, from hand-size to two-foot-wide behemoths; absolute forests of extra lighting stands; wheeled equipment carts laden with wiring, tools, rolls of tape of assorted colors, clamps, and electrical connectors; miscellaneous sheets of plywood; five-drawer mobile parts chests; lighting flags and screens of all sizes; coils of cabling; sand bags; open crates of equipment and supplies; piles of cushions and pads; stacks of wood planks and floor matting; doors, walls, and other pieces of sets; and large wood-and-metal carts laden with an unbelievable variety of production gear.

To think that it is possible for people to actually find what they are looking for in all that mess boggles the mind. Yet, oddly enough, there is a sense of organized haphazardness about it all.

Directly outside the open "windows" of the wardroom set (also known as the mess hall) hangs an immense, flat-black cloth curtain perhaps twenty-five feet tall and thirty to forty feet long. The heavy curtain is covered with thousands of sequins of varying size, each one sewn on by hand. It is suspended from a motorized track in a doubled fashion, forming a giant endless loop, and—in use—is rotated at a very slow speed.

During filming, this curtain is lit with extremely bright lights, which are reflected off each of the thousands of sequins. The curtain is what produces the star-field effect as

The first season floor plan for the standing sets on Stage 9. The biomedical lab would eventually occupy the area, lower left, between the turbolift and the transporter room.

seen from inside the wardroom set. Similar curtains hang near the bridge, conference room, and ready room sets. The amount of handwork that went into the sewing on of all those sequins surely required the efforts of ten seamstresses nonstop for one hundred days—after which they were probably all gently retired to a rubber room somewhere, to sit around quietly drooling.

All the major standing sets are fully enclosed and are topped with iron-and-wooden superstructures that support lighting and rigging equipment. Catwalks thread through this upper area, providing access for gaffers, lamp operators, electricians, and others.

Completely enclosed, with no windows to the outside world, a deserted sound stage is sometimes a creepy place. At night, or on weekends, even on some days when no one

The floor plan for the standing sets on Stage 8. The main entrance is through a door in the lower right-hand corner. Stage 9 adjoins the wall on the right.

is around. None of the sets are lit at such times. The only illumination is provided by an occasional "night light." Augmented by the dim light, the silence is eerie. One's imagination begins to play with the mind. Shadows take shape…and move.

There is a decided air of permanence about Stages 8 and 9, as if *Star Trek* has been an occupant for a long time. That turns out to be the case. Both 8 and 9 have been home to Federation starships continuously since 1986. Prior to that time these same stages were intermittently home to the sets for the ill-fated 1978 attempt at a *Star Trek II* television series, and for the early feature films as well. Moreover, *Voyager*'s bridge and engineering sets are built on the same locations used by the bridge and engineering sets for *The Next Generation*'s *Starship Enterprise*. All in all, *Star Trek* seems intent on occupying both stages indefinitely.

In addition to its standing sets, Stage 8 also provides space for some much-needed support facilities. The craft service tables located along the southern wall give the crew access to light meals, snacks, and beverages during the long workdays on either 8 or 9. Suspended high above the tables is a length of iron pipe from which dangle a dozen or so strings of Christmas lights. They are lit during the holidays to add an ever-so-slight festive touch. The effect is almost lost, in the enormity of the stage. No one bothers to take them down, and so they hang there the rest of the year, unnoticed and unlit.

Further along the wall beyond the tables are a series of fully enclosed lockable workrooms. One is a storage space for foodstuffs and supplies for craft service. Another, an equipment-repair room. Others include a prop-storage room for Alan Sims and an open area for makeup and hairstyling.

Although the craft service storeroom can be locked, it is usually left open when there is shooting on 8. This is mostly as a convenience in replenishing the goodies on the nearby food tables—which occasionally include Ding-Dongs and the like—what some people call junk food. The storeroom is supposed to be strictly off-limits to everyone but craft service people. But that does not deter Brad Yacobian.

Brad's sweet tooth is legendary. He regularly sneaks into the forbidden room and helps himself to the Ding-Dongs. Jan Djanrelian (everyone calls him Johnny John), the craft service man behind the goodies, knows about Brad's penchant for sweets; as a matter of fact, the entire crew is well aware of Brad's habit. So much so that it has become almost a foregone conclusion: if Brad is supposed to be on the set, and you look around and do not see him, ten-to-one he is into the Ding-Dongs.

Dedicated to his efforts as the resupply officer for *Voyager*, Jan tries hard to vary the menu beyond mere snack food.

> Jan Djanrelian: I try to bring in a variety of hot foods when I can. Like from this one Armenian restaurant I know of…hummus, pita bread, tabouli, Greek salad, rice pilaf, balou kabobs, chicken kabobs, beef kabobs, dolmas. And the onions and the olives. Good stuff.

The food is provided, in part, as an acknowledgment by the producers that the demands made on the cast and crew can be so intense that they often have no chance at all to get away for even a quick coffee break. Having food and snacks available on the stage at least offers an opportunity for some measure of relief.

Djanrelian takes great pride in making sure the cast and crew are well supplied with coffee, bagels, sweet rolls, candies, fresh fruit, assorted fresh veggies, soft drinks, juice, bottled water, and, occasionally, hot hors d'oeuvres. For those inclined, there is even an espresso machine.

Judging from the constant traffic flow to and around the tables, the cast and crew agree with Jan's assessment.

In the far opposite corner of the stage, tucked away behind Captain Janeway's quarters, a small table sits inconspicuously in a darkened, half-forgotten area. The table is covered with paint spatters, brushes, and cans of paints of various colors. This is the makeshift workstation of Frank O'Hea, the standby painter. Although not yet ready to retire, he has been painting and touching up sets all by himself for longer than he would care to admit.

Known for his decidedly Irish brogue, a halcyon personality (except around St. Patrick's Day), and a distinctive twinkle in his eye, Frank quietly moves around the sets as unnoticed as his workstation is unobtrusive. He continually looks for a cracked spot here, a chipped place there, anything that needs a bit of touch-up. He prides himself on anticipating the needs of the director, or discovering a surface defect and making it vanish before someone else spots it.

Occasionally he is called upon for an unusual task. During a location shoot in Norwalk, a scene included a couple of horses. Marvin Rush, the director of photography (commonly called the DP), noticed that the brand on one horse was distinctly visible. Not a good idea if you are supposed to be in the twenty-fourth century, and somewhere other than Earth. Frank had to mix his paints to match the horse's color perfectly, and then paint over the brand, so it was no longer discernable. O'Hea has learned to be ready for anything.

One of Frank's specialties is making fake rocks and painting them to look like the real thing. In a large set, such as a cave or a cliff, the "rocks" are built by the construction crew, who make them out of heavy aluminum foil over a sturdy two-by-four framework. Large rocks are also cast from actual molds made from real rock surfaces. Properly painted and detailed, they are difficult to distinguish from the original.

Sometimes—such as for esthetic reasons—a director will want an area of a rock wall filled in with additional rocks, or will ask for more rocks to close in a gap between existing set pieces. Either way, it is the smaller variety that generally falls under O'Hea's skilled hands.

Frank O'Hea: The rocks give me a lot of problems. They have to be done in a hurry. We make them out of tinfoil. I spray paint the sheets of tinfoil beforehand,

then I crumple them up and put a little spatter on them to tie them in so they look like the rest of the larger rocks. I use 'em for closing up openings, too.

It seems as if Frank has this private, perpetual game going, the object of which is to find and correct defects before either Bill Peets, the chief lighting technician—also known as the gaffer—or Marvin Rush can notice them. Then again, maybe it is not a private game. Maybe it is Frank's own way of combating boredom and loneliness. Unlike the rest of the crew, Frank has no one working alongside him.

Perhaps the solitary nature of his work is the reason why, for anyone with a moment or two for conversation, Frank is a ready and willing partner.

In the opposite corner from O'Hea's Paint Shop is a small enclosed room housing Video Playback Operator Ben Betts's equipment. From this room Ben can supply direct feeds to any monitor on any of the sets on Stage 8. He does not need to actually see the action on the set; a special transmitter gives him the same picture the camera is getting during filming. So Ben sees what the director sees. He can also check other monitors at his console, to maintain control over the images he is placing on any of the active screens on the set.

When shooting moves to Stage 9, or anywhere else, Ben takes a custom-built, fully self-contained cart with him, loaded with 3/4" VCRs, monitors and what ever else he needs to provide video to the sets.

Ben Betts: I can control up to sixteen monitors simultaneously. I have a computer-controlled matrix routing switcher which has eight inputs and sixteen outputs, and those are all independently switchable. I can feed the same image to multiple monitors…or any combination. But the video is just one tool for making the show look good. My goal, like everyone else's goal here, is to complement the story, complement the actors, and make the ship more believable. That's the only purpose for this in the first place.

I keep reminding myself that the technology should never get in the way of the actors. And that's the way it is in the show, too. One of the neat things about *Star Trek* is yes, they're this far in the future, and they have all this great technology. But if you look at the stories, it's almost never this fantastic technology that gets them out of these problems. It's always the human element.

The two-story warp core, just part of the spectacular engineering set. J.M. CULLEN.

And therein lies another key ingredient in *Star Trek*'s enduring appeal.

The whole point of fiction is to suspend disbelief on the part of the viewer or reader. Western fiction, Celtic fiction, Roman fiction, cloak-and-dagger spy fiction, turn-of-the-century fiction, science fiction—all fiction genres are the same in this respect. As a consequence, and most especially in filmmaking, the producers do not want the camera, special effects, or anything else to intrude on the viewer's absorption in the story. It is imperative to suspend disbelief so the viewer does believe for those moments that it is all real. All the support elements must remain invisible.

In the science fiction of *Star Trek*, that includes the technology.

This idea of the invisibility of the technology goes back to something Gene Roddenberry established with *The Original Series*. He liked to use the analogy of the Western to make his point. When the hero draws his Colt .45, he does not stop and give the audience a dissertation on ballistics, trajectory, and the physics of firearms. He just uses the gun because it is there. It is part of the environment...part of the storytelling landscape.

The technology is great, but it is the story that is important…and the story is about people, not technology. While the story drives the episode, human beings drive the story. Everything else is merely a supporting part of the environment. Throughout *Star Trek*'s history—in each of its various incarnations—this philosophy has been carefully adhered to.

It is a major underpinning of the *Star Trek* universe.

Next door, Stage 9 is dominated by the engineering set, a two-story structure far more elaborate than any previous *Star Trek* series engineering set. It is more than impressive; it is magnificent. The heart of the set is the starship's warp core, a monolithic technological wonder that rises from the stage floor, extending upward some twenty-five or thirty feet, almost to the very ceiling of the stage. Ladders from the main floor provide the actors with access to a second floor catwalk around the upper part of the warp core. This upper level heightens the feeling of size and spaciousness. No doubt Engineering Officer Montgomery "Scotty" Scott would have given anything for an engineering room like this aboard his beloved *Enterprise*.

The engineering set is, hands down, a stunning creation. Richard James's sweeping vision has been translated into a three-dimensional set the likes of which no starship has ever witnessed before. The centerpiece of the set is the starship's warp core, the engine that drives the ship at speeds faster than light. Fully lit for filming, the warp core is impressive to watch in action, with plasma bursts, and flashing interior lights illuminating a gaseous core.

The man responsible for breathing life, excitement, and movement into James's remarkable warp-core design is Dick Brownfield.

Brownfield's role in production is both traditional and unique. Traditional in that for as long as movies and television have been around, there have been people like Dick Brownfield involved in the productions, creating special effects. Unique, because he is responsible for so many different kinds of effects; many are not even mechanical, and a large number barely stop short of requiring a degree in electronics just to create. He is the bringer of wind, the resident rainmaker, the giver of fire, the lord of explosions. In his skilled hands cast members fly through the air and inanimate objects float easily with the power of levitation.

He is also responsible for certain lighting effects, including the dazzling light show created by *Voyager*'s colorful warp core and the lighting behind the show's brilliant graphics panels. Brownfield's "headquarters" are in a large van—a semi-trailer rig permanently parked behind Stage 10—about equal walking distance to either Stage 16 or Stages 8 and 9.

Brownfield's trailer is his workshop/office/storage facility, and the place where

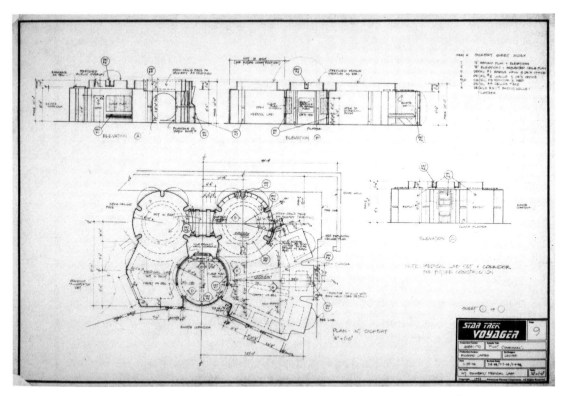

Although Richard James wanted to build the biomedical lab as part of the first season's standing sets on Stage 9, budgetary limitations postponed construction until the second season.

many of his creations first begin to take shape. The interior is stuffed with a decades-long accumulation of assorted parts, wiring, workbenches, tools, drawers, boxes, and Rube Goldberg devices that defy description. There is barely room for Dick to sit and work. Despite the incomprehensible jumble of the trailer's interior, the impression is unmistakable: here is the playground of a man in paradise.

Brownfield himself is on and off the sets half a dozen times every day. In his absence, Wil Thoms, assistant special effects coordinator, is generally Brownfield's on-set representative.

Dick Brownfield: This show, electronics-wise, is more complex than the feature *Generations*, and far more complex than any of the other *Star Trek* series.

Just in physical size alone *Voyager*'s engineering set is more than twice the size of *The Next Generation*'s engineering set.

Apparently Brownfield's efforts have impressed the viewers as being entirely believable. He likes to recount a phone call he received from a fan who wanted to borrow *Voyager*'s transporter room for the weekend. The fan assured Brownfield he would take good care of it, and promised to return the transporter first thing Monday morning.

Built around and into the sides of the engineering set are the remaining *Voyager* standing sets—the turbolift, Jefferies tube, additional crew's quarters, transporter room, sickbay, the medlab (not actually built until the second season), the shuttlebay/hangar deck—which also functions as the holodeck set—and lots of corridors. There is even a smaller area left over, near the hangar deck, for an occasional set wall or two whenever a temporary set is needed to simulate an alien ship's control console, the wall of an alien office or crew quarters, and so forth.

In the second season a medlab set was built, which consumed the only other remaining open area on 9. This generated a bit of resentment among some of the crew, who felt the space was needed to store lighting and other production equipment. The need for adequate storage space is always a problem. When it comes down to a choice between storage space or a new set, storage will lose every time. Sets are what get filmed, help make the show, and pay for the production. It is sometimes frustrating to the crew, but there really is no choice.

A walk through the standing sets on 8 and 9 is a dramatic reminder of how the technology involved in set design and construction continues to evolve.

Compared to the sets of *The Next Generation*, the sets designed by Matt Jefferies for *The Original Series* seem somewhat crude and simplistic. Yet for their day, and the technology available at the time, *The Original Series*'s sets were cutting edge. Twenty years later Herman Zimmerman, the brilliant production designer for *Deep Space Nine* and four of the *Star Trek* motion pictures, created the sets for *The Next Generation*. They represent a quantum leap forward from what was available to work with in the mid-1960s.

And now *Voyager* comes along nearly a decade after *The Next Generation*'s sets were designed. Numerous advancements occurred in ten years. In materials, processes, and experience. Richard James's sets are bigger and easier to film in, and they incorporate features and materials simply not available in 1987. If nothing else, *Voyager*'s sets are a good example of evolution graced by inspiration. Certainly a great deal was learned from the experience with both *The Next Generation* and *Deep Space Nine*. James wisely took advantage of that experience, gave expression to his own vision, and created new sets that are stunning by any measure.

S E V E N

THE SHOOT

Our sound mixer, Alan Bernard? He's the best. He can hear grass growing.

Bill Peets
Chief Lighting Technician

WHEN L.Z. WARD HEARD ED HERRERA'S RADIO message, he could not have been happier. He had been stationed in the alley behind 8 and 9 for nearly three hours, and was ready for an excuse to get a cup of Johnny John's hot coffee, and warm up a bit at the same time. Very little sunlight found its way between the buildings and into the alley; most of the day the area was engulfed by shadows. The early December chill was made all the more penetrating by the absence of warmth from the sun.

L.Z. has been a Paramount Studio security guard since 1988, virtually all of that time with *Star Trek*—starting with the second season of *The Next Generation*. A native Californian, he lives in the San Fernando Valley with his wife Gaylene and their two daughters, five-year-old Kristin and fourteen-year-old Erica. While Herrera plays softball, L.Z.'s favorite sport is basketball. He prefers to play indoors, but the park near his home offers only outdoor courts. Usually it's the same group of friends every Sunday morning, with the emphasis on full-court play.

Speaking softly with Herrera on channel two, L.Z. entered the rear door of Stage 9. From long-standing habit he moved catlike, guiding his 6' 1", 220-pound body quietly across the floor. With filming in sickbay temporarily halted for the *TV Guide* photo shoot there was no particular reason for him to move quietly. It was just second nature.

L.Z. paused momentarily to let his eyes adjust to the semi-darkness, and then began moving slowly across the shuttlebay set. He could hear a mixture of voices floating through the sets, mostly from Bill Peets and the *TV Guide* photographers, who were now in engineering, setting up shots with various cast members. Unauthorized visitors, if that's what the two women were, would not know that. Chances were good they would gravitate to the transporter room initially, simply because it was the first open doorway they would encounter. That meant L.Z. could cut across the shuttlebay set, follow one of the ship's corridors around past sickbay, and intercept them between engineering and the transporter room. With Herrera behind the women, it would be easy for the two guards to locate them.

As L.Z. made his way across the shuttlebay, he silently nodded to Charlie Russo, the set property master, who was sprawled against some crates and boxes at the edge of the set. Charlie, and Randy Burgess, the second company grip, were exchanging comments about the "Caretaker" reshoots coming next week. They had heard the jokes bandied about by other crew members, a favorite of which seemed to be, "I wonder if we'll get this pilot shot before the series is finished." Neither Randy nor Charlie was concerned. It was normal for television pilots to run behind in production. It just seemed to be the nature of the beast, and still is.

Russo, whose nickname is "Beef Three," casts a large, imposing shadow. Ruggedly good-looking, impressively muscular, he is "buffed out," as the saying goes. To the casual observer, Russo is not someone to be trifled with, which belies his actual good nature. He is a stabilizing influence among the crew, always ready to help out should anyone need a hand.

On this December day he is still filled with fresh memories of the ride. Every November Russo helps organize and lead a one-hundred-mile ride by Harley-Davidson

motorcycle owners to raise money for the fight against muscular dystrophy. The November 1994 ride attracted nearly 25,000 bikers, and stretched out for almost seven miles.

At middle age, Randy Burgess is more like an old salt, one who has been in the business for so many years that he is a bit jaded about it all. Not that he does not care anymore about what he does. Quite the opposite. He cares deeply, which is why some things bother him more than they bother most others on the crew. He has a sharp wit, and loves to skewer ridiculous situations brought about by the actions of ridiculous people. Yet he is tireless and patient. A baseball cap seems wedded to the top of his head, partly—one suspects—to hide a balding pate.

While much of Randy's career has been in television, his boss, Bob Sordal, has worked on feature films for most of the forty years he has been in the business. Unlike most of his contemporaries, Sordal has been married to the same woman his entire adult life. He and his wife, who does not care for *Star Trek*, have four grown children—all of whom think *Star Trek* is terrific.

A few years ago Sordal switched to episodic television where, so he thought, the pace would be physically less demanding "for a man of my maturity." Did he get a surprise. He admits the pace is brutal, and deems himself fortunate if his work week does not exceed seventy hours.

Bob planned to retire at the end of *Voyager*'s first season, allowing Randy to move up to the top slot of company key grip. Randy has waited a long time for this opportunity, and has worked hard for the promotion. Generally in Hollywood though, hard work, experience, skill, and years of service are not automatically rewarded with a promotion.

More often than not, people move up when those above them retire, and not before. For a crew member seeking a promotion, the only other choice is to quit, and get hired somewhere else in a higher-level position. In the meantime, you show up each day, do the work in front of you, and try not to think about the price.

Randy Burgess: For the crew, it's up and down, up and down, up and down. It's a case of when you're on, you're moving flat-out, and when you're not on, you relax wherever and however you can. This is no place for babies. This is forty-four weeks a year of brutally long days. It takes a heavy toll on us. Here, and at home.

Beyond the shuttlebay area, near the stage's east wall, Arlene Fukai, the petite, indefatigable second AD, talked on the stage phone with her right hand, a two-way radio clutched in her left. A first-generation Japanese-American, Arlene—whose nickname is

"Lamb Chop"—has lived her whole life in Los Angeles. One of her great dreams is to someday visit her parents' native Japan, and learn more about her own ancestral roots. The phone she held was wired to her "mobile command center"—a movable wooden table fitted with two telephones. The second phone is provided more as a convenience for the director. Stage phones are generally at a premium—invariably at least one of the phones is in continuous use by one or another of the crew.

Arlene's table served as a stand-up desk; the phones were her link to the producers in Cooper and Hart. Part of Arlene's job was to keep Brad Yacobian, Merri Howard, and others apprised of progress throughout the day. When David Livingston had called Merri Howard during the production meeting earlier in the day, he was using one of Arlene's phones.

Maintaining radio contact with Herrera, L.Z. entered the corridor and moved swiftly past sickbay, towards the transporter room. And abruptly found his path blocked. At least ten people were crowded around the entrance to engineering, directly on his left. Intermixed around them was an assortment of director's chairs, light stands, and makeup kits. He quickly recognized each person, but could not see either Herrera or the two women. Frustrated, L.Z. whispered a terse, "Ed. Where are you?" into his radio.

Next to *Voyager*'s bridge on Stage 8, engineering was turning out to be the favored set for cast-member photos. Probably because Richard James designed it as a true two-story set. With the ship's warp core in the center, the set gives photographers visually spectacular results. By the time L.Z. came upon the scene, the *TV Guide* crew had just finished shooting a three-shot of Kate Mulgrew (Captain Kathryn Janeway), Robert Beltran (First Officer Chakotay), and Tim Russ (Tactical/Security Officer Tuvok) on the main-deck level, with the warp core in the background.

Mulgrew, especially, was glad for the few minutes' break she would get before being needed for the next shot, and retreated to her trailer to relax.

Kate Mulgrew: I work eighty hours a week and I've got two days off. It's not even two. If I can make a baseball game and a meal with my kids and get a good night's sleep on the weekend, that becomes a huge focus. I can plan two months in advance for one small weekend of rest. And then I have to negotiate with myself. "Well, if you see this person for lunch, or that person for dinner there goes your rest, there goes the time with the kids, there goes this, there goes that." That's very hard for me.

While L.Z. was attempting to contact Herrera, Scotty McKnight, the assistant chief lighting technician (also known as the Best Boy), and Ian Christenberry, the rigging gaffer, were having problems of their own. They were attempting to satisfy a request for a lighting change by *TV Guide*'s photographer. Their boss, Bill Peets, is in charge of set lighting, but for still-photo shoots Bill occasionally turns the lighting responsibilities over to McKnight. In other words, Peets was opting to "sit this one out."

Aside from the lighting change, the photographer wanted more action from the warp core. Even though he was shooting stills, he wanted to capture a stronger sense of action and realism from the device. McKnight, Christenberry, and Lamp Operator Roger Bourse finally got the adjustments made, and waited for the photographer to set up his next shot. This would be the last of the day—a group shot of the entire cast. Wil Thoms stood by, ready for the signal to speed up the warp-core motors.

The photo session was *TV Guide*'s second cover story on *Voyager*, and was scheduled to run in the January 14–20 (1995) issue—the week of *Voyager*'s premiere two-hour episode, "Caretaker." The first story ran in the October 8–14 issue and was itself unprecedented. For the first time in the magazine's history a cover story was run on a new television series before the show had even been aired. This was a strong testament to the magazine's affections for *Star Trek*, probably because the two entities have had a long and engaging history together.

TV Guide's relationship with *Star Trek* goes back to the March 4, 1967, issue, when the magazine ran its first cover story on the then-fledgling television series. Following that initial article, fourteen more cover stories would eventually grace its pages—as of August, 1996—an honor unparalleled in the history of the publication. In the spring of 1995, *TV Guide* would establish another "first" for itself, by running its first-ever large-format issue—full magazine style—completely devoted to "*Star Trek*: Four Generations of Stars, Stories, and Strange New Worlds."

It was nearly four o'clock. The *TV Guide* photo shoot had been running all day, and was scheduled to continue on Wednesday in the transporter-room set next to engineering. Monday's Call Sheet listed still photos of each cast member starting at 9:30 A.M., culminating in the group shot at 3:30 that afternoon. Events were running a bit behind.

An assortment of people stood around observing, jammed into the entrance to engineering, or in adjacent corridors and doorways—a few Paramount Studio personnel, publicity department people, and crew persons. Off to one side, diminutive Jolynn Baca paced nervously. Jolynn was the account executive for Bender, Goldman & Helper, the public

relations agency hired to handle publicity and promotional efforts for *Voyager*. *Star Trek* was a big client. Jolynn did not want anything to go wrong.

Despite her efforts, the publicity firm's role wouldn't last. Before the end of the second season, Paramount would pull all *Voyager* publicity efforts in-house, combining them with its existing publicity department, under the direction of Trisha Drissi, vice president, Media Relations. Deborah McCrae-Thomas, Jolynn's boss at Bender, Goldman & Helper, would sign on at Paramount and handle *Voyager*'s day-to-day publicity requirements.

Responding to L.Z.'s call, Ed informed his partner that he was near the Jefferies tube and had the two women in sight. They were not twenty feet away, in the corridor by the entrance to engineering, between the Jefferies tube and the turbolift. Ed did not recognize either woman, so was diplomatically waiting until his partner could get a look at them. L.Z. began working his way toward Herrera's position, through the knot of onlookers blocking his path in the corridor.

On the other side of engineering, in the sickbay set, David Livingston was trying hard to quell his impatience. Even though the photo shoot had been scheduled on the Call Sheet, he still did not like having to halt production on "The Cloud" while a magazine took pictures of the cast. On the other hand, he knew it was a necessary intrusion.

Wearing his supervising producer's hat, David Livingston was committed to supporting the press. Wearing his director's hat...well, he was entitled to be frustrated by any kind of delay, press or otherwise. So he used the time to review his script notebook, carefully going over his plans for the scenes that were still left to shoot. A director's script notebook is his bible.

> David Livingston: I do my homework. I come in on weekends and I sit on the stage and agonize over what I'm going to do. Your original plan may be too grandiose and take too much time. So you have to pare it down and come up with the number of setups...which is where you put the camera...each time you move the camera, that's a different setup...you have to figure out how many of those you have to do in a day. I can do about twenty-five. Some directors can do thirty or forty. Depends on their style and the kind of show. But not me, not on *Star Trek*. It's too demanding.

Publicity coverage was vital to a successful launch for the new series. And thus far, media interest had been excellent. Press coverage was becoming an almost daily occur-

rence. Merri Howard had weeks earlier found herself dealing with requests from magazine and film crews on a level she could only describe as intense. *TV Guide, Entertainment Weekly, USA Today, CNN,* The Sci-Fi Channel, United Paramount Network, *Los Angeles Times,* KCOP-TV, *AP Network News, Black Television Entertainment*…the parade was virtually nonstop. It was just the opening salvo.

Each member of the new cast was attempting to adjust to the onslaught of press coverage. Although forewarned by the producers, they were still unprepared for anything like the media interest and scrutiny that was starting to build. Each of the new cast members handled his or her press relationship in a different way. To some, it was a difficult ordeal. To others, it was a delight. To all, the massive attention was completely unexpected.

For Kate Mulgrew, the attention was an actor's dream come true. A veteran of episodic television, Mulgrew knew only too well the damage caused to one's career by being out of the public eye for too long. Hollywood has a brutally short attention span.

> Kate Mulgrew: You get a shot, maybe two or three times in a lifetime, at something that you know can be a very happy marriage…an actor's role…in fortuitous circumstances. And this is where I am. I'll be forty next year. I've really lived a rich, interesting life. And I want to relax enough to really take the bull by the horns…make this character my own. I want this work to be good, and I want it to be multilayered, and complicated, conflictive, dangerous…I want to pick it up and take it places it hasn't been before. When I was a younger actress it was more…full steam ahead…I was driven and all that. Now, this feels right. It just feels great.

Robert Picardo (the Doctor), no novice as an actor, welcomed the publicity—he, too, knew its value—but was completely bewildered by the fan attention. He found it incomprehensible that he could already be receiving fan mail, when the series had not even aired yet. A friend strongly advised Picardo to get a fan-mail manager, "…because you're going to need it. Your character is going to be enormously popular." The actor could only return a blank stare. There was nothing in his experience to help him relate to what was being suggested.

Garrett Wang (Ensign Harry Kim), a professional actor for only two and a half years, clearly loved every minute of the attention. Wang (pronounced "Wong") readily made himself available to all comers. Ethan Phillips (Neelix) and Robert Beltran

(Chakotay), also veteran stage, screen, and television actors, welcomed the media spotlight with trouper-like aplomb. The media, in turn, loved them because they were always ready with a joke or a wisecrack. Both Phillips and Beltran were quickly getting a reputation for being *Voyager*'s resident comedians. More than that, the two seemed to have a sixth sense about when tensions on the set needed lightening up. It was a talent that would be put to good use, and often.

Through it all, Tim Russ (Lieutenant Tuvok), Roxann Biggs-Dawson (Chief Engineering Officer B'Elanna Torres) and Robert Duncan McNeill (Lieutenant Tom Paris) had remained gracious and accommodating of the wishes of the press. They were approachable and easy to interact with. (In the third season Roxann dropped the use of her birth name; in subsequent credits her name is shown as Roxann Dawson.) Each exuded a kind of poise and self-assurance not usually present in those unaccustomed to intense media coverage. They, too, were media favorites.

Jennifer Lien as the Ocampa Kes. ROBBIE ROBINSON.

Jennifer Lien (Kes), on the other hand, was not as quick to adjust to the encounters with the press. Perhaps it was her age. At nineteen, she was the youngest member of the cast. In any event, the newness of the "*Star Trek* experience" seemed to overwhelm her. Lien's responses to questions were invariably monosyllabic, usually vague, and never remotely about herself. Lien gave every appearance of a fragile person running scared while bravely trying not to let it show. Clearly, she wished she could simply disappear until it was all over.

This difficulty inherent in interacting with the press is a sharp reminder that being a member of a *Star Trek* cast—television or feature film—does not come without a price. Playing a recurring role makes extraordinary personal demands on the actors. It automatically means incredible levels of fan/media exposure. *Star Trek* fans in particular are highly possessive, and tend to fasten themselves on to cast members—even extras and stand-ins—to such an extent that "ownership" would be an appropriate term for their

feelings. Under these conditions it is a wonder cast members can achieve any semblance of an offscreen, personal life.

Indeed, hard-core fan affection seems to know no bounds. Most actors can adapt, adjust, and cope with it. Some cannot. At times, this affection is a double-edged sword. When a *Star Trek* actor is perceived by the fans as being inaccessible, or fails to live up to their (sometimes unrealistic) expectations, the letters and E-mail pour in.

Lien's initial discomfort was obvious enough that it made the crew and security personnel protective of her, shielding her from unwanted intrusions. No one blamed Jennifer Lien for her reaction. The relentless press of the media was intense, and completely unlike anything the cast, from Mulgrew on down, had ever experienced before.

Robert Beltran: It is intense. I'm not used to this. It doesn't really bother me yet. But I can see where it could interfere with my ability to stay focused and work when I have a lot of scenes with a lot of dialogue. I'm finding this new to me because in other projects I've done they just don't have the money for this kind of media stuff. The actors have to pay for it themselves. They go out and get a publicist.

I've done that before, and I find that very awkward. You're hiring these people not knowing exactly what they can do for you. What magazines they can get interested in you. So you're just kind of blindly asking these people to do some publicity for you. This is different because you know what magazine it is, you know what television channel it is, you know who it's for.

So it's much easier to do that because it's less stressful than having to go out and hire a publicist yourself, and end up being totally dissatisfied with what they're doing.

The *TV Guide* photographer was ready for his next shot, and was placing the cast on their marks. Mulgrew, Beltran, and Russ were on the main deck level, as before. The remaining cast members were placed on engineering's second-floor level, centered directly above Mulgrew.

The effect was striking, arranging all the cast members in a classy group shot while avoiding the look and feel of a high-school graduation picture. The pose was destined to be used many times, by press crews from all over the world.

L.Z. was now at the opposite end of the corridor from Herrera and could clearly see the two women. "Unh unh. Don't know 'em," he quietly radioed to Ed.

"Roger. Do you want to handle it?"

"Yeah, I'll handle it," came L.Z.'s reply. Herrera acknowledged the message, switched his radio back to channel one, and left the stage to resume his conversation with Greg Agalsoff.

Dealing with the situation was a normal part of the job. L.Z. and Ed worked hard at staying emotionally detached. There was nothing personal in these things. Both men knew that as the show's popularity increased, attempts at unauthorized access to the cast would also increase. Ed was new to *Star Trek*, but he'd been through this before, on productions like *The Arsenio Hall Show*.

Ed Herrera: Most people are pretty cool about it. Women are usually the ones who give us the worst time. They say things like, "Do you know who you're talking to?" And I'll say, "No ma'am, frankly I don't." Men will usually say something like, "Okay, no problem," and they leave. I guess the women think they can intimidate us.

Both Herrera and Ward are polite, diplomatic, and usually ask the visitors who they are there to see. The aim is to determine why they are there, because it is always possible the visit is legitimate.

It did not take L.Z. long to learn that the two women were there to see Kate Mulgrew about a dress the actress wanted to order. L.Z. politely told them they would have to wait outside until the actress was available. He would deliver their message to Mulgrew. With that, L.Z. escorted the women off the stage, suggesting they make themselves comfortable on the bench near the stage entrance.

With nothing to do until the *TV Guide* people left, *Voyager*'s production crew members were temporarily on their own. No one would stray too far, of course. They never knew when their services might suddenly be required on the set.

In the meantime, some of the crew indulged a favorite habit—hanging out at the craft service tables on Stage 8. The extras are rarely far from craft service, often opting to skip a formal meal in favor of Jan's fare. The food is good, filling, and best of all, free. For struggling actors who work as extras, that can make an important difference.

Extras are hired for nonspeaking roles in a specific episode. They are hired by the day,

and only for certain scenes. When Adele Simmons or Jerry Fleck prepares the production boards, one factor they consider when grouping scenes together is the need for extras. All scenes requiring extras tend to be shot on the same day. This keeps casting costs to a minimum.

Being an extra is a tough way to make a living. Most do not—there is not enough steady work to pay the bills. It may be an important route into the business of being an actor full-time, but it is still tough. If PA's are at the bottom of the food chain, extras are in the basement. Extras who work on *Star Trek* productions are lucky; they are treated with respect and work in a pleasant, friendly environment. Elsewhere, on other productions, extras are not so fortunate. With some production companies, extras are not valued for the important elements they add to a scene, and are sometimes derisively referred to as "props that eat."

Acting is glamorous. Right.

After a snack, the crew's options quickly dwindled: some casual conversation, a few phone calls, catching up on some reading, or maybe a fast trip to the restroom. When those things were done, there was not much left to do except sit around the periphery of the set and try not to die of boredom.

But not affable, soft-spoken sound mixer Alan Bernard, who sat comfortably in his director's chair reading the front page of *The Los Angeles Times*. Silver-haired, neatly but casually dressed in slacks and polo shirt, Alan is the perfect picture of a true gentleman, in word as well as demeanor. Though small in stature, Alan has a large presence on the set.

A veteran with over forty years in the business, Alan initially worked with Gene Roddenberry on his first television series, *The Lieutenant*. Bernard has been with *Star Trek* since the inception of *The Next Generation*. His work on that series won an Emmy nomination each of the seven years it was produced, winning the coveted award four times.

Bernard's job is to sit in front of his sound cart, headphones on, adjusting knobs and dials, tweaking the sound-recording equipment, making sure he can hear every bit of dialogue delivered by the actors while the camera is running. At the same time, he constantly checks to make sure his sensitive equipment is not picking up extraneous noises from anywhere else on the cavernous stage or perhaps, as sometimes happens, filtering in from the outside world. He is also the one who turns on the flashing red lights and sounds the loud buzzer when the camera starts to roll.

Alan Bernard: Technically, this is the best television show being done anywhere. I don't think there's another show on television that can match what we do. We shoot a feature every week. And it's feature quality.

Probably one of Bernard's greatest disappointments in life is the fact that, as superbly as he does his job, so much of an actor's dialogue is rerecorded later in a process known as looping.

Nearby, Marvin Rush sat in his own director's chair, sending an E-mail message to his wife, via a hand-held Motorola Marco—his latest and proudest acquisition. Like a futuristic device out of *Star Trek*, the Marco will interpret Marvin's handwritten notes, store them in its computer, and even—as Marvin frequently does—send E-mail messages to his wife via wireless remote connection to the Internet. It is a common sight to see him standing on the edge of the set, communicating with someone on the Internet. Message sent, or exchanged, he clips the device back onto his belt and returns his attention to the action on the set.

As the Marco suggests, Marvin is a true technophile, unabashedly in love with computer-driven cutting-edge technology. He takes great pride in being both environmentally and technologically aware. Rush frequently rides his bicycle to the studio from his home in the San Fernando Valley, rather than burn more fossil fuels in the family sedan. Recently, he went a step further, and became the first member of the shooting company to buy an electric car for his commute to Paramount.

From appearances, Marvin Rush could easily be mistaken for a middle-aged, slightly balding college professor. He is passionate about his work, patient up to a point, and always willing to make suggestions to a director, if the director is willing to listen. Not all are. Some directors are extremely territorial, and want no advice from a DP.

A prudent director will at least give Marvin's ideas a fair hearing. No matter how good a director may be, he or she cannot know the sets as intimately as Marvin Rush. He lights those sets every day that *Voyager* shoots. He did the same for *The Next Generation*. He knows every possible camera angle, which walls will wild—move out of the way so the camera can get in from a different direction—which lights are best used where, and how long it will take for each setup a director may want to make.

For both the DP and the director, it is a fine line to walk. The DP is there to help realize the vision of the director. On the other hand, the director is there to control the activity so that his vision can be expressed the way he or she views it. Between a DP with strong convictions—which Marvin has—and a director with equally strong ideas—which most have—conflicts can easily arise. Rush occasionally finds himself unintentionally stepping on toes he merely intends to support. It is the same dilemma that often faces most human beings: Sometimes it is difficult to know where the line is located.

Nevertheless, properly utilized, Marvin Rush is one of the best resources a good director can have.

It is no secret that Marvin wants to become a director full-time. Television would be great, but features would be bliss. There is evidence that he is making progress toward that goal. Rick Berman had previously agreed to allow Marvin to direct several *Next Generation* episodes, and Marvin makes no attempt to hide his hunger to direct a *Voyager* episode. (He would get his wish, with the second-season episode "The Thaw.")

To his credit, Rick Berman has long held a policy of allowing crew and cast members alike to direct *Star Trek* episodes. Dan Curry, Marvin Rush, LeVar Burton, Jonathan Frakes, and others either have been given additional directorial experience, or have been given their start as directors, as a result of Berman's supportive policies. *Voyager* cast members including Robert Duncan McNeill and Robert Picardo would eventually make their episodic television directorial debut with Rick Berman's blessing.

Curiously, Berman himself thinks the very idea of directing is anathema. He has no personal interest whatsoever in directing—not even one episode.

Rick Berman: People ask me why I never want to direct. I think directing episodic television is an insane thing to do. You are doing in seven days what absolutely should be done in fourteen. You are trying to direct eight pages a day in a medium that really doesn't allow for it to be done properly that way. Most people are put under tremendous stress.

You are dealing with actors whose characters have all been created, who know their characters better than you do. You're dealing in a medium where the producers do the casting, usually. The producers do all the postproduction. You...are a glorified traffic cop...for a week and a half. And you have to perform great acts of grace under tremendous pressure. You have to constantly be compromising, because no episodic directors can do anything but constantly compromise what they want to do.

Then you leave and you go and do *L.A. Law*. You go to another show. And try to do it all over again. A lot of people here want to direct. Editors and actors, and...there's a part of me that believes that they want to direct because it gives them, for that one brief couple of weeks, control. They can take control of that which they have been just a piece of for many years. So when they direct, they go to that stage and they're in charge. I can't believe there's really any other reason they want to do it but that.

I don't need to be a director to be in control. Because I'm in control anyway. And as a result, the last thing in the world I want to do is be getting up at six o'clock in the morning and calling shots and having every three hours to realize that you can't do what you want to do and you constantly have to go to Plan B or Plan C or Plan D. It's a hateful job.

With rare idle time on his hands, Michael DeMeritt, the second second AD,[*] uncharacteristically relaxed in conversation with Michael Risner, the Director's Guild of America (DGA) trainee. Risner would be with *Voyager* for three months; then a new DGA trainee would take his place. It was a great opportunity to get started in the business. If he was fortunate, Risner would be hired somewhere as a second second AD, and begin working his way up the ladder. Many directors or producers began their careers as DGA trainees.

Like Bill Peets, Michael DeMeritt is perpetually clad in shorts no matter what the weather or time of year. Armed with a headset and radio, DeMeritt usually is a man in perpetual motion, roaming the inside of the stage as well as the front area, outside. He is in constant radio contact with Arlene Fukai, Ed Herrera, L.Z. Ward, the first AD, and the DGA trainee. His personal passion is comic books—writing and developing them. At the moment he was telling Risner about his latest efforts to interest a New York publisher in one of his series ideas.

Both DeMeritt and Risner's primary task is to assist the director in quieting down the stage when the camera is getting ready to roll. They, along with Arlene Fukai and Adele Simmons or Jerry Fleck, will yell out "ROLLING!" from wherever they happen to be on the stage at that moment. This, to reinforce the sound of the buzzer—which, by itself, is nearly ear-shattering. DeMeritt is also responsible for finding the actors and getting them to the set in time for rehearsals and shooting.

Between all the various trailers parked out in front of 8 and 9, plus the numerous out-of-the-way areas on the stages, it can take time to locate someone. That doesn't work. To keep delay problems to a minimum, cast members always "check out" with one of the first ADs or the second ADs. In the meantime, DeMeritt, Fukai, and Risner are continually on the move. A vital part of their job is to know where the cast members are at all times.

[*] No, there is not a second second second, or a third third, etc.

In the sickbay set, off to one side of the camera dolly, Cosmo Genovese, the crew's script supervisor, sat in his director's chair, hunched over his well-worn script book. The Grand Old Man of the crew, revered by everyone, Cosmo has been plying his craft as a script supervisor for more than thirty years. While *The Original Series* was in production, Cosmo was also on the lot, nearby, doing the same job for *Bonanza*.

Throughout a typical production day, each crew member works in spurts. Helping set up shots, moving equipment, getting this piece of lighting gear, taking away that no-longer-needed prop, adjusting the intensity of a lamp, repositioning a set wall, on and on and on. Then when the camera rolls, all is still. Nobody moves, except maybe the camera and the actors. Through it all, there's Cosmo Genovese, perched on the edge of the set, always just barely out of the line of fire, but always positioned so he can get a clear view of the scene being filmed.

Reserved almost to the point of being nonverbal, Cosmo seldom moves around on the set, or engages in small talk with anyone. His conversations tend to be job-focused, and most often involve discussions with the director or cast members regarding something in the scene of the moment. He faithfully records invaluable data about the day's filming, including every change in dialogue, the timing for each and every take, no matter how many there are, with careful notations identifying which take is the one the director likes best.

Genovese's work is immensely important to *Voyager*. Fortunately, he is totally dedicated to it. He may get a cup of coffee occasionally, or make a quick relief run. But mostly he can be found throughout the entire day, whether the camera is rolling or not, sitting in his director's chair adding notes to his script book, writing in the margins, and documenting changes or additions.

During the postproduction process Cosmo's annotated script becomes an indispensable tool for others. When a director says "Print it," that is the take Cosmo notes as being the best. This note, like many others Cosmo makes, eventually ends up in the hands of one of the editors—who are obviously looking for the director's best takes as the ones they cut together first. Their work, of necessity, is guided somewhat by Cosmo's information.

No matter what is going on, or how pressured things might be at the moment, it is always easy to find Cosmo Genovese: a quiet "eye," in the storm of activity around him.

In the ship's corridor just outside of sickbay—and close at hand, in case McKnight needed him for something—Bill Peets sat on an upturned wooden box affectionately known as an "apple," reading the latest issue of *Gun Digest*. In his private, non-*Star Trek* life, Bill is a licensed firearms dealer, a collector of some note, and a fair expert in his own

right. A large, intense man with a distinctive gravelly voice, Peets barks orders to his crew with an air of authority gained from some twenty years in the film and television industry. For the last ten years Peets has worked on *Star Trek*—first on *The Next Generation*, later on *Deep Space Nine*, and now on *Voyager*. Winter or summer, he is usually clad in T-shirt and shorts, his massive calves looming larger than some people's thighs.

There is a skill and an art to lighting a set, particularly a *Star Trek* set. Bill Peets is both a master and an artist.

Bill Peets: You can't get any better television than this to work on. The money they spend on sets, the visual effects you get to do. It's a top show to work on. It works long hours. The cast is great. I even have my own little baseball card. I find that quite amazing. I get letters from all over the United States. I got one from Germany, another one from France…fans who want their card signed. That's amazing, 'cause I'm way down on the food chain.

I think *Star Trek* is popular because of the nature of the show. It's where people can't go today. Problems go away. There is no racism. People are pretty much equal. There is good and bad, they still have problems, but they seem to have worked out some of the world's problems that we're going through now. It's turned into something that a lot of people can't live without.

According to legend, the term "apple" originated years ago, because an apple box was used to add a little extra height to a camera, a light, a short actor, or whatever. Later, boxes half that height and dubbed "half-apples" were created, when less adjustment was needed. Now there are quarter-apples, half-apples, and full apples.

Bill Peets preferred full apples for sitting on because, standing on end—which made them just about right for a nice comfortable seat—they were more stable than half- or quarter-apples. Stability was important. Otherwise, the unforgivable could happen: You might lose your balance and fall over during a take, i.e., with the camera rolling. Not a good idea to make noise during a take.

Not that ruining a take is rare. On the contrary, it happens several times every hour. When an actor blows a line, for example. But that's different—expected almost, taken for granted. That's okay. Unless an actor blows a line repeatedly. That is not okay. Then someone like Brad Yacobian steps in and has a conversation with the actor.

Full apples are also the preferred object for one's derriere for a more practical reason. There is not much else to sit on. Director's chairs are provided for the director, DP, sound mixer, script supervisor, all cast members and guest stars, plus a few for makeup. Sounds like a lot of director's chairs. But out of some forty-odd people working on the set, plus extras, stand-ins, publicity folk, and miscellaneous camp followers, there are not that many chairs to go around. Which is neither here nor there because, scarcity aside, the directors chairs are most definitely "reserved seats."

It's a Big No-No to sit in someone's director's chair. Even if it stays empty all day.

The easiest solution to the what-to-sit-on problem is to find an apple. If you can. Given the nature of the work on a stage, and all the stuff piled everywhere, that's not easy. Somewhere in all that mess surely there must be at least one loose apple.

Don't bet on it.

PART

TWO

THE BACKSTORY

ENDOGENESIS

It's dark when we get here, and it's dark when we go home.

Scotty McKnight
Best Boy

AT THE BEGINNING OF 1991, *STAR TREK* ENTERED a period of expansion that was unprecedented in television production. This expansion would continue for four years and would culminate with the launch of *Voyager*, although no one knew that at the time. It was as if Gene Roddenberry's science-fiction child had stumbled into puberty and put on an incredible growth spurt. A whole new set of uniforms would have to be ordered. Lots of them.

Although a number of factors came into play during those four years, what really set the stage was the increasing popularity of *Star Trek: The Next Generation*.

In 1986, seventeen years after *The Original Series* ceased production and after numerous abortive attempts to resurrect a second television version, Paramount finally decided to launch a new *Star Trek* series, with Gene Roddenberry as executive producer. The intervening years had been long, and wearing on *Star Trek*'s creator; he had not fared well physically. Perhaps mindful of his own progressively ill health, Roddenberry began assembling his development team while keeping an eye out for someone to whom he could pass the baton.

Providence, it turned out, was close at hand.

In early 1987, several months after the go-ahead by Paramount, Roddenberry met a young studio vice president named Rick Berman, who was at the time in charge of developing television movies of the week, miniseries, and specials. Berman had joined Paramount two years earlier, initially to shepherd new television projects onto the small screen—shows like *Cheers*, *Family Ties*, and *Webster*. The two men had lunch shortly after that first meeting, and found they shared common interests. Within days, Berman was invited to co-executive produce *The Next Generation*.

Berman was a transplanted New Yorker with a string of award-winning producer credits on his resume. His intense, hands-on producing style had yielded award after award for HBO and PBS, including an Emmy for *The Big Blue Marble* as Outstanding Children's Series. By the time he and Roddenberry met, Berman was no longer actively producing. He was, as they say, "a suit," working out of an executive office far removed from the adrenaline-pumping action of day to day production chores.

As others would quickly discover, Berman was indeed much like Roddenberry in at least one respect. Both men were not satisfied with the title of "producer," "senior producer," or "executive producer." They line-produced. Berman, particularly, seemed to revel in the role.

Normally, the hierarchy of television production places the executive producer at the top, overseeing the entire operation in a more or less executive administrative function. The line producer, by contrast, sits close to the production itself, supervising every aspect of preproduction, filming (principal photography), postproduction, and distribution. In between the two are varying layers of other producers with more specific, departmentalized roles.

Rick Berman, far more than Roddenberry, relished line-producing with a passion—a factor that may have influenced his decision to accept Roddenberry's proposal. In extending the invitation, Gene undoubtedly recognized a kindred line-producer soul.

Berman was manna from heaven. By the time the new series launched in the fall of 1987, Roddenberry had christened Berman heir to the helm, and continued to tutor him in the ways of the *Star Trek* universe.

Complex, driven, with an unquenchable thirst for perfection, Rick Berman is precisely what *Star Trek* needs. It is highly unlikely that anyone else on the planet would be willing to devote the extraordinary amount of time and energy required to do what he does. (How the man has time for anything else, including his family, is a mystery.)

> Rick Berman: I think one of the things that attracted Gene Roddenberry to me…is that I wasn't a trekkie. Not even by the broadest stretch. In fact the first *Star Trek* movie I ever saw, I saw with Gene. I was in college when the show was on. I don't really remember watching it very much. So I came to this very fresh. It was not like I was coming into the temple. It was a television series.

A large, teddy-bear-like, energetic man with an intense demeanor, Rick Berman has lived in the *Star Trek* universe for more than ten years. He has pushed, pulled, shaped, and molded *Star Trek* from a reborn television series into an unprecedented entertainment phenomenon. He has gone from Viceroy of The Great Bird[*] to Lord of the *Star Trek* universe, Maintainer of Meaning, Custodian of the Vision, and Keeper of the True Faith.

But preserving Roddenberry's legacy has not come without a price. After the death of *Star Trek*'s creator, a small but vocal segment of fans were concerned that "Gene's vision" would not be maintained. That it would be corrupted, changed, altered, or otherwise tampered with.

> Rick Berman: I've read articles and letters from some people who show some frustration or anger towards me because they feel that I am sort of a pretender to the throne. That I am trying to take Gene Roddenberry's place as the "creator of *Star Trek*." That couldn't be further from the truth. I never have done that. I have always acknowledged from day one that this show…*Star Trek* in all it's permutations…has been part of Gene Roddenberry's universe.

[*] Roddenberry's nickname was The Great Bird of the Galaxy.

I've tried to carry it on and embellish it. But I've never really seen myself as a visionary, as a futurist...as someone who was trying to take the "created by" credit away from Gene. I was involved in the creation of *Deep Space Nine* and *Voyager* but I've always acknowledged that this has always been Gene's baby. The whole idea, and what *Star Trek* is. So when I see people getting angry in letters and in articles about that it throws me a bit.

Although Berman's commitment to Gene's vision—at least the positive aspects of it—has been steadfast, his producing style is quite the opposite of that of *Star Trek*'s originator. Rick Berman is the man riding the horse. He is the absolute head of the company, under whose watchful eye virtually nothing gets approved without first being blessed by him. His control is so utterly complete that even Berman himself often lapses into the imperial "We." As in, "Make sure We don't hate it."

Under Berman's stewardship the term "hands-on producer" has taken on a whole new meaning. His attention to detail is colossal. His ability to instantaneously shift focus from one task to another without skipping a beat and with apparent total concentration is unbelievable. He seems to flow effortlessly from approving the first edit, frame-by-frame, of an episode of *Deep Space Nine* to reviewing—again, frame-by-frame—an optical effect for a *Voyager* scene, to critiquing, word-by-word, the final-draft screenplay for the feature *Star Trek: First Contact*.

In the corporate world of big business this is usually called micromanaging. Board chairpersons and CEO's do not like to be accused of "micromanaging." The term generally denotes a poor manager, one who has difficulty letting go of control and delegating authority to qualified subordinates. It is true that Berman maintains overall control of seemingly endless minor details in addition to normal everyday line-producing chores. But is this the same as micromanaging? Depends on who's riding the horse. When one has enjoyed the commercial and financial success Berman has achieved thus far, it is difficult to fault him on anything. The evidence is irrefutable.

In addition to producing-style differences, Berman's relationship with the fans is also the antithesis of Roddenberry's.

Gene Roddenberry was readily accessible to fans everywhere, in the same way some actors love that special connection they can only get from being on stage with a live audience. It is personal, intimate, visceral, exhilarating, and energizing. Roddenberry knew that, experientially. He loved that feeling of connectedness. He loved rubbing elbows with

the fans. And they returned his love with undisguised passion.

Berman does not do that. He does not have to. It's his job to uphold the vision, not schmooze with the fans.

Like his predecessor, Rick Berman may have his detractors, but he certainly deserves respect for the Herculean task he has daily performed since agreeing to accept the helm from Gene Roddenberry. Since taking over, he has faithfully shepherded more than three hundred hours of *Star Trek* programming—triple the number Roddenberry oversaw—and the total continues to climb unabated.

Closer to home, Berman occasionally gets unfair criticism from some quarters, primarily because of his astonishing eye for detail, and his refusal to relinquish the hands-on producing duties on *any Star Trek* episode or film. He will not settle for less than what he wants, from anyone. He may not know what that is at the outset—for say, a detail of dialogue, a style of makeup, an optical effect, or an edited sequence—but, unerringly, he knows it when he hears or sees it. It is an impressive ability that certainly deserves respect.

His approach to guiding the helm also does not come without a price for those working with him, who must frequently change, alter, or rework from scratch their concepts and creations. He may be a difficult man to please, but there is absolutely no question that the results show, and that *Star Trek* is the better for it.

Roddenberry was, without doubt, a creative visionary. But he was never the producer that Rick Berman has proved to be.

For Berman, personally, there must be considerable irony in his present position. The success he has worked so long and so hard to achieve has in many ways overtaken and engulfed him, and now pulsates with a life entirely its own.

Star Trek has grown so big that Berman has more work to do now than ever before. Over the last ten years he has steadily added layers of producers and staffers to help ease the workload. This expansion has been mirrored at both Paramount and Viacom. As the number of series, features, theme parks, retail stores, and related ventures proliferates, more people are needed to oversee various aspects of the *Star Trek* universe.

Rick Berman may well be the man riding the horse, but in a purely philosophical sense, he is no longer in charge. *Star Trek* is simply too big. Like everyone else, at every level, he can affect the flow of events—more so, unquestionably, than anyone else. But in the final analysis he, too, can only be swept along by ever-expanding forces, of which he is increasingly only a constituent.

Control is an illusion.

Power is, and always has been, a fickle and transitory traveling companion.

In 1989, however, being in the *Star Trek* driver's seat was a dubious distinction. In fact, success seemed as elusive as a fully cloaked Klingon bird-of-prey.

Despite its much-heralded beginning, after just two seasons *The Next Generation* was not doing well. People were watching, but viewer interest was tepid. Making matters worse, Roddenberry was in ill health, and had ceased coming into the studio on a regular basis. Contributing to Berman's headaches was the fact that writer morale—both staff and freelancers—was low, and turnover was high.

Berman knew the series was in trouble, that it lacked strong action-adventure stories and sharply drawn characters—factors designed to produce conflict. The very same elements that had helped solidify *The Original Series*'s appeal with viewers. Compared to *The Original Series* episodes, *The Next Generation* stories were pretty flat.

Enter Michael Piller.

As a writer-producer, Michael Piller was definitely an action-adventure heavyweight. His series credits included *Simon & Simon, Cagney & Lacey, Miami Vice, Probe*, and *Hard Time On Planet Earth*. Additionally, he was co-creator and executive producer of the syndicated series *Group One Medical*.

Given his background, it is a wonder Piller ever became a writer at all. Not because he lacked interest in the profession. That was hardly the case. When Piller began attending the University of North Carolina at Chapel Hill he had already decided that he wanted to become a writer. Unfortunately, he had the bad luck of ending up in a creative writing class led by a professor who subsequently did everything in his power to discourage Piller, and others, from pursuing careers as fiction writers.

Some university professors are like certain doctors and producers—they like to play God in other people's lives.

It took Michael Piller ten years to heal the professor's ruthlessly inflicted creative wounds.

In the meantime, Piller turned to broadcast journalism, eventually ending up at CBS in Los Angeles. Finally, dissatisfied with the news business and safely distanced in time from his university experience, Piller rekindled his interest in fiction. Not long after, he was earning an income writing scripts. By the time Rick Berman called him, Michael Piller was doing rather well.

Initially, Piller was asked to fix a second-season script. A year later he was offered a staff position as a producer (writer). His agent strongly advised Piller not to take it. Word gets around in Hollywood, especially if problems are involved. Fortunately for *Star Trek*, Piller did not take his agent's advice.

With the studio's blessing, Piller was hired to ride herd on the stories. He jumped into the creative fray and never looked back. He was, however, in frequent telephone contact with Roddenberry. The two men conferred regularly, with Gene providing insights and suggestions when his health would permit.

In retrospect, Piller's influence on *The Next Generation* was exceptional. The Berman-Piller alliance may have been a match made in heaven, but it was without doubt a match also made during considerable adversity.

With Piller ramrodding the writing chores, things began to improve. For Michael, especially, the days were long and brutal; the nights were even worse. He wrote his own original teleplays in addition to rewriting or polishing almost every other story idea that came across his desk. It was in many ways a superhuman effort, but gradually, that effort began to pay off.

By the fourth season *The Next Generation* had really come into its own. Popularity surged, and Paramount knew it was the proud owner of a hit series. As it turned out, the seventh season would be the last. At the end, *The Next Generation* was the highest-rated syndicated dramatic television series of all time, its popularity increasing every week.

In late 1993, rumors of an impending cancellation began to circulate. The news shocked viewers and came as a surprise even to some members of the production company. The series was so obviously popular that few could imagine it might end any time soon. To have a series canceled because of poor ratings was one thing—*Star Trek* had already endured that indignity once before, with *The Original Series*. To have a series canceled while its popularity was *increasing* was unthinkable.

Not only was it thinkable, for a number of reasons it was inevitable.

First of all, there is the obvious matter of cast fatigue, a condition that frequently afflicts cast members of long-running shows. Symptoms include real-enough physical and mental exhaustion, financial independence, and the desire not to be typecast in a particular role. There is no cure; huge increases can occasionally persuade an actor to continue for another year or two, but sooner or later total burnout occurs.

An additional factor influencing the fall of the production ax was the feature-film market. The success of the *Star Trek* movies, built around the cast from *The Original Series*, had convinced Paramount they could indeed have their cake and eat it too. If the cast from *The Original Series* could produce box-office revenues from features, well then so could the cast from *The Next Generation*. The cast and crew would simply segue from one medium to another, and keep on trekkin'. Sounded like a good plan to everybody.

An added incentive for this strategy was the reality that box-office revenues were

falling from movies featuring *The Original Series* cast. Not to mention one other reality—the actors were reaching an age when it was becoming questionable how much longer they would be willing, or able, to continue playing the roles they had all created so wondrously well.

But of all the forces driving the inevitability of Paramount's decision, the one overriding element was cost. There is no cost-of-living index in episodic television. Instead, there is a cost-of-production-increase, governing all.

From one year to the next, every aspect of production gets more expensive. This is generally true in any sector of business; television production is no exception. It is especially true of a *Star Trek* series, readily acknowledged as inherently expensive to begin with.

During *The Next Generation*'s final season the "pattern budget" for each episode was about $1.3 million, according to Tom Mazza, Executive Vice President, Current Programs and Strategic Planning. By comparison, eighteen months later, Mazza said, *Voyager*'s first season pattern budget per episode would be $1.8 million. Every effort would be made to maintain that budget during *Voyager*'s second and subsequent seasons, but it was doomed from the beginning to be a losing battle. Built-in increases guarantee that year after year the per-episode costs will escalate.

Advancing technologies and higher vendor costs bring about a good portion of the increased expenses. A hefty chunk, though, is in the area of salaries and wages. Some of these are contractual raises; others are "negotiated salary increases." What attract the most attention in the press are those increases affecting the cast, but the actual situation is much broader than that.

Producers—from executive to associate—and certain other non–labor-union personnel also work under contract. These contracts may initially spell out compensation for a certain period of time—say two or three years, for instance—but in practicality are renegotiated well before the specified time expires. This is true of contracts with actors, but is by no means limited to them. Adding to the escalation is the periodic renegotiation of guild/labor union contracts, resulting in further wage increases.

Unquestionably, though, the biggest component of increased production costs over any length of time is cast salaries. For the cast of a highly rated series like *The Next Generation*, first-season salaries can be a pale shadow of seventh-, or eighth-, or tenth-season salaries—unless…built into the actors' contracts are specific clauses designed to avoid precipitous annual salary escalations.

It is therefore a simple matter of mathematics: Every year the costs escalate—often dramatically—if the show, *any* show for that matter, is a hit. The more popular a show

becomes, the larger is the compensation people tend to demand, in turn driving the pattern budget higher and higher. Witness the recent demand by *Seinfeld* cast members for $1,000,000 each—per week. Ultimately, something has to give. Eventually, it is the series. It just becomes too expensive to produce any longer.

This is not news to anyone in episodic television production. This is the way it has been for decades, and it is not likely to change any time soon. It is the nature of the beast. And that is why it is easy, for anyone who bothers to think about it at all, to know well in advance that—without certain built-in cost-escalation safeguards—a hit series can only last just so long. As much as Paramount may have wanted *The Next Generation* to continue, the series' fate was, in essence, foreordained.

That being the case, no one wanted a "void" in the television market when *The Next Generation* ended. With viewer interest in *Star Trek* forging ahead at warp speed, neither Berman nor the studio had any intention of abandoning the *Star Trek* ship of state, and most definitely not where the small screen was concerned.

The natural solution was to create a third series, ideally before the last few seasons of *The Next Generation* came to an end. That would allow the "old" to comfortably overlap the first season or two of the "new." It would also give viewers, hopefully, a chance to shift their affections to the new series. Production could continue without skipping a beat. Or so the theory went.

For assistance, Rick Berman turned again to Michael Piller. The alliance had worked before, it could work again. Thus the birth of *Star Trek: Deep Space Nine* began.

Helping matters immensely was the fact that by 1991 Jeri Taylor was aboard as supervising producer for *The Next Generation*. She was therefore available to assume more of the executive-producer chores as Rick and Michael prepared to enter the development phase of the new series. Also joining *The Next Generation*'s writing staff that same year was a young ex-WGA writing intern named Brannon Braga.

It is truly ironic that, in a sense, the very popularity that spawned *Deep Space Nine* indirectly led to *The Next Generation*'s demise.

Birth, life, death, resurrection, new life from old. It is the history of *Star Trek*, the cycle of mankind, and the rhythm of life on this planet. For every life there is a season. On October 24, 1991, Gene Roddenberry died. Around the world computer bulletin boards and the Internet lit up with messages of sorrow at his passing.

One to beam up.

Together Berman and Piller set about creating a new *Star Trek* spin-off. To clearly distinguish it from *The Next Generation*, the series was set on a space station rather than aboard

a starship. Unlike those of its predecessors, the characters in the new series were shaped and molded as a somewhat contentious lot, a metaphor for the all-too-real dysfunctional family. Subsequent experience would prove the space station locale to be a questionable premise, for reasons not entirely clear.

To date, the percentage—or mix—of planet-oriented episodes, compared to the number of ship- or station-based episodes, is virtually identical for *Next Generation, Deep Space Nine*, and *Voyager*. Perhaps moderate viewer response to the station-based nature of *Deep Space Nine* is a commentary on the romantic power of the image of a starship going boldly into the unknown.

By the summer of 1992, development of *Deep Space Nine* was well enough in place to allow the start of production. The series premiere was set for January of the following year. By then, Jeri Taylor was at *The Next Generation*'s executive producer reins full-time.

Piller's influence on *Deep Space Nine* was substantial, in terms of stories as well as character development. The touches have been large and small. An example of the latter is the baseball kept on the desk of Benjamin Sisko, the space station's commander. Sisko, or another character in the show, will often pick it up and sort of absently play with it while talking. Michael is an avid baseball fan, and his passion for the sport is the reason why the ball is among Sisko's treasured mementos. (The sport is no longer popular in the twenty-fourth century, although it can be recreated and played as a holodeck program.)

So far, so good. *Star Trek* had comfortably expanded, continuing its embrace of the twin worlds of feature films and television. But like the big bang, the unfolding of the *Star Trek* universe was still under way.

During the months preceding the January 1993 launch of *Deep Space Nine*, and afterward, Paramount's research department conducted focus groups around the country. This is an ongoing activity, designed to continually monitor the pulse of the viewer. The resultant data helps the studio understand viewer response to any number of questions and issues, from cast-member popularity to more philosophical concepts. One question Paramount was interested in was how viewers would respond to a fourth new *Star Trek* series, which might then run simultaneously with *Deep Space Nine*.

By mid-1993 the studio had decided that the answer was "yes," there was indeed enough room in the hearts and minds of viewers for just such a fourth *Star Trek* series.

This decision to go forward with a new series, eventually called *Voyager,* was the subject of a lengthy conversation between Rick Berman and Kerry McCluggage, chairman of Paramount's Television Group. While the meeting focused on the concept of a new *Star Trek* series, each man was keenly aware there were larger issues underlying the discussion.

The project meant starting from scratch, just as Berman and Piller had done when the decision was made to create *Deep Space Nine*. Tom Mazza would oversee the development from the Paramount side, and would be Berman's primary interface with the studio. Mazza and Berman were old friends—this was the same role Mazza had played in the development of *Deep Space Nine*, and earlier, with the growth in popularity of *The Next Generation*. Among all the studio executives, Tom Mazza probably knows and understands the *Star Trek* universe better than anyone else.

By the end of the conversation both McCluggage and Berman were in agreement on two points essential in shaping the new series. The first of these was that the new spin-off would be a ship-based show. Both men believed a ship-based show not only was needed, but lay at the very soul of *Star Trek*'s beginnings. With *The Next Generation* going out of production and moving into features, viewers would be left with only a space station-based show. Paramount's research indicated there was room for a ship-based show as well.

> Tom Mazza: *Deep Space Nine* is a *Star Trek* franchise. It has distinguished itself very nicely from a ship-based show. It's a nice companion to the *Star Trek* ship franchise, which is what *Voyager* and *The Next Generation* came out of. You can't have two ship shows simultaneously. We know that. We think both fulfill some interesting needs in the marketplace—not just for science fiction, but for a lot of what it is *Star Trek* stands for…that a lot of other people have tried to replicate but haven't necessarily been able to accomplish.

The second point was that the series would be contemporary with *The Next Generation* and *Deep Space Nine*. It would not be set forward or backward in time. This would allow for some interesting story possibilities, particularly with respect to the pilot episode. It would also give viewers a greater sense of familiarity—historically an important foundation block in the *Star Trek* edifice.

A third issue—the captain—was left unresolved. Rick Berman believed a female captain should command the new starship. If so, it would not be the first time in *Star Trek* history that a woman had commanded a Starfleet ship. Episodically speaking, there were precedents for that. But never had there been a female captain commanding an entire series.

> Rick Berman: Who sits in The Chair is very important. This was in fact the next starship to have a show built around it since the *Enterprise* and Captain

Picard. We felt strongly that it was time for a woman to sit in the chair.

McCluggage was not opposed to a female lead, but he was not convinced either. Such a casting move would be highly unusual, to say the least. At the time of their conversation there were no female leads in prime-time hour-long action/adventure episodic television shows. It just so happens that, in *Voyager*, the lead character is the captain.

McCluggage's hesitation was likely based partly on the reality of the larger television landscape—a consideration encompassing much more than just a new science-fiction series. Casting a female in the lead for the new series would not merely be precedent-shattering for *Star Trek*, it would be precedent-shattering for episodic television as well. And of course, there were the demographic studies to reckon with. It had long been known that *Star Trek* audiences were strongly male-dominated. McCluggage wanted to make certain the lead character was someone that audience would identify with.

His position therefore was "let's keep our options open." He wanted Berman to remain open to the idea of considering anyone, regardless of gender. Cover all the bases. Select the best possible captain, male or female.

Berman agreed to the concept. Privately, however, he was convinced he could find the right woman for the role.

A matter of some concern was the issue of timing. Both men agreed that if there were no ship-based series "for a while," this would serve to whet viewers' appetites for a new ship-based show. Looking ahead, a midseason debut in January of 1995 seemed doable. That gave Berman about eighteen months to create the series, get it into production, and backlog enough episodes to sustain a launch. About the same time frame in which he and Piller had developed *Deep Space Nine*.

The importance of a new ship-based *Star Trek* series was, well...paramount. It seems the gleam in the corporate eye was due to more than just the thought of a fourth *Star Trek* series. There were bigger fish to fry, and a new series was an important ingredient in the recipe.

Paramount wanted to start its own television network. A new *Star Trek* series was seen as the linchpin, guaranteeing a built-in audience at launching, and ensuring—theoretically, at least—an easier time of preselling the new series as a carrot to entice television stations across the country to sign on. *Star Trek* was a proven moneymaker in local markets (cities). It was widely believed within the studio that most stations would jump

at the chance to syndicate a new *Star Trek* series, even if it meant joining a fledgling network.

This thinking proved largely correct. Paramount's faith in the power of anything with the words "Star Trek" in it was not misplaced. Well before *Voyager*'s debut in January 1995, the new United Paramount Network would claim nearly 80 percent coverage in households nationwide.

Paramount's desire to launch a television network of its own was something the studio had wanted to do as far back as the 1970s. Although previous efforts had failed to come to fruition, Paramount was determined to succeed. It would be the fifth broadcast television network, behind ABC, CBS, NBC, and Fox. In point of fact, the new network would be a joint venture between Paramount Communications, Inc. and Chris-Craft Industries, Inc.—who owned a series of independent broadcast-television stations. These stations would provide a jump-start to the process of signing up additional stations.

Underlying the desire to create a fifth network was Paramount's long-range goal of controlling the advertising revenue generated by its feature film and television products, from start to finish. With a network of its own, the advertising revenues would likely go directly to Paramount.

For Paramount, driving the consolidation of everything in-house were the twin engines of control and money, each irrevocably bound to the other, each contributing to an improved "bottom line." When Viacom purchased control of Paramount, this philosophy only increased in intensity.

This is not to suggest that having an "everything-in-house" attitude is a bad thing. Television production is, after all, a business. Showing a profit is key to a successful venture—unless the activity is run by the government. Profitability allows a business to stay in business. At Paramount, profits allow the payment of wages and salaries, providing employment for thousands of people. No profitability, no jobs. Increased profitability does not automatically translate into more new jobs, but it certainly helps.

So the conversation between Kerry McCluggage and Rick Berman that early summer day in 1993 was not one of simply creating "another television series." The issues surrounding the project were complex, inextricably intertwined, with far-reaching ramifications. Everything is connected to....

From a dollar perspective alone, the investment would be substantial. McCluggage and Mazza knew the numbers; their staffs had run them many times. Launching a new series could cost $60–70 million (again, according to Tom Mazza) just

for the first year. But no television station would be likely to sign onto a fifth television network without some assurance of a longer series commitment than one year. Stations would also want a guaranteed steady stream of programming in addition to the *Star Trek* series.

In the long run, Paramount's actual investment in a new *Star Trek* series could end up being much higher than just the series. That made for a rather expensive conversation.

For his part, Berman was acutely aware that much more was at stake here than simply creating a new television series. In a larger sense, the fate of the as-yet-unborn Paramount network rested heavily on his shoulders. Perhaps heavier still was the burden of an ever-expanding *Star Trek* universe.

THE VISION

Intolerance in the twenty-third century? Improbable! If man survives that long, he will have learned

to take a delight in the essential differences between men and between cultures. He will learn that

differences in ideas and attitudes are a delight, part of life's exciting variety, not something to fear.

It's a manifestation of the greatness that God, or whatever it is, gave us. This infinite variation

and delight, this is part of the optimism we built into Star Trek.*

Gene Roddenberry
Star Trek Creator

HOSE WHO KNEW GENE RODDENBERRY IN THE
mid-sixties (a few are still alive and in full possession of their mental faculties)
remember quite clearly that what he wanted was a hit series, which, in turn,
would give him a vehicle for expressing his own philosophical and humanistic ideas and
concepts.

Roddenberry reasoned that if he could produce a hit television series, and keep it

* Page 40, *The Making of Star Trek*, by Stephen E. Whitfield (Poe).

on the air for at least three seasons—five would be better yet—there would be enough episodes for the series to make money in syndication. Then he could take the next step toward his long-range goal: to produce a series of continuing features, all tied together thematically. His model was the James Bond features, and he talked about the idea regularly. Either way, the format did not matter; even the genre itself did not matter—science fiction, period piece, Western, whatever. What counted in the long run was a hit series, which he could use as a forum for his views.

The irony is that Gene's dream has been realized, many times over. It just did not come about wholly in his lifetime, and certainly not in the way he originally conceived it. In the last fifteen years of his life, though, he did have the opportunity to witness the growth of his brainchild into an unprecedented entertainment phenomenon, with global impact. It is safe to say that what he saw and experienced during that time was not at all what he could have predicted in 1966, nor was it what he had in mind to begin with.

Roddenberry's widow, Majel Barrett Roddenberry, remembers well her late husband's interest in developing *Star Trek*, at least in the beginning.

> Majel Roddenbery: He never intended any of this. All he wanted was a hit show…and a platform to talk about the things he believed in. Evidently the things he believed in were good things, they were positive things, they talked about a very positive future. He came out with this nice positive, rosy attitude. And that's great if we can make the universe conform to it. Then we've done something. But that wasn't his intention.
>
> I tell everyone the same thing: You don't understand, guys. It could have been a Western, and he would have said the same thing. If you take the costumes off and put us in the Old West, we're gonna use the same lines and it's gonna play the same way. That was Gene's expertise. He was one of the greatest storytellers in Hollywood. He came up with an idea [for a series], this is the way he felt, and surprise…it just seemed to be the way everybody else would like to feel too.
>
> And so they adopted it. That's why the fanaticism over it. Because it was a positive view of the future…there is going to be a future. Gene said, "Yeah, it's not only going to be a tomorrow, but it's going to be a better, gentler, kinder world." But he also said the kind of world we've built (in *Star Trek*) over

the last thirty years will never happen. But the more people use that as a model, it's going to get better. And that's what we need, is for it to get better.

Science fiction had long been an interest of Roddenberry's; a series in that genre was a logical choice.

As he began to develop the *Star Trek* series, his personal views became integral ingredients in the universe he constructed. As the series evolved, he had a lot of help with the process. Many people—writers, producers, art directors, NASA scientists—added to Gene's views and contributed greatly to the fleshing-out of what *Star Trek* came to represent. It was not until years later, long after *The Original Series* had ceased production, that the mythos would begin to grow around Gene Roddenberry's vision. But that is not the way things started out.

Looking back from the distance of time, events always appear differently—even to the eye of the creator. As Majel points out, "After a while, Gene began to believe his own press reports."

Nonetheless, the universe Roddenberry breathed into existence, and into the television consciousness of literally hundreds of millions of viewers, was unique for its time, and in many respects remains so to this day. There is now, indeed, a vision that very definitely is represented by *Star Trek*. One might wonder if this vision, some years after his death, is being maintained. Well, yes and no.

The fact is, *Star Trek* has changed. And not just since Roddenberry's death. More a process of evolution, these "midcourse corrections" have been taking place since the first feature, *Star Trek: The Motion Picture.* Many were initiated by Roddenberry himself. Large and small, the changes have been cultural as well as philosophical.

The Original Series, being the first *Star Trek* of them all, reflected the basic, unrefined version of Gene Roddenberry's ideas, philosophies, and personal views—his "vision of the future." And what a future it was. Breathtaking, exciting, full of hope and promise for humankind. Under his transcendent gaze, the good ship *Enterprise* broke cultural barriers and set production standards that were decades ahead of their time.

One example is the subject of diversity—a hot topic only recently discovered by cultural and sociological pundits and politicos of every persuasion. Yet, one need only look at a single episode—any episode—of *The Original Series* (now more than thirty years ago) to see the evidence of diversity in action on the bridge of the *Starship Enterprise*.

In an age when the battle for civil rights and equal opportunities for all was quite literally still being fought in the streets of America, there on the bridge of this odd-look-

ing space ship were Japanese, Caucasians, African Americans, Russians, and half-breed aliens working side by side. Moreover, they were enjoying the experience! And if that was not enough to raise the hackles on the back of a redneck's nape, their interactions with each other made something else quite clear: They valued the diversity of each other's culture. They actually liked each other!

On this basis alone, given the societal conditions of the times, it is remarkable the series got on the air at all.

On the other hand....

By 1990's standards, on this same bridge were blatant examples of sexism and male chauvinism. Women crew members wore ultraminiskirts. Other female costumes—human or alien—were almost always designed to show women as sex objects, rarely anything else. And women's roles—on or off this great starship—were almost never equal to men's.

These examples are completely opposite to the future Roddenberry envisioned, which was a hopeful place, where everyone, gender notwithstanding, was more or less equal. We know he attempted to push this idea from the beginning, because his very first series proposal featured a woman as the second-highest ranking officer on the *Enterprise*. The actress he had in mind was Majel Barrett, who later became Majel Barrett Roddenberry. But at the time, NBC was calling the shots, including the issue of gender equality.

Star Trek's philosophical changes over the years have perhaps been more subtle than the cultural ones, but they have been every bit as profound.

Again, comparing episodes of *The Original Series* with those of, say, the last few seasons of *The Next Generation*, or those of *Voyager*, the philosophical premise underlying the missions of the ships' crews is entirely different.

Michael Piller: Gene's original concept was like the Peace Corps, where a bunch of Americans went out to teach the universe our value system. Now it's different. Now our greatest interest is to learn. We are explorers, yes, and what we want to do is *learn* from the universe as opposed to *teaching* the universe. It's a huge philosophical transition from where *Star Trek* started.

It also suggests that Starfleet crews, or their human writers, are not as arrogant today as they perhaps were in the 1960s.

Does this mean *Star Trek: The Original Series* is without redeeming qualities? Hardly. Does this mean that *Star Trek*, in all its iterations, does not deliberately strive to inspire and motivate us all? Absolutely not. Does this mean that all those people over the years who have insisted their lives have been altered forever because of the influence of *Star Trek* should now think they've been grossly mislead? Not in the slightest.

Does this mean Gene Roddenberry was not really a true visionary? Not at all. Does this mean his "vision" was a tad self-contradictory, a bit skewed by personal inclinations, perhaps even a mite flawed? Well, of course it was. As Spock might say about all this, "It is not logical, but it is often true."

Roddenberry reflected his time—the time he was born in, grew up in, and lived in. He expressed those times in what he created, most notably, *Star Trek*.

But times change.

Societies change, cultural mores change, attitudes toward one another change. Change is what gives us all hope...hope that the conditions we do not like today will someday change for the better. Evolutionarily speaking, this societal dream has expressed itself exceptionally well over the years in *Star Trek*.

For thirty-plus years now, viewers by the millions have been drawn to *Star Trek*, with a passion that is baffling to many nonfans. Even fans who were born during the long dry spell after *The Original Series* was canceled and before *The Next Generation* started—even these viewers are just as passionate in their loyalty to and interest in all things *Star Trek*. Perhaps it is because all those who faithfully watch consider themselves a part of that universe and, if they could, would choose in a heartbeat to live there. Whatever the dream, there is no denying its power.

This societal dream, this "vision" that has attracted such an ardent following over the years, has its origins in two areas. The first is rooted in science fiction; the second is rooted in the American culture narrowly, but in a broader sense is really planetwide.

Prior to the advent of *Star Trek*—and, to a great extent, after—most film and television science fiction fell into two categories: 1) hokey, joke-oriented meaningless farces steeped in the absurd; or 2) dark, threatening, scary tales of horrific futures.

The hokey shows were things like *Mork & Mindy, My Favorite Martian,* and *Lost in Space.* They were light, nonsensical, with no pretense whatsoever of any reasonable resemblance to reality. They were easily viewed and just as easily forgotten.

On the darker side were television shows such as *The Outer Limits, Twilight Zone*, and films such as *Forbidden Planet, Invasion of the Body Snatchers, Rollerball,* and *Logan's Run.* More recent examples include *Blade Runner, The Road Warrior,* and *Alien.* Central to these shows

was the theme of the mindless, unstoppable, inescapable dread. Each portrays a future that is not a place anyone would willingly choose to live. The images generated linger long afterwards in the consciousness of viewing audiences…haunting the mind, and disturbing the psyche.

Often the chief villain of the plot was technology gone berserk, awry, or benevolently despotic. Whichever way, it was the enemy. If the alien monsters didn't get you first, big bad technology would always be lurking just ahead, laying its traps. These have been familiar themes in science fiction for much of this century. Technology and monsters…one will get you two that…one will get you.

In a great stroke of creativity, author Michael Crichton combined both themes into one, in *Jurassic Park*, and the movie scared the pants off most people who saw it.

The movie *Forbidden Planet* is an excellent example of the technology-gone-awry genre. In the film, our intrepid spacegoing earthmen find a planet with the remnants of one family left. Everybody else—the people known as the Krell—was annihilated long ago. We learn the Krell had fallen victim to their own advanced technology. Soon, that same technology trains its sights on the earthmen. Fortunately, the humans make their escape just in time to avoid meeting the same fate as the Krell.

With rare exception, science-fiction films and television programs have shown us the future all right. The thing is, no one in their right mind would want to live there.

When *Star Trek* came along, it was really very different because it was the first major attempt to portray a future that was hopeful, positive, optimistic. While its stories had action, adventures, and thrills, it was all fairly benign, in the sense that it was not a dark, scary future. It was a future people could look forward to, and were not afraid of having their kids watch along with them.

Not even Roddenberry himself could have predicted that what he was launching would become, in its own right, an entirely separate genre of science fiction.

The cultural aspects of Roddenberry's brainchild are more complex, and reflect the way he saw our society, including the myriad political and sociological problems of the day. His "vision," understandably, included his own ideas about how to approach and solve some of those problems.

The political problems that troubled Roddenberry in the early 1960s included the war in Vietnam. He was very much against that war, and saw it as an illegal intrusion on the part of the United States into the affairs of another country. His solution was to create *Star Trek*'s famous Prime Directive.

Prime Directive. Also known as Starfleet General Order #1. The Prime Directive prohibits Starfleet personnel and spacecraft from interfering in the normal development of any society, and mandates that any Starfleet vessel or crew member is expendable to prevent violation of this rule. Adopted early in Starfleet history, the Prime Directive was a key part of Starfleet and Federation policy toward newly discovered civilizations, but it was also one of the most difficult to administer. In most cases, the Prime Directive applied to any civilization that had not yet developed the use of warp drive for interstellar travel.*

For the purposes of dramatic storytelling, the Prime Directive has been violated at least once in every *Star Trek* series to date (including *Voyager*); still it reflects a model of behavior that all governments today would be well advised to follow.

One of the best examples of what Gene Roddenberry perceived as a humanistic problem lies in an all-too-human frailty—our collective habit of judging others based on how different they look from us. It was this quality that impelled him to create one of *Star Trek*'s fundamental teachings: Infinite Diversity in Infinite Combination (IDIC).

The philosophy underlying the IDIC has evolved into a significant cornerstone of the Vulcan race, of which Spock was the most visible member, and of *Star Trek* itself. Attempting to express this philosophy has fueled *Star Trek*'s repeated efforts in countless episodes to repudiate racism, counteract oppression, and clearly demonstrate by example that we human beings can and must change.

Roddenberry saw this human quality of judging others based on their differences as being so inherent in our species that it could almost be called a genetic trait. If someone—or a group of someones—looks or acts differently from "us," then they must be inferior, weird, strange, crazy or, at the very least, not to be trusted. Therefore, we are justified in denying them the same rights we afford our own.

If they are different enough, then that probably means they are "bad" in some way. That makes it okay to hurt them, because we all know bad people deserve to be punished, right? If they are *really* different from us (especially if they look scary), they must be evil and dangerous. In which case we had better kill them, before they kill us.

The Star Trek Encyclopedia: A Reference Guide To The Future, Updated and Expanded, by Michael Okuda and Denise Okuda, published by Pocket Books.

It is this propensity for "different-equals-dangerous" judgments that has, down through the millennia, lead human beings into war after war after war after....

Gene's attempts to deal with this all-too-human quality resulted in two *Star Trek* canons, both of which are strictly adhered to even now. The first was his philosophy about what today is popularly known as diversity.

For some years now, at every level of government, efforts have been made all across America to compel diversity by act of law. At times, citizens have resisted those efforts. When that happened, the force of law was used. Gene tried to demonstrate that it was possible to achieve that same goal voluntarily. His method, his forum, was *Star Trek*.

Throughout the series he mixed races and cultures with seeming abandon, in a kind of anthropological soup of characters. Every episode demonstrated unmistakably that, yes indeed, we really can get along well together, no matter how strange or frightening we look to each other, or how different our cultures and beliefs may be. As a result, *Star Trek* actively affirms the worth of each individual by affirming the culture from which that person comes.

Star Trek calls us to open our cultural doors to one another, to honor ourselves in each other. *Star Trek* shows us that for a civilization to function more effectively and more...well, humanly...future societies will have to become a truly cooperative community. Every culture will have to contribute to it. Thirty years after Roddenberry first promoted the concept of actively embracing cross-cultural cooperation and ethnic-racial integration, the idea is still odious to the majority of human beings on this planet.

Twentieth-century hang-ups notwithstanding, in the *Star Trek* universe, different does not equal dangerous.

Not satisfied with the results, Roddenberry pushed his philosophical envelope further, and created a family out of all these diverse characters. The families portrayed on Federation starships are multiracial, multiethnic, multihumanoid, but they are all a family just the same, and express themselves in familial ways. They obviously care about each other, share cultural differences, and often are motivated by intense familylike loyalties. That is a very positive, drawn role model for people everywhere, and is one of the reasons people have always been drawn to the *Star Trek* television shows and films.

The message is there, delivered every week, but it is not preached. It is simply part of the sociological landscape, for viewers to see and think about.

The second canon Roddenberry created can be seen in the way in which he presented aliens, and was partially designed to bolster and reinforce the diversity issue.

One of the problems inherent in most mass-media science fiction is that it employs alien characters who are in every way so different from *Homo sapiens* that they have no

human qualities whatever. The result is that, as humans, we cannot relate to the aliens in any sense, not even as sentient beings. We can only fear them.

Roddenberry knew that in order to get his point of view across, he had to have aliens that the viewing audience—humans—could relate to. So he gave each alien race at least one overriding human characteristic, and usually a smattering of other human qualities as well. Practically speaking, that means the aliens are not really aliens anymore. They are humans in alien skin.

Star Trek has consistently done this with exceptional skill. The approach has allowed any number of episodes to explore alien viewpoints, typically those that are different from our own. Through *Star Trek*'s aliens we get to experience what it is like to look at the universe—especially the *Homo sapiens* part of it—from an alien perspective.

Following this canon, the aliens that appear in *Star Trek* episodes by and large have at least one dominant human characteristic. Viewers will invariably recognize and relate to that one characteristic, even when they cannot relate to anything else, and even when they find that characteristic repugnant. The alien character may look fierce, threatening, or completely unrecognizable as a life-form. Nevertheless, that alien character will always embody a particular human trait that human beings can identify with.

From the standpoint of dramatic storytelling this was a very smart move on Roddenberry's part. Human beings do not identify with things they do not relate to. We do not usually get emotionally involved with a square-cornered building, or a humming, blinking machine, for example (unless it's our own personal computer). We do, however, easily get emotionally involved with living creatures of one sort or another…if they exhibit one or more human traits. *Star Trek* has demonstrated again and again that this reaction transcends all imaginable appearances.

The alien race known as the Ferengi, first introduced on *The Next Generation* and now central to *Deep Space Nine*, are a very good example of this approach. The Ferengi are repulsive-looking characters with piranhalike teeth and enormous ears. Not someone you would like to go out on a date with. Watching them, you quickly make an interesting discovery. Their entire culture is based on one particular human trait that anyone can identify with: greed. Everything they do is motivated by greed. If there is no profit in the activity, they will not engage in it. They are not interested.

Most people are not personally attracted to the idea of being greedy. But we all know someone who exhibits this trait. Even though we do not want to emulate it, we can nonetheless recognize and identify with it. The Ferengi, rather than remaining what they appear to be at first glance, have become one of the most popular alien races *Star Trek* has

yet created. Why? Because we identify with them even when we do not want to be like them.

And herein lies one more crucial key to *Star Trek*'s enduring appeal. In the safe, fictitious environment of a twenty-fourth–century starship, we get to see human qualities in action. These qualities will include ones we do not admire, ones we may personally possess ourselves but would be loath to admit we have, and those we have but wish to God we did not. Moreover, we get to look at the affects of those qualities on ourselves and those around us.

No wonder parents have repeatedly said *Star Trek* episodes are among the few television programs they watch with their children.

Counterbalancing a trait like greed are other human traits expressed—to one degree or another—by an alien character. *Voyager*'s Talaxian cook/guide Neelix is a good example. In a romantic scene between Neelix and Kes, the behavior exhibited by the two appears completely human. Take away the makeup and the prosthetics, and the two actors would be doing pretty much the same as any amorous couple on a park bench, in any city anywhere.

It is this insistence on including at least one human trait in every alien species encountered that has helped *Star Trek* promote the ideal of attempting to understand rather than destroy those we fear, or those who are different from us.

A graphic example of this principle can be seen in *Voyager*'s first-season episode "Faces." The script, written by Kenneth Biller, reintroduces us to what at first appears to be a brutal race of people—known as Vidiians—who are callously going around stealing body parts, organs, and tissue from other humanoid species, hence killing them.

The Vidiians were first introduced in an earlier episode, "Phage" (story by Timothy De Haas, teleplay by Skye Dent and Brannon Braga), but viewers were not told much about them. Biller's script gives us the first opportunity to learn something about them, their history, and why they are the way they are.

We discover that these folks are infected with an incurable virus not unlike the flesh-eating virus that has afflicted some humans here on Earth today. Since they have been unable to find a cure (they have been searching for one thousand years or so), the Vidiians have adjusted to the virus in the only way they know: They replace the tissue and organs being destroyed by the virus. In "Faces," we learn the motivation for their actions is survival...a very human quality. We may not like what they are doing, but we can relate to the will to survive.

The Vidiians are willing to ensure their own survival at the expense of other races.

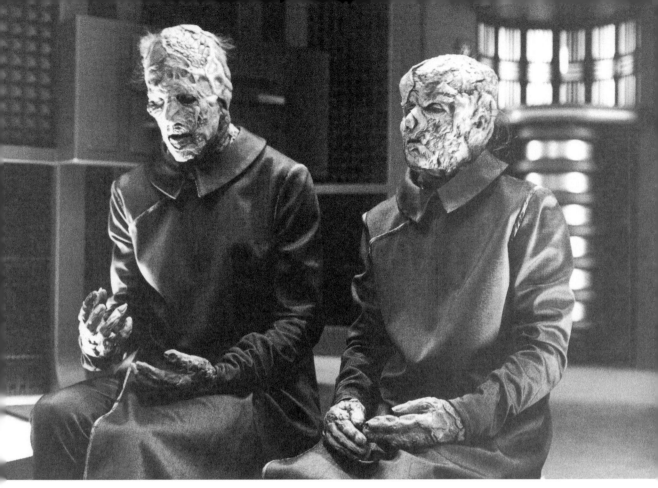

New alien races, like the Vidiians, pose a constant challenge to the crew, and the writers of *Voyager*.

Twenty-fourth–century Starflect personnel would never choose to survive at the expense of other beings...but most twentieth-century humans probably would. Which seems to make the point that sometimes the aliens in *Star Trek* are more human than we humans are today.

There is a deliberate, ongoing effort by Rick Berman to ensure the writers adhere to these canons.

Ken Biller: I got an interesting note from Michael Piller on the (Vidiian) story document when it was approved. Michael was paraphrasing Gene Roddenberry, cautioning me...saying he really liked the story but the aliens

should never be patently evil. They may have a set of values that differ from our own, but be careful of making them mustache-twirling villains. This was something that Gene had always said to Michael.

So I really took this to heart. I never got to meet Gene, but I felt I was getting a bit of his legacy passed along to me from Michael. I worked really hard on that script to make the main alien character...his name is Sulan...to try to make him on some level sympathetic; or at least we should be empathetic with him so we can understand why he's doing what he's doing.

The message Biller wrote into the Vidiian character is that, despite appearances, these are not inherently bad people. The Vidiians are merely trying to survive. Stories like these help us look below the surface of appearances, to see what, if anything, is really there.

But what was new in Roddenberry's version was the fact that he was the first to fold into his television-series format the ideas he saw as solutions to society's ills. He skillfully wrapped these ideas up in entertaining but instructive and insightful stories, and placed them all together in a positive, hopeful, optimistic future. He then held that future up to all of us every week and in effect said, "Look! It doesn't have to be the way you have it right now. It can be better, and it can work!"

Taken as a whole, the visionary body of work that Roddenberry ignited, and bequeathed to all of us, is itself transcendent.

Over the years since its inception, none of that has changed.

The vision is still there. Yes, there have been changes, adjustments, and midcourse corrections along the way. But the vision still holds.

TEN

THE OWNERS OF THE GAME

Star Trek is very much like baseball. The players play the game, the owners own the

teams, but the fans own the game.

Stephen Young,
Star Trek fan

ONE OF THE ELEMENTS REQUIRED BY ANY NEW television series is an audience. But *Voyager* was not just any new television series. It was a *Star Trek* series. And a *Star Trek* audience is not just any audience.

History has demonstrated that *Star Trek*'s core group of viewers are themselves something of a phenomenon, unique to television. Indeed, they are often generational within

families. It is not unusual for fifty-year-old fans—whose own fathers and mothers became fans during *The Original Series*—to also have children and grandchildren as fans. Four generations of fans within the same family.

This pattern of allegiance among viewers suggests that *Star Trek* is having an impact on a segment of the television audience unlike anything previously encountered in the field of entertainment in general. It also suggests that *Voyager*'s reception will likely be measured in large part by this same core group of viewers. It therefore seems useful to look at the *Star Trek* fan base, to see who these folks are, and perhaps to discover some of the reasons why they are such ardent supporters of Gene Roddenberry's creation.

Because without them, there is no game.

A television series is a tenuous consortium of three groups. Together they represent the three legs of a complex process. The company produces the programming, the studio pays the bills and gets the episodes broadcast, and the viewers watch the shows. Each is as much a participant in the process as the others. Some may argue that viewers are passive participants at most, but there is abundant evidence that this is, strictly speaking, not the case.

NBC-TV found this out the hard way after announcing that *Star Trek: The Original Series* would be canceled at the end of its second season. In December of 1967 and January of 1968, a fan-generated groundswell of support began. The effort was secretly initiated and financed by Gene Roddenberry. The campaign itself was masterfully organized and managed by Bjo Trimble and her husband John.

In February 1968, fans picketed Rockefeller Center in New York, and marched on NBC headquarters in Burbank, California. Never had Rockefeller Center been picketed. It was sacrilegious. The longer the network officials ignored the picketers, the more the picketers' numbers grew. In the meantime, other events were unfolding. Bjo and John Trimble knew that the pen is mightier than the sword. Accordingly, they directed the fans to write cards and letters to the network. NBC's corporate office in New York was deluged with more than one million pieces of mail. Network officials were aghast.

Typical of the reaction was Norman Lunenfeld's, who at the time was NBC's vice president of Licensing and Merchandising. At the height of the letter-writing campaign he rushed a visitor across his office, to the window that overlooked the street far below. Obviously distraught, Lunenfeld exclaimed, "Look! Look! It doesn't stop! They're lined up all the way down the street!"

The source of Lunenfeld's anxiety was a procession of U.S. Mail delivery trucks

waiting to disgorge their bags of letters into NBC's mail-receiving department. Afterward, the network would publicly admit to receiving only 115,000 cards and letters, but it was Lunenfeld who privately disclosed the higher figure. He, like others at NBC, was having a rude awakening. The unprecedented protest by fans was more than a mere physical, vocal, and highly visible demonstration. It was also a striking example of the powerful energy fans are capable of generating.

NBC's corporate policy at the time was to reply, by return mail, to each viewer letter received. The fans who took part in the campaign had been informed of this policy by Bjo and John. No wonder Lunenfeld was upset. Answering each *Star Trek* letter was costing NBC millions. So much so, that the network took the history-making step of issuing an on-air announcement on March 1, 1968, near the end of *Star Trek*'s second season. The brief statement assured viewers that *Star Trek* would indeed be renewed for a third season. The subtext was quite clear: Stop writing letters, please.

It was the first time in broadcast-television history that fans had brought a network to its knees.

Passive participants, indeed.

In the baseball strike of 1995, both owners and players also learned this same lesson when fans boycotted the games. Owners' revenues plummeted, massive employee layoffs ensued, and many a vendor suffered financial hardship. When enough fans are missing, the games are not the only things that get canceled.

Without a solid core of fans, and an even wider cohort of reasonably dedicated viewers—which translates into good ratings—no television series can last long. In today's climate of E-mail, cyberspace, the Internet, and virtual everything—including viewer response and feedback—a series can debut one evening and be canceled before coffee has brewed the next morning. The fans/viewers absolutely participate in the process; otherwise there is no process.

Fans are viewers, but not all viewers are fans.

On the most basic level are the hard-core fans. This group has been widely estimated to number about 5 percent of *Star Trek*'s 35 million weekly viewers. That number is just for the United States. Fandom is a well-entrenched movement worldwide. In the U.S., however, at 5 percent, the hard-core numbers figure out at around two million. Any way you slice it, that is a lot of viewscreens.

Rick Berman: Are we trying to please the five percent, are we trying to please the ninety-five percent? The answer is yes to both and no to both. I think what

we do is use our best judgment to please ourselves and hope that we're going
to please as many of the fans and the nonfans as we can.

Whatever the actual number, fans have been a powerful force in the destiny of *Star
Trek* for more than thirty years.

Hard-core fans are relatively easy to spot. On weekends they dress up in costumes,
gather at conventions, and speak Klingon. Well, some of them. Others wear Starfleet uni-
forms, which they have meticulously crafted themselves, or which they have purchased
from mail-order vendors. They are fully outfitted down to the last phaser, communicator
pin, and pip. The detail and accuracy of their creations are remarkable.

There are those too who favor one alien culture or another. Entire fan clubs are
devoted to the Klingon Empire, the Romulan Star Empire, the Obsidian Order,
Cardassians, Ferengi, Bajorans—or other, less established alien races. Devotees wear the
clothing representative of their favorite aliens and, where it exists, utilize that culture's
native tongue. It is impossible to walk among a gathering of hard-core fans and not be
impressed with the high level of creativity, unwavering commitment to their avocation,
and intensity of their passion in pursuit of their favorite subject.

Being a part-time alien is serious stuff. There is even an effort under way by a few
fans to translate the King James version of the Bible into Klingon. There can be no rest
when it comes to missionary work and the spread of the word.

Both within the television industry and among the public at large, fans do not, as a
rule, get a lot of respect. *Star Trek* fans—and the fans of any television show for that
matter—have at times been the butt of numerous jokes and the target of considerable
derision. In general there is grudging tolerance, at best. This attitude is puzzling, given
the pivotal role fans play in the television process. It also seems more than a mite
hypocritical.

For in truth, millions of their counterparts exist in every corner of the globe.

In the U.S. alone, every week millions of men and women spend hundreds, even
thousands of dollars on costumes replete with hats, jewelry, ornaments, and other accou-
trements. Their devotion to detail is astonishing, even down to practicing the way they
walk. These dedicated fans then gather at night and on weekends (especially on weekends),
show off their costumes, speak their own special language, and in general have a great
time.

What is odd about all this is that the general public does not seem to think this
group's behavior is strange.

Which is all the more puzzling since these people are exactly like *Star Trek* fans with one exception. Strictly speaking, they are not called fans. They are called "country-western" people. Or "cowboys." Or "cowgirls." Or maybe just "cowpersons."

When the last Super Bowl was played, hard-core football fans were there. And they were in costumes. Some wore jackets that cost hundreds of dollars. Others were decked out in pricey footwear to match those of their favorite stars. Still others proudly modeled outrageous hats designed to look like large wedges of cheese. Fans at similar gatherings across the country dress like giant chickens, or dogs, or bears, or whatever their favorite team's mascot happens to be.

A few of these fans go so far as to eschew most of their clothes, opting to bare various body parts even in freezing temperatures. They have a language all their own, with distinctive buzzwords, special greetings of a physical nature, unique euphemisms, and peculiarly derogatory phrases that are usually incomprehensible to "outsiders."

They, too, are called fans. Or Cheese Heads. Or whatever.

Strangely, the general public does not seem to think their behavior is all that peculiar either.

Elsewhere, millions of men and women gather in similar groups, and engage in similar kinds of activities. The object of their passion may be Elvis, other stars of rock and roll, rap, golf, basketball, hockey, soccer, automobile racing, motocross, cycling, or any one of the hundreds of other special-interest groups that make up the population of this great diverse country of ours. But make no mistake about it: Whatever the personal choice, the devotion is passionate.

And mostly, these groups dress up in special clothing, speak a special buzzword language of their own, and have regular gatherings where they admire, congratulate, and buy from one another. And mostly, these groups of people are called fans. And mostly, nobody thinks their behavior is at all bizarre, unusual, or odd.

Something is wrong with this picture.

How can it be that a group of people so devoted to a particular television series can be looked upon as being one whit different from their—millions more—counterparts? If there is a logical explanation, *Star Trek* fans would probably like to hear it.

There is a broader group of fans, however, who are also dedicated viewers, but own no costumes and rarely if ever go to a *Star Trek* convention. This group probably comprises the largest segment of *Star Trek*'s viewers. In many respects they are just as passionate about their interest in Roddenberry's universe as the hard-core fans; they are simply less visible.

Often, individuals in this group can be found in chat rooms at various sites on the Internet or one of the on-line services. They are knowledgeable, articulate, and for the most part converse in English. Demographic studies have consistently shown that this group—indeed, *Star Trek* viewers as a whole—tend to be better educated, have higher standards of living, enjoy a better than average income, and be devoted family members.

A third group is made up of casual viewers who do not necessarily watch a *Star Trek* episode every week, but do tune in periodically. This group is an important segment because—or so conventional wisdom holds—some will eventually shift to one of the other two categories. That is what allows the weekly audience to grow in numbers. And viewing audience numbers are vitally important to the survival of any television series.

Taken as a whole, the fans represent the single most important facet of *Star Trek*'s success. As well, by their very presence they help define its universe.

It is, however, impossible to be a participant in a process without in some way also being transformed by it. Behavioral scientists, anthropologists, psychiatrists, and other researchers countless times have demonstrated this maxim. Thus, the fans too are a by-product of the *Star Trek* franchise. Having the arena, the experience has been such that each is no longer the same person as before they stepped inside.

Research shows that this is indeed the case.

At the core of all this devotion, this *Star Trek* passion, is an undeniable, well-documented fact: *Star Trek* changes lives.

On the surface, the idea sounds absurd. *The Next Generation*, *Deep Space Nine*, and *Voyager* are like every other episodic television series: They are works of fiction. They are not real. Not only are they not real, they are meant to entertain. In addition to entertaining, however, *Star Trek*—unlike other television shows—was additionally designed from the very beginning as a vehicle to influence and motivate people to change. The plan—Roddenberry's vision—seems to be having some effect, a fact that has not gone unnoticed. Numerous books have been written documenting countless human lives and human activities that have been forever altered as a result of *Star Trek*'s influence.

There is overwhelming evidence that indicating something truly extraordinary is happening among *Star Trek* viewers. Whatever it is, it's worth looking at because, one way or another, *Voyager* will more than likely be affected by it.

People who watch *Frasier* do not have massive gatherings and share with each other how an episode has changed their lives. Parents who watch *Seinfeld* do not discuss with their children the value of the characters in a particular episode as role models. University professors who watch *Cheers* do not ask their students to write a paper on the moral or

ethical "message" illustrated in a given episode. Jungian psychologists who watch *ER* do not publish articles on the archetypes represented by the series' characters and stories.

With *Star Trek*, they do.

This is not to say that other episodic television is not entertaining, or serves no useful purpose, or has no intrinsic value of its own. On the contrary. One of the advantages of television today is the sheer number of choices available to people of varied tastes and interests. Everything has value and meaning to someone.

Yet, when it comes to things *Star Trek*, clearly something is different. Nothing else compares.

This sentiment is shared by a wide cross section of viewers, representing highly diverse backgrounds, occupations, educational levels, and personal interests. Among the general viewership, there are no stereotypes. Take Santiago Fernandez, for example.

Santiago Fernandez is the General Counsel for the Los Angeles Dodgers. His mahogany-paneled office is in Dodger Stadium—a floor-to-ceiling wall of glass overlooks centerfield, framing a gorgeous view of the stadium's interior. His desk sits along the wall to the left of the windows. Behind the desk are floor-to-ceiling mahogany bookshelves filled with law books and reference materials—the sort of things one might expect to find in an attorney's office.

The wall opposite Santiago's desk—he likes to be called Sam—is also covered by floor-to-ceiling shelves filled with law-related books and binders. But on a couple of shelves are collections of different kinds of books: a tome by Franz Kafka, novels by science-fiction writers such as Philip K. Dick and A. E. van Vogt, miscellaneous *Star Trek* books, and an eclectic assortment of books on philosophy, science, quarks, and the universe.

The first impression one gets of Sam Fernandez is that here is a man who clearly is comfortably in charge of his own world. He has an aristocratic bearing, is impeccably manicured, and is distinguished by a full head of silver-gray hair flecked with black. Sitting coatless behind his desk, his braces give him the appearance of a youthful, more elegant version of Larry King.

On the subject of *Star Trek*, Fernandez is quite eloquent. He has been to only one fan convention—more out of curiosity than anything else—owns no uniforms, and is not active in any on-line forums or fan clubs. Santiago Fernandez is, in many respects, the perfect antithesis of a hard-core *Star Trek* fan. Nevertheless, he is a dedicated viewer and knows his subject well.

Sam Fernandez: As a kid, I watched all the original episodes and have since watched the reruns many times over. I began watching *The Next Generation* with my twins, Michael and Christina, when it first aired. They were only one year old at the time. It has now become a family ritual to watch *Deep Space Nine* and *Voyager*. They're the only two shows on television we watch as a family.

We're not big television viewers. We watch television on a very selective basis. We don't allow the television to become an electronic babysitter for the kids. In our house homework is a priority, reading is a priority. We've read to the kids almost every night since they were old enough to know what was going on.

With limited television viewing in the Fernandez home, what the family does watch takes on greater significance. Evidently, Sam believes there is something about *Star Trek* that makes it important for his family to be exposed to both current series.

Sam Fernandez: First and foremost, it's entertainment. The kind that is wholesome compared to what else is on television. That's one of the things that makes it a family-type show. For the most part you know you're not going to get graphic violence, you're not going to get profanity, you're not going to get graphic sexual scenes. They've explored all sorts of issues, but they've done it in such a way that the family can view it.

It's also a very well developed alternate universe. They've done a really terrific job of creating an environment and a universe where you can identify with the people. Even the technology takes on a life of its own. Everyone who follows *Star Trek* knows about phasers, disrupters, tricorders, transporters, warp speed. The handheld communicator they used in the first *Star Trek* series is now the Motorola flip phone. The desktop swivel screens onboard the *Enterprise* anticipated our modern desktop computers by decades.

"Beam me up Scotty"…it's become part of our language. Everybody knows what it means. I think they've done a terrific job of involving us in that universe. The other good thing about *Star Trek* is that it has always tried in its own way to move our thinking on social issues ahead…at least a little bit.

It is in the areas of social issues and our own humanness that Fernandez finds much of *Star Trek*'s appeal, and its value as an influence in the lives of his children. For a dedicated viewer, he has a surprisingly balanced view of *Star Trek* episodes.

Sam Fernandez: You watch *The Original Series* and you look at Captain Kirk and particularly the treatment of women, and you sort of have to cringe at the sexism that was still there. On the other hand, from the very beginning *Star Trek* was promoting advances in the social agenda…racial integration and things like that. There were moral issues being addressed, and attempts being made more often than not to design a moral to the story into each episode.

The characters themselves reflect the humanness in everyone. If you take all the characters, and view them as a whole, they give you a whole that is greater than the sum of its parts…all of those parts being essentially human, including Spock's analytical self.

Fernandez makes a significant distinction between the *Star Trek*-style of science fiction and all other science fiction in episodic television. A true science-fiction buff, he is also definite about his own tastes, as well as the influence he finds permissible for his children. So far, he finds little else on television that he deems suitable for his family.

Sam Fernandez: *Space Above and Beyond* is a good example of the difference between *Star Trek* and everything else. *Space Above and Beyond* has this dark, gritty atmosphere…an *Aliens*-type atmosphere. The kind where when you're in this starship you can actually *feel* the grease and the sweat and all that. It's not your well-lit, well-maintained, clean starship. Not really inviting.

The other thing is that it doesn't play to a young audience. The dialogue is sprinkled with "hell" and "damn," and I'm sitting there thinking what's the point? The English language is such a rich language, why do they have to resort to that? I don't particularly want my nine-year-olds being subjected to a lot of that stuff. They'll be exposed to enough of that later on as it is.

Santiago Fernandez is typical of the dedicated viewer in at least one respect: He has

definite convictions about the value of *Star Trek* in his own life, and in the lives of his family members. There is no doubt that he finds positive meaning, message, and example in most episodes.

There is abundant evidence that others share his views.

Representative examples are two letters reprinted here by permission of *Star Trek Communicator*, the magazine of The Official *Star Trek* Fan Club. The first is from Mrs. Susan Jennys, a mother in Rochester, Indiana, who had been worried about her son's reading difficulties.

Susan Jennys: Not too long ago, my eight-year-old son was struggling with his reading skills and the motivation to *want* to read. In the past three months, however, something very special helped to turn the tide for him: *Star Trek*. It all began with a *Next Generation* storybook he discovered at our local library. Finally!—a book he thought he might truly enjoy (he's a die-hard *Trek* fan)! That single book opened up a whole new world where no boy had gone before. His reading grades are now As.

For my son, *Star Trek* provided the extra bit of motivation that he needed to build those vital reading skills and, thereby, his self-confidence. In a very real sense, the *Star Trek* universe opened the door for him to discover a whole literary universe. I can only hope that somehow the "powers that be" in *Star Trek* will see this letter and accept a mother's heartfelt word of thanks for having such an impact in one child's life.

Susan Jennys knows from personal experience the value of *Star Trek* as a role model in the life of her young son. Santiago Fernandez is clear about the importance of *Star Trek*'s influence on his twin son and daughter. But what about the adult population? Everyone knows how impressionable children can be. Adults, we can assume, are less easily influenced by these same television shows. But are they? The second letter, from Tim Westul of St. Johns, Michigan, suggests adults are being inspired every bit as much as children.

Tim Westul: I have been a 911 telecommunications dispatcher for the past seven years, serving in counties in both Florida and Michigan. I have been a fan of *Star Trek* since its inception and have found that by interjecting the Vulcan

principle of logic and emotional control, I've become a better listener to my public, and thus a better 911 calltaker.

This is not to say that I sign off by advising people to "live long and prosper"; however, it's been my experience that for whatever reason people call 911, they want a calm, reasonable person at the other end of the line. I am able to steer hysterical callers down the road of reason and achieve my goal of getting the proper information.

I'm proud to say that by applying these particular *Star Trek* principles I have helped four people change their mind about taking their own lives in the past seven years.

We get calls for all types of information, and some of the questions asked would test even a Vulcan's patience. I don't know that if by the twenty-fourth century our jobs will no longer be necessary, but I do know that certain *Star Trek* ideals and principles have helped me become a more competent 911 calltaker here in the twentieth!

A recurring theme that runs through the comments of most viewers is their desire to, in some way, make a difference in the world around them. This theme is expressed repeatedly by people all over the country, who readily cite *Star Trek* as the source of their motivation.

Victoria Murden studied premed at Smith College, went on to obtain a degree in Divinity from Harvard University, then went to law school. Today she is a lawyer and "a policy wonk for the Mayor of Louisville, and I work to turn around distressed neighborhoods." In her spare time, Murden coaches wheelchair athletes in rowing—an experience she says leaves her "humbled by the strength of spirit I see in these athletes."

She does not attend fan conventions, considers herself a "thinking person," will discuss quantum physics with alacrity, but is loath to publicly admit she watches anything other than *The News Hour* with Jim Lehrer. Nevertheless she is a long-time *Star Trek* aficionado, and insists *Star Trek* has changed her life.

Victoria Murden: *Star Trek* helped me to decide to become the first woman in history to ski across Antarctica to the Geographic South Pole. To say that I made up my mind to ski 750 miles across a previously untraveled side of the

highest, driest, coldest desert on the face of the planet because of a television show is embarrassing, but true.

When I heard about the polar expedition, I was working on a Masters in Divinity, at Harvard. In my spare time, I worked with homeless people, and the ethical implications of being a part of an expedition that would spend a small fortune to conquer an ice cube had my brain in a knot.

An old friend took me out to dinner. "You have a chance to walk where no one has ever walked, at least not in the last one hundred million years, and you're worried about pulling people out of dumpsters?" He and I joked about my wanting a "sign" from God. That night in the dorm, I settled in to watch *Star Trek: The Next Generation* with friends. The episode? "Where No One Has Gone Before." "It's a sign from God!" Terry shouted. "You're supposed to go where no one has gone before."

I did not think of it as a "sign," but I was moved by this episode and its theme of transcending boundaries and traveling to the edge of the known universe. I could labor this point in nauseating detail. My thesis for Harvard was titled "Theology of Adventure." Suffice it to say, the night "Where No One Has Gone Before" aired, I decided to ski to the South Pole.

To dare greatly has long been a central theme of *Star Trek* stories. Legions of viewers have written letters attesting to the impact on their lives of one episode or another. Most have also insisted that the stories have helped shape and mold their lives, providing them with guiding principles to live by. Murden is no exception.

Victoria Murden: In *Star Trek*, characters render service by integrating a critical intelligence with ethical action. In the real world, it does not require an education to see the suffering on our streets, but it does require an education combined with a moral will to alleviate that pain. At its best, television links the life of the mind with a real-world struggle for justice and human dignity throughout the world. *Star Trek* allows us to dream a better world. Gene Roddenberry's dream is not as real as was Martin Luther King's, but it may be almost as meaningful.

Real-world courage can base itself on such a dream. It is through such courage that we, as people, stride forward to close the gap between possibility and fact. It is through our daring that we move to fill the expanse between the promise of humanity and the performance of human beings. *Star Trek* calls us to step beyond the "survival of the fittest." Mere survival is fine for apes and antelopes, but as a society of women and men we are challenged by *Star Trek* to hold higher aspirations.

Murden's perception of *Star Trek*'s importance is perhaps all the more significant in that she is not a hard-core fan. Her testimonial would be somewhat predictable were it coming from the hard-core fan segment of viewers. But it does not. This suggests a far wider impact, a far wider sphere of influence than one might at first imagine. If her comments are typical.

It would seem they are.

Stephen Young is a San Diego–based sales and marketing executive, a Vietnam veteran, and a long-time regular viewer of episodic *Star Trek*. Like most viewers, he wishes he could occasionally provide direct input to the producers. He is a participant in *Star Trek* chat rooms on the Microsoft Network and the Internet.

Young is not one of "those people" who live, breathe, and eat *Star Trek*. He has no uniforms, owns no action figures, does not indulge in role-playing, and does not go to fan conventions. And yet, after thirty years of viewing, he is still enjoying everything the *Star Trek* universe has to offer. Why?

Stephen Young: Perhaps the answer, in a small way, can be found in one episode that hit me at a very personal level. In *The Next Generation* there was an episode ("The Hunted") where the main character was an otherwise ordinary person who had been surgically altered and mentally conditioned to be the ultimate soldier. He had escaped from a penal colony where he and others were confined because they could not fit in with normal society. They were despised by their countrymen.

Two lines stand out. One, where he says he can remember in great detail every person he had killed. The second, when he responds to the question "What do you want?" and he screams his answer "We want our lives back!"

Why is that important to me? Because he was *me*! I wasn't the "ultimate soldier," but I was a Marine grunt in Vietnam. I remember every detail of every shot I ever fired, and every person who died as a result. I remember holding an "enemy's" hand until he died. Moments before he had tried to shoot me— only I was a little bit faster.

I remember trying to do the same thing for the best friend I ever had— only he didn't have any hands to hold—or much else remaining of his body. I also remember how I, and countless others, were treated when we returned to "the world" of America. Ever had dogshit thrown at you, or had people who didn't even know you screaming obscenities in your face? Then here comes a *Star Trek* episode twenty-five years later with the central character saying, "We want our lives back!" And I knew in my guts what that felt like.

Probably so did most Vietnam veterans who watched that episode. Young's reaction is an excellent example of what *Star Trek* does. It is what *Star Trek* has always done so superbly well. The series repeatedly holds up a mirror to each of us and says, "Here. Take a good look. This is part of what it's like to be human." It asks—compels—us to look in the mirror, even when at times we do not want to see what is there because it strikes too close to home.

It is supposed to.

Roddenberry designed it that way.

Young agrees.

Stephen Young: While much has been said about *Star Trek*'s leading-edge technology, its lasting value will always be in its willingness to address real issues that we all face. It doesn't preach; it doesn't advocate. It just presents them, and allows (or occasionally forces) the viewers to look at, rather than ignore them. Nothing more. But it doesn't need to, because that in itself is an enormously powerful and courageous thing to do when the tendency in network television is to provide entertainment geared to the lowest common denominator.

The fact that *Star Trek* is still alive and well after all these years would, I

hope, mean that we need and want things in our lives which somehow make us better people. In my own case, it helped to keep me moving on the path toward a future where today I am a whole and healthy person.

I know I can't thank Gene for what he gave us, but I wish I could express to Majel Barrett my deepest appreciation for the role that she played in creating a place where people can look beyond their limitations to the endless possibilities of life.*

Are there others like Santiago Fernandez, Susan Jennys, Tim Westul, Victoria Murden, and Stephen Young?

Only millions.

*You have.

PART

THREE

THE MISSION

THE SECRET MEETINGS

Space got very crowded over the last seven years. We go out and we see the Romulans one day

and the Ferengi the next and the Klingons the next, and you're all neighbors and you say "Hey,

how ya doin'." It's like going to work in the morning.

Michael Piller
Executive Producer

IN JULY 1993, THE WORK ON *VOYAGER* BEGAN. WITH A
definite sense of déjà vu, Rick Berman set about creating, one more time, a new *Star
Trek* television series. To help him with the development process, Berman called on
Michael Piller and Jeri Taylor.

At the time, Piller was heavily involved with *Deep Space Nine*. He and Berman had
created the series together and were its co-executive producers. It was a good mix. Piller

was well grounded in the ways of the *Star Trek* universe, and had the additional advantage of having been through the *Star Trek* series-creation loop once before. Creating a third series should be a breeze. Right.

Acceding to Berman's request probably could not have come at a worse time for Piller. He and Berman had spent a solid year getting *Deep Space Nine* developed, into production, and finally launched the previous January. For the first half of the year, Piller's main attention had been devoted to making sure the first-season scripts established and fleshed out the characters. At the same time, he continued to share the other executive producer chores with Rick Berman.

By the end of June, the *Deep Space Nine* cast and crew were just coming off hiatus—sometimes referred to as a vacation, although not everyone gets one—and gearing up for the second season of production. And then, in July, came Berman's request to develop yet another *Star Trek* series. The dust had hardly settled on the last one! No rest for the wicked or the weary.

Jeri Taylor was by this time a *Star Trek* veteran in her own right, since joining *The Next Generation* as supervising producer in 1990. In 1992 she moved up to co-executive producer, and she became executive producer for the series' final 1993–94 season. She was serving in that capacity full-time when Berman asked her to join the development team. Like Michael Piller, she would have to divide her time between working on an existing series and trying to develop a new one.

An Emmy Award–nominated writer, Taylor is a true "first" in *Star Trek* production. Over the last thirty years of *Star Trek* history she is the first, and still the only, female to carry the title executive producer. Her writing, directing, and producing credentials are impressive and include stints with *Jake and the Fatman, Blue Thunder, Cliff Hangers, Quincy, M.E.* (for which she also directed several episodes), *Little House On The Prairie, Magnum P.I., The Incredible Hulk,* and *In the Heat of the Night.*

One of the reasons Rick Berman wanted to include Taylor in the creation of the new series was his desire for fresh input. He and Michael Piller were already familiar with the way they had worked together previously, developing new characters and new situations. Characters, particularly, have always been the lifeblood of *Star Trek*. Perhaps a fresh perspective would enhance the creative process. The fact that Jeri was female was a bonus, because she could also be a positive influence on the development of the female captain.

Widely popular within the production company, Jeri Taylor is a warm, caring, gentle human being. Despite those qualities, she has ascended the rungs of success in an arena long known for outrageous male chauvinism. She is revered by those who know her, but

works hard at avoiding the limelight. That is not the only thing she works hard at. Episodic television is a brutal business, devouring people as fast as it devours creative material. The price extracted from each individual is, at best, very difficult to endure.

Interestingly, almost without exception, no one complains. If you ask one of the cast or crew, they will readily acknowledge—usually in a flat, matter-of-fact tone, as if they were discussing the weather—the toll demanded by "the business." But rarely does anyone complain.

> Jeri Taylor: I've been on shows that at times I didn't think I was going to survive…and have left after one season because I felt the price was too high. That has never been the case here. It is hard work. It is always hard work. Long days, yes. I was in here at a quarter to seven this morning and I'll probably leave about the same time tonight, and take work home and then work on the weekends.
>
> I have no life. Except for this. What extra there is goes to my husband and my children, who are now grown and require less of me than they did formerly.

At noon four days a week, Rick, Michael, and Jeri met over lunch in Rick's corner office in the Cooper Building. For a man of Berman's position, his office is neither spacious nor luxurious (although this would change dramatically at the end of *Voyager*'s third season). A mahogany executive desk sits in the corner, to the left as one enters. A couch and end table grace the wall on the right; a second couch sits under a window on the far wall, opposite the door. A glass-topped coffee table serves both couches. The walls are mostly bare, although there is a bookcase of sorts, and a credenza behind the desk.

The meetings themselves were rather informal. Meals were brought in from the commissary across the street, a daily reminder that *Star Trek* gave them no mercy. It was all-absorbing. Not even for one hour a day could they be free of its presence in their lives, or escape its commitments.

Berman would sometimes sit at his desk; other times he would share a couch with whomever happened to be sitting there that day. Michael skipped Wednesdays because that was his day for yoga. Later, depending on where the three were at with the development process, Michael would occasionally cancel a yoga class to help speed things along. Typically, the three producers would talk for two or three hours. Then they would break, go back to other more pressing tasks, and meet again the next day.

This pattern continued through July, August, and September.

Nothing was said to anyone about a new series. Officially, these get-togethers were called "developmental lunches," but staff members quickly dubbed them "the secret meetings." At her own request, Jeri became the official note taker, although Michael and Rick kept notes of their own. Each person's notes were passed to the others under strict security.

Michael Piller would hand his PA, Sandra Sena, two sealed envelopes with explicit instructions for Sandra to hand deliver them personally to Jeri and Rick. Piller stressed the "personally" part of the instructions. The envelopes could not be given to the PA's for either person, Sandra had to physically hand the envelopes to Jeri and Rick.

Sandra Sena: I didn't even have copies…couldn't keep copies. I never saw what was in the envelopes. It was really hush-hush.

Secret, yes. Easy, not exactly.

They started with character and concept. What direction could they take that would make the show uniquely different from the others? All three agreed they wanted a female captain. Initially this idea was downplayed to the studio in favor of a neutral strategy— "Let us interview both sexes, and if the best actor we find is a woman, can we hire her?" Paramount ultimately said yes. But not right away.

Contrary to what one might expect, the studio's hesitation about a female captain was not motivated by the entrenched attitudes of an industry long dominated by men. Rather, it was based on uncertainty over the viewing audience's possible reaction. *Star Trek* viewer demographics were well known. And they were predominantly male, ages twenty-five to forty-five. Would the viewers accept a woman as captain of a starship, in the tradition of Kirk and Picard? No one at the studio knew the answer, and they were not sure they were quite ready to find out.

What they did know for certain was they wanted another *Next Generation*. They wanted a show that was in a ship, going out to explore the unknown with a new cast of characters and a brand new starship. They wanted this new series to do to viewing audiences what *The Next Generation* had done—capture their hearts and minds, and not let go.

The choice of a female captain offered one immediate and significant advantage. It would eliminate the problem of fans comparing the new captain to Captain Kirk and Captain Picard. When *The Next Generation* first debuted, the viewers had had a field day debating the merits of Kirk vs. Picard, ending up highly divided over the matter. The two camps are still going at it. A female captain would adroitly sidestep that issue entirely.

So Rick, Michael, and Jeri proceeded "as if," and began developing the series accordingly.

Rick Berman: The problem with a female captain obviously is that you're always balancing…you don't want to turn this woman into a man. You don't want to make it a man's role that you happen to have a female actor playing. You don't want to take away her feminine qualities. You don't want to take away her nurturing and emotional qualities.

But at the same time she's gotta be a Starfleet captain. She's gotta know how to be tough. You could believe that Sisko or Picard or Kirk could walk into a room and kick ass. It's not really all that true with a somewhat diminutive woman like Kate Mulgrew. Those are problems that we find enjoyable to work with and to overcome.

One of the first problems Jeri Taylor found herself grappling with was her working relationship with Michael Piller and Rick Berman. It took a while for her to adjust to the new dynamics and overcome her own "programming."

The problem was both practical and cultural.

On *The Next Generation* there was a well-defined hierarchy. Rick Berman was the boss, Michael Piller reported to Rick, and Jeri reported to both Rick and Michael. The roles and lines of authority were very clear.

In the case of *Deep Space Nine*, that dynamic changed. Michael and Rick were co-creators. Technically speaking, the two were equals. One could not overrule the other. In practicality, however, as head of the company, Berman was still the "boss of all bosses." That meant Piller reported to Berman on everything in general anyway. The lines of day-to-day authority were starting to get blurred. What kept the lines from disappearing altogether was the simple fact that Berman was still the final arbiter of everything related to *Star Trek*.

Nevertheless, entering the *Voyager* project, the two men had had a year to work out an equal—within limits—relationship.

Jeri, on the other hand, came into the equation without the benefit of that experience with either Piller or Berman. What she did have was what everybody else had: the established fact of Rick Berman's insistence on absolute control of every aspect of production. She found it hard to imagine Berman could operate any differently just because she was a member of a series-development team.

Because of their *Deep Space Nine* experience together, Berman and Piller enjoyed a significant working advantage over Taylor. The two men were comfortable arguing with each other as equals, discussing issues, and coming to joint conclusions. Up to that point, however, their relationship with Jeri had been very different. They were accustomed to her being the person who said, "Okay, if that's the way you want it, that's the way it will be." As a consequence Taylor found she had to struggle in the beginning, to give herself permission to be an equal partner. It was a difficult time for her.

Taylor believes part of her internal conflict may have been rooted, culturally, in the fact that she is female. Unfortunately it is still all too true in this country today that most women are raised to be nurturers and caregivers…to support men, but not confront or directly oppose them. So she had a bit of difficulty for a while, dealing with that old childhood programming.

> Jeri Taylor: It was more my having to overcome my own hesitancy, and my own difficulty with the role. Not that I haven't done that in my years in the business…but this had been so strictly codified and regimented that it was a struggle for me. Michael and Rick are both extremely gracious, fair-minded people. There was absolutely no resistance from them in terms of my speaking my mind and having an equal say.

Developing an equal relationship among the three executive producers turned out to be a learning experience for each. In all matters save the new series, the established hierarchy remained the same for all three. For Jeri, that meant that when the daily *Voyager* development meetings were finished, she immediately had to revert to having both men as her bosses.

So…Berman, Piller, and Taylor found themselves trying to establish a new working relationship in which the three were always unequal, but for two or three hours, four days every week, were mostly equal. Got it?

However the arrangement gelled, it did seem to work out satisfactorily for them early on, and the development work proceeded at a brisk pace. The process was not, as some might suspect, a case of designing by committee.

What they all quickly came to realize was that two votes beat one. That meant any one among them at any given time might be in the position of having the swing vote. If Berman and Taylor, say, were each arguing a different position, then Piller became the deciding vote to move the decision one way or the other—unless all three happened to have separate positions, but that was an infrequent occurrence.

Jeri Taylor frequently found herself in the position of being the swing vote—a situation that in the beginning made her very uncomfortable. Within the context of television-series development, Berman and Piller's relationship had reached a point at which they could talk out their differences of opinion. They could argue and disagree in a very fair and constructive way, without becoming petty or personal. If they had strongly differing points of view, each allowed the other to express them.

Jeri had no such experience with either man. Until she became comfortable with her new role, she found herself waiting to state her views on certain issues until the two men had declared theirs. Piller would make the case for doing one thing, and Berman would make the case for doing it the opposite way. Then she would come down on one side of the issue or the other, or often present a third alternative.

> Jeri Taylor: For me, in the early weeks of the process, it was interesting and challenging. Ultimately I think we all worked out a nice relationship. It's not as though I always side with one or the other, or that they side with me. Any one person at any one time might disagree with one or both of the others, but the fabric of the relationship I think is very strong and very fair. Everyone always feels they will be given a say and respected for that opinion, listened to. In that broad sense, it was a remarkable experience.

It was still tough going in the beginning. All three believed they had to avoid duplicating characters and concepts from anything *Star Trek* had done before. Ideally, they wanted to come up with a series that contained some intriguing similarities to *The Original Series*, but also showcased unique differences.

> Michael Piller: That's the key to television development. I think any network executive will tell you that they don't want anything that's so far from the audience's experience that they react with, "What the hell is *that?*" They want it to be familiar, but they want it to be fresh. Whatever that means.

The burning question during those initial sessions boiled down to "How can we create something that is new and fresh and unique, yet clearly *Star Trek*?" How could they make the series different, so that "we're not just ripping off *Star Trek*"? At the same time they wanted to bring something of themselves to the process, while

expanding Gene Roddenberry's vision and finding new ways to explore the universe he created.

It was the desire to maintain the vision that lead them to the series premise.

Over the years any number of episodes had been done in which some alien, entity, or omnipotent being, like the character Q for instance, had whisked the ship and crew off to the far corners of the galaxy. They did not know where they were, and they did not know how they were going to get back. Of course, by the end of the hour the crew solved whatever problem was involved and did get back.

But what if they could not get back? What if they were stuck there? Alone. Completely out of touch with Starfleet. Cut off from everything familiar. So far away that the crew could not return—without some sort of help or intervention—in their own lifetimes.

Michael Piller: We looked at the landscape and asked ourselves what would make this show a contemporary show for the mid-nineties. We saw that we here in America are facing a lot of problems that we don't see any immediate fix for. We are facing social changes that...in order to solve these problems...we are going to have to start things that we may not be alive to see the end results for. That fundamentally we have to do some things for our children's benefit rather than our own.

In metaphorical terms, we created a show in which the cast of characters is so far away from home that they may not live long enough to see the end of their journey. But they are starting on this journey, knowing that at the very worst, at the end of the journey at least their children...their offspring...will be rewarded with the efforts that they have put into it.

I'm not going to say this is what *Voyager* is, but that was a discussion we had as we found our way into it. It's terribly important.

The concept was intriguing for another reason. To Berman, Taylor, and Piller it represented a "back to basics" approach. It was the challenge Roddenberry had faced in his original concept: The crew would be traversing the true unknown. They would have no idea what they were going to encounter. Gone was the familiarity of Romulans and Klingons and Ferengi and all the rest. The writers would have to start from scratch all over again, just as Gene had done in the beginning...with no idea what lay ahead.

Michael Piller: Because Roddenberry, in his original concept, was faced with the very same challenge that we're faced with: We don't know what we're going to face there…the true unknown. He didn't know who the aliens were. He didn't know anything about Klingons. He didn't know anything about Romulans. He didn't know anything Ferengi. He didn't know anything about any of these things when he started.

All he knew about was a bunch of guys on a spaceship. When he turned these guys loose in space he had no idea what he was going to find. That in a sense is what a writer does every time he sits down at the typewriter. Face the blank page. You don't know what you're going to find there.

Now there's no backup. There's nobody to talk to out there. You're on your own; you're in the unknown. It's really what *Star Trek* originally was all about. Some brave guys out there, facing the unknown, on their own. Using their wits and talents and skills to get into and out of the adventure they were encountering.

The more they discussed the premise, the more excited they became about the possibilities.

Berman acknowledges there were, and are, some downsides to the premise. The inherent problem with *Voyager*, from the very beginning, was the fact that the crew would be "sort of lost in space," but not exactly. They know where home is; they are just unusually far away from it.

This presents a fundamental philosophical problem and alters the entire energy of the series.

Rick Berman: *Star Trek* is a show about wonder, and exploration, and uplifting hopefulness. When you are venturing out, going where no one has gone before, then venturing out is a movement like this (sweeps his arms outward). It's a broadening movement. It's a movement of exploration and wonder.

Going home is an *inward* movement (brings his arms and hands together). There's not a lot of wonder and exploration and awe in going home. It has another direction to it. It funnels inward as opposed to outward. Since that's

an important element of *Star Trek* and always has been, that's a problem we're forced to deal with…always looking for that sense of wonder and that sense of adventure, when in fact you're just trying to get back home.

The premise certainly narrows the options and, as Berman admits, is something the writers are always battling. The fact that *Voyager*'s crew is on their way home puts them in the difficult situation, story-wise, of rarely going back to places they have already been. It would not make sense for the ship to periodically turn around, retrace its path, and have some new adventure with aliens they have encountered in some previous episode. You can get away with that occasionally, and the writers have done that, but it will not work as an ongoing story device.

About the best the writers can rationalize is that it will take a season or so for the ship to traverse a particular region of space dominated by a specific alien race. This was done during the first and second seasons, with the Kazon. But it wears thin after a while and begins to strain credibility. If, of course, our intrepid starship is truly trying to get home as quickly as possible.

If that is not tough enough, there is yet another corner *Voyager*'s premise paints everyone into. The writers cannot periodically go back to, say, the Klingon Homeworld to get B'Elanna involved in stories, as they did with Worf on *The Next Generation*. Nor can they continually have episodes set on Earth, or on the Talaxian, Vulcan, or Ocampa homeworlds, as they have done previously with Romulans, Cardassians, and Ferengi. There is very little opportunity for that type of "back and forth" action. The ship is always encountering new space, always moving in a single direction. The options are much more limited.

One could just as easily argue that this forces the writers to be much more inventive, a point that Berman also acknowledges.

Rick Berman: When you're on your way out to explore, you can make a left turn and spend a month somewhere. That's what it's about. It's the Jack Kerouac way of looking at things.

When you're on the way home, it seems kind of frivolous to make that side trip. That's something else that gets to us. Plus we're not in contact with Starfleet. We don't have that authoritative "father figure" organization that we relate to and talk to and report to.

So these are all things that get in the way in a sense. But they're also things that make it more interesting. They are the things we purposely did to make the show move. Not only to ourselves as writers but also to the fans. We weren't just going to give them *The Next Generation* in a different-looking ship.

Perhaps. But it is difficult to convince viewers that you are "boldly going," when what you are really trying to do is get home within your own lifetime.

The following year, when preproduction work began, more than one staffer would privately worry that *Voyager*'s series premise would hang around their collective necks like a cursed albatross—and that viewers would tag the latest *Star Trek* incarnation as a *Lost In Space* with high production values.

Arriving at the premise proved relatively easy. Creating a new cast of characters was something else again.

THE MIRROR

Dramatic license...we take it all the time. We never forget we are doing science fiction here.

Our purpose is to entertain, enlighten, provoke. If we wanted to do science we probably

all would have science degrees and be doing that.

Jeri Taylor
Executive Producer

ONE OF THE HALLMARKS OF EVERY STAR TREK series is the use of specific character types. While these character types are important for purposes of dramatic storytelling, they are equally important as a means of expressing the vision, the philosophy, the most basic precepts of what makes *Star Trek* what it has become.

The most obvious of the traditional characters is a strong captain. This is the Leader,

the Father/Mother/Confessor/Head-of-the-Clan person whom all aboard ship can confide in, trust, respect, and bond with. The sort of person you feel safe with when venturing out on a perilous journey, knowing at your deepest level that this person will get you back safely, no matter what the odds. This character is a true mythological archetype—the hero—and examples can be found everywhere in literature, as well as films and television.

Usually this person is the one around whom the story or the series revolves, the one who shepherds the story from inception to conclusion. Characters of this archetype share many common qualities. They are both leaders and nurturers, and to that extent represent both the male and female aspects of our individual personalities. They possess the kind of innate wisdom we all wish we had ourselves. They are quite often single at the story/series' beginning, and just as often are still single (though not always) when the story/series ends. Examples of this archetype include Mary Richards, *The Mary Tyler Moore Show*; Jean-Luc Picard, *Star Trek: The Next Generation*; Dr. Quinn, *Dr. Quinn Medicine Woman*; and Murphy Brown, *Murphy Brown*.

In addition to classic archetypes, *Star Trek* has become well known for including certain types of characters who are so well defined and so recognizable that they have, in effect, become archetypes in their own right.

From the very beginning of *Star Trek*, the crew has always included a character whose makeup is such that he can comment on human beings—an "outsider," who can make observations about us that we would not necessarily make of ourselves. This character is often the one who holds the mirror up to each of us, so we can see ourselves from a fresh perspective. He—the character has never been a female, although this would change in the fourth season—helps us look at ourselves, the way we act, the way we think, the way we perceive each other and the world around us. This allows us to consider various facets of our behavior in the "safe" environment of a fictional setting—especially those issues that might be too uncomfortable for us to personally confront otherwise.

He has also always embodied a human trait that viewers can unfailingly identify with: the internal conflict over the desire to be different from who it is that you know you really are. To know that you are a certain way, yet wish with every fiber of your being that you were a different way. To hate the way you are, and know you would give anything, even your soul, to not be that way. The eternal, human, gut-wrenching struggle for self-acceptance.

In *The Original Series*, this character was Spock, the half-human–half-Vulcan science officer. Spock approached everything on a logical basis, suppressed his emotions—i.e., the qualities of his human half—and therefore saw the world and humanity in a very dif-

ferent way. He was the window into ourselves, from a logical perspective. And from episode to episode, we watched as he remained locked in an eternal struggle to resolve the conflict he felt between his human half and his Vulcan half. Spock remains arguably the most popular *Star Trek* character of them all.

In *The Next Generation*, this character was Data, an android who always wanted to be human. Because he was an android and could not experience human emotions, he lacked the intensity of the internal conflict as expressed by Spock. Instead, his character was more like the pure Vulcan side of Spock in that Data approached everything from a position of pure logic. This gave the producers and writers of *The Next Generation* the opportunity to comment on and explore humanity in a very fresh and original way.

In *Deep Space Nine*, this character is Odo, an alien who lives among humans by choice (in that series' fourth season, he became one). Since Odo is other than human, his observations—made by someone unlike ourselves—help us broaden our understanding of who and what we are. From there—so *Star Trek* theory goes—it is not so difficult for the viewer to make the leap into the arena of change. Personal change as well as societal change.

In *Voyager*, the traditional function of this "outsider" archetype has been rather uniquely divided between two characters: B'Elanna Torres and the Doctor. B'Elanna represents the struggle for self-acceptance; the Doctor more or less sits in judgement of the human race, making comments that run the gamut from humorous, to caustic, to profound.

The creation of the Doctor character was a masterstroke. The Doctor follows exceptionally well in the tradition of Spock, Data, and Odo. As conceived, he is a computer program, merely one more item in a long list of supplies needed by a Federation starship embarking on a mission. As a computer program, the doctor was never meant to be anything other than a futuristic "emergency medical kit." To fill in only where needed. When the ship's doctor is killed in the pilot, the holographic doctor has to take over full-time.

Jeri Taylor: In the early episodes his movements aboard ship are restricted to sickbay in the same way that holodeck characters are limited to the holodeck environment in which they are created. Suddenly he's the only game in town. His character arc is his coming to terms with his role among the crew.

From being sort of an imperious little despot who expects to appear in sickbay on an emergency basis, order people around, and disappear again…he suddenly finds that he has to confront much, much more. He has to deal with people's feelings and their needs. He must give continuing care…which is

something he wasn't programmed to do.

In the beginning, he doesn't have a name. In the course of the early episodes he decides that yes, he is a member of the crew and deserves respect. The crew treats him like he's a piece of equipment. He begins asking for things and demanding things. He wants a name, he wants to get out of sickbay. There's a wonderful kind of growth in this character.

It is this deliberate attempt to build into each series, and episode, these archetypal characters that helps explain why so many viewers for so many years have insisted that *Star Trek* has changed their lives. This ongoing science-fiction saga has inspired and motivated them to dare greatly, either in their personal lives, or in the world around them. For most of us, it ends up being the same thing, either way.

Consistently, each individual character—both the

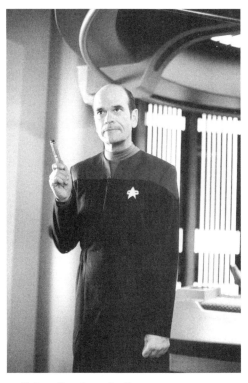

Robert Picardo as the Doctor. ROBBIE ROBINSON.

series regulars and specific episode characters—functions as an individual mirror for us to look into, extending our opportunity to better understand each other and ourselves. By getting to know them every week as individuals, we become more personally aware of qualities, both good and otherwise, that we human beings have a singular knack for expressing.

Examine the characters from the episodes of any *Star Trek* series—or the feature films, for that matter—and this "mirror" function is invariably represented. The dominant quality each expresses will be different from character to character, but the quality—the mirror—is always there.

Voyager is no exception; human qualities are well represented. Jealousy, and the desire to have one's life mean something: Neelix. Greed: Dr. Arridor the Ferengi, "False Profits." The need to prove oneself: Harry Kim. Analytical: Tuvok. Treacherous: Seska. The spiritual quest: Chakotay. Selflessness: Kes, "Phage." Remorse and the quest for forgiveness: Jetrel, "Jetrel." Personal redemption: Tom Paris. The struggle for self-acceptance: B'Elanna Torres. The list goes on.

Every human quality…every human character defect…every type of human being…eventually, all are held up to each of us so that we may take a good, long look in the mirror. Each reflection serves to remind us, "this is part of what it's like to be human."

It is worth repeating that there is a deliberate and careful attempt to craft *Star Trek* characters so these qualities can and will be expressed. No other vehicle of entertainment, in any medium, has so consistently, so thoroughly, and so honestly attempted for so many years to be a social conscience for the television-viewing audience.

Does this suggest that the producers, from Roddenberry onward, believe they have a moral duty to "teach" the rest of us unenlightened humans the proper, civilized way to behave? Perhaps. But the evidence suggests this is, strictly speaking, not the case. A mirror does not teach. The function of a mirror is to reflect. Viewers get to decide if what is being reflected is an acceptable quality within them, personally. Some, at least, may decide a bit of tweaking or refurbishing is in order.

To enhance story possibilities, many of the traits expressed by individual characters are in direct opposition to one another. Aside from creating interesting characters, these qualities have the advantage of representing opposing forces, which provide built-in opportunities for a character to grow and change—the "character arc." Stories have arcs as well, and occasionally span two or more episodes.

Character arcs are actually a metaphor more in keeping with *Star Trek*'s current mission—to explore the universe rather than teach the universe. For individual characters, sometimes the journey of exploration is an internal one. At the end of the arc, the result is usually a new level of awareness, understanding, or self-acceptance.

Stories are important, but it is out of the characters that the stories are born. The two elements are inseparable, but character drives story. In the pilot episode of a new series, both elements have to initially be developed simultaneously. Later, perhaps six or eight episodes into the series, enough is known about the characters to allow each episode's story development to go forward naturally. From that point onward the characters will continue to grow and evolve as each succeeding episode is written.

There is a common perception that *Star Trek* is an action-adventure series, which is why it has such a strong male demographic. Episodes do have their share of action, phaser fights, and that sort of thing. But always, at the core of every story, there is something happening to people. There is a strong emotional, internal conflict—either within a particular character, or between two or more characters.

Jeri Taylor: Supporting that core element of the personal story there is, yes, always some sort of science-fiction premise that's hopefully provocative and

mind-bending. Or there is some threat or jeopardy that comes from outside that our people must rescue themselves from. That is the element that gives the story its dramatic push, its drive. That's the skeleton. But the heart, the organs, the pulsing part of the story is what's going on with the people. And we think that is really what touches something deeply felt inside the audience.

Kate Mulgrew as Captain Kathryn Janeway. ROBBIE ROBINSON.

The message is unmistakable: Stories evolve out of a character's own personal conflict about something. *Voyager* is a character-driven show.

In the beginning, however, the writers are missing a vital component in the character-construction equation. Brannon Braga adds useful insight into both the initial difficulty in finding each character's "voice," and how the problem is resolved.

Brannon Braga: It is a synergistic process. The actors have a lot to do with it. Once we all started to watch these actors—Kate Mulgrew in particular—perform, you have a voice to put with the character. You have mannerisms, you have…even the way they walk across the room can help you add something in the scene or just have the idea of who the people are.

I wrote "Parallax" without having seen any of the actors perform the roles. I didn't know how they were going to do it. And of course none of them did it the way I imagined it. But now I know how these actors are, and it's helping a lot. The actors definitely contribute to the creation of the character.

A process that never really seems to end. A good case in point, again with Kate Mulgrew, is the third season episode "Macrocosm," which featured an alien race known as the Tak Tak. Written, coincidentally, by Brannon Braga, the Tak Tak combined a unique form of body language and gestures with their speech patterns. The resulting conversations with *Voyager*'s crew were interesting to watch. The inspiration for this unusual cul-

tural twist was the fact that Mulgrew has a habit of frequently placing her hands on her hips. In the Tak Tak culture, this gesture is an insult of the grossest kind.

Invariably, the driving force in most episodes is a quality embodied in one or more of the ship's crew members. The purpose of each story then is to create a set of conditions that allows us to explore that quality and find out how the character will respond to it. To see if the character will learn anything from the experience and grow from it. This becomes the character arc. Good arcs are those that take the character from point A (the episode's beginning), to point B (the episode's end), and deposit him or her there having been changed in some way by the experience.

The producers tell outside writers[*]—those who want to come in and pitch a story—to "get one of our people wriggling on the head of an emotional pin of some kind…skewer them and let them wriggle." In other words, put the characters in a situation that forces them to make a tough choice…emotional jeopardy…a moral or ethical dilemma…and then see what happens to them.

In *Voyager*'s first-season episode "Ex Post Facto," Paris is faced with just such a problem. He finds himself tempted to have an affair with a married woman. He is drawn into a relationship with her, but before things can go too far the woman's husband is murdered and Paris is charged with the crime. Near the end of the episode there is an exchange of dialogue between Ensign Kim and Lieutenant Paris that is instructive and insightful, for both character and viewer.

Often the point of the character arc is to lead the character—Paris, in this example—to a new level of self-understanding and self-acceptance, especially of traits we possess and cannot seem to get rid of no matter how we try. Since we cannot expunge these traits, we must learn to live with them in such a way that they do not hurt us, or those around us—the purpose of Paris's character arc in "Ex Post Facto." From this new level of self-acceptance, the character can then accept that same quality in others.

This does not necessarily make the quality "right," but does, by the end of the episode, help teach the character to be less judgmental of others who may someday have difficulty with that very same quality. For the character, arriving at this final point is the end of the arc. For the viewer, it's the mirror again.

Doubtless, there were many men (and women) who viewed that episode and knew

[*]The company is still the only production group in episodic television that will listen to story ideas directly from writers, without the need for an agent. For information, write to: Lolita Fatjo, *Star Trek: Voyager*, Paramount Television, 5555 Melrose Avenue, Hollywood, CA 90038-3197. Include an SASE, and ask for a set of the submissions guidelines. Or call the hotline number: 213-956-8301.

77 INT. SHUTTLECRAFT 77

Paris and Kim... Paris looks weary... Kim intense...

 PARIS
 This is all your fault you know...

 KIM
 My fault...

 PARIS
 I consider you the conscience I
 never had... you're supposed to
 keep me on the straight and
 narrow... .

 KIM
 I tried to warn you...

 PARIS
 (laughs)
 Funny. So did she.

 (CONTINUED)

77 CONTINUED: 77

 KIM
 If it'd been me, I would've stayed
 as far away from her as
 possible...

 PARIS
 Someday it _will_ be you, Harry.
 You'll meet her. And you'll know *
 it's wrong from the first moment
 you see her. And you'll know *
 there's nothing you can do about
 it...

 (CONTINUED)

from painful personal experience what Paris meant. And that is precisely the point. It is invariably the point in *Star Trek*. Hold up the mirror…take a good long look.

Occasionally, the producers will create a character along certain lines, only to have the actor playing that character influence the role in an unexpected way. Such was the case with Robert Duncan McNeill and, again, the part of Lieutenant Tom Paris.

Originally, Paris was cast in a mold similar to that of Kirk and Riker—both notorious womanizers. The first half-dozen or so scripts, including "Ex Post Facto," were written with little or no knowledge of who would play the part, or how he would play it. McNeill was cast, and began playing the role. The writers soon realized that McNeill is anything but a womanizer. He is a happily married man, with children he adores. What he brought to the part so changed the character that today, Paris is no longer written as a womanizer.

Crafting the characters may be careful and deliberate, but the path is uphill, challenging, and strewn with creative boulders. Coming up with the *mix* of characters was also a thorny task.

Among *The Original Series*, *The Next Generation*, and *Deep Space Nine*, it initially seemed that all the possible variations of character types—those that had proven popular with *Star Trek* viewers—had already been used. This presented Berman, Taylor, and Piller with a substantial creative challenge.

At least one of the character types was relatively easy. All agreed early on that the crew should include a Native American. People like Whoopi Goldberg had said many times that seeing Uhura on the bridge in *The Original Series* gave them real inspiration as children…a model of something to strive for. It said to people everywhere, "We're here in the twenty-third century and—racially, ethnically—we're doing very well!"

Jeri Taylor: It seemed to us that Native Americans needed that same kind of role model and that same kind of boost…the future looks good, you have a purpose, you have worth, you have value, you will be leaders, you will be powerful. That was one character choice we had early on.

The process seemed endless. Week after week of thinking, discussing, coming up with ideas, tossing them out, going back to square one and starting the whole process all over again.

By the end of July some story and character elements were starting to emerge from

the haze, tentatively taking shape, however indistinct and tenuous. The origins of some of the character ideas were being formulated. Parts of the story were beginning to surface, such as the idea of a split crew—some Starfleet and some "misfits" (rebels).

Jeri Taylor's handwritten notes dated July 30, 1993, reveal some of these early pieces:

STAR TREK: THE JOURNEY HOME

We get zapped to the ends of the galaxy—it will take 10 years to get home.

We explore on the way.

The misfits are stuck with us.

Messages to Starfleet—one way.

Old person on show

No drunks!

Multi-personality

Androgynous

Holo-Moriarty

Half-breed

Native American

One week later Taylor summarized the discussions in the following document, written for Berman and Piller's eyes only:

NOTES ON "STAR TREK: THE NEW SERIES"

This is a compilation of the notes to date (8-3-93):

PREMISE: Starfleet sends a ship and crew on a dangerous covert mission. The ship is a sleek, nifty new-generation vessel, with some improvements, though smaller than the Enterprise. To accomplish the mission, we must take along someone who has fallen from grace—a former Starfleet officer who may even be in prison. Given a chance to redeem himself, he agrees to help us.

During the course of the mission we must find two other nefarious characters; our former officer may have information about them, or know them, or know the area in which they are working.

The mission unfolds, and during the course of it—perhaps near the end?—we are somehow zapped to the far reaches of the galaxy, somewhere so far that, by conventional means, it will take ten years or so to get back. The Captain steels herself for this journey, and offers uniforms to the three misfits. Two of them accept and take positions on the bridge; the other won't take the uniform, but agrees to serve in Engineering.

The Captain makes clear that the journey home will fulfill their Starfleet job descriptions: they will map and investigate and explore this unknown space. They will get back, and when they do they will have a wealth of information and research to bring to the Federation.

One device we might use is "messages to Starfleet:" one-way communiqués that serve as a kind of log. They realize no one will ever answer—it will take too long—but at least they will know the ship is coming.

THE CREW:
Captain—a human female, Lindsay Wagner type.

First Officer—a human native American male, "Queegquog" person who has renounced Earth and lives as an expatriate on another planet. A mystical, mysterious man with whom the Captain has some prior connection, not explained.

Tactical—a human male, handsome leading man, a hunk with strong sex appeal. He's one of the misfits, the former officer who is trying so hard to redeem himself—maybe too hard, a bit desperate. (Note: "Has to be taught to be independent.")

Conn Officer—an alien female (or male), one of the misfits, the "moderate" of the group on a sliding scale of recalcitrance. Originally thought of as of the same species as the First Officer, a conflictual relationship because the misfit has disappointed the F.O. (There was also mention of their having a telepathic ability between themselves.) Latest thinking is of a half-breed, possibly Bajoran/Cardassian.

"Mayfly"—The alien "scout" for the ship, whom we meet after we've been zapped to the ends of the galaxy. A female (or male or androgynous) with a life span

of only seven years. We first meet her as a young woman; she will age every half season and progress into old age. Each day is a joy to her; she lives in the moment and cherishes every hour.

Engineer—An older human male. Vital and energetic, he has the strength and endurance of the younger officers; but also is a reservoir of wisdom and experience. He takes the rebellious young misfit under his wing and tries to help the angry loner to re-adjust.

Assistant Engineer—A human female (or male). One of the misfits, and the most unredeemed of the lot. He is angry, displaced, alienated; particularly upset that fate has treated him so cruelly. He never signed on for this long mission and he doesn't want to be there. The first crack in his hostility is because of the Engineer; over the course of the series he would be redeemed and find his inner worth.

Holo-Doctor—A human or alien male or female (possibly Vulcan?). The medical officer of the ship is killed during the mission; remaining is the holographic character of the doctor who, like Moriarty, has "awareness" of himself as a holodeck fiction. He longs for the time when he can walk free of the Holodeck. (Some discussion about the fact that one of the crew must become a "student" of this doctor. Maybe one of the misfits had been kicked out of medical school.)

POSSIBLE TITLES:
"Star Trek: The Journey Home"
"Star Trek: Galaxy's End"
"Star Trek: The Return"

OTHER IDLE THOUGHTS:
A clone or genetically engineered being.
Last of a species.
Man without a country.
Man on the run.
Former aliens we might like to see on the ship: Yridians, Carvallans, Soup Guy.*

* A reference to making one of the new characters a shape-shifter, the same species as Odo in *Deep Space Nine*.

The birth of an alien, a la "The Child"* which matures rapidly.
Nick Locarno.
Tasha's sister.
An omnipotent being who has lost its powers.

Within these notes can definitely be seen the beginnings of what later became the premise for the series, the nature of the ensemble cast, and the pilot episode story itself.

The name "Nick Locarno" refers to a character featured in "The First Duty," a fifth-season episode of *The Next Generation*. Locarno made a mistake, for which he was expelled from the Starfleet Academy. The actor who guest starred in that role was Robert Duncan McNeill.

The notation "Tasha's sister" is a reference to Ishara Yar, the younger sister of Natasha Yar, a series regular at the start of *The Next Generation*. This was roughly eight to ten years before *Voyager*'s time period. The actress playing the part of Natasha, Denise Crosby, wanted to be released from the series and so her character was killed off in the first-season episode "Skin of Evil."

Both notations are significant for what they represent.

In the minds of the producers, Nick Locarno's troubles could, and eventually did, make interesting backstory material for one of the rebel characters—Tom Paris. With Ishara Yar, once she was established, it is presumed she is still alive and very much a part of the *Star Trek* universe. Therefore, both of these characters represent resources that can be drawn upon by the writers.

This concept is one more fundamental element in *Star Trek*'s appeal, and is an outgrowth of one of the canons Gene Roddenberry established: Wherever possible, the *Star Trek* universe will be consistent.

Once a fact, character, theory, law, history, device, event, species, reference, or any other piece of data—no matter how large or small—is introduced in an episode, it is forever more a part of *Star Trek* lore. Nothing is discarded, forgotten, or ignored. The result is that writers and viewers alike have three decades of history to play in—a rich tapestry of history and detail every bit as complex and interconnected as the Earth we live on and the galaxy in which it resides.

Just as our collective history and human experience here on Earth continues to grow day by day, the same is true of the *Star Trek* universe. It continues to expand with

* Refers to a second-season episode of *The Next Generation*.

every episode of every television series and the release of every new film. Yes, that too. A point established in a *Star Trek* film becomes part of the overall *Star Trek* universe and is both used and referred to in subsequent television episodes. The reverse is also true of anything established in a television-series episode.

This has given everything a sense of connectedness beyond mere consistency. As a writer or a viewer, you always know what to expect from what has gone before. The rules have been clearly established, and are just as real as Newton's third law of physics. The terrain has been mapped and recorded so faithfully that it can be referred to as easily as looking something up in the *Rand-McNally World Atlas*.

> Michael Okuda: It's this feeling of familiarity that makes *Star Trek* work. There is an identifiable look and feel about it all. The times may change, the people may change, the aliens and the ships and the planets may change, but everything still feels familiar. Everything in *Star Trek* still operates by the same laws. And there is always a family of likeable characters doing extraordinary things. And everything is a direct descendent of the *Enterprise* and *The Original Series*.

Augmenting this feeling of connectedness is the simple, practical matter of budgets. Once a set has been built for one episode—say, a Romulan bridge—it is retained whenever possible, for future use. That saves a lot of money. As a set is reused, its very appearance tends to reinforce the overall feeling of consistency of the series.

Indeed, so much detail has been established over the years that entire volumes of compendia, encyclopedias, chronologies, and technical manuals have been published, as a convenience for the fans, to help them keep track of everything.

In her notes, Taylor's cryptic notation, "Holo-Moriarty" is revealing as well, and has direct bearing on *Voyager*. It is a reference to Professor James Moriarty, a holographic character who first appeared in *The Next Generation*'s first-season episode "Elementary, Dear Data," and again in the sixth-season episode "Ship In A Bottle."

Moriarty was the villainous adversary of Sherlock Holmes, and was re-created by Geordi La Forge (LeVar Burton), using the *Enterprise*-D's holodeck computer. The computer did such a great job of re-creation that Moriarty became, in essence, a sentient being with complete self-awareness.

Here, clearly, are the roots of the character that eventually evolved into *Voyager*'s Holographic Emergency Medical Program, now simply known as the Doctor. It is a typi-

cal example of the producers' ability to build on an element established years earlier, in a completely different *Star Trek* series.

It is also a clever use of "resources." By drawing on technology established in *The Next Generation*, the producers gain credibility with the fans—they keep track of such details—with respect to the Doctor's existence aboard *Voyager*. This is the sort of consistency fans have grown to love about *Star Trek*. Because Berman, Taylor, and Piller are familiar with the landscape, they can take advantage of features of the terrain in creating characters, stories, and indeed entire new series.

It is fair to say that as a result of all that has been established, *Star Trek* long ago ceased to be classifiable as mainstream science fiction. It has become a true genre of its own. Authors who write within this new genre, following the same conceptual guidelines dictated by the nature of any other genre, have written hundreds of novels to date. More are added to dealer's shelves every week. Many of these novels, like Jeri Taylor's *Mosaic*, have even appeared on the *New York Times'* Bestseller List.

Taylor's notations graphically illustrate the usefulness of the massive amount of information accumulated thus far. It is all related, works completely synergistically, and functions every bit as well as a real, living, expanding universe.

This is not simply new to a science-fiction series. It is new to episodic television *and* feature films.

By now, Roddenberry's canons may well be so important that their continued observance is probably crucial to *Star Trek*'s survival. "Don't stop doing what works" would seem a wise mantra to live by. Violate the canons often enough, drift too far from Roddenberry's concepts, ignore enough of the previously established precepts of the *Star Trek* universe, and the result would likely be the same fate suffered by all once-popular episodic television shows. *Star Trek* simply would not "work" anymore, in the way in which it has worked for over three decades.

This is not an impossible scenario.

If history is a valid frame of reference, then it seems clear that Hollywood does not know how to avoid killing the goose that laid the golden egg. Many a good series has eventually run out of steam, degenerated into farce, suffered from overexposure, or self-destructed in other, equally effective ways. All because the premise and concepts that launched the series in the first place were gradually eroded, distorted and, finally, disavowed.

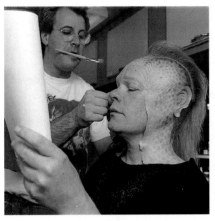

Ethan Phillips, being transformed into a Talaxian by makeup artist Scott Wheeler. The process, which takes almost three hours, may require Phillips to report for makeup as early as 4:00 A.M. ROBBIE ROBINSON.

After the latex-molded appliances have been cemented to Phillips's head and face, a flesh-colored base and powder are applied to make the appliances blend in with the actor's natural skin tones.
ROBBIE ROBINSON.

Letting the base coat dry for a few minutes, before the next step. Note Roxann in the background, getting her Klingon makeup applied. ROBBIE ROBINSON.

Neelix's distinctive spots are applied with an airbrush. The elaborate latex pieces can be used only once. At the end of the day, the appliances are removed and discarded.
ROBBIE ROBINSON.

Bill Peets checks the light levels on a stand-in for Roxann Dawson before the actors are brought in to film a scene in the mess hall. A wild wall has been removed to provide access for the camera. ROBBIE ROBINSON.

The same scene, but now with the actors; this was a rehearsal prior to shooting. ROBBIE ROBINSON.

The rolling starfield
outside the mess hall.
ROBBIE ROBINSON.

One of *Voyager*'s corridors,
as a makeshift wardrobe area.
With storage and work space
at a premium on the stages,
portability is everything.
ROBBIE ROBINSON.

Experience on *The Next Generation* led Richard James to make some changes and design improvements into *Voyager*'s sets. Corridors, for example, are better lit and easier in which to film.

ROBBIE ROBINSON.

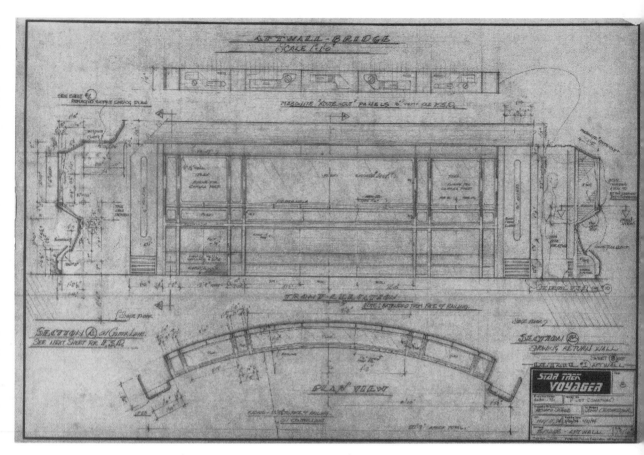

One of the many construction blueprints for the bridge.
This shows the aft wall, behind Janeway's chair.

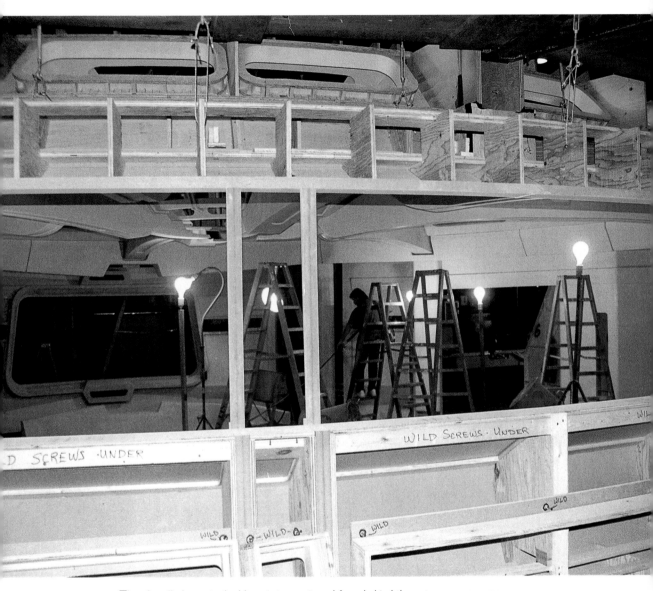

The aft wall shown in the blueprints, as viewed from behind the set. ROBBIE ROBINSON.

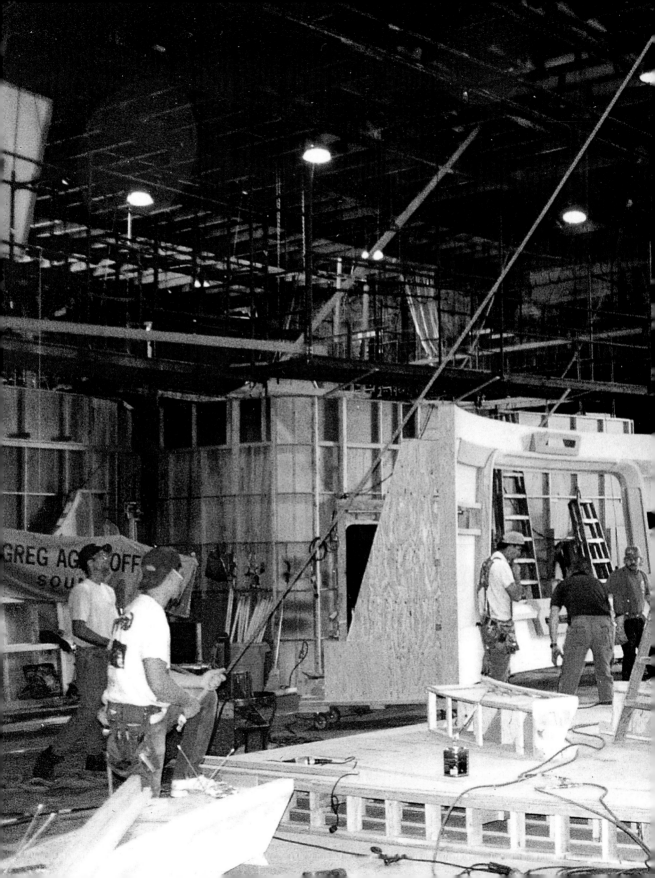

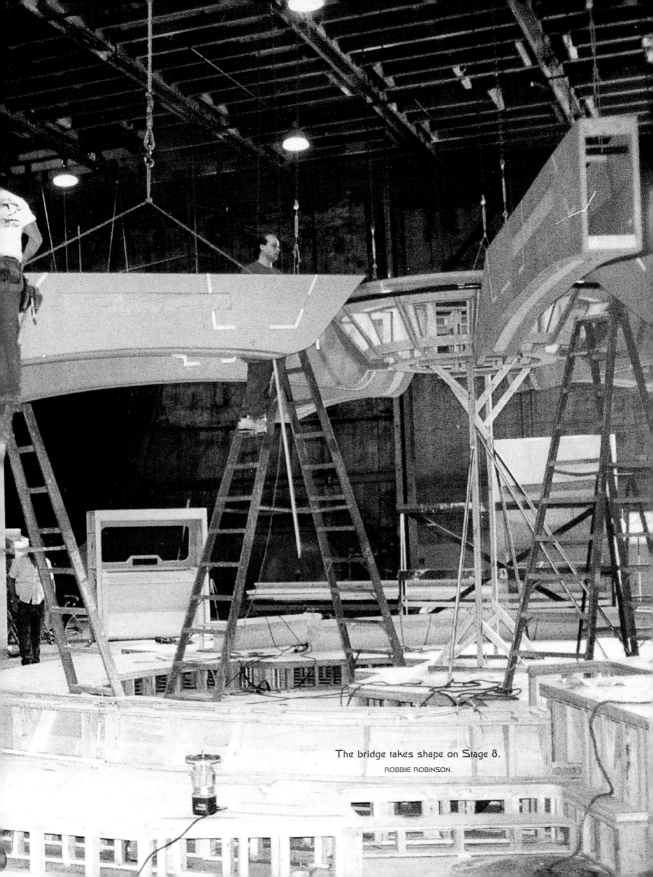

The bridge takes shape on Stage 8.
ROBBIE ROBINSON.

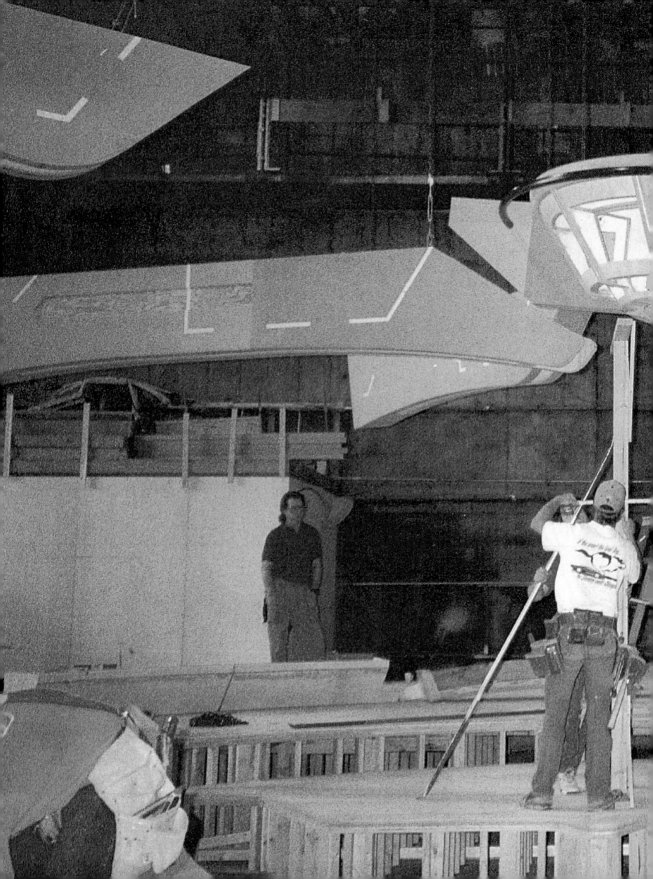

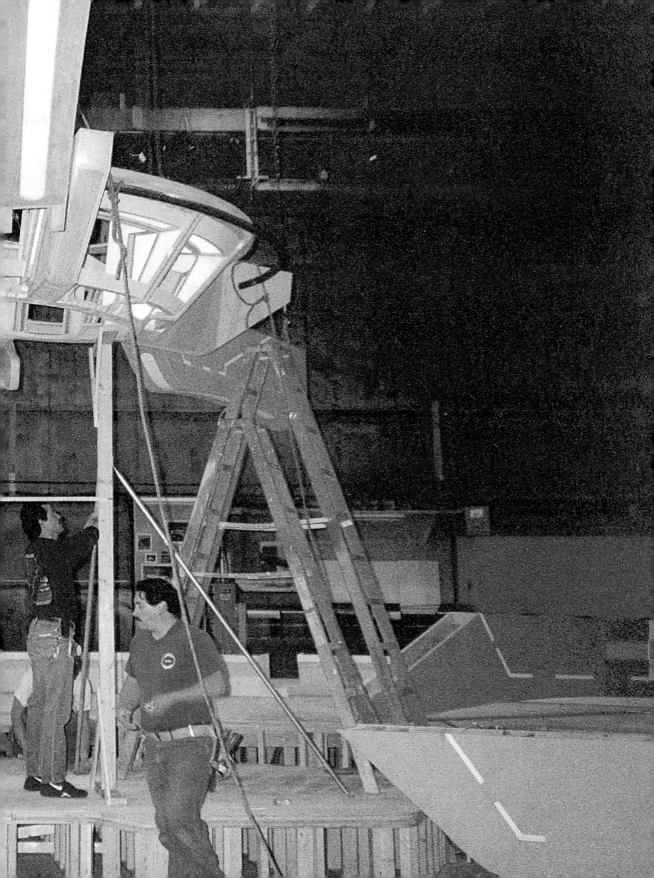

The viewscreen was built as a single, wild unit. ROBBIE ROBINSON.

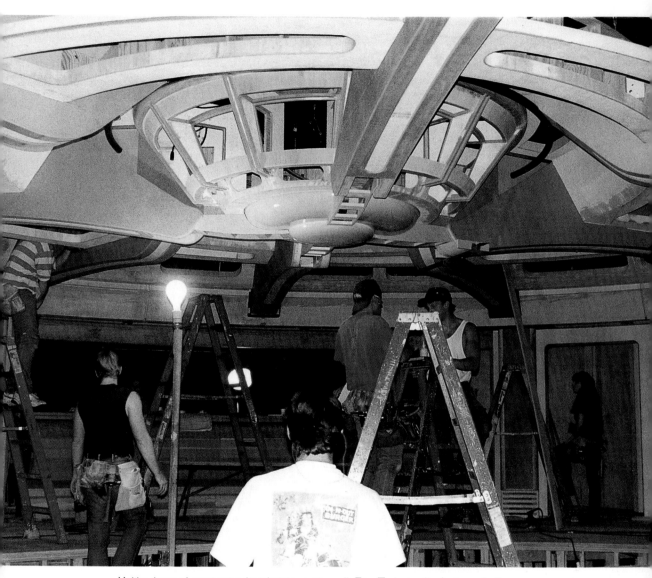

Unlike those of most episodic television series, all *Star Trek* standing sets are built with a full ceiling. This one, for the bridge, was more difficult to build than most. ROBBIE ROBINSON.

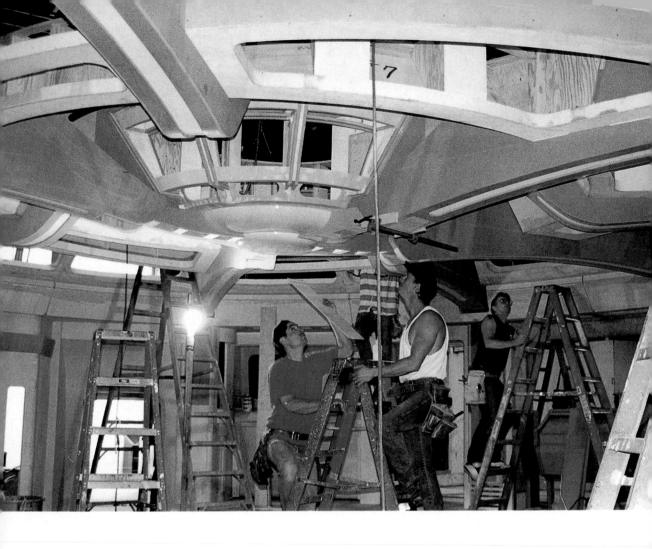

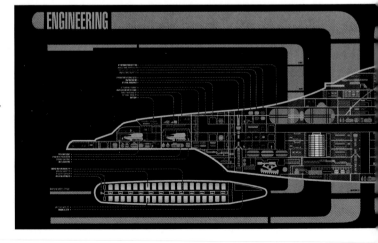

ENGINEERING

A closer look at the ship cutaway drawing of *Voyager,* as developed by Doug Drexler.

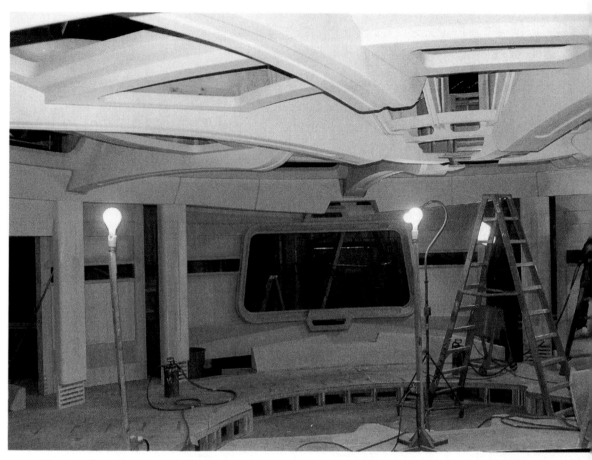

The bridge's ceiling nears completion. Seven thousand feet of wiring are still to be added.
ROBBIE ROBINSON.

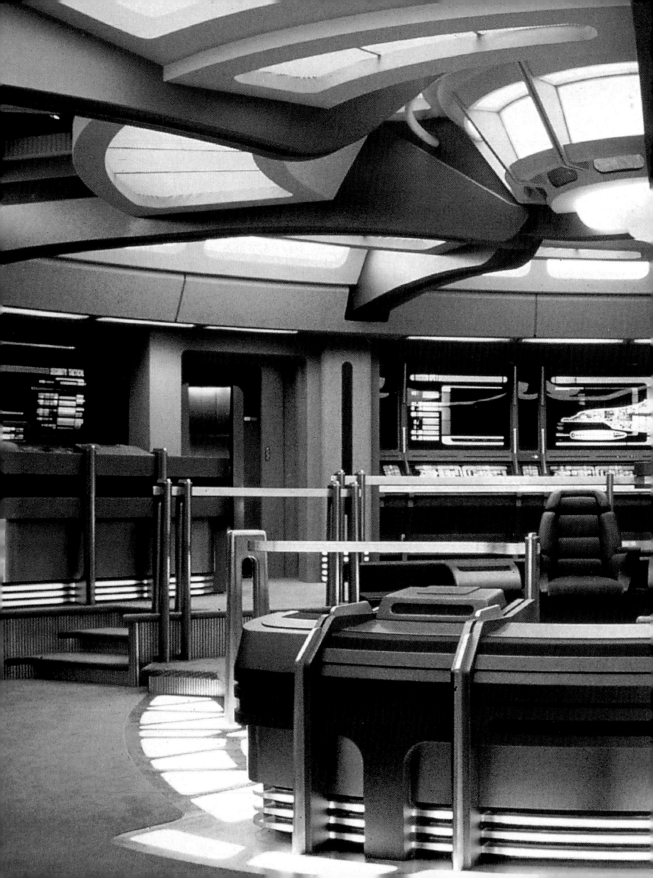

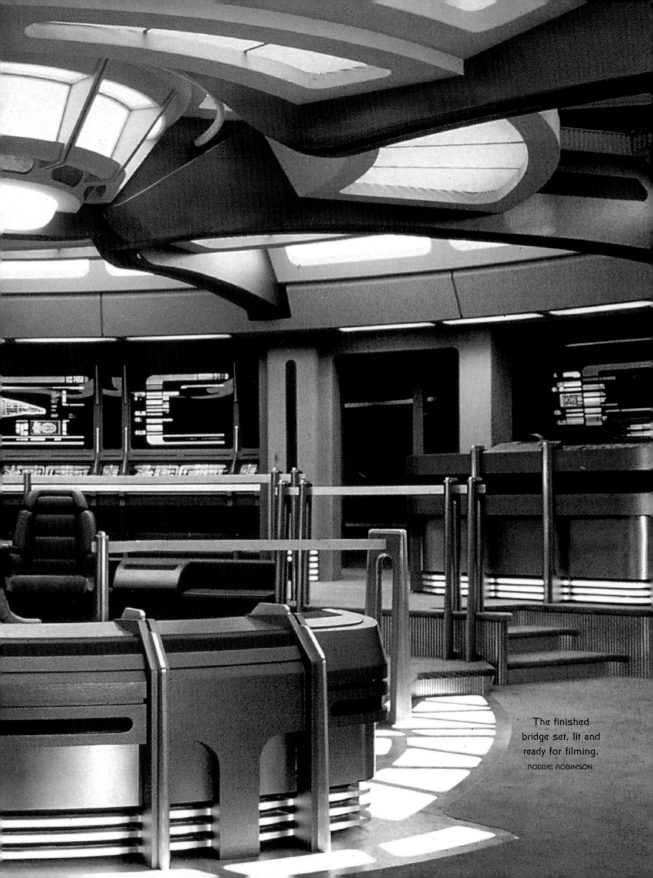

The finished
bridge set, lit and
ready for filming.
ROBBIE ROBINSON.

The captain's ready room; the windows are from the observation lounge from *The Next Generation*, but flipped over. ROBBIE ROBINSON.

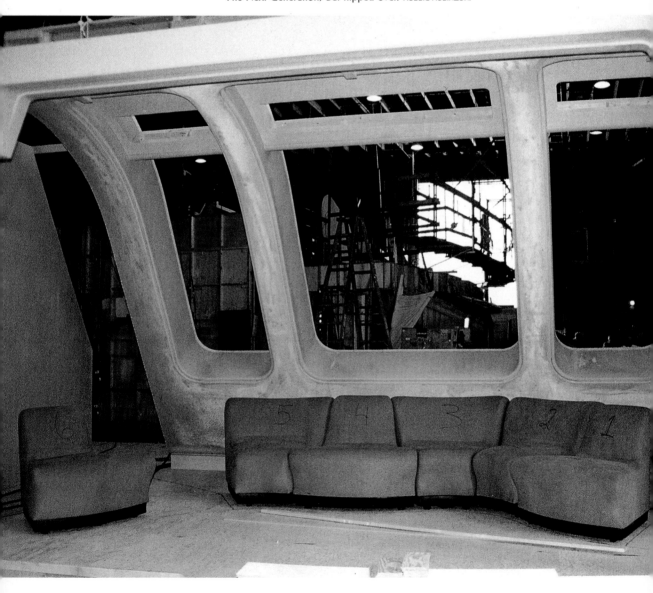

Voyager's transporter room stands in the spot previously occupied by the same set for *The Next Generation*. ROBBIE ROBINSON.

Richard James makes a point, during the construction of the transporter room set.
Behind him is one of the hallways created for *Star Trek: The Motion Picture*
and later used in *The Next Generation*. ROBBIE ROBINSON.

The transporter set from *The Next Generation* was stripped down and given a fresh new look for *Voyager*. The lights in the ceiling are actually the light pads from the floor of the original *Enterprise*'s transporter. ROBBIE ROBINSON.

Though cavernous, a sound stage never has enough room. For "Caretaker," the barn set
was built right up against the chamber set where *Voyager*'s crew are medically
"sampled" by the Caretaker entity. ROBBIE ROBINSON.

Advances in technology and an expanded budget have enabled *Voyager*'s art department to eliminate most backlit graphics and certain postproduction visual effects. In their place, monitors display graphics and animation sequences fed by "live" video playback decks.

~~ACT FOUR~~
ACT THREE

FADE IN:

24 INT. BRIDGE (OPTICAL) 24

Janeway ENTERS from her Ready Room and crosses toward *
the Engineering station.

 TUVOK *a* *
 We're ready to try ~~the~~ visual link *
 with the Romulan ship, Captain.

 JANEWAY
 Good work.

 KIM
 We didn't have any trouble
 configuring the protocols... but *that*
 ~~there's a slight~~ phase variance in
 the radiation stream ~~of the~~
 ~~wormhole that~~ gave us a few
 problems. Torres is going to
 balance it manually from
 Engineering.

 PARIS
 Okay, we've got the communications
 frequency locked in.

 JANEWAY
 On screen.

They all look at the Viewscreen, which crackles with
staticky interference. We can see the Romulan
scientist (TELEK) in the cockpit of a shuttle-sized
craft, with intermittent breakup of the picture. Telek
looks at her, unsmiling.

 TELEK
 I presume you are Captain
 Janeway...

Janeway regards him. He is a crucial element in their
ability to send a message home, and she wants to play
him just right. She approaches the screen, smiling.

 JANEWAY
 Yes. I want to thank you,
 Captain, for maintaining contact
 with us.
 (beat)
 It means a great deal to me, and
 to my crew.

 (CONTINUED)

Here is just part of one scene.

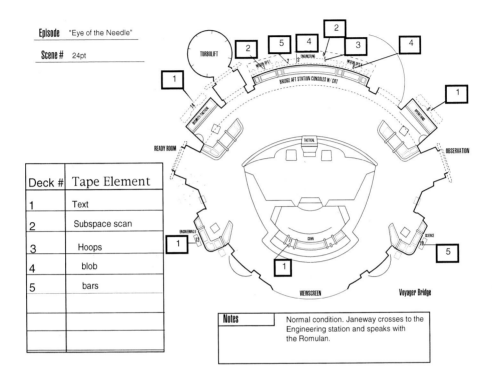

Episode "Eye of the Needle"

Scene # 24pt

Deck #	Tape Element
1	Text
2	Subspace scan
3	Hoops
4	blob
5	bars

TURBOLIFT

BRIDGE AFT STATION CONSOLES W/ CRT

ENGINEERING

READY ROOM

TACTICAL

OBSERVATION

ENGINEERING II

CONN

SCIENCE

VIEWSCREEN

Voyager Bridge

Notes Normal condition. Janeway crosses to the Engineering station and speaks with the Romulan.

A diagram of the bridge, with the location of the video monitors indicated around the outside perimeter. The chart on the left is keyed to numbers one through five within the black squares. They show what each monitor will display during the filming of the scene.

Art created to show ship status and scanning.
This art is done as animated video on playback loops.

VESSEL STATUS 081358

382526

SCAN ANALYSIS 21166

SCAN PARAMETERS 4069680

SUBSPACE EMISSION SCAN 247

LCARS 40274

02-654598

03-875683

04-765465

05-224353

06-578565

VERTERONS	18478	037	82671673
OMICRONS	7822	183	1883008
NEUCLEONS	72899	747	74538283
CHRONITONS	38	07	382
GRAVITONS	61748	0	18478037
TETRIONS	82671	673	7822183
TACHYONS	83	6	72899747
PHOTONS	74538	283	538107
PROTONS	0157	382	61748110
ELECTRONS	18478	037	82671673
DUDERONS	22	3	008
DEKYONS	72899	747	74538283
BOSONS	1883	006	72899747
QUARKS	74538	·	107
POLARONS	0157		61748110

SUBSPACE SCAN 11556

LCARS 40274

02-654598

05-224353
05-224353
05-224353
05-224353
05-224353
05-224353
05-224353
05-224353
05-224353

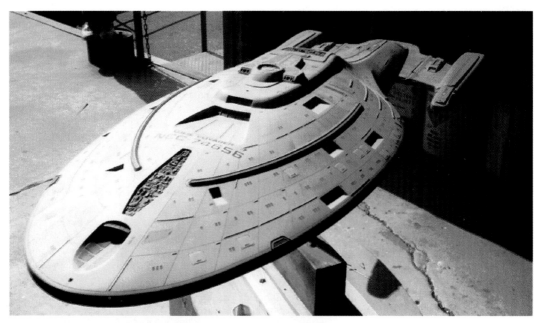

Special effects artists talk of beauty passes, model makers talk of happy snaps. After countless hours of work, it is usually the last thing that is done before the finished model is crated and delivered to the client. Here are some happy snaps of the *Starship Voyager* and her model maker Tony Meininger.

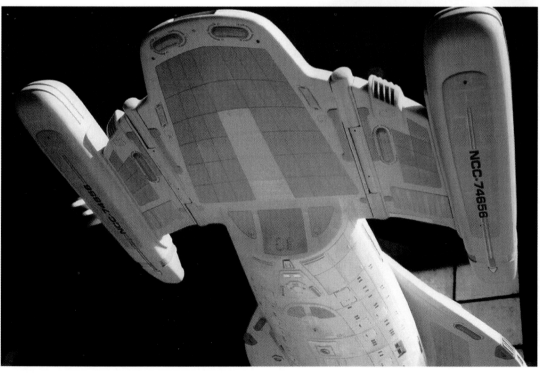

Sharing a break in the filming, veteran director Kolbe discusses the next shot with the new captain and the crew. ROBBIE ROBINSON.

On location, during filming for the pilot. Even on location, in the middle of a desert, the director's chairs are sacrosanct. ROBBIE ROBINSON.

The script called for the *Voyager* crew to escape to the surface via a hole in the ground. However, it's up to the *Voyager* production crew to dig the hole. ROBBIE ROBINSON.

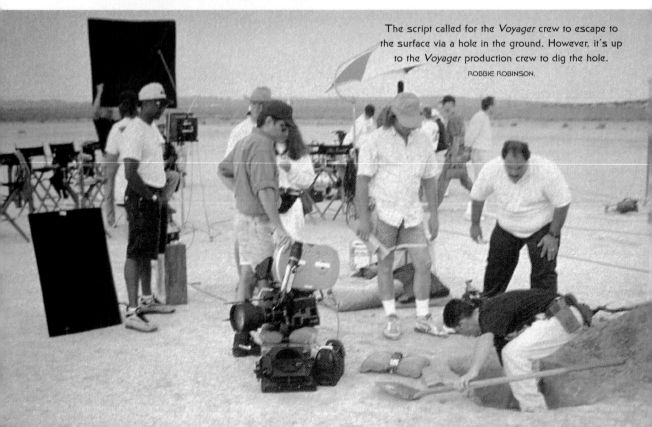

Kolbe pauses to share some insights with Mulgrew. ROBBIE ROBINSON

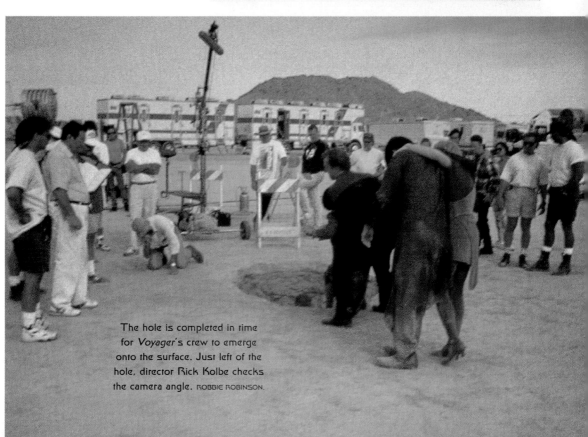

The hole is completed in time for *Voyager*'s crew to emerge onto the surface. Just left of the hole, director Rick Kolbe checks the camera angle. ROBBIE ROBINSON.

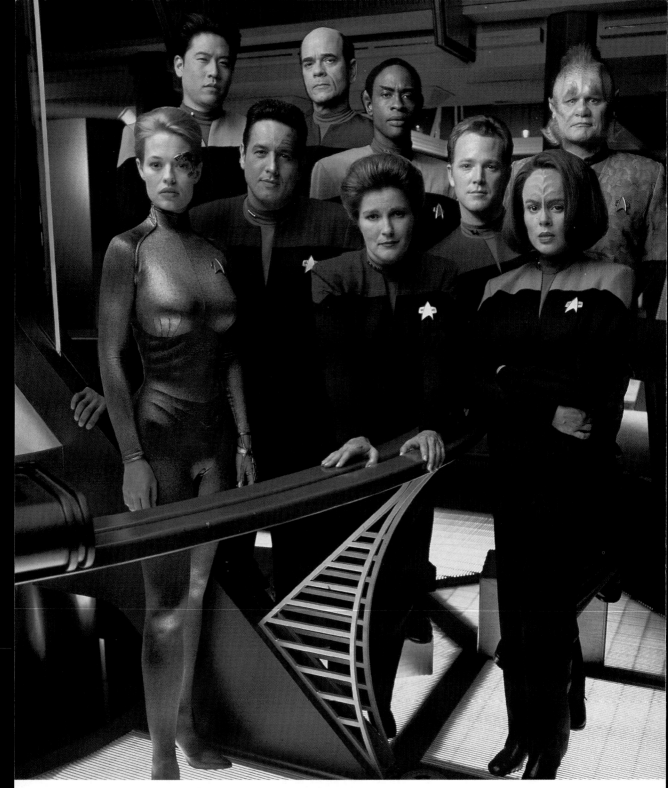

The cast publicity photo for season four of *Voyager*. Jeri Ryan, Robert Beltran, Kate Mulgrew, Robert Duncan McNeill, Roxann Dawson, Garrett Wang, Robert Picardo, Tim Russ, and Ethan Phillips. Note the ever-useful apples and half-apples under Phillips and Russ. JULIE DENNIS.

T H I R T E E N

THE CREATIVE PROCESS

I never saw *The Original Series* when it was first on because I was in high school, and

then in college. I was very busy growing my hair, reading Proust, and all that.

Ethan Phillips
Neelix

THROUGH SEPTEMBER OF 1993 THE THREE EXECUTIVE producers continued their four-times-per-week meetings, posing questions, ideas, and alternatives, and gradually sketching out the characters and the story for the pilot episode. No idea was too outrageous or preposterous to throw out for discussion. The three worked together in a nonjudgmental, noncritical environment, where it was safe to fully embrace the creative process.

Piece by piece, the puzzle began to take shape.

In one of Jeri's early periodic summaries of these meetings can be seen a glimpse of more character development for the Doctor, the first inklings of Tuvok's character, and for the first time the use of the name *Voyager*:

8-6-93

FURTHER THOUGHTS ON CHARACTERS

The Holo-Doctor represents a new, state-of-the-art technology which has capitalized on the serendipitous incident which created Moriarty, and has programmed a holographic character which has self-awareness of his situation and his limitations. We spoke of a programmer who created the doctor but made him a bit bland... when we're on our mission the Conn officer decides to play around with the programming and "tailors" his personality... maybe injecting some quirks and oddities... maybe changing it from time to time (to fit her moods).

A possibility is to consider Dwight Schultz: Barclay would have been working on this program and finally takes a leave to put on the polishing touches (on a TNG episode). He creates the character in his own image.

RECOGNIZABLE ALIENS

The older Engineer might be something we've never seen before: a black Vulcan. He's about a hundred and seventy, really old, but embraces that. He is a fount of wisdom and strength for the young, angry assistant engineer.

The Conn officer might be a human/Klingon combination. She would be a metaphor for those who are trying to suppress or ignore some aspect of themselves (anger, hatred, lack of control, etc.) that actually can't be ignored. She wants to eschew her Klingon nature, finding it primitive, violent, savage, unattractive.

NEW POSSIBLE NAMES:
THE VOYAGER
RETURN OF THE VOYAGER
FLIGHT OF THE VOYAGER
MISSION OF THE VOYAGER
VOYAGER'S MISSION
GALAXY'S RIM
OUTER BOUNDS

The first paragraph of Jeri's summary indicates that the three executive producers were still following the idea of developing a holographic Doctor character, possibly by expanding on the Moriarity concept. Moreover, they were still considering how to explain the Doctor's existence, if he was to be a holographic yet sentient being. In other words, they liked the concept; now how could they explain it or justify it, with any credibility, to the viewers—so that it fit with what had been previously established?

The fact that the three producers would even consider such a problem is amazing. No other television production would likely bother to consider the point. The character would simply appear in the story and that would be that.

Star Trek prefers not to work that way.

Everything is connected to everything. The holographic character is springing forth out of *Star Trek* Federation technology, since the holographic program is an integral part of a Starfleet ship. There must therefore be some precedent, some preestablished scientific basis, some preexisting event or known fact that would explain this new technological wonder. Few other television series in production today are as consistently concerned with this level of faithfulness to detail.

One potential answer to the problem of how to justify the existence of the Doctor character (to viewers) lies in the second paragraph of Taylor's summary.

During August of 1993, as the three producers were having their secret meetings, *The Next Generation* was still early in its production schedule for the seventh and final season. What Jeri Taylor's notes indicate is that the three were considering writing an episode for *The Next Generation* for the sole purpose of "establishing" the creation of the holographic Doctor. Such an episode would, of course have all the normal derring-do viewers had come to expect from a *Star Trek* episode. But that would be secondary. *The real aim would be to establish the precedent for the Doctor.*

Then, along comes *Voyager* a year or so later and—surprise!—the ship carries a holographic doctor character. All very normal and familiar to regular *Star Trek* viewers. In the end, the producers abandoned the idea of writing this episode, probably because of the later effort required to establish the Maquis. In the pilot episode "Caretaker," the Doctor was simply introduced as a normal part of the ship's equipment.

The point is, because of the nature of the *Star Trek* universe, the writers and producers can go either forward or backward in time to conveniently establish whatever may be needed to support an entirely separate effort—in this case, a new and different series.

This is an example of the type of cross-series promotion only *Star Trek* can do, and has done many times, with great effectiveness. In episodic television this is a promotional and production advantage of cosmic proportions.

Another point of interest is Taylor's reference to the half-human/half-Klingon character. The traits suggested in this paragraph are exactly those in the makeup of what finally emerged as the human/Klingon character, B'Elanna Torres. More important, though, is what these characteristics represent—one of *Star Trek*'s central canons: Each series-regular *Star Trek* character will embody in its personality at least one human trait that viewers will strongly identify with. Preferably this trait will represent some sort of internal conflict, quest, or emotional quality that can drive that character to extremes of behavior under its influence.

Taylor's notes about the B'Elanna character make it clear that achieving this goal is a deliberate creative act:

> She would be a metaphor for those who are trying to suppress or ignore some aspect of themselves (anger, hatred, lack of control, etc.) that actually can't be ignored. She wants to eschew her Klingon nature, finding it primitive, violent, savage, unattractive.

Carefully, intentionally constructing the nature of each new character is an essential element in the overall, complex series-building equation. Within the psyche of every character will be the seeds for rich story possibilities, and all-too-human behaviors that will strike a familiar—and sometimes painful—chord with virtually any viewer.

> Jeri Taylor: We wanted to make her a person somewhat at war with herself. Representing those of us…and there are probably many of us…who have some aspect of our personalities that we really, really wish we could shed. You know, "If only I didn't do 'X,' I'd be a terrific person." So her character arc in the series will be to learn self-acceptance.
>
> Rather than trying to reject part of herself—learning to accept herself as a whole person, and to learn to live with what she is and accept what she is and find worth in all the parts of her, rather than wanting to shun an important part of herself.

A perfect use of this character trait can be seen in the first-season episode "Faces," in which the alien Vidiians physically separated her into a fully Klingon B'Elanna and a fully

human B'Elanna. Roxann played both parts. The episode allowed her character arc to be significantly progressed, by helping her to appreciate the strength and positive aspects of those qualities within herself that she had previously despised. More progress along the path toward self-acceptance.

From the very beginning this has been one of *Star Trek*'s hallmarks—the ability to provide the audience with a cast of characters representing a broad aggregate of human emotions, traits, hang-ups, and phobias that, collectively, people will have little or no trouble identifying with. This is powerful stuff. Involvement on a personal emotional level is crucial to maintaining a committed, loyal audience every week.

However, emotional involvement or identification alone will not guarantee the success of a series. There must also be exciting, interesting, quality stories that catch the viewer's interest from week to week. One without the other definitely will not work. But the time invested in creating the characters will pay big viewer dividends in the long run.

Roxann Dawson as Chief Engineer B'Elanna Torres. ROBBIE ROBINSON.

There is plenty of evidence this strategy works exceptionally well. *Star Trek* viewers—not just hard-core fans—have proven again and again their passionate interest in and favoritism for a specific character. They have also proven ready to debate, at the drop of a warp core, the merits of their favorite *Star Trek* character over someone else's choice.

The creative process is not a straight line. Often an idea or concept would be posed by one of the three producers, talked about, then put on the back burner for a while, for each to think about. Later it would be brought up and discussed again. This might then result in the idea being discarded, changed, or developed further.

An excerpt from Jeri Taylor's handwritten notes is a good example of how this process typically begins:

We are looking for <u>another</u>
way home all the time ——————-
worm hole, etc.
7 years? Or
50 years?

<u>Sleep on it</u>

<u>Story</u>
New ship's being commissioned ——
They take it for mission.

Next, we see this process at work in Jeri's notes two days later, as some of the earlier ideas show evidence of further development, while new ones have been introduced in their discussions:

8-10-93

We posit "Badlands," a turbulent area of space where some ships have been lost (some of them might crop up during the series). But it's a hiding place for our bad guys, who think they're invulnerable.

We take Locarno along, who knows the area, having been with the baddies.

IN THE FAR REACHES:
Maybe there are "gangs" who are the villains. They don't respect the prime directive, and have interfered with many non-warp cultures. They come in and "squat" on a planet. They're basically bullies.

The Mayfly is from a world that has been squatted on.

At least two gangs—Crips and Bloods, in competition for influence.

The doctor is killed going through the bubble.

We may lose an older Mayfly and take the young one with us.

We're gone for a *long* time—fifty years or so.

STORY THOUGHTS:

Probably 30 minutes setting up, getting Tactical on Board, going into Badlands to chase the other two; we get caught in the phenomenon while tractored to the baddy ship, when we come through on the other side, we're still tethered but something weird has happened to the other ship—it's empty, it's six days older, it's a derelict.

The first thing we notice is the reference to the "Badlands." This will end up being an important element in Act One of the pilot episode, "Caretaker." It is also evident that the "Locarno" character is a definite "go" for inclusion in the cast of characters. And the reference to the "gangs" is the first hint of what will develop into the race of aliens known as the Kazon.

Although the Kazon are notorious for their many warring sects, the producers do not know that yet. Instead, at this earliest stage they simply refer to them in a shorthand "Crips" and "Bloods" fashion. There was never, of course, any intent to actually use these gang names in the series itself. At that time, in early August, it was just a convenient shorthand method of clearly indicating to each other what would be inherent in the as-yet-undeveloped alien race.

Six days later, Taylor's notes reflect the efforts to continue developing the warring gangs:

8-16-93

STAR TREK: VOYAGER
STAR TREK: THE VOYAGER
STAR TREK: VOYAGER LOST
STAR TREK: LOST VOYAGER
STAR TREK: DISTANT VOYAGER
STAR TREK: FAR VOYAGER

Further story thoughts: The two baddies we've been hunting for are captured by the Crips and taken to the Mayfly planet. The Crips have a rival (or

more), for territory; they vie for new worlds, wiping out people on the way. Maybe on some planets they get along with the native population. But generally, they begin, like skinheads, to practice "ethnic cleansing."

Possibility: we make amends with one of the gangs—but not the other, making us enemies of that gang. They are after us for the duration of the series.

Perhaps there are three gangs, with constantly shifting relationships and allegiances. Just as we think we have it sorted out, the balance shifts again.

In the last paragraph of Taylor's notes lie the seeds of the warring Kazon sects. Over the course of *Voyager*'s first two seasons, this idea was developed into a significant contin uing story element.

In a longer summary dated the next day, Taylor recaps progress to date made by the three executive producers. This summary covers character development as well as story development, and will become the much-discussed subject of a meeting between Rick Berman and Kerry McCluggage.

8-17-93

What is the moral issue which will be addressed in the pilot? Is it the decision to behave as Starfleet people, even though there is "no more" Starfleet as far as our situation is concerned? Perhaps there are temptations to settle on a planet ... to make a new life in this unknown territory... but ultimately we realize we have to head for home, exploring and gathering information, because that's what we, as Starfleet, do.

This means there has to be conflict—those who want to remain. Who might that be? Our Captain... no. Queegquog? Seems he'd be loyal to her. And the Vulcan engineer? Hmmmm… maybe—it might seem the <u>logical</u> choice. otherwise it might come from the baddies, who will ultimately be redeemed and come to realize that being Starfleet is the way to go (except the assistant engineer).

UPDATE ON CHARACTERS:
CAPTAIN: A white human female, Lindsay Wagner type.

FIRST OFFICER/OPS CONN: a human native American male,

"Queegquog"* person whose people have renounced Earth and live as expatriates on another planet. This man has made another choice—to re-enter the world of Starfleet. He is a complex, mysterious man with whom the Captain has some prior connection, not explained.

TACTICAL: A human male—might be ethnic?—handsome leading man, strong sex appeal. He's one of the misfits, the former officer who is trying hard to redeem himself —maybe too hard, a bit desperate.

SCIENCE OFFICER: A half-human, half-Klingon female, one of the misfits, the "moderate" of the group on a sliding scale of recalcitrance. She becomes science officer because of her background; her involvement with the baddies was because of her scientific ability. She also is tapped to become the ship's "doctor," studying with the holo-Doctor... with whose program she is continually futzing.

"MAYFLY": An alien female, delicate creature whose entire life span is only about nine years. We first meet her as a young woman; she will age every half season and progress through the series into old age. She lives in the moment and cherishes every hour. We might want to endow her with some kind of special, super-human ability. She might function as a scout/gang expert.

ENGINEER: A black Vulcan male, older. Vital and fit, he has the strength and endurance of the younger officers; but also is a reservoir of wisdom and experience. He takes the rebellious young misfit under his wing and tries to help the angry loner to re-adjust.

ASSISTANT ENGINEER: A human male—might be ethnic? One of the misfits, and the most unredeemed of the lot. He is angry, displaced, alienated; particularly upset that fate has treated him so cruelly. He never signed on for this long mission and he doesn't want to be there. The first crack in his hostility is because of the Engineer; over the course of the series he will be redeemed and find his inner worth.

* This is a reference to a character type, specifically, a character in *Moby Dick*. They wanted to build a character like Queequeg into the series, and did—the Native American, Chakotay.

HOLO-DOCTOR: A human (or alien) male, possibly Barclay (or Dwight Schultz). The medical officer of the ship is killed during the mission; remaining is the holographic character of a doctor who, like Moriarty, has "awareness" of himself as a holodeck fiction. He longs for the time when he can walk free of the holodeck. The science officer is assigned to be his "student," learning to become the medical officer. She fusses with his program, giving him various personality traits from time to time.

WHAT WE KNOW OF THE STORY:

There is an area of space that is like the Bermuda Triangle: ships tend to disappear there, for unknown reasons. But we learn that it's being used as the "Badlands"—a hiding place for daring bad guys. We are sent in to capture a ship of these bad guys. To that end, we procure the services of a former, fallen Starfleet officer who jumps at the chance to redeem himself and who is made the Tactical Officer of the ship.

We enter the Badlands and find the bad guy ship. During our efforts to tractor it, something happens in the anomaly, and we are flung through an incredible array of effects and come out of it in deep deep deep space. We are still tethered to the bad guy ship—but something's weird about it. It's empty, or aged, or shot up. How did that happen? And where's the crew?

We soon realize that we're so far from Federation space that it would take fifty years or so to fly back. What are we to do? Search for a world where we might assimilate? Keep chasing the bad guys? Why? Our orders are somewhat meaningless—there's no more "Starfleet" as far as we're concerned. We can't even send messages. Why bother?

Our first instinct is to try to find out how we got flung out here, and if we can get flung back again. But there's no information, no clues—except the bad guy ship, strangely deserted. We investigate it, and decide we'd better find those two guys. They might, through their experience in coming through, have some idea what's happened and how to get back.

We're able to track them to the planet of the Mayflys, and find they've been taken prisoner by the Crips—a gang which, in conflict with two other

gangs, competes for territory in this region of space. During this time we encounter our Mayfly and another of her species—an older one, near the end of a brief life span.

Our adventure allows us to rescue the bad guys from the Crips, and we end up with them, and the Mayfly, on board. But the rescue has incurred the wrath of the Crips and we must extricate ourselves from them. One possibility: we forge a truce, or understanding with them—only to learn that in doing so we have ensured the enmity of the Bloods, who swear to eliminate us.

Ultimately, we make the decision to head home. Some may never get there … but it's the journey, the decision, which matters. During this time the two bad guys will have shown themselves to be helpful, and are offered uniforms and positions on the ship. The Science Officer accepts; the Assistant Engineer refuses to don a uniform, but reluctantly accepts a job rather than be bored to death.

We will continue to do what Starfleet does—explore and investigate—and whoever makes it back will arrive with a wealth of knowledge to enrich the cultural coffers of the Federation. We will live responsibly, living up to expectations, even though no one's there to make sure we do, because it's the right thing.

The series concept and characters were taking shape all right, but the studio had not yet put its stamp of approval on either one. Rick Berman subsequently met with Kerry McCluggage in an attempt to sell McCluggage on the work thus far.

McCluggage was hesitant about the idea of a female captain, but agreed to keep the character for the time being. The door, however, was left open to a male captain should McCluggage not later be convinced that a suitable actress could be found.

Of greater concern to McCluggage was the series premise. He did not think catapulting the Starfleet crew off to another quadrant of the galaxy, isolated and cut off from home, was a good idea. It sounded like a bleak premise, one that he was concerned might not be appealing to viewers. Perhaps McCluggage was something of a prophet in his own land. Certainly he knows a great deal about *Star Trek*, which is itself unusual for a studio executive. Most studio chiefs are not intimately acquainted with the details of a television series being produced under their stewardship. It is a credit to McCluggage's leadership that he knows *Star Trek* so well.

Berman, on the other hand, as did Piller and Taylor, felt strongly about what they had come up with, and believed it could be kept positive and hopeful, rather than being presented as negative and unappealing to viewers.

Rick Berman: We are now faced with creating new aliens, new political circumstances, new space anomalies, and new problems for us as we try to get home. All of which will serve as vehicles for growth for our characters. So they're out there learning in the unknown.

The studio was very concerned when they first heard the pitch. They felt the idea of the ship being so far away from home was a bleak premise…a hopeless premise. It wasn't quite "out there" like *Star Trek* is used to. It's "getting back." We convinced them that it didn't have to be bleak. The inspiration of the captain, the professionalism of the crew.

And frankly we made a concession to finally finish the sales job…we put the one-armed man out there—which is the other entity that we met in the pilot. It's out there somewhere. We will try to find that entity and contact that entity more than once during the next several years because we know that the entity has the ability to send us back home.

In the corporate world this is known as CYA—Cover Your Ass. The "entity" is a nice little "out" to have lying in the weeds out there somewhere, just in case they need it. If viewer feedback, surveys, and focus groups indicate the series needs to make a fundamental shift, well, they can make contact with this other entity and get home faster than viewers can switch channels.

Another obvious "out" was to conveniently find a wormhole back to the Alpha Quadrant and Federation territory. The groundwork for this possibility was deftly laid in "Eye of the Needle." While our brave explorers were not able to use that wormhole, still the episode clearly helped viewers get used to the idea that a wormhole just might be out there waiting for *Voyager*, should the series need it.

The idea of actually invoking such a safety net is not appealing to the producers.

Michael Piller: I'd be very disappointed if that happened. Time will tell. That would rob the freshness of the show. It would turn it into a very traditional,

straight-ahead-to-the-original *Star Trek* show. There's an emotional investment that comes with being away from home under those circumstances…the impact that it makes on every person on that ship.

They suddenly realize they may never see their home again, their loved ones again. The stakes, the investment they have in trying to get home again. It's a very strong motivational underpinning of the series.

Taylor expresses a similar sentiment, focusing on the creative challenge rather than the question of "what if this doesn't work."

Jeri Taylor: It's like walking a tightrope with a net or without a net. Yes, that's available. I don't think about that because I think you need to keep that sort of nervous energy going creatively…saying to yourself, "No, I don't have an easy way out. I have to keep coming up with ways to make this intriguing and interesting."

Whatever reservations McCluggage may have had were, for the moment anyway, overcome by Berman's arguments in favor of both character and concept. The project could proceed. However, Jeri Taylor's handwritten notes of August 20 clearly reflect McCluggage's concern:

> 8-20-93
>
> Discussion of Mc/ meeting ——————
> Keep female Captain.
> But: isolating people is symbol
> of bleak future.
>
> Our goal: get home ———-
> optimistic ———- positive spin

Easier said than done.

THE BIBLE

We have to be the strongest element in the living room. There is so much that's competing

for the viewer's attention. It's not like theaters. So what we do better be good, it better

be positive...something they want to keep inviting back in.

Marvin Rush
Director of Photography

KNOWING THAT A MAJOR HURDLE HAD BEEN SUCCESS-
fully negotiated (a qualified "okay" was better than a "no") Berman, Piller, and
Taylor pressed on with the development work.

Much of the discussion focused on expanding the series' concept in greater depth.
The result would become a document known as a series "bible." Although many television
shows do not have them, in all of episodic television there is no more important instru-

ment.* *Voyager*'s bible describes the characters, the setting, the series premise, the story line, and other general information about the series concept.

The bible is just what the name implies. It becomes the reference authority upon which the pilot script is written, and remains the primary source upon which writers rely when scripting every subsequent episode. A *Star Trek* bible is updated many times throughout the life of the series. After two or three seasons, it will in many respects be considerably different from what was used for the pilot episode.

As a practical matter, *Voyager*'s bible is a *sine qua non*. Without it, not much is possible. This is not *Law and Order*, or *Chicago Hope*, where the writers can pick up the phone and call a lawyer or a doctor for research and technical advice. Who does the writer call for information about a starship? Or a Vulcan? Or for an explanation about how the transporter operates? A number of such arcane details are in the bible.

Constructing a bible for *Voyager* is a bit complicated.

Star Trek is like a vast continuum. Its discernable characteristics include an unending passion for morality plays; delving into such human notions as right/wrong, good/bad, life/death, and honor/duty; the—often—skewed perceptions formed by the eye of the beholder; a reverence for all that has come before, and all that is yet to come; and an eternal enthusiasm for the way things really ought to be among *Homo sapiens*.

In this context, *Voyager*'s bible cannot simply be about a new television series. It must contain the foundation for all those discernable characteristics created, espoused, embraced, and fostered over the last thirty-plus years by *Star Trek*. It is, in a philosophical sense, the *nature* of the series it describes. As such, the three producers' task was necessarily considerably more thoughtful. The design of all significant elements, including but not limited to the characters, had to be approached with all that had gone before firmly in mind.

This is not merely rare in episodic television. This is extraordinary.

On an everyday mundane level, developing *Voyager*'s series bible meant fleshing out each of the regular characters in the series' cast, designing the ship for which the series was now to be named, figuring out who the real bad guys are and what motivates them— and, in general terms, populating and sketching in the initial details of the Delta Quadrant. Most of this effort would at first be applied with a broad brush. Finer details would be added as the series developed.

Once begun, the process would never actually be completed. When the *Voyager*

* Some would argue that a contract is more important. They might be right.

CONTINUING CHARACTERS

ELIZABETH JANEWAY

A human, Janeway is by no means the only female
Captain in Starfleet. But it is generally acknowledged
that she is among the best -- male or female. She
embodies all that is exemplary about Starfleet
officers: intelligent, thoughtful, perspicacious,
sensitive to the feelings of others, tough when she has
to be, and not afraid to take chances. She has a gift
for doing the completely unexpected which has bailed
her out of more than one scrape.

The daughter of a mathematician mother and an
astrophysicist father, Janeway was on a track for a
career in science. Her natural leadership abilities
manifested themselves quickly, however, and she was
rapidly promoted to ever-more-responsible positions.
And because of her hands-on experience in various
science posts, she brings to her captaincy a greater
familiarity with technology and science than any
captain we've yet experienced.

Her relationship with her mother, a Starfleet
theoretical mathematician, was particularly close, and
she used to enjoy talking with her, discussing esoteric
issues of math as well as down-to-earth issues of life.
Her mother was her role model, and bequeathed Janeway
with warmth, sensitivity, intellectual curiosity, and

An early draft page from the *Voyager* bible. Background details are given for each character—essential information when crafting a script.

series ended (as all things must), there would perhaps be feature films to follow. Each would conceivably add more detail to this new quadrant of the *Star Trek* universe. Assuming yet a fifth series at some distant date, still further detail from time to time would end up being added to *Voyager*'s region of space.

From their first meeting in July, Berman, Taylor, and Piller had agreed the series would utilize an ensemble cast, as does *The Next Generation* and *Deep Space Nine*. By late August, eight characters had been tentatively identified. The exact number would be determined by the requirements of the story. An additional factor would be the types of human qualities the producers decided they wanted each character to represent. As always, the use of the character-as-mirror was never far from the producers' minds.

Star Trek did not begin life with an ensemble-cast format. When *The Original Series* premiered in 1966, it centered on three main characters—Captain Kirk, Science Officer Spock, and the ship's chief medical officer, Doctor McCoy. These three were accompanied on their voyages by a supporting cast of recurring characters. Although these characters carved out their own strong following among viewers, most episodes revolved around Kirk, Spock, and McCoy.

Structurally, this was a reflection of how things were in the 1960s world of episodic television. Most series followed a similar format, with the emphasis on a few cast regulars, supported by a varying number of recurring characters. *Bonanza*, *I Spy*, *The Wild Wild West*, *The Man From U.N.C.L.E.*, and other television shows contemporary with *The Original Series* all used two, three, or at most four regular series characters, supported always by a varying number of recurring cast members and guest stars. The notable exceptions were the soap operas.

In the early 1970s things changed. Shows like *The Brady Bunch* premiered with an ensemble cast, ushering in a new cycle in the structure of episodic television. The new approach soon became the norm, and stayed that way. By the time Roddenberry began developing *The Next Generation* in 1986–87, an ensemble cast appeared to be the mainstream way to go. But even though the format was eventually adopted, an ensemble cast was not considered at the outset.

Some might argue that the shift from *The Original Series*'s troika to an ensemble cast in *The Next Generation* represents the first major shift away from the vision. It is, after all, a rather fundamental change. That is not the case. It was Roddenberry who finally implemented the new cast format for *Next Generation*. He had even thought about the idea years earlier, when he was attempting to develop the ill-fated *Star Trek Phase II* series. Since *Deep Space Nine* had also followed suit, it was a natural assumption that *Voyager* would employ the same structure.

There are inherent advantages in an ensemble cast. The acknowledged masters of the format are the soaps. Their ability to "hook" a dedicated audience and never let it go is titanic. They have been successfully employing the structure for decades, proving repeatedly that an ensemble cast provides unlimited opportunities to get the viewer emotionally involved with the show. If a viewer fails to personally identify with one character, well, there are others— often many others—to choose from.

A considerable advantage offered by an ensemble cast is the potential for story lines. *Voyager* would be out of touch with Starfleet for a very long time. A large cast would provide plenty of opportunities for character interplay and conflict, and a sizeable pool from which to draw story possibilities. Add to this the imaginative approach the writers and producers take to story ideas (well, most of the time), skillfully weaving the involvement of the characters into those stories, and the result is often almost magical.

As the month of September began, the secret meetings started becoming less secret. A few staff members were brought into the development efforts, reflecting the need to enlarge on the work to date. Michael Okuda and Rick Sternbach were among those plugged into the information loop. Each would begin formulating data surrounding the ship, new technology, a raison d'être for *Voyager* ending up in the Delta Quadrant, and a host of other technical details.

Both Michael and Rick were well placed to lend assistance. At forty-six, Sternbach, in particular, has already had a long association with *Star Trek*, dating back to his tenure as a senior illustrator on *Star Trek: The Motion Picture*, in 1978. Coincidentally, he had worked in the same office now occupied by the *Voyager* art department, barely ten feet away from his present work station.

A Connecticut transplant, Rick has had a burning interest in space travel since he was a child. His bedroom bookshelves were filled with stories and pictures of interplanetary explorers and other-world colonies long before Sputnik ever left the ground. Influenced by both the space program and his architect father, Sternbach naturally gravitated to paint, airbrush, and illustration board.

After his work on the first *Star Trek* feature, he spent the next eight years on the late Carl Sagan's highly acclaimed *Cosmos* series. At the same time, Rick was illustrating for astronomy and science-fiction magazines, as well as doing ongoing graphics-design work for NASA. But *Star Trek* was firmly in his blood, and it was not long before he was back, as a member of the art department staff for *The Next Generation* in January of 1987. He's been with *Star Trek* ever since. Sternbach jokes that in his spare time, he lives with his wife and two children in the San Fernando Valley.

Rick Sternbach, senior illustrator for *Voyager*, helps fill the *Star Trek* universe with new starships, props, and other-worldly objets d'art. STEPHEN EDWARD POE.

To augment the producers' efforts, outside consultants were engaged to do research on the background for certain characters. The Mayfly was a good example. There had been a continuing discussion about giving her one or more forms of psychic ability. Still thought of as a female, she was nicknamed the Mayfly because, like the insect, she would have a short life span.

Zayra Cabot, who was Jeri Taylor's PA at the time, was assigned the task of doing parapsychological research. For help with this task, Zayra enlisted the services of Joan Pearce Research Associates, a consulting firm known for its interest in exploring the paranormal.

To learn more about the Native American background of Chakotay, the producers enlisted the aid of internationally acclaimed Jamake Highwater, a move indicative of the care taken, wherever possible, to base their efforts on authenticity.

Founder and president of the Native Land Foundation, Highwater is a celebrated critic and commentator of the arts, and a close associate of the late Joseph Campbell. He

is the author of more than twenty-five books, collectively hailed as the most influential body of work about Native Americans in the second half of the twentieth century. The producers obviously felt that Chakotay was in good hands.

One of the major story elements for the pilot episode involved the "bad guys," or "misfits," *Voyager* would be pursuing into the Badlands. Beyond the pilot, the misfits were intended to play a big role in *Voyager*'s crew for the life of the series. It was important to determine who these people were, and what motivated them.

> Michael Piller: Rick Berman, Jeri Taylor, and I asked ourselves, "What will make this an interesting crew?" The answer for us was to find ourselves chasing an outlaw group. We all get tossed onto the other side of the universe and everybody has to team up in order to survive. That seemed to be an interesting dynamic that would give us plenty of story material.

Once the three executive producers agreed on the basic premise, the next step was to create an identity, or backstory, for the outlaw group. Rick Berman was particularly concerned that the group not be too cutthroat, too much like pirates. He felt it would not work. He wanted *less* inherent conflict among *Voyager*'s crew than there is on *Deep Space Nine*. Berman believed that ultimately these people needed to wear Starfleet uniforms and to become a strongly bonded crew…even though there would be strains, conflicts, and stresses because of their origins.

The search for a twentieth-century parallel to the outlaw group's identity eventually lead to a band of French resistance fighters in Nazi-occupied France during World War II known as the *Maquis*.

> Jeri Taylor: Rick wanted to preserve the idea of a noble cause behind the Maquis's criminal activities. To establish that noble cause, during *The Next Generation*'s final season we created a Cardassian-Federation–negotiated peace in which there are colonies caught in the middle of a demilitarized zone. These colonists are not willing to compromise their own personal principles and the investment they've made simply for the sake of political harmony between two distant governments. It's an Israeli-West Bank situation.

An early draft of the series' bible lays the foundation for the Maquis:

In the 24th Century, there has never been a conflict as bitter as the long, unending struggle over territory along the Federation-Cardassian border. We return to this part of the Star Trek lore to set the back story of some of the major characters of STAR TREK: VOYAGER.

We have established that a new treaty between the Cardassians and the Federation has led to an uneasy peace. Several Federation colonies caught in the newly established Demilitarized Zone along the border have chosen not to disband even though they are now within the jurisdiction of the Cardassian Empire. This has led to bitter conflicts between colonists from both sides.

Without the continuing protection of Starfleet, a number of Federation colonists have decided to go <u>beyond</u> the law to form a defensive wing called the Maquis. They have been joined by a few Starfleet officers who believe in their cause and have resigned their commissions. Some of their members have even been kicked out of Starfleet and found their way to the Maquis as consolation. If they're ready to fight, no one asks questions about their past because every volunteer is needed. As a group, the Maquis are non-conformists who are no longer dedicated to Federation rules of conduct. They have a number of small ships that strike pre-emptive and retaliatory raids against the Cardassians. Some consider them heroes.

Having established an identity for the Maquis, the next step was to make them familiar to *Star Trek* viewers. In mid-1993, eighteen months before *Voyager* was scheduled to debut, work began on the first of four Maquis-oriented episodes. Two were aired on *The Next Generation*** and two on *Deep Space Nine*.[†] By the time *Voyager* premiered, with the new Starfleet crew in hot pursuit of a Maquis ship, regular *Star Trek* viewers already knew about the outlaw group.

This is yet another example of *Star Trek*'s ability to create—in advance—an element in one series for the sole purpose of providing familiar backstory in an entirely separate, new series.

In the months leading up to *Voyager*'s premiere, this mix of Starfleet and Maquis personnel was widely discussed in the press. In real life such a situation would, inevitably, lead

* "Journey's End" and "Pre-emptive Strike."
[†] "The Maquis," Part I and Part II.

to tension—perhaps worse—among a crew. Dissension on the bridge of a Starfleet vessel? Many thought the idea was tantamount to heresy. It is not, however, without precedent in American history.

The Maquis-Federation strife is similar to the situation faced by United States military personnel, many of them West Point graduates, at the start of the Civil War. They were trained, fully competent officers and enlisted men. When the conflict broke out some, like Lee and Jackson, chose to join the rebels.

The producers intended for there to be a certain amount of conflict between the two crews in the first few episodes. Then, as the series evolved, there would be fewer rough edges and less frequent tension between the Maquis and Starfleet.

The *potential* for conflict was as far as Rick Berman was willing to go.

Berman was determined to avoid creating a mixed crew that would be constantly "banging heads." He was convinced that most people liked and identified with the family that got along well—even when that was not the case within their own families.

Rick Berman: We were looking for a middle ground here. We wanted to get the Maquis into Starfleet uniforms, with a captain who had to pull together diverse groups of people into a functioning, solid, effective unit. It would get pretty irritating, and cumbersome, to have the Maquis tension in every episode. But it comes up now and then during the course of each season.

The device is a clever one. For purposes of dramatic storytelling, the Maquis offer unique opportunities. Certain *Voyager* episodes would be impossible without them. The second-season episode "Meld," for instance. During a murder investigation, Tuvok mind-melds with a sociopathic killer—a Maquis.

Michael Piller: The whole story is based on the fact that nobody really knows about the backgrounds of these Maquis. Nobody knows where they came from, nobody asks for resumes. The murderer is a man who joined the Maquis because he really, really likes to kill. Finally he kills somebody aboard *Voyager*.

If we had no Maquis on the ship you would never find a human Starfleet officer—one who's gone through the complete Starfleet training—who would do that. It just doesn't happen. In another series of episodes we had a

spy[*] aboard *Voyager* who is a Maquis, spying against the Federation, sending reports to the Kazon. Ordinarily, no one in Starfleet would ever be a spy for the other side. It would never happen. So there are stories to be told because of the Maquis background, and they are coming out. It's just not every week.

The Maquis, integrated with a Starfleet crew, represent yet another facet of Gene Roddenberry's original vision of the future: infinite diversity in infinite combination.

Behind the desire for a relatively conflict-free crew over the life of the series was the need to support a more basic tenet: consistency. Although *Voyager* was a new series, it still must operate within the existing *Star Trek* universe. It was this tenet that drove the approach to the way in which *Voyager*'s crew would function and conduct themselves, from day to day.

So even though the ship and crew are in the Delta Quadrant, seventy thousand light-years from Federation territory, and *Voyager* could therefore function pretty much as it wanted to, Janeway decides that it will function as a Starfleet ship. They will obey the rules; they will obey the Prime Directive; they will do everything as though they were operating back in the Alpha Quadrant and accountable to Starfleet.

This is the way it has always been. There is a certain framework within which the *Star Trek* universe has always operated, and as a consequence, millions of viewers now have decidedly firm expectations about its behavior. There are all sorts of endless things the producers have no desire to violate. If anything, they want *Voyager*—as a ship-based series—to be seen very much in the spirit of both *The Original Series* and *The Next Generation*: an upbeat, hopeful, positive view of the future. This means a positive view of people, showing them as somehow better behaved than people now, generally handling their problems in a more rational fashion.

Deep Space Nine was created intentionally with a different kind of construct, one that allowed for more conflict between the series regulars than the two previous series. *Deep Space Nine*—as a space station-based series—was not created in the same vein as either *The Original Series* or *The Next Generation*. *Voyager*, on the other hand, is a starship-based series. The producers felt it should be kept very close to Roddenberry's original vision.

Rick Berman: Plus, since we're not in contact with Starfleet we don't have that authoritative "father figure" organization that we relate to and talk to and

[*] Michael Jonas.

report to. Things like this get in the way, in a sense. But they're also things that make it more interesting, and they're things that we purposely did to make the show move. Not only to ourselves as writers but also to the fans. We weren't just going to give them *The Next Generation* in a different-looking ship.

Still, the decision was risky because the series' premise stripped away much of what was familiar and comfortable to the viewing audience—regular contact with Starfleet; popular aliens such as the Romulans, Cardassians, and Ferengi; and so forth. Later focus-group studies indicated this was indeed an issue, but also indicated that viewer concerns tended to dissipate as time went on and viewers adjusted to the ship's new environment. What also helped, in the first and second seasons especially, were episodes written with some of these familiar elements in them.

A ship "out there" on its own fits with Jeri Taylor's personal theory about why people respond to *Star Trek*. She believes there is something universally appealing about the idea of being in the unknown…about charting unknown territory…of being away from the safe and the comfortable and the familiar, encountering dragons and beasts…of pursuing a quest. Taylor believes these ideas and concepts are, by their very nature, true to the original intent of *Star Trek*.

Those familiar with *Star Trek* would hardly disagree. There is no question but that boldly going into the unknown is what Gene Roddenberry was talking about.

Excerpts from Jeri Taylor's September 1993 notes provide insights into ongoing efforts to clarify important elements. Her notes also chronicle the emergence of what would later be developed into key aspects of the series.

9-9-93

Version Two: Procreation

We are the match he's looking for in DNA; he needs pieces of a strand to build a new Mayfly. "Give me a child."

After sampling us, he discards us.

He's a deity—keeps the balance of power in the area. He feels himself essential to the well-being of the system, like a powerful parent. We're able to say to him, "Let go. Your children are stronger than you think. They'll be fine."

9-10-93

The dying goo-man is the protector of the Mayflys—sees the fragile balance of their society cracking. If it does, they'll be overrun by the Crips and Bloods.

She's a curious, eager person—breaking from her culture, wanting adventure, unwilling to settle for what everyone else has settled for.

The Bloods and Crips have taken over the Mayfly planet, and they are now a third world culture. Everything is given them, they're taken care of. Our girl is a heretic because she wants to work—till the land, become self-sufficient. "Our people are stronger than he thinks."

But goo-man feels they'll be "run into the sea" when he dies, by the Blood and Crips.

At the end, there's a standoff to hold the B's and C's back; so we have to go to the array to use it (to get back) but end up destroying it to keep the B's and C's from taking control of it.

9-15-93

MUCH DISCUSSION OF JOBS.

Michael introduced the notion of a "joined by necessity" move at the end of the story, in which the raiders and SF* join forces in order to survive, and the raider captain negotiates for his people to have certain key positions on the ship.

The last configuration seemed to go like this:

CAPTAIN: SF, human female
FIRST OFFICER: R.[†] native American male

TACTICAL: R/SF, white American male, midway between both groups.
SECURITY: R. human male, preferably ethnic of some kind.

* SF = Starfleet
† R = Rebel (Maquis)

SCIENCE/MEDICAL TRAINEE: SF/alien, Mayfly female.
ENGINEERING: R. human/Klingon female.
MEDICAL: SF, holographic human male.
UNKNOWN: SF, black Vulcan male.

The order in which *Voyager*'s primary creative steps occur is bible, story, and script. None is written by committee. One producer writes a draft—the task fell to Michael Piller—and the other two read it and make comments. These are generally in the form of "notes"—either on the draft itself, or in person, verbally. The notes are then incorporated into the next draft, and the process repeats itself until everyone is satisfied with the result. Since both the story and the script would be based on the series bible, that had to be written first.

Enough information was established so that Piller could begin writing the draft bible. It was of necessity a work in progress. The writing proceeded concurrently with the development meetings the three producers were still holding. As new details were agreed upon, Piller would revise the draft accordingly.

Jeri Taylor: We tossed out more than we kept. We finally ended up bringing a Vulcan onto the bridge for the first time since *The Original Series*, but making him black, and never even commenting on it...which I think is a nice way of doing it.

On September 21, the research report was received from Joan Pearce, providing a laundry list of psi abilities, with supporting information, for the producers to choose from. After examining the possibilities, the decision was to give the Mayfly character at least some measure of telepathic ability to begin with, and then see how stories developed from there. About the same time, Jamake Highwater forwarded seven pages of research suggestions regarding Chakotay's background. One point unresolved was his tribal ancestry.

Two days later Jeri's notes indicate the black Vulcan male had become the security officer. That same week, Rick Sternbach began sending Rick Berman memos in response to requests from the producers for developmental input on the new starship. In a four-page memo dated September 25, Sternbach concludes with a section spelling out the first glimpse of the new Federation *Starship Voyager*:

The Voyager sounds to be a leaner, meaner starship, smaller than the Enterprise-D. A ship half the size of the Enterprise is still an impressive vessel. If Voyager is roughly 3/4 the size of the Enterprise, that puts it in the same class as the Bortas, the new Klingon attack cruiser, or the Enterprise-C.

We can assume that the Voyager is part of a class of starships that entered into its R&D cycle ten years after the Enterprise-D did (the Galaxy Class took 20 years to build). That would allow the Voyager to benefit from a number of systems improvements, while taking less time to fabricate in the Yards.

We'll talk about the actual design as things progress; in the meantime, I'll at least start some rough doodles.

Michael Okuda also began providing input on technology, and the Delta Quadrant itself. In a September 27 memo to Berman, Okuda begins with the philosophy which guides the design of virtually all Federation starships:

> Thoughts on the ship:
> The challenge, of course, is to make this ship dramatically different from previous Star Trek starships, while retaining a strong family connection with those who have preceded us.
>
> Suggest we give the starship the ability to land on a planet surface. This is not something we'd want to (or could afford to) do every week, but this could be something that sets the new ship apart from previous vessels. Maybe it'd be something we could do two or three times a season.

Okuda goes on to suggest other story elements such as curtailing the use of the ship's replicators in order to conserve power, thereby setting up the need to rely more on fresh foods—which the crew will periodically have to search or barter for. This in turn yields additional story possibilities. And Okuda gives a name to the region of space into which *Voyager* is thrown:

> Notes on the Delta Quadrant.
>
> Since the Gamma Quadrant is the province of ships from DS9, suggest that this new show be set in the Delta Quadrant.

One of the few things we know about the Delta Quadrant is that the Borg homeworld is located somewhere there. This might present opportunities for the Borg to be recurring bad guys.

As September wore on, Piller continued working on the bible, revising the draft when the three agreed on changes, and incorporating new material as they developed it. By the end of the month he was ready with a first draft of the bible. It included a page-and-a-half story synopsis for the pilot episode, and thirteen pages of background—back-story—for nine series regulars:

> CAPTAIN: KATE JANEWAY. SF, white human female.
> FIRST OFFICER: CHAKATOY. R, Native American male. No tribal ancestry identified.
> TACTICAL/SECURITY: VICON. SF, black Vulcan male. 150 years old.
> CONN: TOM PARIS. Former SF, former R. white human male.
> OPS/COMMUNICATION: JAY OSAKA. SF, young human male.
> ENGINEER: B'ELANNA. R, half Klingon, half human female.
> INTERN/MEDICAL: DAH. Alien—Ocampa female (the Mayfly).
> DOCTOR: DOC ZIMMERMAN: SF, holographic white human male.
> GOFER/GUIDE: FELUX. Alien—male.

First drafts are called by that name for a reason. In Hollywood, first drafts of almost anything are quickly lost in a blizzard of paper, as successive drafts appear, one after another. Piller's first-draft bible was no exception. Even when it was done, it was never really done. The first *Voyager* bible would be followed by a number of revised editions, and would continue to evolve until the start of the first season. Only to be continually updated and revised throughout the life of the series.

For the time being, though, Piller's first draft gave enough information upon which to continue the building process. Additional material was developed by the producers and a widening circle of staff members and outside consultants. Meanwhile, Piller began expanding on one specific part of the bible—its one-and-a-half page story synopsis. This was the next step, to write a draft of the pilot story. Not the script. It was much too early to start work on the script.

F I F T E E N

STATE OF FLUX

I don't know if he is anatomically correct. Why would you program a holographic doctor with

anything underneath his uniform? What's he going to have? Empathy?

Robert Picardo
The Doctor

WHEN MICHAEL PILLER BEGAN TOILING AWAY ON the first draft of the pilot episode's story, in his first floor office in the Hart Building, he was not writing in a vacuum. Since the very first development meeting among the three producers back in July, each had had their hands full tending to the exigencies of the moment—producing episodes for the last season of *The Next Generation* and the second season of *Deep Space Nine*.

Throughout *Voyager*'s birthing process Piller was still working daily as the co-executive producer for *Deep Space Nine*, overseeing every story for every episode, from idea to shooting script. In addition to writing a number of them himself, Piller rewrote or polished virtually all the rest. Jeri Taylor was still co-executive producer for *The Next Generation*, with much the same duties and responsibilities as Piller's. Rick Berman was still *the* producer over both series.

True to form, Berman actively participated in every step of each series' episodes from preproduction, through principal photography, to postproduction. His own work schedule was further exacerbated by his growing involvement in the upcoming feature *Generations*. (Berman's workload makes a workaholic look like a couch potato.)

No one needed more to do. The "normal" demands of episodic television production were tough enough for the producers to deal with. *Voyager,* especially for Piller, added a layer of time-consuming labor to work schedules that were agonizingly overtaxed already. But Piller was not alone by any means. Everyone in the company maintained a grueling pace. The privilege of working in the business never ceases exacting its price.

The issue of the personal price everyone pays, for the privilege of bringing viewers their favorite television show every week, is a curious phenomenon. On the one hand, the business is all-consuming for most people who work in it. On the other, while everyone acknowledges the price, no one whines or complains much about it.

Nor does anyone seem to be running for the exit sign. Ian Christenberry, the tall redheaded rigging gaffer for Bill Peets, matter-of-factly states the obvious.

Ian Christenberry: Sometimes you have to work sixteen, eighteen, twenty hours a day, seven days a week. There are some nice benefits from working in the industry, but the downside of it is that it takes its toll, and it just consumes your life. It's very difficult to have a significant outside life when you're pouring yourself into a project on a day-to-day basis and putting in those kinds of hours.

It's true. Hang around people on the lot for a while and this theme is heard from almost everyone, no matter what their job entails. What is surprising is everyone's level of acceptance of the way things really are, in spite of their common perception that episodic television "demands everything out of you" it can get. The same perception seems more or less true of features, but the personal cost is particularly grim in episodic television,

where the pace is virtually nonstop every week for long stretches of time.

Whether people complain or not, one inevitable result can be measured by the high toll that it takes on them. It is very costly. The divorce rate is high; alcoholism and drug abuse are high. It uses people up. Even if a person does not fall into those kinds of traps, there are other tolls...other prices exacted from people's lives.

At a dinner party one Saturday evening, Michael and Denise Okuda affirmed this point during a conversation with a friend.

Denise Okuda: We have no social life during the week. None. The only time we have for socializing is on the weekend. Because the schedule is so brutal, the hours are so tough, that by the time we do leave the studio and get home, we turn into pumpkins. We just collapse.

There is also a widely held belief that once a person is elevated to the ranks of producer or executive producer the situation changes dramatically for the better...then it is not all work...there might even be time for socializing. That may be true in other production companies, although it is highly doubtful, but not at Paramount, and not for *Star Trek*.

Jeri Taylor: Basically I have no social life. This job absorbs most of it. I do things to keep myself healthy. I work out...and that kind of thing. I don't think I'm killing myself, but it's a very grueling and demanding and all-consuming kind of job. I don't think it's any harder for me than anyone else. I think it's less hard for me than it is for the crew on the stage, who work longer hours than I do. Frequently fourteen, sixteen, and more hours each day. Yesterday Rick Kolbe was predicting they'd be on the stage eighteen hours. That's just a killer. You can't keep that up very long.

People who work in television production advise newcomers and wanna-bes to know the price going in. "If you want to play in this universe, understand what will be expected of you, and what the conditions are really like. If you don't want to pay the price, you better not play. Not in this universe anyway. Maybe some other one, but not in this one."

Then why do these people do it?

The answers are all over the map. For some, it is the money—generally quite good, depending on one's guild, job, or title. For others, it is the feeling of exclusivity. Working in television production is akin to working in a small, closed community. After a few years, you know almost everyone, either personally or through a mutual acquaintance. This generates a feeling of closeness and camaraderie not usually available to the working population at large. And for some, working in the *Star Trek* universe—in any capacity—is its own reward. Robert Blackman, the Emmy Award–winning costume designer for both *Voyager* and *Deep Space Nine*, elaborates on this theme.

Robert Blackman: It's important, in a world that becomes darker and more corrupt by the moment, to have something of value on a little square screen that comes beaming into our living rooms. Most of what we see doesn't strike our heart and soul, doesn't have us look at things and say, "Right. I get that. That could be Bosnia."

It might be something going on between the Klingons and the Romulans, but it's the same story. These parallels get into the viewers' conscious minds or at least in their subconscious minds. It affects them and makes them think, "Gee, this is a complicated problem." And these are issues that are morally important.

There is so little these days that allows us to do that...that gives us that spark of hope. I think of *Natural Born Killers*, and I think of *Pulp Fiction*. They're interesting moviemaking, and they may even be good moviemaking. There is no redemption at the end of either of them. There is no sense of hope. I find myself not interested in that stuff anymore. I want something that helps us *improve*. Not reinforce what we already know. Why? What's the point of that?

I suppose I should be patient, but it's very difficult. But this is why I stay with the job.

Despite everything else demanding the attention of Berman, Piller, and Taylor, one subject was never far from their minds: the female captain.

Historically, *Star Trek* always seemed to have a certain reticence in casting strong

women in continuing leadership roles. After Roddenberry's failed attempt to secure NBC approval for a female second-in-command for the first pilot, he seemed to give up on the idea. When *The Original Series* aired, it was with women relegated to minor, often demeaning roles of no great consequence. This was, it should be remembered, a prevailing male attitude at the time. However, that approach had changed little with the advent of *The Next Generation*. When Jeri Taylor joined the series she was determined to alter the attitudinal landscape.

> Jeri Taylor: Gene gave the women on *TNG* very traditional roles for women and it was difficult to break them out of that mold. That was one of the tasks that I took on for myself when I first came to the show. I think we did some very nice stories for Crusher and Troi that took them away from that more traditional role. And female fans responded. They loved it.

The team of Berman, Taylor, and Piller was convinced that a woman was the right choice for top command of a starship. Besides, they liked the creative challenge the concept presented. They asked themselves, "What kind of man could we put in command of this starship who would be so different that we wouldn't be repeating ourselves?" They were unable to answer their own question satisfactorily. Thus, it was time, they believed, to take a bold choice…to force themselves into a different kind of storytelling by placing a woman at the helm.

The studio was likewise interested in "bold choices." What they wanted, though, was a little reassurance.

Paramount routinely conducts "maintenance studies" on all of its television series, including *The Next Generation* and *Deep Space Nine*. Nothing is left to chance, nothing is taken for granted. The studies utilize focus groups—moderate-sized groups of viewers—spotted throughout the country. The purpose is to monitor how well a series is doing and to test concepts for new projects.

In the early Fall of 1993, still nervous about the possible reception a female captain might face with *Star Trek*'s traditionally male-dominated audience, the studio decided to test the waters a bit. The method chosen was to piggyback a few pointed questions during some of the ongoing *Deep Space Nine* focus groups. Paramount had not yet made a formal announcement, but the word had already spread through the Internet that the studio was going to move forward with a new *Star Trek* series called *Voyager*.

Tom Mazza: We said "What do you think of the captain? Who should it be?" Unsolicited, about forty to fifty percent of the people in the groups said "a female captain." My gut instinct was there was no reason why it shouldn't be a female captain. Not to say we should cover every minority, not to say we should cover each gender. It's just a matter of what *Star Trek* represents, and perhaps the time had come. It was interesting to see viewers say that.

There were also some participants who were apprehensive about the idea. About half of the people in each group gave a positive response, saying they thought the new captain should be female. The reactions of the other half were almost always split between "that's interesting," and "no, no, no, no, no."

Tom Mazza: A few of the guys in the groups would say "it has to be a man…we had Kirk, we had Picard, we have Sisko…it has to be a man." But the majority of the answers confirmed my own instinct that it was time for a female captain. It was a gamble. But a gamble that could pay off, and also that would help distinguish *Voyager* from the other series.

The focus groups confirmed something else. Viewers were not especially thrilled with a *Star Trek* series confined to a fixed-base space station. People wanted ships. Ship-based shows inherently meant action, danger, excitement. In other words, *Star Trek*.

Michael Piller: I had approached the writing of *Deep Space Nine* from an entirely different point of view, which was as a character study. It was deeply psychological, the story of a man's rebirth. I think my own work on *Deep Space Nine*'s pilot…attempted to be important. I felt it was the first *Star Trek* without Gene Roddenberry and it needed to be not just a good television show but an *important* television show.

I think that some critics agree. We had very high ambitions, and I think we succeeded in that.

Piller was obliquely stating a hard lesson learned. "Critics" do not number in the millions, as do the "viewers." Numbers are equated with popularity. In the world of

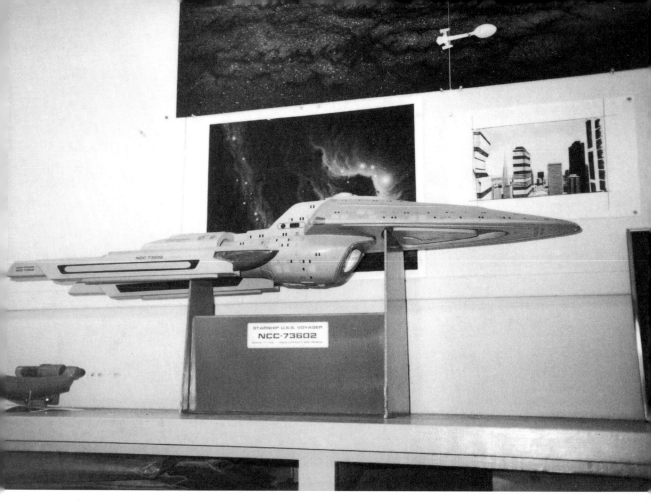

A concept model of an early design for the *U.S.S. Voyager.* Clearly visible in this work-in-progress are elements that were ultimately included in the final ship design approved by Rick Berman.
STEPHEN EDWARD POE.

episodic broadcast television, numbers—not content or perspective—are what define a show as being popular. The lesson has sting to it, but does not have to be fatal.

As Michael Piller began writing the first draft of *Voyager*'s pilot story, he could not help being influenced by the data from the focus groups. He knew only too well that the ghost of *Deep Space Nine* was peering intently over his shoulder.

Across the lot, in the art departments for *The Next Generation* and *Deep Space Nine* (*Voyager*'s did not exist yet), Michael Okuda, Rick Sternbach, Doug Drexler, and others continued discussing starship designs and starship technology, and making preliminary sketches. It was a tough challenge, considering the predecessors. Rick Berman wanted a

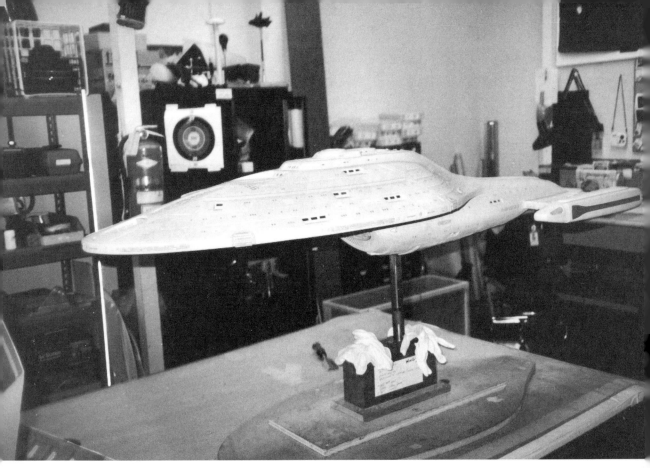

The finished *Starship Voyager* model, ready for filming at Image G motion-control photography studio.
STEPHEN EDWARD POE.

smaller, sleeker ship than *The Next Generation*'s starship, the *Enterprise*-D. Perhaps bullet-shaped. But different.

Not a lot to go on.

Nevertheless, the show's designers were well up to the challenge. Small meant less crew. They suggested "around two hundred." Sleeker meant a ship designed for action rather than purely exploratory or scientific purposes—missions that might be a little more dangerous. That meant no families on board. Bullet-shaped...well, that was eventually accomplished by elongating the traditional saucer-shaped portion of the ship.

"Eventually" is the operative word. Designing starships was relatively easy. Getting Berman to approve one of them was another matter entirely. Begun in September of 1993,

Voyager's design would not be final, and the finished model delivered to Image G for motion-control photography, until October 19, 1994. Including Computer Generated Image (CGI) details for the moveable nacelles, the complete design would not be finalized until two months later, in mid-December—six weeks before *Voyager* was scheduled to premiere.

One early idea posed by the producers was for the ship to be equipped with a cloaking device. Okuda researched the idea, and responded with an October 1, 1993, memo presenting "Thoughts on a new cloaking device." In the memo Okuda points out that the goal is to give the ship the advantages of a cloaking device, but at the same time give it sufficiently different characteristics that it does not look as if Starfleet is merely copying Romulan technology.

In *The Original Series*, it was the Romulans who invented the cloaking device technology, and who tried very hard to keep that technology out of the hands of Starfleet. Militarily, the cloaking device was an enormous advantage because it rendered the Romulan ships invisible.

Is it merely coincidence that, thirty years later, the United States Air Force unveiled a new stealth technology that effectively renders aircraft invisible, at least to enemy radar? Or is this yet another example of *Star Trek*'s uncanny ability to portray the ideas and concepts for new devices and new technology that are later developed into reality? Could this be one more demonstration of *Star Trek*'s continuing ability to influence people's lives, and the way they think about the world around them—simply because people see, and their imaginations are inspired?

Perhaps.

Certainly there is no end to the list of such coincidences. They have been well documented over the last thirty years, and continue to surface daily. Jim Van Over swears that some of the graphics used by the National Football League to display player statistics look as if they were influenced by Michael Okuda's design approach. The same is true for certain on-set graphics used in NBC's *Dateline* news magazine show.

Recently a special program (*After the Warming*, written and narrated by James Burke; produced by Maryland Public Television and Film Australia) aired on *The Learning Channel*, the subject matter of which concerned global warming. The story was told from the perspective of the year 2050, looking back over a long period of time.

The host-narrator spoke to the audience from a high-tech room designed to help chronicle and demonstrate what had happened to planet earth in the previous centuries. The room was referred to as a "virtual reality generator," and it not only looked remark-

ably similar to a *Star Trek* starship holodeck, it provided the same three-dimensional imagery capabilities.

Coincidence? Or influence? In either case, the Romulans were way ahead of us with cloaking devices, but it looks as if we are catching up.

Okuda's concern, in approaching the cloaking device problem, was to avoid the impression of ripping off the Romulans. Starfleet, he was certain, was competent enough to design their own. He then explained in some detail how such a system might work for *Voyager*. The memo concludes with a reminder:

> A note on cloaking devices in general. I am told that Gene was significantly opposed to Starfleet using cloaking devices because "our people are scientists and explorers, so they don't go sneaking around." I would think it should be possible to set up this cloaking device so that we can rationalize that Starfleet doesn't equip our heroes with such a thing, but that our heroes have improvised this because of the dire situation they're in.

After reflecting on the matter, the producers eventually discarded the idea.

Every story has a point of view. The perspective from which it is told. Berman, Piller, and Taylor wanted something fresh for *Voyager*'s pilot episode, an approach not previously used.

> Michael Piller: This is a story of how the family comes together. We decided to tell it in a unique way…from the point of view—at least in the beginning— of one of the lesser-ranking officers, Paris, which we felt would make it different from all other *Star Trek* pilots. Because all the others had taken the captain's point-of-view—starting from the center.* So we thought it would be interesting to introduce our captain through the eyes of one of the other characters, and we follow *his* development.

The three had earlier decided that Paris's character arc would be one of The Fall, and then Redemption. Which meant that in telling the story of how this "family" comes

* Writer's shorthand. The captain is the center, or focus, of all the cast members. Usually it is from her perspective that the story is told.

together, Piller also had to weave in the character arc for Tom Paris. And he was struggling with it.

In a memo to Berman and Taylor dated October 6, Piller begins with the following statement:

> The good news is that I think once we complete Paris's arc in the second hour, most everything else will fall into place. The bad news is I still don't see the arc and that's what we need to talk about today.

Piller details his progress, but also lays out his uncertainties and questions.

> We've now set up a quest for redemption, for rebirth in traditional Joseph Campbell terms (I'm wondering by the way if Paris isn't getting too close to Han Solo) and it seems to me we somehow will need new plot elements in part two to force Paris to confront his demons and conquer them. But I'm not living well inside this character yet and I'm not sure I understand what those demons are.

A later paragraph provides a stream-of-consciousness insight into the—almost painful—Gordian knot he is enmeshed in.

> Some of the turns that pass through my mind that don't quite seem to work at first glance include: in the array, Paris doesn't follow orders and that's why we're recaptured so he ultimately blames himself for Osaka's fate...or maybe it's too early, maybe he does something the second time they go to the array that gets him in trouble with the Captain or maybe even all the way down on the planet...somewhere maybe Janeway busts him and confines him to quarters for the rest of the mission and something happens which he alone has to act upon in order to salvage their hopes of getting home or getting Osaka back. In his old pattern, he would turn his back and not take responsibility (do you sense my struggle for the character's identity? That doesn't feel right as I write it). Or is he locked in the brig and fools the holographic doctor so he can escape and do whatever he has to do? (I like that).

Piller's memo certainly gives a unique window through which to get a glimpse of the creative process. The memo also shows the close working relationship between the three producers as they go about the process of creating a new *Star Trek* series. It is a "safe creative space" in which it is okay to not know…to be uncertain…to have self doubts…to give voice to internal conflicts. Writing is inherently personal and solitary. To write in concert with one or more other human beings requires a kind of emotional vulnerability that is nearly the same as physical nakedness.

Berman and Taylor would meet with Piller later that day, and together the three would discuss possible solutions to the points Piller was struggling with. The points would be resolved somehow, and the process would continue. It was the way they worked.

The developmental work was also now becoming slightly more public.

Paramount formally announced its intent to launch a fifth television network, to be anchored by a new *Star Trek* series, *Star Trek: Voyager*. Programming would begin with fare for Monday and Tuesday evenings, expanding appropriately as new material could be developed. Launch date was set for January 16, 1995. *Voyager* now had a firm date for its premiere. From that moment forward the clock was ticking toward show time.

The announcement generated tremendous publicity. Within days Paramount, and especially the *Star Trek* art department, was deluged with requests for information. Of special interest to the press was the design of the new starship. They wanted drawings, illustrations, sketches, doodles on a napkin, anything that would give their readers a first glimpse.

Alas, nothing firm—meaning approved by Berman—was yet available. In a memo to Rick Berman, Rick Sternbach addressed the issue.

> I'm beginning some preliminary sketches of the starship, based on the initial requirement that this be a smaller vessel. These early shapes should boil down into a few clean drawings within the next week.
>
> In light of the current crop of media reports concerning Voyager, I'd like to ask for a short meeting, when feasible, to cover the basic design of the ship (a new major ship will require a long lead time for drawings), deadlines for miniature bidding blueprints, and other scheduling questions.

The following week Michael Okuda and Rick Sternbach sent Berman, Piller, and Taylor an eight-page memo setting forth in some detail the early concepts for the ship and

its technology. This was a preliminary draft of what would later develop into *Voyager*'s technical manual, which runs nearly forty pages and describes the ship and its technology in great detail. The technical manual is to the ship what a bible is to the series, and is widely distributed to all departments. It reads like a real-life overview of a real-life starship.

And why not? Between Okuda and Sternbach the two men represent prodigious experience with Federation starship design and technology. They have produced technical manuals for starships before. *Voyager*'s tech manual is patterned after the style and content of the technical manuals they developed for *The Next Generation*'s *Enterprise* and *Deep Space Nine*'s space station, and contains some of the same "boilerplate" information.

This is precisely the advantage *Star Trek* has over all other science-fiction television shows or feature films: all that has gone before. Over thirty years of accumulated knowledge and experience. It is a powerful base from which to build anything new.

On the same day Okuda and Sternbach sent their preliminary draft, Michael Piller was delivering a draft of his own, for the story. It ran thirty-six pages, and would undergo numerous revisions and rewrites, but it was a start. In this first draft, Felux has been changed to Felox. Chakotay has now been given a tribal affiliation, Sioux.

The story draft was read by Berman and Taylor, who each made copious notes—comments, suggestions, and ideas. The two then met and talked with Piller, who made notes of his own. Afterward, he began the second draft, which was delivered about two weeks later, on November 1. More notes. Four days later Piller completed a third draft. In it, Chakotay had become a Hopi.

The meetings, notes, and revisions continued all the way through February. Oddly enough, one of the major sticking points was the names of the characters. Some of them kept changing. Around mid-February there was a flurry of faxes, lists, and memos suggesting various names. In the draft of the series bible dated February 15, Vicon's name was changed to Nivok. Kate Janeway became Elizabeth Janeway; Jay Osaka became Harry Kim; Felox became Neelix; and Dah was changed to Kes. Changing Kes's name was probably a wise move. One can just hear the fans saying "Duhhh?"

Curiously, in the story draft dated the same day, Neelix was Neelox, Kes was Kess, and B'Elanna was B'Elanna Cortez. We live in a constantly changing universe. There were more name changes the very next day. The story draft dated February 16 lists Tuvok, B'Elanna Torres, Neelix, and Kes as among the names for the final cast of characters. Chakotay lost his tribal affiliation and was simply referred to as being "from a colony of American Indians."

The February 16 draft, although considered complete, would still undergo additional changes well into March. Beyond that, the script would keep changing even after principal photography had begun. The series bible would also be revised periodically to reflect the newer versions.

A major hurdle had been crossed. Now it was time to start drafting *Voyager*'s pilot-episode script.

THE PRESSURE COOKER

I feel like I'm sometimes juggling twenty eggs in the air at the same time. If even one of them breaks it's going to be a disaster. At the end of the day I think "God! Where did the day go? I didn't even have time to go to the bathroom!"

Wendy Neuss
Producer

BY EARLY MARCH, LIFE IN THE PRESSURE COOKER was starting to look grim.

The three producers had a script to write; or rather, Michael Piller had a script to write. What neither Berman, Piller, nor Taylor had was time. For them, the episodic-television production landscape was rapidly getting crowded. Concurrently, the demands on their time were worsening.

At this point Berman was almost entirely focused on the feature, *Generations*. Piller, along with producer Ira Steven Behr, was riding herd on *Deep Space Nine*. And Jeri Taylor was overseeing all remaining production on *The Next Generation*. One bright spot was the fact that the media attention had died down a little, but that was no cause for celebration. Plenty of other brushfires were burning that needed attention.

For the next three months the entire production company would be under a form of siege that would leave many of its personnel suffering from overwhelm, overload, and burnout. Everyone found themselves trying to divide their time between various productions until there was nothing left to divide. By early June, emotional and physical circuit breakers would be popping everywhere.

A closer look at the production workload reveals why.

First of all, there was *The Next Generation*.

Although production was coming to the end of its seven-year run, the series was experiencing a massive buildup to the final episode, "All Good Things…"

Additional people were needed in virtually every department. Because of all the other productions going on, finding them had become a significant problem. For Jeri Taylor and Merri Howard, the job was not getting any easier. Just the opposite.

Most departments normally worked on both *The Next Generation* and *Deep Space Nine* simultaneously. Hair, makeup, wardrobe, construction, the mill, script supervision, props, postproduction—all found their days increasingly consumed by the demands required to support *The Next Generation*'s production efforts.

Typically, when departments need additional help on a production, they hire people from off the lot. Michael Westmore, for example, may hire as many as twenty-five additional makeup artists, sculptors, and mold makers for a single *Star Trek* episode, depending on the need. In his case, the more aliens there are, the more extra help is required.

The catch here is that while the department's body count may temporarily increase, the department heads cannot at the same time increase themselves. Production companies do not offer clones as part of their employment-benefits package. Moreover, all temporary personnel have to be familiarized with the script requirements, have their work supervised and checked, and (most likely) be counseled when the pressure becomes too great—and it does.

Already spread too thin, Westmore, Merri Howard, Richard James, Bob Blackman, Peter Lauritson, Dan Curry, Michael Okuda, Rick Sternbach, and others now had to somehow carve out additional time to accomplish the extra work required to wind up the series. For Jeri Taylor, there was no relief; she had to oversee it all.

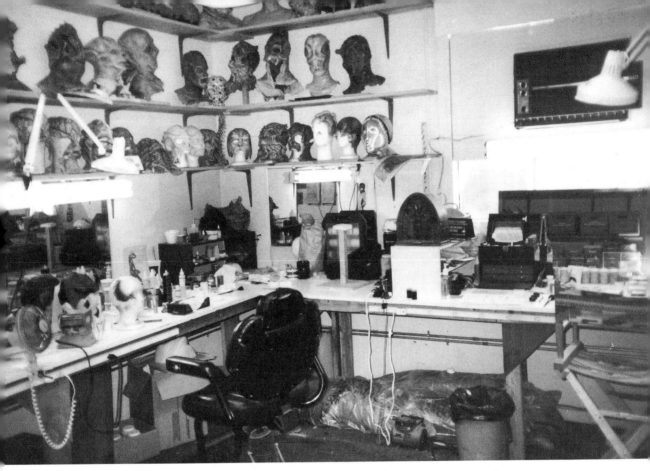

This sculpting and finishing lab in a small building near Stage 9 is one of several different locations utilized by Michael Westmore's staff in creating the makeup and prosthetics for *Star Trek*.
STEPHEN EDWARD POE.

For many people, Taylor included, there was only one answer: The hours and the days had to get longer.

Michael Westmore: Everybody here is really married to the business, Monday through Friday. My wife jokes about it. She sends me off to Camp *Star Trek*, and she gets me on Saturday and Sunday. She knows from the time I get here Monday morning until Friday night the odds of getting hold of me are slim. She beeps me if she really needs to get me.

I'm one of the few people I know...including members of my own family...who's only been married once. Everybody in my family has been married

The term "shoehorn" was invented to describe the tight fit at Jim Van Over's workstation. Denise's computer is in the background.
STEPHEN EDWARD POE.

three to six times, including my dad. They all work in the business. There's a toll taken from the amount of hours you have to spend here. You don't have a life outside. You can't carry one on.

One of the many people brought in by this urgency for additional help was Jim Van Over. Michael Okuda needed extra coverage in the area of animation. He contacted Van Over, a long-time friend who at the time was working for a desktop publisher in Sunnyvale, California.

As luck would have it—for Michael, *Star Trek*, and Van Over—Jim had just been laid off by his employer. He promptly came to Los Angeles and began splitting his time between *The Next Generation* and *Deep Space Nine*. On weekends he commuted back to Sunnyvale to be with his wife, Barbara, and to attempt to expedite the sale of their house (no such luck) so she could move right away. At one point Jim complained to Doug Drexler about the commute and his long-distance marriage. Doug looked at him, grinned, and said, "Yeaahhh…*but!* You get to work on *Star Trek!*"

After a year or two of maintaining a long-distance marriage, Barbara finally resigned her position as a manager at a major computer company, and moved to Los Angeles to join her husband.

Second, there was *Deep Space Nine.*

In general, Michael Piller and Ira Behr faced the same problems and conditions as those dogging Jeri Taylor. The series was ending its second year of production. Piller and Behr were intent on making sure the season ended on a high note. The producers wanted viewers to come back in the fall. So there was added pressure for everyone to produce a better-than-average final episode. That required more time and attention by all departments, in turn demanding more of the three producers' time.

Third, there was *Star Trek Generations.*

The feature was not scheduled to wrap its own principal photography on Stages 8 and 9 until May 18. At that, five additional days were set aside for stage use, in order to "pick up" any last-minute shots that might be necessary, as a contingency factor. Thus, *Generations* was still demanding time from many of the seasoned crew who had been pulled off their regular jobs on *The Next Generation* to work on the feature. Most were not yet available to come back and lend a hand with any of the other production needs.

Aggravating the situation was Berman's penchant for hands-on producing, and his constant drive for quality. Producing the feature was no different. He remained heavily involved in all aspects of its production. Berman's pace would not ease up when

Generations finished shooting. Most of his time would then be absorbed by supervising and approving every frame of film including editing, optical effects, music (scoring), foley (sound effects), looping, and so forth.

Good luck trying to get a meeting with him. To the rest of the world—except for periodic *Voyager* meetings—he was all but inaccessible.

Fourth, there was *Voyager*.

The new series was no longer waiting in the wings. Development was committed, and no longer a secret. *Voyager's* preproduction phase had not officially begun yet, but it was getting closer. Which meant it was becoming increasingly necessary for additional personnel to spend time working on the new series. That drained even more time away from everyone's already insane workloads.

Fifth, there was the track record.

Berman, Piller, and Taylor knew that *Voyager's* pilot could not simply be good. It had to be spectacular. In episodic television it is possible for a series to recover from a weak episode here and there. A bad pilot? Not likely. A series is usually dead at the starting gate if the pilot flops. This was a new *Star Trek* series. Number four. None of the three previous pilots had flopped. How long could the producers keep rolling a string of sevens?

This made the pressure—especially for Piller—bad enough, but for *Voyager* it was only the beginning of the heat. For the first time in nine years of television episodes—as of *Voyager's* premiere, and excluding the features—a major new *Star Trek* starship would be introduced. This, after a long line of distinguished and popular starships dating all the way back to the first *Enterprise* in *The Original Series*.

Heaping fuel on the fire was the issue of the woman captain. Precedent shattering, to say the least. Could she fill the chair as fearlessly and popularly as Kirk and Picard? No one really knew with any certainty. Although feedback from the focus groups provided some measure of reassurance, it could still be a crapshoot either way.

And finally, there was the United Paramount Network.

Paramount was hanging its corporate hat on *Voyager* to help the tyro network set sail onto a new ocean of profits. The new *Star Trek* series was the centerpiece of UPN's planned programming-launch schedule. The studio was betting heavily on *Star Trek's* appeal to help it sign up television stations faster, and in greater number, than its rival at Warner Brothers. A flopped pilot would founder far more than a single television series. It could sink a huge investment.

It was against this backdrop that Michael Piller began writing the script for the pilot episode—still, as yet, untitled.

While Piller worked on the script, *Voyager*'s staff and shooting crew were beginning to take shape. Early in March, Berman asked Merri Howard to begin spending time on *Voyager*'s preproduction effort. A preliminary budget had been established. Now schedules needed to be created to allow for a buildup in staffing, set design, and construction, and an orderly transition scheduled to ensure the earliest availability of Stages 8 and 9. As soon as *Generations* wrapped, both stages had to be cleared to make way for construction of *Voyager*'s standing sets. Important milestones were established for the months of April through August. Principal photography was set to begin on August 15.

In April, Merri Howard shifted her attention full-time to *Voyager*. On April 6, she was joined by Richard James as production designer, Andy Neskoromny as art director, Rick Sternbach as senior illustrator, and two senior set designers. Within a month or so, James's art department would swell to a full-time staff of fifteen.

Voyager's pilot episode was a two-hour special. That meant ten acts. Because *Voyager* was to be a syndicated series, each one-hour episode would be structured in five acts. Before a full draft of the script could be written, the producers needed to break down the story into ten separate acts, and then break each act into its main scenes. This is done during a lengthy meeting, in a process known as breaking the story. The document that comes out of this is called a "beat outline." A beat is a very short description of one scene. A beat outline is a list of the major scenes in each act, and covers the entire story. Once they could agree on the beat outline, a draft of the script could be completed.

Breaking the *Voyager* story required more than one meeting. The usual routine was for Berman, Piller, Taylor, and Brannon Braga—who was no longer needed to write episodes for *The Next Generation*—to meet in Jeri's office, where they could use a large whiteboard mounted on one wall near her desk. As they broke the story into acts, Jeri would list them on the whiteboard. Then they would take each act, in order, and break it into its major scenes. It was a long process, and stretched over several weeks.

One of the consequences—and advantages—of the process is that the story gets changed. The story break identifies "holes" in the story—places where the story does not work, is weak, or is incomplete, and so needs changing. Which is why the producers do not like to draft a script until the beat outline is finished.

The beat-outline meetings continued through March and into April. As changes emerged, they were incorporated into the story. By mid-April the beat outline was more or less firm. The first three acts of that outline follows:

"STAR TREK: VOYAGER"
Beat Outline by Rick Berman, Michael Piller,
& Jeri Taylor
April 13, 1994

TEASER

1. <u>INT. MAQUIS SHIP</u>
 On the run from Cardassians. Est. Chakotay B'Elanna and Tuvok—they proceed
 into Badlands. Run into strange beam—white out.

ACT ONE

1. <u>EXT. CONSTRUCTION SITE—PENAL COLONY</u>
 Paris is working as carpenter. Sex beat* with
 supervisor. Janeway arrives—she makes offer.
2. <u>EXT. PARK</u>
 Janeway lays out deal. Some back story on Paris he accepts.
3. <u>EXT. SPACE</u>
 Shuttle approaches DS9.
4. <u>INT. SHUTTLE</u>
 Paris and pilot see Voyager for the first time.
5. <u>INT. DS9</u>
 Paris enters Quark's—see Kim being scammed by
 Quark. Rescues him.
6. <u>INT. DS9 AIRLOCK CORRIDOR</u>
 Paris and Kim exit turbolift chatting about Kim's
 first posting, but he knows all about this class
 ship.
7. <u>INT. VOYAGER—CORRIDOR</u>
 Kim directs Paris.

*A reference to a scene with sexual overtones. This beat is important because it helps establish that Paris is a
womanizer.

8. <u>INT. SICKBAY</u>
 Kim and Paris meet the doctor—has attitude
 toward Paris.

9. <u>INT. READY ROOM</u>
 Janeway talks to boyfriend on monitor. Paris and
 Kim enter—she takes them to...

10. <u>INT. BRIDGE</u>
 She assigns Kim to Ops. Set a course.

11. <u>EXT. SPACE</u>
 Voyager departs.

ACT TWO

1. <u>INT. PARIS' QUARTERS</u>
 He chats with father—exits to...

2. <u>INT. OFFICER'S MESS</u>
 Paris enters, sees Kim with doctor and others.
 They leave. Paris tells Kim backstory. Kim
 says, "I choose my own friends." Call from the
 bridge—approaching Badlands.

3. <u>INT. BRIDGE</u>
 They enter Badlands. Follow trace of Maquis—
 maneuver through holes. Get swept up by ion beam.

4. <u>EXT. SPACE</u>
 Big optical effect.

5. <u>INT. BRIDGE</u>
 Lots of dead and wounded—Where are we? Reveal
 array on viewscreen.

6. <u>EXT. SPACE</u>
 Voyager array and Maquis ship.

ACT THREE

1. <u>INT. BRIDGE</u>
 Est. edge of galaxy. Maquis ship dead in space.

Some TECH about array—call from engineering -
chief dead. Core breach in progress. No response
in sickbay. Paris and Kim go there to assist.
Janeway heads for engineering.

INTERCUT

2. INT. ENGINEERING
 Janeway coping with crisis.
3. INT. SICKBAY
 Paris and Kim overwhelmed—doctor is dead. They
 summon EMP Zimmerman. As crisis ends, optical
 effect wipes sets. All disappear except
 Zimmerman.
4. INT. ARRAY—ISOLATION CELLS
 Old man arrives chatting greetings. Janeway
 demands explanation—he ignores her.

Michael wrote, Jeri rewrote, and Rick made notes when he had time. Periodically all three met, discussed, made more notes, and then Michael went back to the computer again. Between early April and mid-May the script went through four drafts, finally emerging with a name for the pilot episode: "Caretaker." With each change, enough details were clarified so that a few more departments could begin their own developmental efforts.

Merri Howard continued adjusting her preproduction schedules and began circulating revised production-planner calendars, projected through August. Much of the organizational effort and departmental coordination fell to Merri during April and May. When Brad Yacobian shifted over to *Voyager* on June 3, the two began to divide up the rapidly growing responsibilities.

Al Smutko began planning construction crew schedules based on Merri Howard's calendars and Richard James's emerging design concepts. Robert Blackman began sketching designs for the Maquis' clothing as well as costumes for Neelix and Kes. Michael Westmore began researching designs for the alien makeup for the Gazon (later Kazon), the Ocampa, and of course Neelix and Kes.

Suzi Shimizu and Cathy Huling worked with Merri Howard on the budget break-

downs for each department. According to Mazza, the pilot itself was initially budgeted at around $6 million, but would swell to over $8 million by the time the pilot aired. Tracking all expenditures, especially at this early stage, was a critical function. Shimizu and Huling were perfect for the task. From this point forward communication and coordination throughout the company would be imperative.

Although the "Caretaker" draft seemed to be coming along well, something about it bothered Michael Piller. It took him a while to figure out what he thought was wrong with the story, and when he did, Piller detailed his thoughts in a memo to Rick Berman and Jeri Taylor.

In this particular memo, Piller lays out his recognition of a structural and thematic problem, his struggle to find a solution, and then the breakthrough.

Among other things the memo is a good example of the producer's ongoing attempts to adhere to one of *Star Trek*'s major canons: The *Star Trek* universe is consistent. Even to the point of incorporating the same conceptual characteristics in each of its pilot episodes.

May 24, 1994
TO: JERI & RICK
FROM: MICHAEL
RE: THE MISSING LINK ON VOYAGER

I think I've got it. It came to me very late last night in bed which is usually a good sign. The only thing I think this story is missing, the one thing that every Star Trek pilot has had, is the bend in reality. A touch of fantasy.

The Cage had the prison that took you to the greenswept park with the imaginary Susan Oliver.

Encounter at Farpoint had an Inquisition with an omnipotent being.

Deep Space Nine had the metaphysical interrogation by the prophets.

Our story works, I believe, but it is all real in 24th Century terms—it never leaves the baseline universe as we know it. In fact, it never goes into the UNKNOWN.

The fix may be simple. Here's the idea I came up with: what if the inside of the Array isn't test tubes and probes. What if, when we're transported off Voyager, we find ourselves suddenly in the Heather on the Hill from

Brigadoon, beautiful people coming to greet us, embrace us...or on the beach of Bora Bora with naked Polynesians coming to greet us...or it's the Orientals from Shogun...or some other earth-like metaphor for voyagers who've landed on strange shores. If the entity can create himself as an old man and a bagpipe, he can create an entire environment from his data bank scans, can't he?

So, it seems briefly like an idyllic environment we've come to...the entity in some appropriate guise, tells us relax, I don't mean you any harm, but Janeway knows better not to trust what she sees...Tuvok says it's a hologram...

The Polynesian natives, if we go that way, are putting leis around our neck, dancing the dances to the drums and it's hard not to get caught up in this if you're Kim or Paris. It's almost like we were in an old 19th Century whaling ship thrown off course by a hurricane, says Kim.

But quickly, the idyllic setting becomes dangerous...not exactly sure how...but instead of probes, some optical zapping might occur, (looking for something more subtle, indigenous to test for this DNA particle)...then one laughing native girl pulls Kim into the bushes as native girls are wont to do...but as he expects carnal delights, he winds up being grabbed by an optical beast and disappears.

Problems occur: how do we show the entire crew of Voyager has been taken to this wondrous environment ...(yes, Captain, the rest of them are just over the ridge)(matte shot on the beach maybe?)(a cast of hundreds?)

How do we find the Maquis? Maybe we never get to the test for the DNA particle in this sequence—maybe Tuvok uses a tricorder to track down the source of the holographic generator, stumbles into the real world where the Maquis are on ice...which sets off a melee and we're all zapped into unconsciousness right there on the beach. And when we wake up we're back on the ship, more confused than ever.

So, the result is—we never actually see the interior of the Array except for that Maquis on ice moment which might be a matte shot with a few close-ups of the Maquis we know. Every time we go to the Array, we go to this environment. We'd have to lose the tubes...well, let me take that back...maybe

they reveal in the very last sequence as he's dying, the signal that he's dead, is the dissolution of the fantasy environment and they reveal that he's an ooze monster.

This probably only adds another million to the budget. But it only affects about twenty pages or so—maybe only ten in a substantial way.

Anything here, guys?
Michael

While Piller presents his solution, he also raises questions and problems. These will eventually be resolved, or simply go away. His basic concept will end up becoming the "farmyard" scene—a key element, and the one that introduces us to the alien known as the "Caretaker." The result works wonderfully well, thematically as well as dramatically.

Michael Piller and Jeri Taylor both also grappled with other problems in drafting the script.

Michael Piller: The second hour always seemed to dog us. The biggest danger in the pilot was in creating a story that nobody cared about. Instead of taking the approach I took with *Deep Space Nine*, I felt this time the audience was ready for a slam-bang action-adventure. So we spent less time on any individual character, which in a way would have been easier to write because you really get into the meat of the characters. Instead we played the adventure off the family. So the only true character arc in this show is Paris's.

Technology works reasonably well, but it doesn't hold up the show. I'm much more comfortable writing a show about a character than I am about events or technical enigmas. When we got to that second hour and we started to get into the mystery of this underground planet and the Array, there was a little question mark in our minds about how to do it in such a way that the audience would care.

I think we solved those problems. But it was many, many rewrites by Jeri and by myself before we got there. It has huge thematic explorations about the welfare state, about religion, and about a variety of other subjects. It works on a lot of levels. I think it's less pretentious than some of our other *Star Trek*

shows. Our ambitions this time, versus *Deep Space Nine*, were to tell a really great adventure, and introduce a family. So our ambitions were a little less lofty. I also think they might be a little more popular.

With "Caretaker" shaping up well, the producers turned their attention to more pressing matters—such as the first season's episodes. Stories needed to be generated. Alien species developed. Characters fleshed out. Crew relationships explored. Doc Zimmerman's role investigated further.

As *Voyager*'s preproduction activities continued to grow, other related events were taking place.

The United Paramount Network was steadily making progress signing up stations in major markets. The competition with Warner Brothers' rival startup network was at times acrimonious. There were only so many television stations around who were unaffiliated with one of the four existing networks. As the month of May came to an end, UPN had signed up thirty-six stations in eight of the country's top ten broadcast markets. Not enough yet, but it was a healthy beginning.

SOMETHING OLD, SOMETHING NEW

You're talking about sets that go all the way back to 1977. The basic structure on Stage 9 since the attempted *Star Trek Phase II* television series. Which became *Star Trek: The Motion Picture*. A lot of that wood is going to be twenty years old pretty soon.

Rick Sternbach
Senior Illustrator

THE DISTRIBUTION OF THE COMPLETED DRAFT script to all department heads and key staff members automatically set in motion complex mechanisms of production. Most of the people involved had worked with each other and with *Star Trek* for so many years that, for each, just getting the script was enough. They all knew what to do next.

Richard James, for example, wasted no time getting started with his production-

design efforts. At first, the only full-time member of his *Voyager* art department was Andy Neskoromny, who would be art director for the "Caretaker" pilot episode. There were two principal design areas waiting to be addressed—the standing sets, and the *Starship Voyager* itself. The standing sets were those that would be built on Stages 8 and 9. These were interiors of the ship, such as the bridge, and once built would remain in place (standing) for the life of the series.

Stages 8 and 9 have more or less been home to *Star Trek* since 1977, when Gene Roddenberry and Paramount were preparing to launch a revitalized series called *Star Trek Phase II*. The standing sets for that series were built on 8 and 9, but were never used because Paramount decided not to do a television series. Instead, the sets were recycled to produce the feature *Star Trek: The Motion Picture*. As each subsequent feature was filmed, the sets for the ship interiors were also built on 8 and 9, again reusing many of the set pieces each time.

When *The Next Generation* was being prepped in late 1986 and early 1987, Stages 8 and 9 were once more used for the standing sets. Where possible, previous set pieces were recycled yet again. Once *The Next Generation* wrapped its last episode in early 1994, the series' sets were re-dressed and refitted, a few stylistic changes were added, and the sets magically became the ship interiors for the feature *Star Trek Generations*. As soon as that film wrapped at the end of May, the feature sets were scheduled to be torn down and *Voyager*'s erected in their place.

Literally, in their place.

Voyager's bridge would be built in the same spot occupied earlier by the bridge for the *Enterprise*-D in *Star Trek Generations*, and before that, occupied by the bridge for the *Enterprise*-D in *The Next Generation*. Similarly, the rest of *Voyager*'s interiors would occupy the same relative spaces, including orientation on the stage, as their predecessors.

The *Star Trek* universe is consistent. Even on a sound stage.

Rick Sternbach: It was very strange. We had TNG ending. We had to shoot "All Good Things...." Once that was done, we rebuilt the sets for the feature. Once the feature was done, the process started all over again. Rip, bang, cut, tear. And *Voyager* was born. My first exposure to Star Trek was working on the first feature back in 1978. I've seen this lumber a lot.

The "lumber" Sternbach refers to remains in surprisingly good condition despite its years of service, and represents more than merely someone's attempts to recycle sets and

save money on construction costs. This "lumber" is an odd sort of historical record—wooden, silent sentinels to the history of *Star Trek*.

Traditionally, the design of all Federation starship interior sets has begun with the bridge. It is often the focal point of the action in an episode, and is the actual as well as the symbolic seat of power. This is where the chair is located—the seat of command, where the captain sits. When the captain is sitting in the chair, everyone knows the ship is being commanded by that one man or woman.

The bridge is also like the living room in the viewer's home. This is where the *Star Trek* "family"—the crew—gathers every week for their adventures. There is a particular sense of security about these gatherings when the "head of the family" is present. The crew may well be facing high danger, but their leader will make sure they prevail.

Today, the bridge of a Federation starship is more than a television or movie set. It has become one of those modern-day mythological symbols that are instantly recognizable virtually anywhere in the world. What is interesting about its visual impact is that if you ask people how they feel when they look at a *Star Trek* bridge, most will say it makes them feel good.

All of which was not lost on Richard James. He knew the starting point in his design efforts was *Voyager*'s bridge. Once he created a particular "look" for the bridge, that visual theme would drive the design of the remaining interior sets.

Television production is a very reactive business. "Show me some sketches" generally means "I'm not sure what I want…but I'll know it when I see it…and this isn't it." Getting something approved by Rick Berman meant going through a similar experience—his continuing demand for quality is legendary. Virtually every person in every department has, at one time or another, experienced Rick Berman's classic reaction the first time, to anything: "I hate it." And then round after round of changes occur. In fact, Berman's reaction is so common that quite a few offices have a sign on the wall with the simple declaration "I Hate It."

There is no question, though, that Berman's style gets results, and staff members are supportive of his insistence on quality.

> Jim Van Over: The changes he makes, when you first get 'em back you think, "I don't want to do this again!" But…with no exception in the time I've been here have the changes not made it better or more clear. There have been times when we've looked at the script, scratched our heads, and said, "We'll try this," and we do it that way and send it off. Then it comes back with a note from Mr.

Berman saying, "No, it's supposed to be 'this'" And I go, "Oh. That makes it clear. Now I understand what the script meant."

So there is that support from Mr. Berman, and also from Jeri Taylor, and Michael Piller. They are very good at hitting the mark. "I hate it" is not helpful, in one respect. But if I hate it, that means there's something wrong with it. Until I don't hate it anymore it's not gonna happen, it's not gonna fly. He's really good at that.

Forewarned is forearmed.

In addition to Andy Neskoromny, James asked for concept sketches from set designers, illustrators, and scenic artists including Louise Dorton, Gary Speckman, Doug Drexler, John Chichester, and Jim Martin. Some, like Chichester, Speckman, and Dorton, were just finishing with *The Next Generation*. Others, like Drexler and Martin, were working on *Deep Space Nine*.

James at first considered designs that were completely different from any previous Federation starship. Because *Voyager* would be smaller, sleeker, and faster than the *Enterprise*-D, James asked for designs that were more like a military ship. His basic instructions were to "look at everything. No concept is too far out."

Richard James: I just wanted to feel like we'd explored all avenues by the time we had come up with the finished design. I wanted to feel a certain satisfaction that other avenues had been explored. We arrived at the "look" we have for certain reasons, not just because it was the only thing we considered…which it wasn't. We went through the gamut of ideas and concepts.

It was a useful exercise. The farther afield he went, the more he confirmed that the designs "just weren't *Star Trek*." There were no familiar mythological symbols. With each set of sketches, James and Berman began narrowing down the search for thematic elements. Gradually, more recognizable *Star Trek* concepts began to emerge. At the same time, James was succeeding in creating a starship bridge that was obviously different, more advanced in appearance, and more innovative.

As it happened, the concept sketches that Berman approved were the ones James liked the best, giving the bridge a kind of layered look, starting from the back of the bridge

A construction blueprint for the main viewscreen on *Voyager*'s bridge.

and then tiered downwards in three levels to the conn position in front of the main viewscreen. The resulting design gives the bridge a new type of dimension, making it unique for a Federation starship. At the same time it is instantly recognizable as a *Star Trek* starship bridge, thereby maintaining the familiarity loved by viewers.

With Berman's seal of approval on the concept, the real design work could begin. The overall layout of the bridge was known in broad brush strokes only. The next step was to establish the details of each crew member's position. What controls would Janeway have access to while sitting in her command chair? Would she share those controls with her first officer, Chakotay? Or would he have his own? What about the conn officer, Lieutenant Tom Paris? What did his control console look like? And the security officer, Tuvok—how did his station function, and what controls could he access?

In the beginning the questions seemed endless. The design challenge was made somewhat easier by thirty years of established Federation procedure and protocol. James could build on what had gone before, helping to keep the *Star Trek* universe consistent. At

the same time, he had creative license to innovate. *Voyager* was supposed to be one of the Federation's newest and most advanced ships, and James had already formulated several distinctly new criteria for the bridge.

The main viewscreen would be smaller, but would remain in its traditional location, to give viewers a sense of direction and orientation—forward, left, right, and so on. The control consoles were redesigned to create a unique appearance, with circular touch-screen button pads, different configurations, and new graphic elements with additional lighting. The appearance of order and functionality was emphasized. Viewer believability was always important.

Gone were the backlit graphics used on *The Next Generation*'s *Enterprise*-D. James wanted video monitors in their place, lots of them. Technology had advanced considerably since 1986–87 when the *Enterprise*-D's bridge had been designed. James intended to take advantage of new materials as well as new equipment. At the same time, he and his designers developed new methods of integrating the video monitors with surrounding graphics so that the video graphics displays were not obviously twentieth-century television monitors stuck through set walls.

The walls themselves were of particular interest to James. In *The Next Generation*'s standing sets, production suffered at times from the constraints of certain set walls that did not move. This often limited the types of shots a director could make. James was determined to design the sets with as many wild walls as possible, to give the stage crew maximum flexibility in filming each scene. This would reduce the time needed to move the camera, re-light, and set up for the next shot. That saved money.

Walls were not Richard James's only concern.

Typical television production sets have only three sides. Very rarely will they have a fourth wall, to make it an enclosed room. The camera shoots from where the missing wall would normally be located.

Not *Star Trek*. Most *Star Trek* standing sets are six-sided sets. Four walls, a fully detailed floor, and a fully detailed ceiling. This allows the viewer a much stronger sense of say, the bridge, as being real, and is a prime example of the believability factor at work. No matter what angle, or "window," the camera gives the viewer to peer through, there is always a sense of completeness.

In its final configuration the bridge is really quite impressive. Standing in front of the conn position, back to the main viewscreen and looking up and past where the captain and first officer sit, one sees this long, brightly lit set of panels along the back wall. The cen-

terpiece of these panels is the detailed cross-section drawing of the ship in profile—the one done by Doug Drexler and Wendy Drapanas. The view is impressive. Without doubt, James's creation is the largest, most spectacular bridge in *Star Trek* history.

> Doug Drexler: If you don't believe in the technology, you're not going to believe in any of it. You have to believe that this ship really does work. And that there's a well-organized Federation crew running it. You can't just throw some blinking lights in there and expect it to look believable. Boy, does it show when someone does that. Look at *Babylon Five*. As a viewer, I do not believe they run an entire station from that room. It doesn't look functional.

With the bridge design well in place, Richard James set about carrying the visual theme throughout the remaining sets. Next was engineering.

Like the bridge, engineering has always played a central role in *Star Trek* lore. Danger, thrills, explosions, extraordinary courage under fire, treachery, intrigue—all these and more have taken place in engineering. In short, this set is important.

James decided to enlarge the engineering set just as he had done with the bridge. In doing so, he went outward *and* upward. He placed the starship's famous warp core as the focal point, and built the set around it. By expanding the design outward, he gained two distinct advantages. The first was to achieve a greater sense of unity and uniformity. Moving from one side of the "room" to the other feels like actually moving around within a full structure that has purpose and function and accessibility.

The second was to create a set that would offer much more flexibility in camera angles, as well as freedom of movement by cast members. The actors could actually walk all the way around the warp core, with the camera following them—which afforded an extra dimension of both depth and motion, while permitting new camera angles and perspectives.

To expand upward, James added a second floor to engineering, again built around the warp core. A catwalk permits actors to be filmed climbing up to the second floor and moving around while there. This also enabled him to redesign the warp core itself, extending it almost to the ceiling of the second floor. To emphasize the warp core and heighten the dramatic effect, James asked Dick Brownfield to create an interior light structure that, in operation, gives a colorful gaseous appearance. The effect is quite impressive. As with the bridge, new computer consoles and workstations were designed, carrying through the thematic elements James wanted to stress throughout the ship.

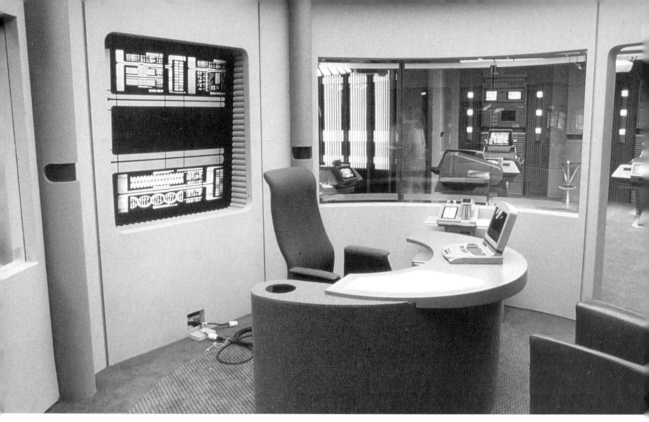

The Doctor's office looking out into sickbay. J.M. CULLEN.

The result of the efforts by James and his design team is stunning. There is a strong sense of fullness, a tremendous illusion of size and depth. Engineering just looks huge.

While the bridge and engineering were being developed, James also had staff members working on the remaining standing sets. Sickbay was enlarged, and designed with distinct areas for patient treatment and care, along with a well-defined trauma center. The Doctor's office was located in a glass-walled room adjacent to sickbay proper. Plans were also made to include a bio lab, but the set itself was not built until the second season, due to budgetary limitations.

Stylistically, the "look" of the transporter room was almost totally changed. James retained the floor and ceiling, but everything else was redesigned to conform with *Voyager*'s other interior sets. The new transporter set is striking, and distinctly different from previous transporter rooms, yet is still very much a recognizable cousin. As Michael Okuda says, "You can still see the bloodlines...same nose, same ears...the same family genes."

A VISION OF THE FUTURE

A close-up detail of the construction blueprint for the transporter set. The "look" is fresh, but the wood has been recycled through a number of earlier starships.

In a tip of the hat to *Voyager*'s ancestral roots, James could not resist building a bit of nostalgia into the new transporter-room set, repeating an element first introduced by Herman Zimmerman in the transporter-room set aboard the *Enterprise* in *The Next Generation*. James used the large light pads that were originally from the transporter room aboard the very first *Enterprise*, in *The Original Series*. Except Captain Kirk and his crew stood on them. Like Herman Zimmerman before him, Richard James mounted the light pads in the ceiling.

Where possible, James created rooms, corridor entrances, turbolifts, and other spaces leading directly into or out of a primary set. This technique adds to the viewer's sense not only of the size of the ship but also of direction. Viewers can more easily "follow" Captain Janeway as she moves, from, say, the bridge directly into the ready room, or from a corridor directly into the transporter room. The feeling of connectedness—of each separate set being a contiguous part of a larger whole—is enhanced as well.

The same design philosophy was applied to the wardroom, ready room, quarters, hangar deck, holodeck, and ship's corridors.

Wendy Drapanas: *TNG*'s *Enterprise* was like a battleship. *Voyager* is more like a destroyer. Swift, fast, good killing power, with newer, more updated technol-

ogy. We extended the corridors so we have a longer "walking, talking" corridor area for filming as opposed to the *Enterprise*. We don't have to fake it as much on *Voyager* as we did the corridor shots on the *Enterprise*. This gives the ship a longer look. Richard James also gave it more of the gray look, which brings it down in size a bit and gives it that cruiser/destroyer look.

An example of marrying the new with the old can be seen in James's approach to designing the ready room. The windows in this set, like those in the briefing room, were the same long, upward-slanting ones used in the old Ten-Forward set from *The Next Generation*. James turned them upside down, added an upper panel to block off the unneeded top area, and…voila! Instant new windows. Recycling saves time and money.

Richard James: We got called one day from NASA, congratulating us on how we figured out all these things. They said we must have had numerous months and years of technology experience and training, trying to figure these things out…how this thing works…how you use it. And we said, "No, we just kind of draw it out." They just don't seem to understand at all.

The holodeck is a new design, as is the wardroom. The latter includes a kitchen of sorts, which Neelix uses to prepare "real meals"—as opposed to replicator meals. In actuality, it is Alan Sims who does the cooking whenever a scene is filmed with Neelix cooking in the kitchen. Sims cooks the food just off the set and brings it into the "kitchen," where Neelix magically prepares his chef's concoctions. Just another average day in the life of a *Star Trek* property master.

As a matter of practicality, any sets needed for holodeck scenes—those scenes that are supposed to be taking place in a holodeck-created environment—are actually built on Stage 16. There is no space on either 8 or 9 to accommodate them. Some of these sets are used periodically, and so are "fold and hold sets." Meaning they are carefully taken down and stored, usually at a facility off the lot, for reuse later. Sets that are needed only once, for a specific episode, are referred to as "swing sets" and are also generally built on Stage 16.

For Captain Janeway's ready room, James created a large, more expansive setting than the one occupied by Captain Picard aboard the *Enterprise*, with a sitting-room area and large windows looking out into space.

One of the reasons Richard James has been so successful in having his designs executed so superbly is Ed Charnock, the paint foreperson. Ed is one of the unsung geniuses

Mike Okuda's office in the *Deep Space Nine* art department, after having been ravaged by a quantum singularity. STEPHEN EDWARD POE.

of *Star Trek*. He can take a two-by-four and make it look like marble, brick, wood, oak, titanium, or virtually anything else besides wood. Charnock is a master of his craft.

One theme evident throughout James's designs is a sense of coherence.

Richard James: What we've also tried to do is give the ship an overall organization. We try to make it clear that this is operations, this is engineering, this is science. We like to give it a sense that there is a strong organization to it. As viewers, we may not know what that organization is, but there's a strong sense of it. Even if some of the graphics are so small that you can't read them. Still, overall, there's a sense of identity to each of the sets we create.

But at the same time we, as the designers, don't actually know how sub-space radio works, for example. So any particular organization or theme will work, as long as its strong, as long as the viewer can believe "yes, this might be the way subspace radio works."

What James is talking about is carefully giving everything within *Voyager*'s design a sense of rationality to it. Michael Okuda echoes James's philosophy.

Michael Okuda: Yes. What we take advantage of is…a lot of the fine details we let drop below the threshold of legibility, so that I believe as the viewer that "if I could just get close enough and read those instruments then I'd find out how this really works." And if we ever do get that close, then we'll take the extra time and we'll write that copy and we will hopefully come up with cool stuff.

But until that's required, we are going to put our energies into areas where it's going to pay off. And where it pays off is in the broad strokes.

This is an excellent example of Gene Roddenberry's believability factor. When viewers see the result on their television screens, the illusion they have is that everything is sensibly grouped, there is an orderliness about everything that suggests that yes, it all functions just the way they say it does. In spite of the fact that viewers may not understand how something works, or they can't read the numbers or the letters…still…there is this semblance that the ship and everything in it is rationally organized, and that it can and does work.

George Lucas was once discussing *THX-1138*, and he said that he did not really want to figure everything out about the particular culture portrayed in that film. He wanted to give the film the slight feel of a foreign-language movie. They are speaking a language that you, as the viewer, do not understand, but you can tell there is clearly a logical structure to everything. You just do not know what it is. But you become convinced that if you were to study it just a little more you might be able to figure it out. In the meantime, Lucas said, you can still revel in the fun of the strangeness.

Richard James: I think that approach clearly shows in *Star Wars*, and I'd like to think that Gene Roddenberry came up with basically the same idea thirty years ago, and that's what we're still trying to do today.

Designing the sets was only the beginning of a lengthy process that would bring them into reality on 8 and 9. People like Al Smutko and Tommy Purser, the construction foreman, would have to make sure the sets were built and painted. Then Bill Peets, Randy Burgess, and Dick Brownfield and their crews would take over and make them come alive. Lights, video, mechanical effects…all had to be in place by August 15.

THE SYSTEM

It's about movement, and sixteen hours a day in them. Heavy-duty spandex is uncomfortable.

It retains heat and odor. We dry-clean them every night, but still the odor gets baked in.

Over time they become stinky.

Robert Blackman
Costume Designer

ON MAY 9, 1994, CONSTRUCTION BEGAN ON *VOYAGER'S* standing sets. Stages 8 and 9 would not be cleared of the sets for *Generations* until the thirty-first, so the initial *Voyager* work was carried out in the mill, and on Stage 16.

In the *Voyager* art department, efforts were still being made to finalize the exterior design of *Star Trek*'s newest Federation starship. The ship's technological capabilities, as

well as the overall design, had been under discussion among Okuda, Sternbach, and the producers since the previous October. Six months of thought, discussion, and concept sketches had already gone into the process when Richard James segued over to *Voyager* in early April, from his duties with *The Next Generation*. By then, the starship's general capabilities and overall shape were reasonably well established. Technically speaking, the design was his responsibility, so in a sense, James was playing catch-up.

Given the status of the design process, his only disadvantage was one of time. Other people's.

Once the design was locked in, Rick Sternbach would have to draw up full-scale blueprints for the five-foot model. That would take time. Building the motion-control model would then be contracted out—most likely to either Greg Jein or Tony Meininger, both master model makers. That would take time. Then, Image G, the company that would do all the motion-control filming, would have to run film, lighting, and motion tests on the model. More time. After that, if all went well, actual filming of the sequences needed for inclusion in "Caretaker" could get under way. Literally months of work lay ahead, to get everything ready for the first frame of usable film.

But not until Berman okayed a final design.

The problem was pinning down Rick Berman. The feature *Star Trek Generations* was consuming his time to such an extent that some people began complaining that the television side of *Star Trek* was taking a back seat to feature-film production. Approvals on ship designs apparently were not the only decisions slow in coming.

Despite some people's frustrations, a certain amount of progress actually had been made.

The previous October, Berman had laid down certain criteria: a sleeker design, more bullet-shaped. Smaller than the *Enterprise*-D. Two engines, but no nacelles—that would have been a first for *Star Trek*, but the idea was later abandoned. He also wanted something on the ship to move.

Rick Sternbach: The producers decided that…something about the ship had to move…had to articulate. Not so far as to become a "transformer robot."* That would look silly. But just something that the Enterprise couldn't do…something new…that we hadn't seen before. But something that made

*A reference to certain popular children's toys.

sense, from a Starfleet-engineering standpoint. Logically, it fell to the engines. Something on the engines would have to move. Either before we went into warp or afterwards. So we began playing with that.

From that starting point, *Voyager*'s design slowly evolved. The task itself was not difficult. Richard James and his art-department personnel clearly understand the elements that go into a Starfleet starship. The details are easy. As Sternbach points out, "All of the little elements that we see on the *Enterprise* have been essentially repeated on *Voyager*, just in a new package." It was the shape of the new package that seemed to take forever.

By April the "package" was not yet final, but it was certainly becoming clearer. In an attempt to further refine its character, Sternbach wrote a memo to Berman, to which he attached a series of scale drawings comparing *Voyager*'s possible size with various editions of the *Enterprise*.

STAR TREK: VOYAGER
Technical Memo

To: R. Berman
 M. Piller
 J. Taylor

From: R. Sternbach
Date: 26 Apr 94
cc: M. Okuda

I'd like to get a clarification as to the scale of the *Voyager* prior to beginning the next phase of the miniature design, that being a preliminary set of drafted plan and elevation views of the ship, necessary to settle on major hull contours, deck lines, and locate surface details.

The accompanying drawings show two possible sizes of the ship, compared to the other Starfleet vessels we've seen. The first pegs the *Voyager* at about 1,000 feet, similar in length to the 1701-A *Enterprise* from the features. That ship had a crew compliment established around 435.

The second drawing expands the scale to roughly 1,250 feet, halfway between the feature *Enterprise* and the *Excelsior* (which is also the *Enterprise-B* from "*Generations*"), which supports about 600 crew.

Mike Okuda and I both opt for the 1,000 foot version, for two reasons. First, the smaller crew would tend to "fit better" in a ship of that size, especially when one considers that the feature *Enterprise* held twice as many people. There would then be a more consistent proportion of ship length to crew. Conceptually, 200 people would find a larger *Voyager* to be rather palatial, when it was assumed that we were looking toward a no-nonsense destroyer or frigate type of vessel.

Secondly, we would have a greater opportunity to achieve a true sense of human scale, which we really have never been able to see visually with the 1701-D series *Enterprise*, a ship we all know was far too big for its own good from the beginning. This human scale would be attained through the use of the windows and Bridge, which automatically will be larger in proportion. In the final 4'–5' miniature, Dan Curry has suggested that we will be able to insert small backlit sets and figures, visible through the windows from the outside. Of course, one of the best uses of scale of the *Next Generation*'s *Enterprise* was the animated figure in the Obs lounge, only seen in the opening titles.

Please let me know what you think.

In Sternbach's drawings can be seen at least one reason for Rick Berman's hesitation over approving a final configuration. Compared to its predecessors, *Voyager* had a decidedly tadpole-shaped nose. Understandably, Berman was not satisfied, and asked to see more design sketches.

More discussions followed. More "I hate it" responses. Richard James was wearing a path between his office and Berman's.

As always, the challenge was to make *Voyager* as different as possible from the *Enterprise* while still being a recognizable cousin. In achieving that goal the question was, how many design elements could they change? Take the saucer...could they reshape it? Could they eliminate it—which is what Michael Okuda wanted to do? Could they rearrange the engines? How else could they play with the overall symmetry?

In the end, the decision was made to take the shape of the *Enterprise*-D saucer, rotate

it ninety degrees, and stretch it slightly along its fore and aft axis. The warp-engine nacelles, now reinstated, were also reshaped, and dropped to a lower horizontal position. This allowed the nacelles room to articulate upward to a forty-five degree position as *Voyager* accelerated to warp speed. According to the series bible, this feature is part of an advanced technology that permits the ship to fly at warp speeds without damaging the fabric of space.

What? Sounds like CYA. That's because it *is* CYA.

Why? Well, because *Star Trek* fans notice things. And they have very long memories.

The explanation for the articulating engine nacelles was necessary, if *Voyager* was to have any decent warp capability at all—and therefore any chance to make it back to the Alpha Quadrant.

> Jeri Taylor: In the last season of *The Next Generation* we put ourselves in a bit of a predicament when we did an environmental show in which we discovered that warp speed is damaging the fabric of space. Suddenly everyone had to confront the fact that the space travel and exploration which they took for granted and which provided a great deal of bounty in terms of knowledge and information and interchange with other species might be damaging the environment.
>
> It was a wonderful way of making it hit home to viewers that the internal combustion engine, which we take for granted and which gives us many wonderful things, is also damaging our environment. Our people had to confront this issue. What we decided was that Starfleet would limit warp speed to warp five except in terms of extreme emergency, for which they would have to give special dispensation.
>
> Having established that fact, we had to live with it. So one of the things that *Voyager* has is some kind of new filtration system or something…what amounts to a cleaner burning fuel…that allows us to go at higher speeds without damaging the environment of space. Because it would take us a lot longer to get home from the Delta Quadrant than seventy years if we could only go warp 5.

A *Star Trek* canon again: Once a fact is established, it exists forever, and must be taken into account if and where appropriate.

Jeri Taylor's comments about the warp engines and the environment are not merely representative of a need to explain away, or "live with," a previously established story point. They also reflect *Star Trek*'s long-standing role as a voice of social conscience. This role is expressed through story points, as her comments illustrate, as well as through character types and character actions.

An example of the latter occurred during the filming of "The Cloud." After returning to her office from the production meeting on "Eye of the Needle," Jeri got a call from David Livingston, who was directing a scene in the Chez Sandrine set on Stage 16. Livingston was questioning a point in the script, which called for an extra to stumble when leaving the bar.

> Jeri Taylor: I feel very strongly about the messages that television sends out. Particularly to the young people. While I am by no means a teetotaler, the suggestion television often manages to make is that every episode of recreation, of romance is associated with alcohol. I think that that's not a good message.
>
> It's perfectly possible to go to a party and have a good time without drinking. It's perfectly possible to have a romantic interlude without drinking. To suggest otherwise is irresponsible. And to suggest that people drink to the point of inebriation and that's sort of a ho ho funny joke is simply a message whose time has passed. I feel the same way about not showing people smoking.
>
> If he stumbles when he's going into or out of a bar then the association is there. We can't run a crawl (message on the screen) that says, "He's stumbling because he has a sore foot." People will look at him and say, "He's drunk." I think that's unnecessary. More than unnecessary, it's a bad decision.

Another interesting aspect of the final *Voyager* design is that the ship can land on a planet surface and take off again, something no Federation starship had ever been able to do before. Viewers were treated to the first example of this feature in the second season opener, "The '37's." The landing pads, while fine in theory, did not seem to work out very well. In that episode, when the pads were extended they looked rather dinky, scale-wise, compared to the rest of the ship.

This was not lost on the producers, who took steps in postproduction to strategically place rock outcroppings and other terrain features so as to partially obstruct the audience's view of the pads.

That design feature notwithstanding, the general result satisfied Berman that *Voyager* was indeed different, while remaining a "recognizable cousin." With Berman's blessing on the "package," Richard James asked Rick Sternbach to begin preparing the working blueprints from which the motion-control model would be built.

There were other questions about the ship that needed to be addressed. The class designation, for example. All Federation starships fell into specific class designations. Michael Okuda sent Berman a list of a dozen or so possibilities. Berman chose *Mercury*, but later changed his mind and decided the class designation should be *Intrepid*.

Then there was the registry number. All Federation starships had registry numbers. This was established in *The Original Series* with the first *Enterprise*'s designation of NCC-1701. The numbers have grown over the years as, we assume, the number of Starfleet vessels has grown as well. In a separate memo to Berman, Okuda broached the subject.

> To: Rick Berman
> From: Mike Okuda
> Subject: *U.S.S. Voyager* registry number
> Date: 10 June 1994
>
> Rick:
> As we close in on the design for the *Voyager* miniature, we also need to select a registry number for the ship. Although this is in many ways a bit of minor trivia, as you know, it is trivia of some interest to many fans.
>
> Therefore, I'd like to offer the following thoughts:
> Over the course of the various Star Trek shows, the Starfleet registry numbers have increased. In the original series and the movies, they ranged from the *Republic* (Kirk's first ship while he was in the Academy, NCC-1371), to the *Enterprise* (NCC-1701), to the *Excelsior* (NCC-2000).
>
> In TNG, we saw several movie-era ships (which would be fairly old in the TNG time frame) that had numbers in the NCC-20000 to 50000 range. Ships in TNG that were presumably newer than the *Enterprise* (i.e. the *Sutherland*, Data's ship in *"Redemption, Part II"*), had registry numbers in the 70000 range. The runabouts in DS9, which were intended to be a very recent type of vessel, all had registry numbers in the 72000 range. Many of these numbers were hard to read, but an amazing number of fans freeze-frame their VCRs.

(We have been assuming that the *Enterprise* was a special case in Starfleet's numbering system, that it was allowed to keep its older number because of the historic importance of Kirk's old ship, but that this is not Starfleet's normal policy.)

I'd therefore like to suggest that the *U.S.S. Voyager* have a registry number that is at least 73000, to show that it is the most advanced in the fleet. The exact number is not really that important, but I think a lot of fans would appreciate it if we retained this bit of continuity that has been interwoven into the show.

One of the elements of Star Trek that many fans have indicated their fondness for is its internal consistency, including the illusion that we have given the organization of Starfleet a lot more thought than any of us really have.

Please let me know what you think.

Berman chose 74,656 as the registry number.

It has also become traditional for Federation starships to have a commissioning plaque on the bridge. Aside from listing the series' "launch" crew, the plaque usually contains a motto of some sort. After a month or two of suggestions being passed around, Berman chose an excerpt from "Locksley Hall," by Alfred, Lord Tennyson:

For I dipt into the future, far as human eye could see; Saw the Vision of the world, and all the wonder that would be...

A fitting motto, to send *Voyager* on her way into the unknown regions of space.

According to the "Caretaker" script, a new starship and all new sets were not the only items that needed creating. There were alien encampments and underground enclaves, Maquis and Gazon ship interiors and motion-control models, a shuttlecraft, a farmyard, and assorted other sets to design and build. And then there were all the props. Richard James and his staff were not just swamped; they were trying to outrun a tsunami.

As if that was not enough, the Array issue had yet to be settled. The Array was the home base of the Caretaker entity. It played a significant role in the pilot, including the climactic ending. Trouble was, every concept sketch submitted to Rick Berman was rejected. Always with a critical eye for details, he refused to compromise on an element of key importance to *Voyager*'s pilot episode.

Foam core models (*Voyager* in fg. and the Array in bg.) are often used to create silhouettes needed in the preparation of matte shots. STEPHEN EDWARD POE.

No matter who presented what, Berman could not seem to agree with anyone on what the Array should look like—except that it had to be enormous. If early concept discussions were any indication, in scale, the Array would make *Voyager* look like a fly against an elephant.

Big. That was it. Before the concept dust finally settled, Richard James would think *Voyager*'s design process had been a piece of cake. Nor would he be alone. No one else could agree on the Array's design either.

Already stretched well beyond any reasonable definition of "thin," postproduction producers Peter Lauritson and Wendy Neuss were at their wits' end. *Star Trek* has always been big on optical effects, blue-screen work, and motion-control photography. *Voyager* merely increased the complexity with the addition of animation and computer generated

images. Compared to other television productions, *Star Trek*'s postproduction contingent is a small army.

But this "army" was experiencing a procurement problem.

Just as Richard James, Michael Westmore, Bob Blackman, Bill Peets, Randy Burgess, Merri Howard, and everyone else were faced with increasingly daunting deadlines, so too were the troops in postproduction. It was not only the Array problem that was the source of their anxiety. It was all the other work that could not be started until approvals were given on various designs for models, matte paintings, animation sequences and so forth. No wonder Lauritson and Neuss were getting frantic.

Eventually, it seemed like everyone in the company, except perhaps Ed Herrera and L.Z. Ward, got into the let's-find-the-Array act. Even Image G personnel began coming up with concept sketches. They were at least as frustrated as everyone else, because they had to shoot the motion-control footage. Their work could not begin until a design was approved and a model built.

More than one hundred design concepts were examined and rejected. The process stretched on for several months. For those who would be left to do the actual work, the stress became terrible. If the postproduction elements were not completed in time to be inserted into the pilot so the January airdate could be met, the producers would not be blamed. Paramount executives would not be blamed. Network officials would not be blamed. The postproduction people would take the heat "for not getting the job done."

Never mind if three months of work must be done in one. Or if bodies become physically wrecked attempting to pull off the impossible one more time. Or if people become so emotionally drained by the stress that they simply stop functioning. Or if some families finally disintegrate because "this time" was not supposed to happen again, and so has become "the last time."

It is no comfort to production company personnel to know that what they go through is not limited to episodic television. Unfortunately, corporate America is highly skilled at creating these types of situations, and does so, every day. It is not fair. It is not even personal. It is the system.

Near the end, one emotionally exhausted staffer, in tears, held up a stapler from her desk and said, "Well? Does that look like an Array? Maybe that could be an Array. How about this Scotch tape dispenser? Upside down, that could be the Array."

Making television shows is glamorous.

The final design, when it emerged, had a central elongated core, wider around the middle than at the blunted ends, with an assortment of paddlelike arms projecting out-

ward in all directions. But by then, nobody cared. Except perhaps Dick Brownfield. It would be his job to blow it up with explosive charges while cameras recorded the Array's demise. Some of his coworkers would have paid big money for the pleasure of pushing the button.

Things were getting dicey. With all departments working on getting "Caretaker" ready for the cameras, Michael Piller, Jeri Taylor, and Brannon Braga turned more of their attention to considering what to do for an encore. The first season was scheduled for twenty-two episodes, counting the pilot. But only one script had been drafted. They needed story ideas, and from them, scripts. The three began holding story conferences, discussing ideas for the first few episodes. By early June they had identified six possible stories, with three more one-liner concepts from Rick Berman. Not enough.

Piller, Taylor, and Braga went into "pitching fever." By invitation only they started taking pitches—story ideas—from outside writers. Although *Star Trek* has an open script policy, the producers did not want to open the *Voyager* process to the general public quite yet. It was necessary to first clearly establish the series' premise, and the "voice" of each character—their motivations, personalities, and idiosyncrasies. Initially, they took pitches only from people from whom they had previously purchased stories or scripts. The effort paid off. When casting started in July, they had purchased almost a dozen stories, and had two scripts in development.

For Brannon Braga, casting was a nightmare. The writing staff numbered three people—Michael, Jeri, and Brannon. When casting started, Michael and Jeri were tied up every day with Rick Berman, going through the casting process. That left Brannon to take pitches...two or three a day, every day. Plus, he was trying to write the script for the second episode. The pressure was intense.

Through all of this frenzy of activity, Paramount was keeping a close eye on *Voyager*. Kerry McCluggage still had reservations about the series' premise. He read the draft of the script and, in early June, sent his own notes to Rick Berman, expressing his concerns. The following week, Berman, Piller, and Taylor forwarded a memo to McCluggage, addressing those concerns.

Interestingly enough, one of McCluggage's concerns was over the Prime Directive. As the script was written, he felt Captain Janeway might well find herself in the position of violating it. That would be a no no. The fact that the chairman of Paramount's Television Group would be worried about violating *Star Trek*'s Prime Directive is itself an indication of just how seriously the studio views the worth of *Star Trek*.

It is also, once again, an indication of just how thoroughly conversant one of

Paramount Studio's top brass is with the ins and outs of the *Star Trek* universe. McCluggage's knowledge and concern are highly unusual in an industry noted for studio executives whose primary interest is in the bottom line.

In their response, the producers specifically addressed McCluggage's concerns:

> We've managed to keep Janeway from a direct violation of the Prime Directive, and we believe it's important that she not cross the line and meddle overtly with the destiny of the Ocampa—or we risk sending a message to viewers that we're abandoning one of the basic principles of the Star Trek franchise. She will, however, provide the satisfying message that they are not doomed; rather, they are being given an opportunity to grow and flourish— an opportunity she will guarantee by the selfless act of destroying the Array.

...and a point of clarification regarding the Caretaker, the Array, and Janeway's dilemma:

> We will address language which confuses the distinction between the Array and the Caretaker—one being the hardware which supplies power and energy, the other the entity which operates the hardware. It is the Caretaker who is dying; the hardware will remain intact after his death and could provide the means for the Voyager crew to return home—or the means for the Gazon to destroy the Ocampa. Janeway will eschew the former in order to prevent the latter.

The producers' memo went on to address each of McCluggage's other concerns, and to reassure him that the next draft of "Caretaker" would incorporate the appropriate changes.

Across the lot, not far from McCluggage's office, costume designer Bob Blackman was making his own preparations, based on the script. He had finished his work on *Star Trek Generations*, and could now concentrate on "Caretaker." After six seasons with *Star Trek*, Blackman knew that the closer they got to principal photography, the greater the pressure would be on everyone. He also knew how long it could take Rick Berman to approve anything. That always created a ripple effect for everybody else, who then had to deal with

compressed time frames. Blackman intended to get as much of a jump on the process as possible.

He started first on the Starfleet uniforms, basing the design on what he had developed for *Deep Space Nine*. Those, in turn, had evolved out of changes Blackman had instituted during *The Next Generation*'s third season. Since *Voyager* is contemporary to both those series, his approach supports the sense of wholeness, of completeness, of continuity in the *Star Trek* universe.

Change, if and when it comes, must be based on some logical need or reason, rather than change for the sake of change, or change for the sake of new visual interest or simply to provide additional marketing capabilities.

Bob Blackman: For *Voyager*, I went back to Bill Theiss's* original design, a one-piecer, and taking a NASA point of view. I went to the blue jumpsuits that the astronauts wear and examined those for a while…what made them so interesting and workable…and then modified them.

For the job-identification aspect of the uniforms, this yoke that Bill came up with was brilliant. He did it in black on the utility uniforms. We do it in color. That horizontal line at the shoulder turns the normal person into a hero. It just gives them heroic proportions without doing anything. What Theiss did with that sort of jigsaw thing in the front narrowed their waist. He put the black at all the danger areas so the women could wear the Spandex as well as the men. It was wonderfully conceived. It was a way of making any body…any shape…look good.

Through a series of sketches, Blackman removed all the stripes and color detailing from the *Deep Space Nine* uniforms, primarily because he felt they were too distracting to the eye of the viewer. The result was a more simplified uniform, which was still distinguished by its trademark colored yoke, denoting the job function of the wearer, i.e., services, science, command.

The *Voyager* uniforms tend to accentuate the actor's face, which is exactly Blackman's intent. With his background in theatrical design, he believes that what happens in the

*Costume designer for the first two seasons of *The Next Generation*.

actor's face is what is important. The face is the canvas. Therefore much of his work is designed to lead the viewer's eye back to the face.

The Starfleet uniforms were easy. Blackman did not need to know who the actors were who would wear them. He rarely knows that information in advance. Designing the costume for Neelix was easy as well. The script did not give him much to go on except the fact that Neelix is discovered in some kind of junkyard in space, and needs a bath. After the bath, according to the script, he dons a "twenty-fourth–century leisure suit."

That was all Blackman had, but it was enough. He made some sketches, ordered some outrageous fabrics, and waited for a body to put them on. Rick Berman would make the final decision on what Neelix would wear—or anyone else in the series—so until the role was cast, Blackman could go no further. His approach to Kes's costume was similar, except Jeri Taylor's advice was to design something that would suggest a young spritelike woman.

Blackman welcomes Rick Berman's meticulousness and attention to the smallest of details.

Bob Blackman: Rick is a very particular man. He has the most extraordinary eye of any producer I've ever worked with. He can look at something and instantly spot what needs improvement. Sometimes it startles me because I look at it and realize he sees something I've missed.

I come up with something I think is magnificent, and then he points out something and I look at it and I go, "Whoops, you're right." Or, "Wow! Yeah, that's it, sure, right." He has the most amazing eye. And his important sense of detail just goes right into who I am because I believe God is in the details, and that's the end of that. I'm very detail oriented.

Blackman's attention to detail posed an unexpectedly frustrating problem for him when he first joined *The Next Generation*'s third season. The problem was color—Starfleet uniform colors, to be specific. The actual colors are maroon, gold, and teal. Fine. No problem. Except when Blackman would see "his" uniforms on film, after an episode had been shot, they were not the same colors!*

*Déjà vu. This same problem gave Gene Roddenberry fits during the filming of the pilot for *The Original Series* in 1966—until, like Blackman, he figured out what was happening.

The gold was showing up okay, but the maroons were coming out rust, and the teals were coming out blue. No matter how hard Blackman worked, adjusting the colors to get the uniform colors in the episodes to match what they were like offscreen, the colors would always end up being wrong. It was driving him crazy, until he started talking with postproduction producers Peter Lauritson and Wendy Neuss.

That's when he discovered that the film lab was color-correcting the film, and the uniforms along with it, to make the film compatible with the requirements for the blue-screen insert shots. With that bit of enlightenment, Blackman surrendered to the process and stopped worrying about the uniform colors.

As the pressure mounted, nerves began to fray. Egos began to surface. Territorial attitudes began to show. Politics became the order of the day for some people on the lot. Under the circumstances, it is amazing that everyone involved "held it together."

In any business, in any industry, some things go with the territory. Much of the entertainment business, and what happens in it, is ego-driven. Politics goes with the territory. It is not a matter of company versus studio. Or one department versus another. Or one guild versus another. As long as there is a group of human beings working together, and there is a hierarchy in place, there will be politics. Toes will get stepped on. There will be rejection. There will be capricious decisions made. For no reason. And then, the next week, some of those decisions will get reversed or changed again.

It goes with the territory. It's part of the system.

So is having one person in final authority. When it comes to producing *Voyager*, as in all things *Star Trek*, that person is Rick Berman.

The idea of three producers running a series as equals, as a triumvirate, traditionally doesn't work in Hollywood. Invariably there is one strong person overall, and everybody reports to that strong person. Like a starship, there can be only one captain. Otherwise, there would be chaos.

With more pieces of the preproduction process falling into place, it now seemed as if the forces of gravity had at last been overcome. From June onwards, the pace—and the pressure—would continue accelerating as the time to principal photography shortened.

SHOW & TELL

Roddenberry didn't want a Klingon on the bridge of *The Next Generation*. Bob Justman

suggested the idea and Gene resisted it. Fortunately, Bob's idea prevailed. I still think it

was the single most brilliant decision they made. It's such a powerful statement

about what we can achieve and overcome.

Michael Okuda
Scenic Arts Supervisor

U PPERMOST IN THE PRODUCERS' MINDS WAS THE question of who would play the captain. They were not alone. The thought was never far from the minds of executives at Paramount, UPN, licensing/merchandising vendors, the fans, the crew, the writers, and probably almost everyone else on the planet at one time or another. As far back as the previous September, names had been bandied about like a roll call of women members of the Screen Actors Guild.

There were eight other continuing roles to cast, but it was the captain who was the hot topic of conversation whenever the subject of *Voyager* casting came up. Ironically, it would be the part of the captain that would be filled last, and then only after principal photography had already started.

Rick Berman: There is something very specific and unique about acting on *Star Trek*. This is true for our cast regulars as well as for our guest stars. *Star Trek* is not contemporary. It's a period piece. And even though it's a period piece in the future as opposed to a period piece in the past, it still necessitates a certain style of acting and of writing that is not contemporary. It's not necessarily mannered like something that would take place in a previous century, but it's probably closer to that than it is to contemporary.

Berman is serious. In his mind, casting any *Star Trek* part is one of the most critical aspects of maintaining Roddenberry's original concepts. His concern also helps explain why *Star Trek* "works," and so many other science fiction shows do not.

Rick Berman: There are many actors who are wonderful actors. Gifted actors. But to play a character…to play a Starfleet officer in the twenty-fourth century is very difficult for them. They've got a "street" quality about them. They've got a very American twentieth-century quality about them. They'll have a regional quality about them…or a Southern accent…or they'll have a New York accent or a Chicago accent.

They will have certain qualities about them that's very contemporary, that just doesn't work when you're trying to define this rather stylized, somewhat indefinable quality that makes somebody "work" as someone who lives in the future.

One of the first things that destroys futurist science fiction for me, whether it be movies or other television series, is when you see actors who are *obviously* people from the 1990s America. We're always looking for people who have a somewhat indefinable characteristic of not being like that. And it's hard.

Almost everyone involved with casting the role of *Voyager*'s captain agrees the process was long and difficult. Rick Berman reflects: "It was long and difficult when we were casting Patrick Stewart and Avery Brooks, too. This one was maybe a bit longer, maybe a bit more difficult than either one of those."

A major understatement, by some accounts.

First of all, the role itself was a very high-stakes piece of casting. There was enormous pressure to find the "right" person to follow in the footsteps of Kirk, Picard, and Sisko. Guess wrong, and Paramount's investment would be in serious jeopardy. It was a very real concern.

Second, not every actor thinks *Star Trek* is a super gig.

Michael Piller: The available pool of talent who are willing to commit to do a series that's probably going to run for seven years is not as deep as you might think. There are a lot of wonderful actors and actresses who don't want to do episodic television for seven years.

Third, this would be the first starship to have a series built around it since the *Enterprise* and Captain Picard. Who sits in the chair was widely believed to be crucial to the series' success. Rick, Michael, and Jeri knew they could find the right woman, but Mazza and McCluggage ended up requesting that men be considered as well.

The search began. And continued. June passed. July. August was creeping up on them. So was the August 15 start date.

Michael Piller: Every available actress for this part was read or spoken with. Everywhere. Anybody. We could not find somebody that all of us agreed on.

Either amongst themselves, or between the three producers and the studio executives. The dozens of possibilities considered included Blythe Danner, Linda Hamilton, Patsy Kensit, Kate Mulgrew, Susan Gibney, and—among the men—Nigel Havers of *Chariots of Fire* fame.

Rick Berman: Michael, Jeri, and I felt that unless somebody had a really strong negative feeling, we were open to pretty much anybody that would attract two

of us. The only people we had to convince were one or two of the Paramount executives[*] who were gonna be involved in approving our selection.

The actors in the beginning that they were not crazy about...I believed they were right. They were actors that none of us felt all that strongly about to fight for. They wanted...they were maybe more interested than we were in a "name." They were maybe more interested than we were...in a "babe." In an attractive, sexy woman.

While the search for the captain proceeded, the countdown was continuing toward August 15. In addition to the captain, there were eight other roles to cast. Piller and Taylor were virtually sequestered with casting sessions throughout June, July, and August.

The routine was fairly straightforward—the initial screening of actors for the pilot was done by the independent casting agency of Nan Dutton and Associates, along with Kathryn Eisenstein and Libby Goldstein for Paramount. All who survived this initial round were then scheduled for a reading with Michael Piller and Jeri Taylor. Those who made it through that step were called back for a session that included Rick Berman. If the actor survived *that* round, there was a third callback for a reading in front of the casting people, the producers, Kerry McCluggage and Tom Mazza representing the studio, plus executives from the United Paramount Network. It became quite a roomful.

One of the first actors to sail through this process was Tim Russ. The actor was already well liked in the *Star Trek* universe.

Rick Berman: Tim Russ was the first runner-up for the role of Geordi eight years ago, and I always liked Tim. I liked his acting, I liked his voice, I liked his looks. So we were always giving him roles. There was really no role for him in *Deep Space Nine*, but we gave him roles on *Next Generation* as a guest star.

And we gave him roles as a guest star on *Deep Space Nine*. I gave him a role in the movie [*Star Trek Generations*] on the *Enterprise*-B with Kirk and that gang. And then finally we got an opportunity to put him into a role on *Voyager*. He's a wonderful actor.

[*]Kerry McCluggage and Tom Mazza.

Being cast as Tuvok must have been a vindication of sorts for Russ, after losing the Geordi role to LeVar Burton in *The Next Generation*. Then, eight years later, finding himself playing a continuing character in yet another *Star Trek* series. Russ is philosophical about the casting.

Robert Duncan McNeill as Lieutenant Tom Paris. ROBBIE ROBINSON.

> Tim Russ: I always equate this business to standing in line at a movie theater and not knowing how close you are to the doors. You know you're in line, but you don't know how many people are ahead of you. So you wait. If you get out of line you're dead. If you choose something else to do you're not ever going to get there. If you stay in line, and stay with it, you may get there.
>
> In some cases the movie may be sold out once you get right up to the door. In that case you've got to wait until the next movie. You can do anything you want while you wait, but the one thing you must never do is get out of the line.

Not a bad philosophy about life, either.

Another actor called in for an early reading also was no stranger to the producers: Robert Duncan McNeill (on the set he is called Robbie). His performance some years earlier as Nicholas Locarno in "The First Duty" was well remembered.

The call could not have come at a better time for McNeill, but he initially said "no" to the request for a *Voyager* audition. His experience is a useful look at life as a working actor.

That June he was living in a tiny apartment in New York City, doing a play in a small nonprofit, off-Broadway theater, and earning the grand sum of $300 a week. He was flat broke. His wife had just had their second child, a son, that April and was staying in Connecticut with her family because they had no money for furniture. McNeill was sleep-

ing on the floor. The play was getting great reviews, but not bringing in enough money to live on.

The end of June his agent called and said he needed to go to a casting office and get videotaped for a possible *Star Trek* part.

Robbie McNeill: They faxed me the "sides"…just the pages of the scene they wanted me to do. I didn't get to see the whole script. Just the sides. No character breakdown or anything. For some reason I thought it was for *The Next Generation* or something. I didn't know about *Voyager*. Going on tape is a long shot because you don't usually get anything from tape. So I didn't really work on it very much.

When I got to the casting office the director told me it was for a regular in a new *Star Trek* series, and that they had requested me. Oops. I said, "Uhhhh….I think it's best that I don't read for you right now, because I didn't prepare." This was on a Friday. "Let me take this home over the weekend and really learn it, and come back in here on Monday. Can we do that?"

The casting director agreed. McNeill spent the weekend studying the scene, returned to the office Monday, and went on tape. The end of that week his agent called and said the producers wanted to do a test deal.

Robbie McNeill: On television shows they usually audition lots of people, and then pick two or three to test with the studio people. It was very exciting for me because I knew I'd made the cut. Especially under the circumstances, because I had no money, and was getting nowhere with other auditions in New York. So when *Star Trek* said they wanted to do a test deal I was thrilled.

A couple of weeks went by, and Robbie was still doing the play. Then he got a call saying the test was for the following week. They would fly him out and back. Naturally he was thrilled, but for Robbie, the timing was bad. It meant he would miss one, maybe two performances of his play. The problem was, there were no understudies for his role, no one who could step in and play the part in his absence. If he left, even for a day, the play

would be forced to close, and no one would get paid. Robbie asked if the audition date could be changed. The answer was no.

The next few days were torture for him. He talked it over with his fellow actors at the theater, his agent, and his wife. McNeill finally told his agent to call and say he could not make the date, that he was committed to the play. The producers would understand that if the situation were reversed, and he had a commitment to *Star Trek* and walked away, that would not be the right thing to do.

> Robbie McNeill: So I took a *really* big risk and said "no," in favor of my $300-
> a-week job. But I felt like it would be wrong to leave, because it would force
> the play to close, and put everybody there out of work.

McNeill was lucky. His agent called and said the test would be rescheduled for the day after his play closed.

There is something to be said for integrity.

When he arrived in Los Angeles it was a Sunday evening, the test was for noon the next day, and he was extremely nervous. He had suddenly realized the stakes involved. Monday morning he looked through his clothes and his heart sank. He had nothing presentable to wear.

He took a deep breath, and decided to go to a mall and buy some new clothes to wear for the test. He had no money, but he did have a credit card that was not yet maxed out. He could charge whatever he bought. Robbie reasoned that if he did not get the part he could return the clothes. On the other hand, if he got the part he would keep the purchases. At noon he showed up at the Cooper Building in his brand new clothes…and discovered there were ten other men reading for the same part. In conversation with one of them he learned he was the only one actually testing.

> Robbie McNeill: I thought it meant one of two things. Either they have decid-
> ed this test is a waste of time but they flew me out here so they're gonna go
> through the motions. Or they haven't found anybody else but me to test, so
> they're still looking in case I don't work out.

He was indeed the only one testing, and was asked to go in the room (the same one used for production meetings) and warm up—read through the scene once, before the

studio people arrived. This had never happened to him before, to be the only one testing. In truth, it rarely happens, because the producers usually want several options for the studio to choose from.

When McNeill went in to warm up with Berman, Piller, and Taylor,` he still had a short beard he was wearing for the play. Berman asked if he always wore a beard. Robbie said no, only for the play he was in. Berman wanted him to shave off the beard because it was hard to picture how McNeill would look for the part. Robbie was willing, but he did not have a razor.

> Robbie McNeill: I went in and did my warm-up read, and thought I fell flat on my face. I knew the lines cold, but for some reason I kept having to look at the page. I was so nervous. So I walked outside, and I just knew they were thinking, "Boy, have we made a big mistake." And I'm thinking, "I'm the only one testing and look what I just did in front of these people. They don't like me with a beard, and I just blew the scene."

Outside, in the hallway, Robbie caught his breath, and thought, "Okay, that was just the warm-up. It's not too late."

Then Michael Piller came out, and said he had a razor in his office. Robbie followed Piller to the Hart Building and shaved off the offending beard, all the while mentally beating himself up and thinking that he could not blow the reading again.

Clean-shaven and back in the Cooper Building, McNeill realized he was okay. Apparently he had needed to release his nervous energy during the warm-up. In any case, he went in for McCluggage and Mazza, and "just had a great time." To him, the read went great, and he felt like he had really nailed it.

Apparently he was not alone. Several hours later he got a call saying the role of Tom Paris was his. He could keep his new clothes. After more than ten years of "paying his dues" and working in the trade, Robert Duncan McNeill finally had a steady gig.

Like McNeill and Russ, Roxann Dawson was also an early choice. For her, the casting process would be easy—one audition and two callbacks. Makeup would be another story. Playing a half-human, half-Klingon required wearing a prosthesis. Roxann was a seasoned actor, but did not know what a Klingon was, and had no experience wearing anything like what Michael Westmore had designed for her character. The first time she saw herself in the mirror, fully in character, she cried. She would later laugh at the incident, and confess that the visual adjustment was easier than she thought it would be.

Roxann Dawson: I was very interested in the part, mostly because it shoots in L.A. and it would be nice to stay home and have a life and see my dogs and my husband. I had never done a science-fiction show, didn't know anything about *Star Trek*. The first time I saw an episode was the night before my test.

Roxann became an avid fan immediately, even before she knew she had landed the role of B'Elanna Torres. She was amazed at the subject matter covered in *Star Trek* episodes, and could not believe she had lived her life on the planet oblivious to what *Star Trek* was doing. Somewhere she had formed the impression that *Star Trek* shows were not rooted in anything real.

Roxann Dawson: Actually I think the subject matter in the show is much more real and pertinent than most of the other things that are on television. I think it's the modern mythology of our time. I think it deals with subject matter in an elevated kind of way that enables us to look at it with a new perspective. And examine everyday moral and ethical decisions and choices that we have to make, but in a way that allows us to be a little bit removed from them. So we can see it with more objectivity.

Another early selection was Jennifer Lien. Only nineteen, she would be the youngest member of the cast. Her age was precisely what intrigued the producers. They wanted a young woman who looked somewhat childlike and fragile, to fit the profile of an alien with a nine-year life span. Lien was new to *Star Trek*, but not a newcomer to acting. By age thirteen she was doing Shakespeare and musical theater, and guest starring on Oprah Winfrey's *Brewster Place*.

At sixteen, she moved to New York for a continuing role in the soap *Another World*. Roxann also had a role in that soap, but not at the same time as Lien. By the time her agent called and asked her to audition for the part of Kes, she was definitely a professional. The call changed her life—at least for a while—because she had planned to leave the next morning for New York, to appear in a short film.

Garrett Wang's first *Voyager* audition was July 1. It was almost his last. Although Garrett had been acting for seven years, he had only been auditioning professionally for about the previous two. He had just gotten what he felt was a great part in an independent feature film when he got called to read for *Voyager*. His mind was on the feature, not

Engineering is one of *Voyager*'s most striking, complex standing sets. Designed by Richard James, the two-story set is truly breathtaking.

television, so when he went to read for Nan Dutton, he was not at all prepared.

Dutton was furious. After a severe tongue-lashing, she sent Wang home to study his sides. It took five callbacks before he made the cut to read for McCluggage and Mazza. He did the read and left with lots of notes, but without the part. Astonishingly, he was called back a sixth time. Again he was told he did not get the part, but that he was still in the running. By that time he was beginning to ask himself if he really needed the grief.

A week later Garrett was called back again. This time he felt he had nothing to lose. He read the scene the way he believed it should be done, and left the Cooper Building. That was August 6. The next day his agent called and told him he had the part.

Meanwhile, the search for the captain continued. It was now obvious that the August 15 start date could not be met. Production was postponed to the day after the Labor Day weekend, Tuesday, September 6. Everyone involved in preproduction heaved a huge sigh

of relief at the reprieve. Many of the sets were not ready to shoot, and the delay would add precious time to people's work schedules. When Bill Peets and Randy Burgess heard the news they and their crews were working madly in engineering. Bill looked at Randy and said, "There is a God, and she loves me."

Finally, two captain candidates emerged whom all three executive producers had good feelings about. One was Susan Gibney, whom Rick was particularly fond of.

Rick Berman: She's a marvelous actress. She had guest starred for us in *The Next Generation*, and did great work. We've used her with great success in *Deep Space Nine*, as well.

Berman felt so strongly about Susan Gibney that he put her in makeup and a Starfleet uniform and—on August 10—filmed her on the bridge, in a scene with Tim and Roxann. It did not convince the studio.

McCluggage and Mazza rejected both Gibney and the second actress. Gibney was good, they agreed, but they believed she was too young for the role. So the producers had to go back to square one and start the whole process all over again.

It was about this time that Kate Mulgrew came in to read for the role. Kate's acting credentials were more than impressive. She was a veteran of both theater and film, and was well versed in episodic television. She had a reputation for being a hard-working professional, easy to get along with, and well thought of by other cast members and production crews alike. The producers liked her, but in view of the resistance they were experiencing from the studio, they opted to continue the search.

For Kate Mulgrew, it was a heavy personal disappointment. She needed the work. Steady work. Her house was up for sale, and times were tough. Life as a working actor had been a struggle for a number of years. But Mulgrew was not about to pack it in. She had been in the business too long not to know the truth of what other actors like Tim Russ were talking about. After the audition she thought, "Well, if they don't pick me, it's their loss."

She was right, in ways even she could not have predicted.

When Ethan Phillips got the call from his agent telling him about the *Voyager* audition, he was living in New York, but attending the Sundance Film Festival in Utah. Phillips is an accomplished actor, with impressive experience on the stage, in feature films, and in television. He is no stranger to episodic television, having spent five years as Pete Downey

(the Governor's press aide) on the hit sitcom *Benson*. Nor is he a stranger to *Star Trek*. Phillips played a Ferengi henchman in the "Menage à Troi" episode of *The Next Generation*.

Ethan flew back to New York on a Thursday, picked up the sides, and looked over the scene that night. Friday morning he went into the casting office, read for the part of Neelix—on tape—and left.

> Ethan Phillips: I can't tell you the number of times I've read for a series on tape in New York, and nothing comes of it. There's an old actor's joke in New York that the tape always disappears somewhere between here and L.A. There's probably some huge bar in Kansas that's filled with actors' audition tapes. So I just dropped it. It was just one of many I go in on.

The next day the casting office called and asked Phillips to read for the part of Doc Zimmerman—also on tape. The following week he went in and read again, this time for Zimmerman. About a week later his agent called from L.A. and said the producers wanted him to fly to California and test for the role. The agent did not know which role he would be testing for. Two days later his agent called again and confirmed that the test would be for Neelix.

There was now serious interest in him, so Ethan put additional effort into studying for the audition. At the same time, he did not want to change anything he had done on the tape. He knew that the reason the producers wanted to see him was because they were happy with what they saw on tape and probably did not want any adjustments at that point.

Phillips flew to L.A., hired an acting coach named John Kirby—whom Phillips regards as one of the best coaches in the city—and worked on the scene. When he went in for the read, there was a woman sitting next to him who was auditioning for the captain. She asked if he'd seen the pictures of what the producers were planning for Neelix. That's when Ethan found out he was auditioning for "a prosthetic guy." Up to that point, he was still thinking that the Neelix character probably looked like Ethan Phillips in a *Star Trek* uniform.

> Ethan Phillips: But it didn't affect the audition. I was nervous and I read the scene. They smiled and seemed to like what I was doing. I went back out and there were three other actors there at the time. Two testing and one reading.

A gentleman from England and another guy. They read, then the producers told us all we could go and they told the English guy to stay. So I knew it was all over.

I got back to New York, and the next night my agent called and said they wanted to see me again the next Monday. I had these plans I'd been working on for months and it would be really tough to cancel them. He got back to me later and said never mind, it wasn't necessary. They don't need to see you again. Then I really knew it was over. They didn't like me.

I knew they had five days to pick up the option.* On the fifth day I called my agent and said, "What's going on?" He said, "Well, you're still very much in the game. It's between you and Robert Picardo for the role of Neelix." I didn't know Bob was reading for the role. Bob and I have gone up against each other for parts for twenty years. Sometimes he gets them; sometimes I get 'em. I think he has a little more cachet in the industry than I do, so that depressed me.

At 3:30 P.M. Los Angeles time, 6:30 New York time, I called back once more to see if he'd heard anything, and my agent said, "I don't know, but I have it from a source at Paramount that the role could be yours." Then he got a phone call so he put me on hold. When he came back he said the call was Business Affairs, and that I had the role.

The producers wanted Phillips back in Los Angeles the very next day, Tuesday, August 9. He then spent that week doing makeup and wardrobe tests. Since the producers still had not cast the captain, he flew back to New York to pack up and move out to L.A. He would not return to Los Angeles until August 30.

Ethan Phillips: And it was great, because, you know…sometimes… you just work so hard, and it doesn't happen. You don't get the part.

*According to Screen Actors Guild rules, if an actor tests well, the producers have five days to confirm the deal. During that time, the actor cannot sign with anyone else.

Perhaps Phillips was destined to play the role of Neelix, whose duties aboard *Voyager* include being in charge of the wardroom, and cooking for the crew. He did, after all, have on-the-job-training for the part some years earlier. At age sixteen, Phillips spent a year traveling around the world as a crewman aboard a merchant marine vessel working…in the officers' wardroom.

In late July, Robert Picardo was getting set to open a play at the Mark Taper Forum in Los Angeles. He was heavily involved in several other projects as well, and the last thing he had in mind was auditioning for more work. Then he got the *Voyager* pilot script from his agent, who suggested he read for the Zimmerman role.

Picardo was admittedly not very knowledgeable about *Star Trek*, and did not know its history or the traditionally important role nonhuman characters have always played. Without benefit of that background, he looked at the script, noticed Zimmerman had a rather small part in the pilot, and decided the role did not look very interesting. Just some humorless guy. He was ready to say, "Thank you, but no thank you," until he spoke with a friend who was auditioning for Janeway.

Having guest starred on *Deep Space Nine*, she gave him an enthusiastic *Star Trek* synopsis and urged him to read for the part.

> Robert Picardo: So at her behest I stayed up late that night and read the script.
> I fell in love with the part of Neelix, because Neelix is so charming in the
> pilot. He was described as humanoid, but that didn't scare me away, because
> I'd worn appliances several times before. I told my agent I wanted to read for
> Neelix. The producers said physically I wasn't right for the part. They wanted
> someone a bit shorter, maybe on the stout side. (Picardo isn't tall but he is
> trim and slender.)

The producers were familiar with Picardo's work and liked him enough as an actor that they indulged his request. He read for Neelix, felt he was successful, and was optimistic. Until he found out a day or two later that he had not gotten the part. He thought, "Well, okay. It's over," and refocused on preparations for the play at the Mark Taper.

Then his agent called and told him the producers really liked him, and wanted him to reconsider reading for the Doc Zimmerman role. Picardo looked at the part again, but still didn't see the potential. He also spoke to other friends about *Star Trek*, and was told

how the producers develop the roles of all the cast members equally. That did it for Robert, and he agreed to read for the part of Zimmerman.

> Robert Picardo: I was impressed enough with the quality of the script and all of the producers and people I'd met who were attached to the production. And I'd heard such great things about what a nice family they were to work for, by friends who had made guest appearances on the show, so I decided to pursue it.

Because of his Neelix readings, Picardo read only one time for the part of the Doctor, and that was for the producers, studio, and network executives.

> Robert Picardo: Then it was quite a wonderful surprise to find that the actor who'd been cast in the role of Neelix was an old friend of mine whom I greatly admire. Now I have the pleasure of working with him.

In contrast with Garrett Wang's experience, *Voyager* was one of the least painful casting processes Robert Beltran had ever experienced. Probably because at first, he was indifferent to the idea of playing Chakotay—or any role—in a *Star Trek* series. His was also one of the last roles cast.

> Robert Beltran: I was never a science-fiction fan, but I told my agent okay. I felt neutral about the audition, didn't much care one way or the other. I went in the first time and wasn't really trying to get the part. They asked to see me again, said they wanted to see more of an edge to the character. I thought okay, I'll give them a little more edge.
>
> After I'd read the two scenes the second time, Michael Piller said do it again, but pretend like this guy is the villain of the piece. Right away I understood what was lacking in the previous readings, and it made me relax more and have more fun with the character.

Apparently the producers were pleased with Beltran's response to Piller's suggestion. After the second run-through he was told he would be notified when to come back to read for the studio.

And then Genevieve Bujold was suggested for the role of captain. On paper, at least, she seemed to solve everyone's objections. She was attractive, the right age, and an Academy Award–winning actress; had name recognition; and even had a pleasing French-Canadian accent. She was experienced, strong, intelligent, charismatic. Although she had never done episodic television she did have impressive credentials in feature films.

She was offered the role without even reading a scene. The search was at last over. Suddenly everyone was optimistic, enthusiastic even.

Everyone, except Rick Berman.

Rick Berman: In meeting her…she's a very lovely lady…I immediately sensed this wasn't a person who was the slightest bit ready to live through the drudgery of episodic television. It's a vastly different world from features. So, I sat her down and said "I want to play a *major* devil's advocate here to you." I explained to her in painful detail what a nightmare episodic television is.

Up at 5:00 A.M. on Mondays and Tuesdays, working till 1:00 A.M. on Thursdays and Fridays. Almost no rehearsal time. Instead of doing one or two pages of script a day like in features, she'd be doing seven or eight. Never knowing her directors, and working with them whether she liked them or not. I painted as dismal a picture as I could…even worse than it actually is. I sent her home to Malibu to talk with her children and to discuss it over the weekend.

She called me first thing Monday morning and she said, "Reek, Reek, I have an answer for you. And the answer is Oui." I asked Michael and Jeri to come over here and I said, "Well, she said 'yes.' Actually she said 'oui,' but she said yes." And I still didn't buy it. I still said this ain't gonna work.

Michael Piller was happy; Jeri Taylor was happy; McCluggage and Mazza were happy. Even the media were happy. Rick Berman felt like a lone voice in the wilderness.

T MINUS TEN

Star Trek postproduction is involved from the start, right from the script. We try to avoid

hearing those words, "We'll fix it in post." It's just too expensive.

Peter Lauritson
Supervising Producer

ALTHOUGH CASTING WAS A MAJOR FOCUS OF attention during June, July, and August, there were other aspects of *Voyager* that were being developed simultaneously. While the actors were being auditioned, the sets were being built and rigged, and the costumes were being created. There were whole new alien races to design, postproduction elements to set in motion, and more names to change. The alien Gazons became the Kazons.

Based on what he had read in the script, Michael Westmore had been busy working out concepts for the Ocampa and the Kazon, and of course, the makeup and appliances for B'Elanna, Chakotay, Neelix, Kes, and Tuvok.

Michael Westmore: Gene Roddenberry's idea was that he wanted to see a little piece of humanity in our aliens, that we always find the little piece of the person in the makeup. That we don't design something that is so large that it has to have mechanics and two people to run it. Or that the mouth just opens and closes like a trap.

There's a couple of times we've done it, but always with a specific reason. The eyes all line up where eyes are supposed to be for humans. It's a person in there blinking, not a robot or something.

And Rick Berman is a big advocate of Gene's approach. I have to sell my ideas to Rick. I couldn't take an alien to him that was an inch thick with rubber. He wouldn't buy it. I may have five inches on the back of his head, or sticking out of his forehead. But around the eyes, around the mouth, I've got to get that mask thin enough so that he can see it move when they move their faces.

Ethan Phillips as the Talaxian, Neelix. ROBBIE ROBINSON.

Once Roxann had been cast as B'Elanna, Westmore and the producers decided to take advantage of her natural beauty by emphasizing the human side of her character. Westmore softened the classic Klingon forehead, and eliminated the fierce-looking teeth. The result is clearly a character with a strong Klingon heritage, but attractively human as well.

For Neelix, Westmore wanted to emphasize qualities that seemed to fit the character, whom he felt was a bit of a rogue, playful, definitely the scamp, but capable of a serious side as well. Much of the character's inspiration came from the animal kingdom.

The muttonchops evolved out of those of a warthog. The eyebrows are reminiscent of the playful and mischievous meerkat made famous in *The Lion King*. And the custom-made contact lenses worn by Ethan Phillips are patterned after a lemur's eyes. Westmore designed special teeth that are small and square-shaped, because he wanted to subtly support the idea that Neelix is a vegetarian.

> Michael Westmore: What makes our aliens and humans work so well is that they can communicate with each other. There was a love scene between Quark, for example, and Mary Crosby. She was a Cardassian. Here was this large, orange, baldheaded, big-nosed piranha-toothed guy doing a love scene with a scaly gray woman.
>
> You could strip all the makeup off them and they wouldn't have done the scene any differently. If the two of them had been doing this in some movie they would have still looked in each other's eyes the same way, had the same caressing hand movements. It's so human, the viewers really aren't seeing something that they're not familiar with.

And while Westmore went through innumerable concepts for Chakotay's tattoo, he succeeded in creating one that is composed of simple lines, yet is both generic and unique at the same time. The tattoo is distinctly different, but does not represent any identifiable tribal culture anywhere on earth. A neat trick.

Designing the alien look of the Kazon was not as much of a problem as was making the masks for the actors, because there were so many. Westmore had to hire extra make-up artists and mold makers to help get the job done. It takes time to make the appliances, but it also takes several hours to get each actor into the appliance, fully made-up, and ready to go on the set.

After *Voyager* premiered, fan reaction to the Kazon makeup was merciless. Most letters were a derivative of "they look like they're all having a bad hair day." Westmore takes it in stride.

> Michael Westmore: We do get letters from fans about what we do, especially about doing only two-armed, two-legged aliens all the time. It would be nice to do other things. We don't have time. Time and money are a constant factor.

Across the lot, on the first floor of the Cooper Building, Peter Lauritson and Wendy Neuss were busy setting up the postproduction requirements for "Caretaker." Unlike most other television series, *Star Trek* has inherently been a heavy "post" show. The series consumes great quantities of matte paintings, optical effects, burn-ins, computer-generated images, graphics, and animation, in addition to the more normal elements of postproduction—such as scoring, looping (dialogue that is rerecorded after filming), and foley (sound effects). All these separate "pieces" must be edited, mixed, composited, and finally combined together into one final digital videotape master.

The organizational and logistical problems are enormous.

Wendy Neuss: Post is a huge part of the show. I was here for a couple of months before we even got into what really is post for most shows. Most television shows, the postproduction people kind of come in towards the end, when they've got the thing shot, and they put it all together.

We have to be involved with them (the entire company and the pre- and production process) on such an integral basis, such a step-by-step basis, because they don't know what they can shoot. It affects the whole script and it affects the way everything is shot...we have our visual effects people on the set for a lot of the shots...we're a major important part of the process.

Although *Voyager* is shot on 35mm film, completed episodes are distributed to stations on videotape, and also by satellite uplink.

As head of postproduction, Peter Lauritson is continually pushing the technological envelope, in terms of what newly emerging techniques, processes, and hardware he can implement. Computer generated imagery (CGI) is a good example.

Previous to *Voyager*, CGI had been prohibitively expensive for *Star Trek*. The effects achievable can be awesome, but so can the bill for services. CGI has been used only occasionally for *Deep Space Nine*, and not at all on *The Next Generation*. Fortunately for *Voyager*, advances in hardware and software have brought the technology within at least a limited reach, budgetarily.

What really made CGI possible for Lauritson to use on *Voyager*, however, was the willingness of Santa Barbara Studios, in Santa Barbara, California, to produce CGI footage of the new starship at a reasonable price. The capability suddenly offered great new possibilities for visual effects involving the ship.

Peter Lauritson: For instance, one of the difficult things with a model...you always need a mount holding it from the top, the bottom, or the back. That limits your camera moves and some of the things you can do. If you wanted to get in really, really tight (close), and then pull out to get wider view, you're generally going to have to use two different models.

You have to build a great big section to cover the part where you're really tight, because the camera lenses and the detail on a model that is very small isn't going to allow you to get that close. So you have to build both a big section and the model. And then you have to be ingenious in the way you seam them together. We've done pretty well with that in the past but it's been limiting.

With CGI we can literally be inside the ship and pull back, out through a window, and keep pulling back to infinity, all in one smooth camera motion. That's part of the magic of the computer version. You can also do things like having the ship do corkscrews much more easily and seamlessly, and so on. So there are definite advantages to using that technology that we're trying to utilize on *Voyager*.

The cost is still such that CGI can only be used for certain shots, most notably *Voyager*'s stunning opening "flyby" of the ship, which is the main title sequence seen at the beginning of every episode—and brilliantly conceived by Dan Curry. This is why Lauritson—during June, July, and August—was so concerned about progress on the design of the ship, and the construction of the motion-control model. As with all the other aspects of postproduction, Peter had to plan ahead well enough so that after the cast and crew were finished shooting, his department could complete the pilot on time to meet its January air date.

As if to remind everyone of the complexity of "Caretaker"'s post requirements—and the planning necessary to accomplish them—on August 12 Wendy Neuss circulated a "Director's list of opticals." The script called for ninety-seven optical effects in all, not counting the CGI sequences. Most shows have three or four.

When "Caretaker" premiered the following January, it would include some half-dozen computer-generated image sequences, in addition to Dan Curry's breathtaking main title footage. All the background images for the Badlands scenes are CGI. With

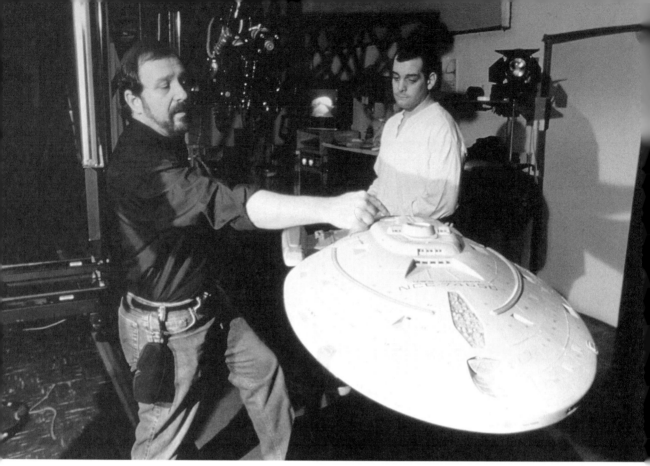

At Image G, Dan Curry oversees *Voyager*'s first appearance. GENE TRINDL.

motion-control footage of *Voyager* composited with them, the result looks as if the entire scene was filmed at the same time. A few minutes later in the episode, *Voyager*'s main viewscreen shows a giant energy wave heading straight for the ship. This too is CGI. In moments, viewers watch the ship being helplessly tossed about by that same wave. In this sequence the ship as well as the wave effect are computer generated.

Another example of Lauritson's and Santa Barbara Studios' efforts comes near the end of the episode, where the Caretaker being reverts to its true alien form. In the scene, the Caretaker metamorphoses into a semitransparent blob, with visible but somewhat indistinct internal organs. As the alien dies, the blob calcifies into a small quartzlike substance.

Some of the sequences generated for "Caretaker" would become stock footage, available for use in subsequent episodes. The scene in which *Voyager* jumps into warp drive, for instance. Hardly an episode airs that does not include this scene.

Shots like these are the reason why Lauritson is so excited about the ability to use emerging technologies to enhance *Star Trek*'s impact.

In addition to the changes that McCluggage had requested, other changes—some major, some minor—continued to be made. Among them, a name change for the captain. Elizabeth Janeway was changed to Kathryn Janeway—a substitution prompted by advice from the research consultant, Joan Pearce and Associates.

> Jeri Taylor: We became aware…and I was embarrassed that I hadn't thought of it myself…that Elizabeth Janeway is a very prominent feminist author. She is the wife of Elliot Janeway. The people that do clearances for us recommended that we not use the names of well-known people. Because it might embarrass them or whatever.
>
> We later got word secondhand that Elizabeth Janeway heard that there was an Elizabeth Janeway as captain on the ship, and she was tickled pink! But we had already changed it by then.

For a variety of reasons, script changes would not end until long after the filming was over, well into the postproduction process. Partly because accuracy and believability are major—and constant—concerns. The majority of these changes occur before, or during, filming and stem from the fact that every script is subjected to a thorough "tech" process (for "technical"). Each character name, reference, and word of dialogue is checked for technical accuracy, believability, or possible legal ramifications.

There are four separate and distinct perspectives from which a script is "tech'd."

Joan Pearce and Associates checks each word of the script for potential conflicts and clearances of every possible description. The research firm functions as an "early warning system," helping *Voyager* steer clear of problems—foolish or otherwise.

Excerpts from seven pages of suggestions regarding the pilot script, as submitted by Pearce, provide an insight as to why it is necessary to "tech" each script:

PAGE REFERENCE

5/8 <u>coherent tetryon beam</u>—We find no prominent proprietary use of this term.

8/11	Federation Penal Settlement, Midway Island - Series background. Midway (in the Pacific) is actually two islands. They belong to the United States.
8/13	I served with your father on the Al-Batani - We find no listing for a prominent vessel with this exact name. In some Arabic dialects, it means: 'my belly.'
18/24	Caldik Prime—No listing.
18/24	Ensign Kim…new operations officer—This is a very responsible job for an ensign. Even on a smaller vessel, a higher rank would be indicated. Lieutenant?
34/46	trianoline—We find no prominent proprietary use of this exact term.
34/46	We lost our nurse too—Why they do not have corpsmen begs explanation.
73/112	Boh-dye—In Chinese, this means: lame and stupid. In Japanese: spiritual awakening. In Vietnamese: Father is pissing.
	Do you want to change it?

Yes, they did.

At the same time, Jamake Highwater checks each script for relevance and accuracy to Native American details and issues. Understandably, his primary focus is on anything that concerns Chakotay. For example, his comments about the pilot script included the following:

Page 1:
I suggest that the face tattooing be generic even though the eastern

tribes who extensively used such tattoos are largely extinct. It would still be less controversial to use some other facial tattoo style as the springboard for the design.

Page 8:

I'd drop the term "spiritual diary." With rare exceptions (all of them in South America), literature was oral in the Americas. It would be a wrong move to suggest otherwise. Traditionally Indians do not commit spiritual ideas to writing, particularly since no North American tribe evolved a written language.

By the way, I think it's fine for Chakotay to speak in modern vernacular (like the rest of the crew). But you should keep in mind that if/when he speaks to his tribal leaders or elders, you should go back to the syntax of *Journey's End*.

Page 11O:

The line "Isn't that some Indian custom?" Suggest you use "Wrong tribe!" That works, and is very funny.

Each script is also checked by Andre Bormanis, for scientific and technical accuracy. Andre is *Voyager*'s science consultant. He looks primarily for mistakes or problems from a "real science" perspective—those that conflict with known science, theorems, and laws of physics. The following are examples of his comments on the "Caretaker" script:

Technical Notes —- "Caretaker"—7/25/94

* Act 4, sc. 77, p 48 (bottom)

Tuvok: "… in effect, a waiting room—to pacify us, prior to a <u>bionomic</u> assessment…"

Bionomics is really the science of ecology. Since the Caretaker has created a suitable holographic environment for us, he already has at least some bionomic data. The term 'biometric' would be more suggestive of a physical examination. Therefore suggest:

"…in effect, a waiting room—to pacify us, prior to a <u>biometric</u> assessment…"

* Act 5, sc. 92, p. 56 (top)

Janeway: "…there are no (<u>tech</u>) particles in the atmosphere…"

Suggest: "… there are no <u>tropo-nuclear dust</u>"; or, nucleogenic particles in the atmosphere…" 'Tropo-nuclear' is a hybrid term I invented from Troposphere (the layer of the atmosphere where clouds form) and nucleation, the process by which ice crystals form. 'Nucleogenic' is just a derivative of nucleation. I could defend either one if confronted by an atmospheric scientist.

* Act 9, sc. 137, p. 95 (top)

Janeway's Com Voice: "<u>The Transporters aren't working. You're going to have to find a breach in the security barrier when you get to the top…</u>"

This seems a little unclear; don't they get to the surface by way of a security breach? Suggest something like: "<u>The transport sensors aren't working. You're going to have to get to the top to establish a transporter lock…</u>"

And finally, Michael Okuda and Rick Sternbach "tech" a script from a "bogus science" standpoint—the twenty-fourth–century science and technology upon which much of the *Star Trek* universe is based. Wherever possible, anything previously established, going all the way back to *The Original Series*, must be acknowledged, adhered to, or dealt with in the appropriate manner. Okuda and Sternbach read each script, keeping an eye out for violations and inconsistencies that would pose any type of conflict. Their comments, like the following "Caretaker" excerpts, are widely circulated, to alert everyone of changes that may need to be made, and why:

Scene 17, page 12. Stadi: "Sustainable cruise velocity of warp factor nine-point-nine-seven-five…" Although the "actual" speed of warp travel is somewhat flexible, a sustained speed that high would theoretically get us back to Federation space in only about 10 or 12 years. Suggest: "Standard cruise velocity of warp factor nine-point-oh." This would leave our emergency maximum velocity rather nebulous as needed. Or, since the normal cruising speed of the Enterprise was only warp six, we could easily make this warp eight, thereby making the 75 year figure even more credible. I believe that the slower we can make our ship, the better for storytelling.

Scene 21, page 14. Paris: "Romulan ale in a tall glass."

Comment: We've seen Romulan ale a couple of times before, notably in Star Trek II. It is a light blue liquid with no bubbles.

Scene 32, page 26. Paris: "A plasma storm might not leave any debris..."
Comment: It's unlikely that even an unusually powerful concentration of plasma could so totally destroy a ship. Suggest "A plasma storm might overload a probe's sensors." Or: "A probe's sensors might be useless in a plasma storm."

It is not difficult to see the end result of thirty years' worth of dedication to this magnitude of consistency. It appears each week on the small screen and shows up in motion picture theaters all over the world. It has also given *Star Trek* a seemingly unsurpassable advantage over other science-fiction programs. The reality is, it takes time to invent things. It takes time to "think up" the details. *Star Trek* has a thirty-year head start on everyone else.

From the writer's perspective, this is an incalculable advantage.

Brannon Braga: Specificity and limitations spawn creativity. You have this Gene Roddenberry universe where the Starfleet people are ideal human beings. They've pretty much gone beyond their pettiness, their racisms, and their conflicts. You've got twenty-five years of *Star Trek* history and lore and technobabble. It's great.

Thank God there's all that specificity. That's a whole bunch of stuff I don't have to come up with. That's a whole bunch of texturing I don't have to come up with. I can use it. I can focus on the story lines and characters. It's a big help. I know how Starfleet people act. I don't have to make it up as I go along.

Even with all the script checking and rechecking, sometimes things get missed and are not caught until the camera is rolling on the set or, later than that, in some phase of postproduction—or worse, until fans start writing letters about something everyone overlooked.

We live in an imperfect world.

By the beginning of July, *Voyager*'s production staff was having regular preproduction meetings, optical meetings, planning-the-schedule meetings, and meetings about the next meetings. Part of Merri Howard's job was to keep it all straight, and somehow keep everyone informed in a timely fashion. One of her chief forms of communication was the Memo To Distribution, like the one she circulated on July 21.

To: DISTRIBUTION Date JULY 21, 1994
From: MERRI HOWARD

Subject: UPCOMING MEETINGS

The following is a list of meetings, scouts and stage walks that will take place over the next few weeks. Please leave the appropriate dates and times open:

THURSDAY, JULY 28, 1994

1. A tech location scout will leave the Cooper building at 7:30 A.M. sharp for Norwalk (Farm set) and the Convention Center (Ocampa Settlement) returning at approximately 12:00 P.M.

FRIDAY, JULY 29, 1994

1. A tech location scout will leave the Cooper building at 7:30 A.M. sharp for El Mirage (Kazon Settlement) returning at approximately 1:00 P.M.

MONDAY, AUGUST 1, 1994

1. A tech location scout will leave the Cooper building at 7:30 A.M. sharp for Griffith Park (Construction Site & Park) returning at approximately 9:00 A.M.
2. After returning from the location scout there will be a stage walk on stage 8 lasting until approximately 11:00 A.M.

TUESDAY, AUGUST 2, 1994

1. There will be a stage walk of stage 9 beginning at 9:00 A.M. and lasting until approximately 11:00 A.M.

WEDNESDAY, AUGUST 3, 1994

1. Part I of the VOYAGER pilot production meeting will tentatively take place at 12:30 P.M. in the Cooper building conference room. This meeting will last approximately 3 hours.

THURSDAY, AUGUST 4, 1994

1. Part II of the VOYAGER pilot production meeting will tentatively take place at 12:30 P.M. in the Cooper building conference room. This meeting will last approximately 3 hours.

FRIDAY, AUGUST 5, 1994

1. Part III of the VOYAGER pilot production meeting will tentatively take place at 12:30 P.M. in the Cooper building conference room. This meeting will last approximately 3 hours.

TUESDAY, AUGUST 9, 1994

1. The final pilot optical meeting will be held in the Cooper building conference room. The time for this meeting has not been set yet.

The memo's distribution list was fifty-one names long.

One of the reasons for the "stage walk" referred to in Merri Howard's memo was so that appropriate personnel could stay updated on the status of set construction. (At the time of the July 21 memo, everyone still thought the August 15 start date was firm.)

Stage walks are conducted for every new episode, usually a day or two before filming begins. People involved include the director, sometimes a producer, Richard James, Bill Peets, Marvin Rush, Randy Burgess, Brad Yacobian, and Adele Simmons or Jerry Fleck. An earlier, separate stage walk is conducted with just the director, to help him or her prepare for the episode, and to identify any special needs the director may have for that show.

While script changes and casting interviews were going on between the Cooper Building and the Hart Building, a flurry of activity continued elsewhere. On Stages 8 and 9, things had been especially intense. Of all the standing sets, the bridge was closest to completion.

Bill Peets, Scotty McKnight, and their crew were rigging as fast as they could, but the complexity of the job was an order of magnitude much larger than the bridge of *The Next Generation*'s *Enterprise*. It ended up taking them two solid weeks just to rig the bridge.

Bill Peets: We took everything we learned from *The Next Generation* and applied it to *Voyager*, in terms of rigging for lights. These sets are not just better. They are three times more technical. On the bridge alone we put in over seven

thousand feet of wire, just to light the lights. I don't know how many individual lights there are. I've lost count.

The bridge was only one standing set. There were eleven more on 8 and 9, plus seven additional interior sets specifically for use in the pilot. Time was once again the enemy.

Over on Stage 9, in engineering, Dick Brownfield was having problems with the warp core. For nearly two months he had been trying to get Richard James and the producers to agree on the colors he could use in creating the swirling, gaseous effect he had designed. Eventually, everyone settled on a combination of straw yellow, white, and blue. Breathing a sigh of relief, Brownfield thought the issue was history—until he discovered that Rick Kolbe, who was set to direct the pilot, did not like the colors.

This prompted a visit to the engineering set by Berman, who wanted to see firsthand what it was that Kolbe was objecting to. Rick Berman visiting a set was like a Command Performance. Those in attendance included Piller, Taylor, James, Kolbe, DP Marvin Rush, and some of the shooting crew. Bill Peets lit the set, and Brownfield ran the warp core so everyone could see the effect he had created.

The heart of Brownfield's design was a series of four motors, each driving the rotation of an aluminum-encased ball, and each ball set at a different axis angle to the others. Interior lights were reflected off the balls, onto the surface—the "skin"—of the warp core. The motors determined the speed of the swirling effect, and dimmer switches controlled the intensity of the lights. It was an ingenious design. The result looked for all the world as if the warp core were filled with a swirling, multicolored gaseous material.

Berman watched the device for a few moments, listening to the comments of those around him. Kolbe still did not like the colors. At length, Berman told Kolbe to shoot some footage of the warp core in operation. They would then reconvene in the Cooper Building and screen the footage to see what it actually looked like on film.

And that is exactly what they did. Berman listened to Kolbe, who once again voiced his objections to the colors. He thought they looked too artificial, not real enough. The issue involved more than just the colors. The speed of the swirling was also debated. The faster the motors turned, the faster it looked like the gas was swirling inside the warp core. Some people in the room felt the motors should run more slowly; some felt the motors should run more quickly.

After more discussion, Berman made the final decision. The colors would go away. Instead, the warp core would use blue only, and the motors would run at full speed. That was the end of the discussion, but not the end of the warp-core controversy. Well into

Voyager's fourth season there would still be conflicting positions taken by various producers regarding the speed of the motors. Eagle-eyed fans would notice that the warp core ran faster in some episodes than in others.

For Brownfield, a more persistent problem was noise. The mechanism inside the warp core was anything but quiet. That could not be allowed to remain a problem. Brownfield and Alan Bernard were often at odds over noise. On the one hand, Bernard's sensitive sound equipment could pick up a mouse breathing at one hundred paces. On the other, everything Brownfield did made noise. It was inherent in his work. Somewhere there would be a happy medium, but so far it had eluded Brownfield.

Dick Brownfield: I could easily solve the whole problem right now, by just going out and buying a new plasma field, but I can't find one. The stores all seem to be out of them at the moment.

Rick Sternbach finished the blueprints for the five-foot *Voyager* miniature near the end of July, and turned them over to Tony Meininger, who would build the model. During the design process, Dan Curry had kept a close eye on things because he would be responsible for the motion-control filming at Image G. He was therefore very much involved in the progress, particularly in offering suggestions on the placement of model mounts.

Curry wanted to make sure the surface features of the ship were designed with mounts in mind. Well-placed mounts—by which the model could be suspended—would allow for good camera angles that might not otherwise be available for him to use. That, in turn, allowed him more creativity in the design and filming of the motion-control sequences.

For the new cast, much of August and the first week of September were all about wardrobe fittings, makeup and hair sessions and—beginning August 8—camera tests on the bridge and other standing sets. The time would be easier for some than for others. For Bob Blackman, the difficulties more or less started with the dilemma in creating the right costume for Kes. Partly because of Jennifer's own personality, and partly because the producers did not know at first what they wanted.

Robert Blackman: Kes was difficult because she is a very mild-mannered, very quiet, introverted person. She acts when she walks onto the set. When she's not on the set, she's this very quiet person. But she's a dynamite actress. They cast her because they loved her. So I did these drawings kind of on the theme of a sprite. We went to the producers with her in this costume of pastel

Starships created while you wait. A small portion of Tony Meininger's model shop. Tony is one of *Star Trek*'s premiere model makers. STEPHEN EDWARD POE.

colors, and it was awful. They hated the costume. Jennifer fled from the room. She was panic-stricken. I kept saying to them, "She's just quiet. She'll be great. She's just quiet."

But we had to change it. We threw all her clothes out...all the prototypes. They wanted me to try more of a Peter Pan look, and that didn't work. Then Saint Joan came up. And that's sort of the image we're working with now. We haven't clearly defined her yet. They know that they've got a really good actress. They know that she will be able to do what they want her to do, as soon as they figure out what they want her to do.

In the end, Blackman created four different outfits for Kes, to start the pilot with.

PART

FOUR

SHOW TIME

FALSE START

So they sent me a premise for a story. I read it, and panicked. I thought, "I can't write this."

But then I started looking at it and decided it really wasn't about space creatures, it was

about eating and sex. And I thought "Well, I can write about eating and sex," and

suddenly I had a handle on it.

Kenneth Biller
Co-Producer

FOR GENEVIEVE BUJOLD, THE WEEK OF AUGUST 29 was all about contracts, makeup, and wardrobe fittings. The week included a very short "meet and greet" session in Rick Berman's office. Those present included Michael Piller, Jeri Taylor, Tom Mazza, Rick Kolbe, Genevieve, her manager, and of course, Rick Berman. Kolbe, in particular, had been quite enthusiastic when he first heard Bujold had been cast as the new captain. He had long been an admirer of her work.

The conversation was mostly chitchat—the sort of stuff people say when they are trying to get past the newness of a situation and get comfortable with one another. It never works, because getting comfortable with one another always takes time. But human beings in those situations keep trying anyway.

Genevieve sat on the couch, her manager perched next to her. Because the seating in Berman's office was limited, almost everyone else stood around and tried not to look nervous. Kind of like high-level "hanging out." Genevieve seemed relaxed, though a bit frail. She reiterated to everyone her willingness to take on the role. She was ready to begin.

After it was over and everyone had left, Kolbe remained behind. Berman asked the director what he thought about Bujold. Kolbe replied that he had two impressions. One, that she looked very fragile, sitting there. And two, it was going to be either a total triumph or a total disaster. He did not think there would be anything in the middle.

One of Bujold's first requests dealt with the name of her character. She wanted the captain's first name changed to Nicole, which was Genevieve's own birth name.

Jeri Taylor: That had an intense personal meaning to her. We were a little uncomfortable with it because, who would know it was her real name? We were afraid that people would think that we were going with the name Nicole because of Nicole Brown Simpson, which was in the news. We were afraid that might give it that sort of swarmy, exploitive feeling.

Despite the producers' misgivings, Elizabeth Janeway became Nicole Janeway.

An intensely private person, Bujold rarely granted interviews with the press. The fact that she had signed on with *Voyager*'s maiden journey did nothing to alter her aversion to the media. This was not a good sign. Press interest in *Star Trek* actors is legendary. It is part of the job, whether the actor likes it or not.

If the producers were apprehensive about these early signals, they did not show it. Perhaps they were keeping their fingers crossed, hoping that the prospect of a publicity problem would go away as the new captain settled into her role. It could happen.

Bujold's reluctance to "meet the press" did not stop the media from attempting to do what they normally do. The Hollywood trade papers were filled with the news of her signing. Feature stories ran in newspapers and magazines. Bujold was profiled on any number of television shows all over the world. For an intensely private person, Genevieve had

stepped into a cosmic spotlight. One, as it developed, that was completely beyond her realm of experience or comprehension.

The *Star Trek* universe does not ask much of its icons. It demands everything.

When Robert Beltran returned to the Cooper Building for the final studio/UPN reading on August 31, he really wanted the role of Chakotay. What had precipitated his change of heart were two factors.

First of all, he'd heard that Genevieve Bujold had been cast as the captain. He liked her work, and wanted to be in a series with her. Second, in the intervening time since his last reading for the part, Beltran had been surprised to learn how many of his friends were *Star Trek* fans, and how excited they were for him that he might be in a *Star Trek* series. Most said he would "have it made." His attitude changed. Suddenly he was no longer indifferent about the role.

Beltran went in for the read and "gave it everything I could." Two days later, on September 1, his agent called and said he had the role.

> Rick Berman: Robert Beltran was a very, very smart pick for us. He is a handsome, Native American–looking guy, square-jawed, great voice. He's very on the nose. There were those of us who were nervous about that, but he has just turned out to be great.

The producers' apprehensions about Beltran being "on the nose" were based on long experience with casting. The phrase is usually not a great recommendation for a part because it means the actor is, for that role, very obvious and predictable looking—a stereotype of the character-image they were searching for. The old silent film-era image of a dark, leering, mustache-twirling man cast as the villain is someone who is very much on the nose. Producers generally do not like an actor—or anything else—to be too on the nose. Occasionally, however, it works. In Beltran's case, it works extremely well.

Like most actors, Beltran does not like the usual casting process. His experience at Paramount was atypical.

> Robert Beltran: Casting, to me, is unpleasant. For other studios (not at Paramount) they put you in this little arena like a little bullring. And they all sit around you and they're all looking at you like you're some specimen in a lab. It's a very sterile and intimidating thing that you have to go through.

So in comparison to other network auditions I have had it was really painless. Luckily I didn't go into it right away longing for the role. I've been rejected enough in the business in the twelve or thirteen years that I've been doing this to not really get too excited about something before it's given to me.

That same week, Ethan Phillips reported back to the lot, having completed his move from New York. There were only a few days left before the start of shooting the following Tuesday. The producers hosted a luncheon for the new cast, to help everyone get acquainted with each other. Some, like Phillips and Picardo, had worked together before. Most knew of each other. Genevieve was missing from the group. Rumor had it that she did not want to be there with everyone else.

After the luncheon, Robert Beltran had a private meeting with Berman, Piller, and Taylor.

Robert Beltran: We talked about how some people are very sensitive to anyone playing an Indian role. I said the same thing I said in the auditions—I'm Mexican. I think of myself as Mexican. Meaning I'm Mestizo, which is a blend of European blood and indigenous Central American. So I think it's perfectly within my right to play an Indian. They said fine, that's what we wanted to hear. That was that.

Later, Beltran called Jeri Taylor and suggested they move Chakotay's tribal background south of the border. He could be Mayan, Aztec, Inca, even Olmec. These were all cultures known to be highly advanced in science and astronomy. Taylor eventually agreed, and the change was gradually incorporated into the series bible.

Tuesday morning, September 6, shooting began at 8:00 A.M. with a scene in the mess hall. The only cast members present were Robert Duncan McNeill and Garrett Wang. Although those present felt some sense of excitement—that this was indeed the beginning of a new *Star Trek* series—still, with only two cast members present, it somehow did not feel quite "real" yet. The next day, Wednesday, would be different. The Call Sheet indicated that Genevieve Bujold would have her first scene as a Starfleet captain—fittingly enough, on the bridge.

Later that day the actors and crew moved across the street to Stage 17, for a *Deep Space Nine* scene in Quark's bar with Armin Shimerman.

Other *Voyager* cast members, in particular Jennifer Lien and Robert Beltran, while not involved in those early scenes, would spend the bulk of the week in makeup and hair tests. This meant they would show up for makeup and hair each day, then hang around the set until there was a break in the filming. Marvin Rush would hurriedly film one of them— Jennifer in her latest hair-and-ears combination, or Beltran with the latest version of his tattoo. The videotape was then rushed across the lot to the Cooper Building for Rick Berman's approval.

Lien got off rather lightly. For Beltran, it was a different story. He and Westmore went through the process over and over—and dozens of different tattoo designs—before, at week's end, Berman finally approved a style that he felt was "just right" for the character.

Wednesday morning. The Real Thing. Set call was not until 9:00 A.M., because Rick Kolbe had shot late the night before. Even with a late start, McNeill and Wang were still officially a forced call, since they

Robert Beltran as Commander Chakotay. ROBBIE ROBINSON.

did not get their full twelve hours in between. Garrett thought that was not too bad. The series had barely started and he was picking up extra pay already. Several months into filming he would view the matter differently.

Everybody was uptight. The cast and crew had heard all sorts of rumors about Bujold. She was standoffish, and did not mix with anyone on or off the set. She refused to have photographers on the set, and refused to do publicity interviews. She did not like sitting through makeup, and insisted on looking more "natural." No one knew what was true about her and what was not.

The area around the bridge set was crowded, more so than usual. Jerry Fleck, Arlene Fukai, and Michael DeMeritt were doing their best to keep the curious onlookers off the stage, but they were losing. So were security guards Ed Herrera and L.Z. Ward. Suddenly it seemed as though everyone who had a "legitimate" need to be on Stage 8 showed up all at once, including crew, miscellaneous departmental personnel, and Paramount staffers. With various and sundry other people, like Jolynn Baca (there to han-

dle what publicity she could), the crowd was nearing one hundred. They could hardly be blamed. *Star Trek* history was being made.

Kolbe waited patiently for 9:00 A.M., and Genevieve's appearance on the set. He was not at all intimidated by the idea of filming an Academy Award–winning actor. Kolbe was quite confident. He could afford to be. The director knew *Star Trek* filming requirements like no one else. He also knew that Genevieve did not. This fact worried him a bit, but he did not share his concerns with anyone. Instead, he exchanged small talk with Marvin Rush, Alan Bernard, and some of the other crew members while he waited.

At 9:00 A.M. Genevieve Bujold walked onto the bridge, resplendent in her command uniform, captain's pips gleaming brightly from her collar. Kolbe welcomed her to the bridge. Genevieve handed him a single red rose, distributed one to each of the crew, and was ready to begin.

Kolbe started rehearsing the first scene, which included Bujold, Russ, Wang, and McNeill. The scene was near the beginning of the episode, and had Janeway entering *Voyager*'s bridge for the very first time.

Kolbe lined up the shot. Marvin Rush lit the scene. They rerehearsed the action, which had Janeway entering the bridge from the turbolift. Kolbe was not happy with the way Genevieve moved. The personal energy that he wanted from her was not there. He wanted her to step onto the bridge—which is the first time the viewers see the *Voyager* bridge—and sweep across the bridge as if it were her own living room. He wanted her to take it over, with the kind of energy that says, "I am the boss."

```
27    INT. BRIDGE                                         27

      as they ENTER from the Ready Room to see the most
      advanced, impressive Bridge facility in the history of
      Star Trek... several officers and Supernumeraries are
      working... the Security Officer is a human Ensign named
      ROLLINS.  The first officer is a human named CAVIT, who
      stands by Lieutenant Stadi who is at conn...  preparing
      the ship for launch...

                        JANEWAY
            My first officer, Lieutenant
            Commander Cavit... Ensign Kim,
            Mister Paris...

                                        (CONTINUED)
```

27 CONTINUED: 27

Cavit shakes their hands... is a little remote with
Paris...

 CAVIT
 Welcome aboard.

She motions to the Ops console and begins to move toward
it...

 JANEWAY
 (to Kim)
 This is your station. Would you
 like to take over?

 KIM
 Yes, Ma'am.

 JANEWAY
 It's not "crunch" time yet, Mister
 Kim... I'll let you know when.

Kim moves into Ops, acknowledging the other officer.
Janeway goes to the center of the room, leaving Paris
behind and his lack of a station is uncomfortable for
him, but that's the way it is... Janeway nods to Cavit...

 CAVIT
 Lieutenant Stadi, lay in the course
 and clear our departure with
 Operations.

 STADI
 Course entered. Ops has cleared
 us.

 CAVIT
 Ready thrusters...

 KIM
 Thrusters ready.

A beat. Janeway sits in the Captain's chair.

 JANEWAY
 Engage.

28 EXT. SPACE - DEEP SPACE NINE (OPTICAL) 28

As Voyager departs the station on its first adventure.

 FADE OUT.

 END OF ACT ONE

Kolbe felt the way Genevieve walked onto the bridge was much too hesitant for what he wanted to portray. So instead of rolling the camera, they kept talking about the scene. They rehearsed it again. Kolbe said he wanted more speed, more action, more energy. He kept urging her to "take over the set." But nothing really changed.

Rick Kolbe finally decided to begin shooting anyway. Everyone was ready for the first shot. Alan Bernard checked his sound levels and put the stage "on the bell." In the streets outside the stage, the loud buzzer could not be heard, but the red lights began flashing. Herrera and Ward stopped all traffic.

On the bridge, they did the first take. Kolbe still was not happy, and concluded he was simply not getting through to Bujold. An agonizing process ensued, with Kolbe doing take after take after take, and deciding he was still not getting anywhere. Time was slipping by. Jerry Fleck kept looking at his watch. He was not alone. The day's shoot was rapidly falling behind.

Eventually, Kolbe gave up trying to change Genevieve. At some point he decided to keep shooting, let the producers look at how many takes he was going through, and let the numbers speak for themselves. By then he had done more than fifteen takes on Janeway's entrance onto the bridge.

Rick Kolbe: She never did get it right. So I figured, let's just see how the producers will react to it. I didn't want to push the panic button then.

The scene eventually neared the end, reaching the point where Janeway gives the "Engage" command (made famous by Captain Picard in *The Next Generation*), sending the stalwart *Voyager* crew off into the unknown, on their first thrilling adventure together. It was a moment laden with high excitement, the promise of unimaginable dangers, a sense of wonder and magnificence, a moment larger than human life itself.

Alan Bernard put everyone on the bell. Mike DeMeritt yelled out "Rolllliiing!" Kolbe waited until the camera was at speed, then called out, "…and…Action!"

Genevieve solemnly walked over to the chair, sat down, folded her hands in her lap, closed her eyes, and said in a small soft voice, "Engage."

Stunned silence.

For a moment no one moved. Then Kolbe recovered from his astonishment and yelled, "Cut!" It was clear that the director needed to give the captain a lesson in how to fly a starship.

Shooting stretched well into the evening.

Because of the late night, Thursday morning's crew call was not until 10:00 A.M. Genevieve was due on the set at 11:00. The scene was in the ready room set, next to the bridge. Kolbe rehearsed the first shot, which had Janeway sitting down, then getting up and moving about twelve feet toward the bridge. Again, for the director, it was like pulling teeth. The first shot took about twenty takes. The crew set up for the second shot, Marvin relit, and Kolbe had Genevieve rehearse the action. After a number of failed takes, the actress stood next to Kolbe and announced in a voice loud enough for everyone to hear, "I don't think I'm right for this."

Rick Kolbe: At that moment, God's hand came in and said, "Lunch." And we had hardly accomplished anything—two or three shots, or something like that. We went to lunch and I went over to her trailer, knocked at her door, and said, "Genvieve, I'd like to talk to you."

We talked for about twenty minutes. She told me that it wasn't right, that she shouldn't do this, she wasn't right for it, it took her nine years to get used to one director, and now she had to stare down the barrel of oncoming directors every other week. And I said, "I've always had great respect for you. I love you as an actress. I think you have it inside you to give us the strength that I want."

She said, "No, I want to be a scientist."*

I said, "Yes, that is a part of your profession, but you are also the Starfleet captain."

"I cannot be the Starfleet captain; I don't have that strength."

I said, "I disagree with you. *Anne of the Thousand Days*...."

"That was twenty years ago. I don't want to do this anymore."

I said, "What I'm hearing is you don't want to do this part."

She said, "This very well could be."

I said, "Well then, I have to let you know that I now have to make a phone call, because this is a series."

She said, "Good, let's do it."

*Janeway's character background includes the fact that she is a scientist.

So I got up, kissed her on the cheek, went out and made a phone call. Then Rick, Jeri, and Michael came down and talked to her. After they got out of the trailer, we shut down, and that was the end of Genvieve.

I told Merri Howard later that I had the same feeling I'd had after a combat mission in Vietnam, which is kind of like you're ready to throw up.

Later, Berman would confirm, "Every reason she gave us was one I had warned her about." Hearing the truth is one thing. Experiencing it is quite another.

Kolbe and Fleck went back to the Cooper Building to work on the production boards. Between the two of them, they revised the schedule so shooting could resume the following Monday, concentrating on scenes that did not involve Janeway. This would allow production on "Caretaker" to continue, and give the producers perhaps a week to come up with a new captain.

The difference between being a feature-film actress and carrying the lead in episodic television is like night and day. In features, Bujold would get to take a long time just to think about what film she wanted to do next. She would get long rehearsal periods, she would have months to get to know her director (singular).

One observer described it as something like asking a novelist to take a job at the *New York Times*, and be required to write six-page articles, complete and ready for the presses, every eight hours.

Rick Berman: She really didn't have a clue. It's just an entirely different style of plying her trade. I was right after all. I got to gloat and say "I told you so" to everybody. But I'm not glad I was right. I wish I hadn't been right. But one thing I *am* glad about is that it happened on the second day.

Two months into production Genevieve's decision would have been devastating. A day and a half in... well, it was a problem that could be handled.

Finding a new captain took all of the following week. Rick Kolbe tried to keep shooting, concentrating on scenes that did not include the captain. That daily became more and more cumbersome. Finally he gave up, the producers agreed, and production was halted until a new captain could be cast.

The three executive producers went back through their lists. Kate Mulgrew was called in for a second reading. Berman had liked her when she had read some weeks ear-

lier. They also called back the other finalists they had felt strongly about. Mulgrew made the final cut, although she believed she had muffed the chance. Susan Gibney was also included—Berman was not ready to admit defeat. But it was not to be. Paramount still felt Gibney was too young, and cut her from the finalists. The producers ended up with a group of four women who all came in to read one last time. Each knew that one of them would be selected as the new captain.

> Rick Berman: It was a very nervous day. By the time they had each read for the studio guys I think Michael, Jeri, and I all agreed that Kate was the best. The studio guys agreed. And that was that. We've never had a situation before where we lost somebody and had to go back to the drawing boards and "call in the usual suspects" again. It was a long and difficult process. It always is.

All three executive producers are quick to defend Bujold as a feature actress, especially Jeri Taylor.

> Jeri Taylor: But television is a fast-paced business. It doesn't stop for anything…or anyone. In retrospect, you need someone exactly like Kate Mulgrew, who is a seasoned, veteran performer…who understands the rigors, who understands the discipline required, who has the incredible ability to focus…to shut out all the distractions and just do her work.

And so the search for *Voyager's* captain finally came to an end. Except for one last detail: Nicole Janeway again became Kathryn Janeway.

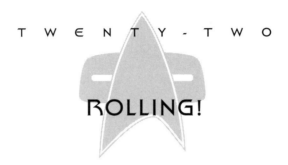

TWENTY-TWO

ROLLING!

The standard of excellence is unbelievable. Even to the finest detail. And the stories... people honor each other. It's ethical; it's moral. Everywhere else on television just the opposite seems to be the rage. *Star Trek* stands firm. It is glorious to be human. It is glorious to be any species.

Kate Mulgrew
Captain Kathryn Janeway

MONDAY MORNING, SEPTEMBER 19, KATE MULGREW stepped onto the bridge and took it over. Watching her, it was as if she had been on that bridge her entire adult life. Gone were the long attempts to rehearse scenes—it simply wasn't necessary. A run-through or two, shoot the scene, and on to the next one. Gone was the small quiet voice. Mulgrew delivered her lines with a clear, firm voice, resonating with the strength and energy of command. There was no doubt in anyone's mind that this captain owned the bridge.

A scene on the bridge during the pilot episode, "Caretaker." From the first shot, Kate Mulgrew was clearly at home in the role of the captain of the *Starship Voyager.* ROBBIE ROBINSON.

Rick Kolbe could not have been more pleased. Nor could the rest of the cast and crew. Mulgrew quickly became known as a team player, but at the same time the one who was leading the show. She was obviously in charge of *Voyager*'s crew in scenes on the set, and "took charge" of the cast members off the set—much as a mother hen might do with her brood.

She was warm, friendly, accessible to everyone, and the consummate professional. She was usually the first cast member on the set for a scene, was always on time, and unfailingly knew her lines. In short, she was a pleasure for everyone to work with.

Rick Berman: I knew from the day that Kate Mulgrew came on the show that the cast was just perfect and that she was—like Patrick Stewart—she was the

head of the cast as well as the actors who played them. She has a certain degree of personal authority, I guess, with her fellow actors, just as the captain does with her fellow crew members. The cast never ceases to please me.

Berman's sentiment about Kate Mulgrew is widely shared. Denise Okuda's observation is typical.

Denise Okuda: I'm very impressed. There's an obvious synergy with these actors that I certainly did not feel when Genevieve was here. And there was a lot of tension, too. Now that Kate's on board, the actors seem to have a really good chemistry.

Mulgrew's instant attachment to *Voyager* makes it seem as if she were born and raised on science fiction. Or, at the very least, came to the role with a strong science-fiction background.

Kate Mulgrew: Not at all. I had none. I hadn't a clue what it was. Science fiction? What is that? But I've become increasingly curious as I've been playing Janeway. Both of us are interested in science, but my personal interest is far more mystical. Science is a logical kind of thing, if you think about it. It's a logical extension of the rationale part of our imagination.

Whereas my imagination is arrested by the mystical. The spiritual. I love to read, I love to think, I love to read the ideas of people who are hard edged. I need to realize it in my mind's eye. So I try to endow Janeway with some of these qualities that I have, so that the viewer can have a hook that will enable them to let their imaginations go even further.

As if to put her imprint firmly on the production at the outset, Mulgrew gathered the cast together in her trailer one evening that first week. The occasion ostensibly was to rehearse lines. But the get-together was an informal one, and allowed each person to relax and settle in. Everyone hoped for a long-running series. It was important that they establish a close rapport as early on as possible, that they become a tight-knit group.

This "mother henning" of the cast came naturally to Mulgrew, and reflected the

influence from her childhood. At age ten, while *The Original Series* was being launched, Kate was growing up in the country, outside Dubuque, Iowa. Her father was often away, building roads and bridges. The oldest of eight girls, she developed a closeness with her sisters that she describes as "a great strength in the blood ties." She is also "profoundly attached" to her parents. Gathering the cast around her was simply an expression of the importance she places on close relationships.

Over the coming months, members of the cast and crew, the producers, and studio personnel would all comment on how swiftly the *Voyager* cast bonded, and how quickly they acknowledged Kate Mulgrew as their leader. It was said that it had taken three years for the cast of *The Next Generation* to bond and truly become comfortable.

One would think, for *Voyager*, this had all been planned long before anyone could know.

Michael Piller: This was a very long and complicated and in some ways catastrophic casting process. I think that when we look back at that choice from some distant point in the future, we will just have to wonder if there isn't some guiding hand in the universe that took us on the right course. Because I believe Kate is truly the best possible choice we could have for the part.

To outside observers, the Genevieve Bujold incident was an aberration that should not have happened. To put the matter in perspective, however, perhaps what really happened was a case of history repeating itself. Roddenberry shot the entire pilot for *The Original Series*, only to have it rejected by NBC. A second pilot was shot, with a mostly different cast, including a new captain (Shatner). In the *Star Trek* universe there is a precedent for changing captains.

From the very first take it was apparent that Mulgrew was having the time of her life. So, too, were the rest of the cast. For Ethan Phillips, the part of Neelix was beyond his wildest dreams.

Ethan Phillips: When I was at Cornell, sharing a house with eight other grad students, somehow we started this ritual of watching the original *Star Trek*. We were just blown away by this show. We would crowd around this television....I still get chills thinking about how powerful that series was.

I was a drama student; everybody else was studying art, political science,

biology. But the show spoke to all of us, no matter what our fields of endeavor were. We all responded to it. It was the most exciting moment I've ever had in television except maybe when I was a child and saw that CBS show *Panic* in 1957 and it scared the hell out of me.

We were all very much into "theatuh." I found myself saying, "Man, if this stuff is going on in television, geesus that's a lot more interesting than the plays we're doing here!" For me it validated the whole idea of going into television as an actor. You can tell stories that really affect people. Reach out to people.

It validated the medium of television in a way that I don't think any other series could have done at the time. It was wonderful. And now to find myself twenty years later on the show is bizarre, and wild, and fantastic.

Phillips also discovered that he liked wearing a prosthetic appliance. He had heard other actors say the devices were very "freeing," because they bring a sense of anonymity to the actor, which permits actors to hide behind the mask, and be as uninhibited as they want, without feeling embarrassed or self-conscious. With the added advantage of not worrying about what someone will say to him or her later, on first meeting—because people generally do not recognize the actor without the appliance.

It did not take Phillips long to begin adding dimension to his character. He quickly began informing visitors to the set, "Neelix is very handsome, very sexy. He was a male model on his home planet, you know."

Robert Picardo, on the other hand, was still trying to find out who the Doctor really was, and how to play him. Being unfamiliar with *Star Trek*, he would regularly show up in Lolita Fatjo's office and borrow tapes of episodes from *The Next Generation* and *The Original Series*. He kept saying, "I don't know anything about this." Lolita kept telling him not to worry; he would be terrific.

Picardo believed he was at a disadvantage compared to other cast members, with respect to fan recognition. Until the second or third episode aired, he continued to believe his character would not be popular with viewers. He believed people would be attracted only to characters who are warm and lovable. Perhaps. But in the case of the Doctor, he could not have been more wrong.

Picardo did, however, recognize from the outset a unique function his character plays, as one of *Star Trek*'s ever-present "mirrors."

Robert Picardo: At first, no one takes an interest in him as a person, like a human, with feelings. It has its parallel with people today who do a job and are just treated like a number. They don't get a lot of consideration.

A holographic doctor is sort of the ultimate functionary. He's just a component that you plug in. He's designed. He's not a person, he's a machine. The Doctor is a metaphor for people who work in a service position and wind up getting depersonalized. Unless they are needed, they are ignored. They are made to feel they are invisible.

Eventually, over the first few seasons, the Doctor's character arc would allow him to evolve to a level at which he would have greater control over his own destiny. But in the beginning, it was likely that millions of viewers could and would identify with Picardo's character assessment.

Kate Mulgrew was experiencing adjustments of her own to the role of Captain Janeway. There certainly was no doubt in her mind about who was in command of the starship. And she seemed quite comfortable with Janeway's position, and the difficulty facing the ship and crew as a result of the series' premise. The adjustments she struggled with were more philosophical, and grew out of her own questions about femaleness.

Kate Mulgrew: Is it possible for a woman to be profoundly authoritative, and at the same time very, very compassionate? Gentle? Tactile? I think that's what we want in human beings. I also think perhaps there might just be a scintilla of hesitation on the producers part, about all that.

Massive self-doubt might be a better way to phrase it.

The problem was a lack of experience. Not on Mulgrew's part. On *Star Trek*'s.

Roddenberry, Berman, Piller, Taylor, et al. have more than thirty years of experience with male starship captains in command of a continuing series. The territory is well known. But they have zero experience with a female in the same role. None.

So the problem is, how does she behave? She must obviously be in command. But does she have to be overtly, masculinely macho, in order to be an effective, believable captain? No one knew. Jeri Taylor probably had a better read on the character than anyone else. After all, Janeway was mostly Taylor's creation. Still, no one knew. This truly was unknown, unexplored territory.

It would take almost three full seasons for the writers to find Janeway's "voice"—to understand her personality well enough to write dialogue and scenes that Mulgrew could perform with complete conviction.

In the beginning, there was a constant search for the middle ground. Somewhere in between a simpering weakling and an aggressive Amazon warrior.

The problem is an important one to resolve, because it deals with a highly charged cultural issue of contemporary human beings—the role of women in positions of authority. Janeway is a character set four hundred years in the future. According to *Star Trek* canons, there is definitely gender equality. We have at last come to understand that women are indeed different from men. They do not have to act the way men act just because they command a starship. They have a different approach and a different rationale, and they handle situations differently than their male counterparts would.

> Rick Kolbe: It's a learning process for all of us. Kate goes through a metamorphosis trying to figure out how she would be four hundred years from now. As a director, I have to deal with it. The writers have to deal with it. And it's 1996—we're doing it in 1996.

Fortunately, Mulgrew was willing to tackle the problem with a passion, and learn along with everyone else.

It was a good thing Kate was willing to set a fast pace. There was a lot of catching up to do. The January air date was still firm, but the production was now more than four weeks behind the original start date. The only way to catch up was to hit the ground running, not stop, and not look back.

Compounding the production squeeze was the fact that "Caretaker" was not a "one-shot" television special. There were twenty more episodes that needed to be shot, and the first of these—"Parallax"—would air the week following *Voyager*'s premiere. Moreover, "Parallax" was scheduled to begin shooting Monday, October 24. That did not leave much time to finish shooting the pilot.

Tuesday and Wednesday of that first full week in September, the shooting company would be on location at the Los Angeles Convention Center. Working through the previous weekend, Richard James, Al Smutko, and their crews had transformed the facility into an alien set—a city far beneath the planet surface—for the Ocampa race. This was Kes's homeworld, and it played prominently in the action of the story.

The finished set was huge, magnificent, and visually quite interesting. Jim Mees had dressed the Convention Center set with truckloads of materials and furnishings. Bill Peets had brought in special riggings. The set was complicated and very expensive. But it did not look like the Convention Center any more. The area had been transformed into a futuristic underground city.

In all, twenty-eight days had been allotted for filming the pilot—seven of them on location. In addition to the Los Angeles Convention Center, off-lot sites included Griffith Park, a farm in the Orange County community of Norwalk, and the El Mirage Dry Lake Bed in the Mojave Desert.

Although *Voyager*'s standing sets were finished, there was still plenty of other set construction to do. There was the Ocampa enclave to build on Stage 11. This was more like the interior of a large cavern, with hydroponics and other accoutrements of life underground, apart from the "city" represented by the Los Angeles Convention Center. There were sets and partial sets to ready for trucking to the other location sites. Additional sets included a barn, a chamber, an interior of a Maquis ship, and a combination "tunnel" and "access" shaft.

This latter set, built on Stage 16, began in an underground room below the stage, and towered some thirty feet above the stage floor. Inside, a steel staircase wound its way up from the bottom, to an "escape door" near the top. The script called for some of *Voyager*'s crew to scramble up the stairwell in an attempt to reach the planet surface and avoid being trapped underground.

To heighten the sense of danger and drama, Dick Brownfield had rigged the staircase to break away and fall to the bottom at just the right strategic moment. The stunt could be deadly if something went wrong. To help support the structure and counterbalance what went on inside the shaft, Al Smutko had his crew weld steel scaffolding in place all around the exterior of the set, from floor to ceiling.

Al Smutko: You don't want to have to do too many takes with this kind of thing. Stuff has to fall off and plunge down the shaft. Of course some of the shaft walls are wild, so people can get in there and shoot. In the finished shots you look down the shaft and it looks like it goes forever. This was a very expensive set. But it worked extremely well.

The staircase set cost about $250 thousand dressed and ready to shoot. It was used one day. The next day it was torn down and discarded.

In all, Richard James spent about $2.5 million on sets for "Caretaker." The overall budget for the pilot was originally established at about $6.5 million. Decisions in late November would push costs considerably higher.

Voyager was now in full production. Each passing day more film was shot. This triggered a number of other activities. Every morning Rick Berman, Jeri Taylor, Michael Piller, Peter Lauritson, Supervising Editor J.P. Farrell, and others would screen the dailies—all of the footage shot the day before.

J.P. has three full-time editors on his staff, Bob Lederman, Tom Benko, and Daryl Baskin, with an assistant editor for each—Eugene Wood, Jim Garrett, and Lisa De Moraes. Lederman and Benko were set to edit "Caretaker"; Baskin would edit "Parallax." Succeeding episodes would be taken in rotation, similar to the way in which the visual effects supervisors were each assigned to alternating episodes.

Screening the dailies followed a set pattern every morning. Berman would comment, and J.P. would take notes and later give them to Lederman and Benko, who would then begin editing (assembling) the footage into scenes. Gradually, as more footage was shot, the editors would have enough film to actually begin assembling the scenes into sequences, eventually filling in all the missing scenes and ending up with the first rough cut of the entire episode. Since "Caretaker" was a two-hour show, the editing process would theoretically take twice as much time to finish as a regular one-hour episode. Thus the need for two editors working simultaneously, to speed up the work.

For a variety of reasons, things did not work out that way.

This process of looking at dailies, making notes, and editing the scenes together was supposed to continue throughout September and October, at which time Berman would be able to screen a rough cut of the pilot. Missing, of course, would be all the enhancements such as optical effects, blue-screen shots, music, and sound effects. But the basic story would be there, in its proper order. That was the plan, anyway. Not until well into December did the rough-cut screening finally take place.

It was during the morning ritual of screening dailies that The Problem was first noticed.

Hair.

Kate Mulgrew's hair.

During the first few days of filming Mulgrew had worn her hair down, so that it naturally fell about her shoulders. This was the style the producers had chosen from a number of alternate concepts designed by Josée Normand, the department head hairstylist.

Jeri Taylor: When we saw the first days' dailies we began to feel this was a mistake, because she has hair which is somewhat fine. When she moved her head you could sort of see through the hair. There wasn't enough hair there (to create a solid mass). So we thought well, maybe this is not the hairdo, and began doing other styles on her. After a while—fairly quickly, actually—we found the hairdo she has now, which is up on her head. The executives at the studio really liked that hairdo a lot.

In the meantime, though, while everyone was trying to decide on a different hairdo for Mulgrew, she continued shooting scenes with her hair down. Once the new style was approved, the rest of the pilot was shot with Mulgrew's hair up.

In the *Star Trek* universe it is necessary to have a reason for things happening. Everything must have rationality to it, a consistency. How could the producers explain two different styles of hair?

Well, they could reshoot those scenes with her hair down.

No, they could not.

Jeri Taylor: Two of the days that we shot her with the hair down were on location at the Convention Center. It had been a very costly location. We couldn't go back to recreate it. We didn't have the money to do that. So we decided that for this one segment in the middle of the show, when she went down to the planet, her hair would be down. You know, people do change their hair…it seemed perfectly legitimate to us.

But not to the studio.

Jeri Taylor: The studio executives liked the way she looked with her hair up so much that they wanted us to explore the possibilities of reshooting to get her hair up for that segment. Which meant going back to the Convention Center, reconstructing the set and a few other things.

This was no small undertaking, and McCluggage and Mazza knew it. But a lot was riding on *Voyager*'s launch. The new series was the linchpin of the United Paramount

At the Los Angeles Convention Center, during original filming of a scene in the Ocampa underground city, from the pilot episode, "Caretaker." Note Kate Mulgrew's hair, which led to this scene (and others) being reshot. ROBBIE ROBINSON.

Network's programming launch—and its game plan for success as the fifth network. Studio and UPN executives were afraid the differences in Mulgrew's hairstyles would distract viewers. They were worried that viewers might think their starship captain was more concerned about her hair and how she looked, while preparing for a dangerous "away mission" (off the ship), when she should really be focusing on solving the problem at hand.

The executives were not willing to risk having anything in the pilot that would lessen its potential dramatic impact on viewers, and possibly dampen enthusiasm among *Star Trek* fans. Especially not hair.

At a minimum, inserting Mulgrew's new hair (with her underneath it) into the pilot would require reshooting two days on the bridge, two days in the Ocampa enclave, and at least one day back at the Convention Center. There were plenty of problems with the idea,

The rebuilt Okampa enclave set on Stage 18, during the hectic reshoot for "Caretaker."
ROBBIE ROBINSON.

starting with the fact that the Ocampa enclave set had already been struck (completely torn down). Worse, there was no guarantee that the Convention Center, usually booked years in advance, would be available at all.

At the very least, both the Ocampa and Convention Center sets would have to be recreated from scratch. It was a huge undertaking, aside from the expense involved. No one really believed Paramount would okay the reshoot when they found out how much it would cost.

Despite the final cost, Tom Mazza and Kerry McCluggage both agreed: "Do it."

The reshoot was a staggering complication. Production was by now well under way on "Parallax," with "Time and Again" scheduled to go before the cameras in little more than a week. Rick Kolbe was set to direct "Phage," and "Eye of the Needle" as well—the

latter slated to roll the first week in December. But he would also have to be available to direct the "Caretaker" reshoots, whenever those scenes were ready.

Kolbe's schedule was a problem, but there were others. The Convention Center would have to be rebooked, if it was available at all. New sets would have to be built. Stage 11 was no longer available, as it was now occupied by a feature production. A substitute had to be found on which to rebuild the Ocampa enclave. The best option was Stage 18, but that was normally reserved for *Deep Space Nine*'s swing sets. A window of four days' time was identified in early December. About the time Kolbe was supposed to direct "Eye of the Needle." It would have to do. They would have to make it work.

The planning went on, and became a logistical nightmare. Somehow everything had to get done in time to make the air date. It was bad enough to have to reshoot scenes. What made it worse was the fact that the new footage had to be filmed to a predetermined length. To the second.

Lederman and Benko had been hard at work trying to get the first rough cut ready. Suddenly they found themselves in an impossible situation. New scenes were going to be shot that would replace some of those already edited together with the rest of the footage. The "old" scenes would have to be removed—creating holes in the episode—and the "new" scenes inserted in their place. In such a way that viewers could not tell where the surgery had been done.

In order to have a prayer of doing that, Kolbe had to have the actors re-create the new scenes so they were identical in length to the ones being removed by the editors. A pause between lines of dialogue just a second or two longer than what was done in the earlier version of a scene would be enough to throw off the timing, and the new footage would not "fit" in its appropriate hole.

Episodes have a predetermined length for air time, usually forty-six minutes per hour, which cannot be exceeded. Thus, filming had to be timed to the second (to the frame, actually), for each scene reshot. Otherwise the scenes would not fit, and the pilot would be either too long or too short. That would be catastrophic. Arlene Fukai would be on the phone to postproduction every day, from the set, getting the timing needed for each scene, so Kolbe could film to the exact length required. By the time the "Caretaker" scenes were being reshot—on top of what was by then going on with "Eye of the Needle"—the pressure was, by any measure, insane.

The editors were feeling the pressure at least as much as Kolbe. With the reshoot yielding new footage, which in turn required the disassembly of previous work and the reassembly of those same (but new) scenes all over again, plus other changes, Lederman

and Benko would find themselves hard-pressed to get the job done, even on the revised schedule. Each man would also be on the phone constantly with postproduction, getting new running times for each scene, again to the exact frame. The small, windowless cubicles they work in every day became pressure cookers of a different kind.

The task of timing everything out, and feeding the exact footage numbers to the sets each day of the reshoot, fell to Wendy Neuss.

Wendy Neuss: I wasn't working on *Deep Space Nine* when they did the pilot. I was on *The Next Generation* at the time. But I'll never forget what those people went through. They were just dubbing and remixing and redoing and reshooting up to the last minute. I thought "Uh! What a mess!" you know? "Those poor disorganized fools." And of course there I was, in the same situation, working on *Voyager*.

The gods of production have a twisted sense of humor.

Just because "Caretaker" was being shot and reshot did not mean the producers had nothing else with which to occupy their time. During the months of September, October, and November, the Hart Building was a hotbed of activity for more than just the pilot. Brannon Braga had completed the teleplay for episode two, "Parallax," and was well along with writing the teleplay for episode four, "Phage." Michael Piller was finishing the teleplay for episode three, "Time and Again." As soon as he completed the script, he would immediately start writing the draft for episode five, "The Cloud." And Jeri Taylor was deeply engrossed in developing the teleplay for episode six, "Eye of the Needle."

Sitting at her desk in the Hart Building, across the hallway from Jeri Taylor's office, Lolita Fatjo knew it was at last crunch time. She also knew it would *stay* crunch time until the following April, when *Voyager* went on hiatus for two months. It was Lolita's responsibility to proofread every story, every script, every rewrite generated by Piller, Taylor, and Braga. When Ken Biller joined the writing staff in October, she added his output to the pile.

Lolita also checks every script for continuity of details (the *Star Trek* universe is consistent). The Klingon Homeworld, for example, cannot be referred to as the Klingon "home planet." Believability, and the suspension of disbelief, spring from the detail.

Several months earlier, Janet Nemecek had been hired to assist Lolita, as activities cranked up toward the start of production. Janet takes the diskettes from each of the

writers, puts them in screenplay format on her computer, and Lolita sends the drafts out to be printed and distributed.

Every draft. And every change.

Each time a change is made to a script—even a single word change—a new "change" page is generated, color-coded for identification. Some scripts get so many changes they look like all the colors of the rainbow and all the hues in between.

> Lolita Fatjo: On *Star Trek* there are so many changes. I am certain that we put out more revisions on every episode than any show in town. A lot of the changes are basically cutting things because the scripts are so long. We have so many special effects and opticals that it's difficult to judge how long some of those things will take. It's always kind of sad because I've seen some great scenes get cut. But what can you do?

Lolita also handles the open-script program created by Michael Piller when he first joined the staff of *The Next Generation*.

By early October, Paramount had decided it would create a web site on the Internet, to help support the ever-expanding interest in *Star Trek*. Over the next several months proposals were drafted and an initial staff assembled. One of the early members of the new department was Guy Vardaman, who had been working for Viacom Consumer Products. As part of his job, Guy developed a strong familiarity with fan-club actvities and fan-related publications worldwide. With a strong background in computers, it was a small step to make, from print media to the world of digital media.

Eventually Paramount formed an entire new division, Paramount Digital Entertainment, and made a deal with Microsoft Network for the launch of their new web site. It went online in mid-1996, at www.paramount.com. Like every other *Star Trek*-related activity, it did not happen overnight and it did not happen without a lot of lost sleep and many weekends with no days off.

Fans, ever vigilant, got wind of the new web site and posted messages on the Internet. The following one was typical:

MSN & PARAMOUNT ARE PUTTING IN A STAR TREK AREA ON MSN. I READ ABOUT IT IN THE STAR TREK COMMUNICATOR ISSUE 106.

IT WILL BE THE ONE OFFICIAL STAR TREK INFO SPOT WITH INTERACTIVE PARTICIPATION WITH ALL THE LATEST COOL STUFF.

ITS SCHEDULED TO BE HERE IN EARLY 1996 (SOON I GUESS) YAHOO!!!!!

Also in early October, Michael Okuda found himself at one point going out to Tony Meininger's shop to help finish the surface detailing on the *Voyager* model. Time was getting short, and Image G needed the model so they could start filming the motion-control sequences. One of the *Deep Space Nine* art department staff volunteered to go along and help.

While Okuda and the "volunteer" (who must remain nameless) were working, Wendy Neuss dropped by to check on Tony Meininger's progress. She was starting to have anxiety attacks over the time crunch. Wendy immediately saw Michael and "Mr. X," both of whom, of course, she knew quite well. She also knew that because Mr. X worked in the *Deep Space Nine* art department, he was not officially supposed to be working on anything connected with *Voyager*. Grateful for the eleventh-hour assistance, Wendy winked at Okuda, then looked at Mr. X, grinned, and said in mock surprise, "Oh! And thank you very much, whoever you are!"

This is not an isolated incident. There are lots of "ghosts" and "volunteers" in the production company who put in time unofficially, simply because they have a passion for the *Star Trek* universe. *Star Trek* engenders that sort of never-mind-the-rules-and-forget-about-the-money-we'll-all-pitch-in-and-get-the-job-done-anyway attitude.

During the third week of October, Tony Meininger delivered the five-foot *Voyager* model to Andrew Millstein and Tim Stell at Image G, who were waiting to begin the motion-control photography. Image G was also scheduled to film other miniatures for the pilot, including the Array, the Maquis ship, and the Kazon ship. Filming would be done under Dan Curry's direction, although Curry was already spread pretty thin with all the other optical and blue-screen work needed for "Caretaker." The situation only got worse after "Parallax" started shooting.

Like everyone else, Curry found himself trying to juggle the production requirements of the pilot while simultaneously handling the same chores on each new episode being filmed. David Stipes would end up supervising much of the late-night work at the Image G facility.

And on Stage 16, Dick Brownfield got to play.

After Image G finished the motion-control photography on the Array, Brownfield took the model to Stage 16 and blew it up. Not because it had become the bane of everyone's existence, although that was a possibility. Necessity was the real reason.

Near the end of the pilot, Janeway destroys the Array. Brownfield's "playtime" was strictly business, caught on film for that climactic scene. But it required two takes to capture the desired footage. The first time Brownfield blew up the Array, it came apart only partially. After he repaired the model and reset the charges a second time, the Array blew itself apart quite nicely.

Even as he engineered his magic, Brownfield could not entirely put aside a disturbing thought shared with everyone else involved with *Voyager*: not knowing how viewers would react to a series with a woman captain. Everyone was stressed about it. Most believed viewer acceptance would be high, especially with Kate Mulgrew in the role. But no one really knew. In thirty years of *Star Trek*, this situation had never happened before. What everyone did know was that on January 16 the jury would get the case, and then the verdict would not be long in coming back. *Star Trek* viewers are not noted for their reticence about expressing themselves on their favorite subject.

Overriding the concern about the woman captain, though, was simply the sheer magnitude of the work that needed to get done before the January premiere. Every department was under tremendous pressure, working feverishly on multiple tasks at the same time. The writers, as the fount of everything that followed, were among those least visible, yet most pressured.

In their respective offices in the Hart Building, Piller, Taylor, Braga, and Biller were all writing teleplays. But they had other duties that required their attention, siphoning time away from their computers. Several times every day each had to listen to "story pitches" from outside writers. These are sessions, either in person or by telephone, in which the freelancer is given twenty minutes to present a script idea.

Story pitches absorb precious writing time for the four producer/writers, but they also ensure a steady stream of ideas for scripts. Generally, the producers will buy a story idea they like, and one of the four will then write a teleplay based on that idea. Occasionally a freelance writer will write a complete script, but this is primarily limited to writers who have previously written scripts for either *The Next Generation* or *Deep Space Nine*.

Then there are story-break meetings, out of which the beat outline is developed. As Ken Biller observed, "The term is appropriate because we beat it to death." These meetings can take two or three hours, and generally occur two or three times each week. More

time away from writing. There are also production meetings, casting sessions, press interviews, note-taking sessions with Rick Berman, and...more time away from writing. During those early months of production, the days got longer, the evenings got later, and the weekends began to blur into an endless stream of days.

The physical body can take just so much stress. At some point, all the body parts get together, take a vote, and say, "We're not doin' this crap anymore." And the body stops. In some way, it just stops. For Ken Biller, it was his back. The pain became so intense by early December that he could not work even a semblance of normal hours. Lying flat on his back in bed was the only thing that brought a measure of relief.

For Jeri Taylor it was virtually her entire body. Exhaustion took its toll, and daily it became more difficult to put one foot in front of the other. Sandra Sena walked into Jeri's office one morning and found Jeri immobile, sitting at her desk with her head in her hands. Jeri looked up, managed a weak smile, and said almost apologetically, "I guess I need another cup of coffee."

Jeri was not alone.

In different variations on a theme, this same scenario was being played out throughout every department working on *Voyager*. Al Smutko and his crews were literally hustling seven days a week. Forget Sundays. Forget days off. As December began, the schedule worsened. He was forced to squeeze in building the sets for the "Caretaker" reshoots—slated to begin December 12—in between building sets for the season's episodes, which were now in full swing. This placed additional stress on Bill Peets, Bob Sordal, Randy Burgess, Jim Mees, Ed Charnock, and their crews, all of whom had to rig, paint, light, dress, shoot, and tear down each of the sets. It was a scramble to keep up.

Postproduction was no better off. Peter Lauritson, Wendy Neuss, Cheryl Gluckstern and the entire staff were seemingly everywhere at once, trying to keep ahead of the oncoming tide. The more footage shot, the more work there was for them to do. Adding to their burden was the fact that much of their work was off the lot.

On an average day, Wendy Neuss and Dawn Velazquez might be at Modern Sound, in Hollywood, supervising the recording sessions with the actors as they looped their lines. Peter Lauritson might be a few blocks away, at Unitel, supervising online editing. Ron B. Moore might be at Amblin Imaging, in Santa Monica, supervising the creation of an optical effect. Bob Bailey might be at Illusion Arts, in the San Fernando Valley, reviewing progress on a matte painting. David Stipes might be nearby, at Image G, supervising motion control photography. And Dan Curry might be ninety miles north, at Santa Barbara Studios in Santa Barbara, supervising the design of a CGI sequence. It was no

The beat-outline board in Jeri Taylor's office, where many a *Voyager* story has been beaten into a state of useableness. STEPHEN EDWARD POE.

comfort for any of them, sitting in traffic, knowing the clock was ticking. Meditation time.

J.P. Farrell's staff of editors, in a way, were fortunate. They could at least stay out of the line of fire. The editing rooms were like an insulated world of their own, located at the back of the lot, upstairs in the old Hagger Building. J.P. was not so lucky. He had to make all the meetings in the Cooper Building, and that alone was more than a full-time job.

Rick Kolbe was pressed to the wall as much as anyone, perhaps more so. Kolbe had

directed "Caretaker"; turned right around and directed the third episode, "Phage"; and then went straight into preparation for "Eye of the Needle," the series' sixth episode. He was trying to research and prep one episode while directing a different one, and at the same time review the director's cut (the first full edited version of an episode) of yet a third.

Compounding this insanity was Kolbe's need to prep and direct the reshoots on "Caretaker." "Eye of the Needle" was scheduled to start filming on Wednesday, December 7, for a normal seven-day shoot. But the "Caretaker" reshoots were scheduled for Monday and Tuesday, December 12 and 13. That meant Kolbe—after shooting the first three days of "Eye of the Needle"—would have to break his concentration on that episode, refocus his thoughts on "Caretaker," and try to get both himself and the actors emotionally charged up to re-create the energy of the "Caretaker" scenes he had shot two months earlier. And then, two days later, on Wednesday the fourteenth, do the same thing all over again by trying to resume the energy and focus on "Eye of the Needle."

An outside observer might easily wonder if there was just a touch of the irrational in all this.

All the more so because what *Voyager*'s production company was going through at that time was not, and still is not, an isolated incident that only happens to one particular television series. This ongoing—because it never stops—maelstrom of activity and constant change in every area is part and parcel of episodic television production. At every studio.

For *Voyager,* the complexity and magnitude of the overall task inevitably results in things being late. Much of this lateness originates with the scripts. It is not anyone's fault, really. It is simply a product of the way the system works. The very nature of the scriptwriting process automatically condemns each new script to being "finalized" (a euphemism, at best) at the eleventh hour: Story. Rewrite. Notes. Rewrite. Beat outline. Notes. Rewrite. Draft script. Notes. Rewrite. Second draft script. Notes. Rewrite. Final draft script. Notes. Change pages. Etc., etc., etc.

Any writer who gets too emotionally attached to his or her words will soon be history, for *Star Trek* scripts, anyway. For word-ownership-sensitive writers, or writers who are prima donnas with their words, the process is ruthless. And unforgiving—writers of this ilk will not be asked back a second time.

After a first-draft script goes into distribution, subsequent changes can—and often do—materially affect what any given person in any department is working on at the moment. This entire cycle of change is the order of the day for *Star Trek*, and will proba-

bly remain so for as long as one of its series is in production. It is the nature of the beast.

One of the most dreaded apparitions is the sight of PAs Kat Barrett or Andrej Kozlowski riding up on a bicycle with change pages for the current script. On the stage, especially, what follows is a daily ritual—Arlene Fukai, Michael DeMeritt, Cosmo Genovese, or other crew members struggling with a handful of multicolored change pages, hurriedly updating their copies of the script.

Rick Kolbe: Everything is last minute, so you cannot find the best alternative. You have to build sets overnight, which costs an enormous amount of money, which never shows up on the screen. The same set is there, but it costs three times as much because it has to be constructed over the weekend and during the night because everything was late and the decisions were made late.

The writers have the advantage of saying, "So it's two days late." Well, if I go two days over on my show, it's going to cost a lot more money. I will have everybody who wears an Armani suit on my back. At the same time, everybody wants a James Bond movie, but they want it for $1.8 million. It puts the onus on us in the shooting company because we have to pull it out of the fire now.

Nobody sits there and says, "Yeah, well, the script was late." If we get behind, we go over budget. Then the arrows will fly in our direction. Ultimately nobody will watch the final show and say "Yeah, you sure went over budget on that one." They will say either it looks good or it doesn't look good. If it doesn't look good, it doesn't matter whether you were under budget or over budget. The chances are good that you will be working on some other show very soon.

The whole process is a kind of cinematic madness.

In thirty years of *Star Trek* production, nothing has changed. It still so often comes down to scripts at the last minute, budget problems because of that, and long brutal hours for everyone down the line. The years go by. Production technology advances. Editing equipment gets more bells and whistles. The work expands to absorb the time saved by all the new technology. That negates the advantages gained in time saved. Round and round. It's like running in place. No matter how fast you run, you have the feeling you're not ever going to get anywhere. Everybody still suffers. Nothing changes. Especially not the price.

But viewers have their favorite show every week.

TWENTY-THREE

WARP SIX

"Futuristic" does not automatically mean "peculiar." The first answer is not always the right

answer. Let's think about it and see how much we can push it over the edge so it's

still believable but not at all what you think.

Jim Mees
Set Decorator

THE THANKSGIVING HOLIDAY SLID BY ALMOST unnoticed. The demands of *Voyager* blurred the days into meaninglessness. The new series was racing firmly into its first season of production. For a significant number of the company, matters were continually compounded by the fact that they also had work to do on *Deep Space Nine*. By the time of the production meeting for "Eye of the Needle" on Monday afternoon, December 5, the last thing anyone needed was another

complication. So of course they got one, in the form of the five-acts-to-four pronouncement by Rick Berman. As people left the meeting and went their separate ways, the load each carried was definitely getting heavier.

Call it a Christmas miracle or largesse from the gods, or maybe someone up there just decided the kids needed a break. Whatever it was, it was more than welcome, because the Call Sheets distributed Tuesday morning showed little immediate change. All sets would work on the days originally scheduled. Jeri Taylor's skillful rewrites of the act endings were such that minimal changes were needed in the production boards, in turn enabling Adele Simmons to make quick work of the boards, and Arlene Fukai to get the revised Call Sheets out in a hurry.

Reading the Call Sheets in their respective offices early the next day, both Richard James and Al Smutko breathed heavy sighs of relief. Their staffs and crews had more than enough to do as it was; they could use a bit of good fortune. There was still an incredible amount of work left to do for the "Caretaker" reshoots, but relief from any problem at this point was a gift from the gods.

When Alan Sims read his Call Sheet he was elated. The metal cylinder that Berman had insisted needed more work now had more time as well. It was not scheduled to be used on the bridge until the end of the following week. Sims immediately relayed the news to the model maker. And immediately focused his attention on getting the props ready for Monday's "Caretaker" scenes at the Los Angeles Convention Center.

And so it went, as each person read the revised Call Sheets. Wendy Drapanas was more than pleased. According to the production schedule, the Jane Eyre set would not work until Monday, December 19. That meant she had much more time to complete the portrait of the woman…the one with the unrecognizable face. Likewise, over in the *Deep Space Nine* art department, Denise Okuda and Jim Van Over let out a chorus of gleeful yells as they read the revised sheets. It did not mean anyone was out of the woods yet. But maybe, just maybe, the impossible could get done after all.

Richard James's PA, Tony Sears, was also delighted. He was almost frantic, trying to support the needs of James and the entire art department staff, just trying to get ready for the "Caretaker" reshoot. The news from the Call Sheet didn't exactly give him more breathing room, but it helped.

Until 1989, Tony had worked as a theatrical director at the Art Center on Hilton Head Island, North Carolina; he still returns there annually to direct a play. It seems odd that an aspiring director should end up spending the last five years working in film and television art departments, but Tony does not mind.

Tony Sears: It's given me a point of view on directing that I might not otherwise have had. In an art department you really have to break down a script carefully (decide what sets need to be built) because you've got to create the setting that the actors are going to act in. So the art department experience gives me a different perspective, more complete than, say, only thinking about, "Where do I put the camera?"

Being a PA is a double-edged sword. On the one hand, you get all the grunt work. All the crap jobs that no one else wants to deal with. The department gopher ("Tony, go for this; Tony, go for that"). On the other, it is an ideal position from which to springboard to a higher position "in the business." As an on-the-job-training-by-fire-learning-opportunity, being a PA is hard to beat.

Many PAs have their sights fixed on directing, writing, or producing. They work on a studio lot as a PA because it gives them a chance to participate in creating for television and film, and to learn some things they might not otherwise learn while working as a waiter or parking cars. For Tony, being Richard James's PA is a much better deal than waiting tables.

As a general rule, PAs don't get a great deal of respect. They are at the bottom of the food chain. And there are some people who never let PAs forget their place— Hollywood is legendary for inflated egos, temper-tantrum-throwing supervisors, and tyrants who rule their departments or crews like a royal fiefdom. Being a PA has about as much glamour attached to it as a chunk of used asphalt. To some executives, the replacement values are about the same.

Still, for those who can hang in there, endure the insults of man, machine, the system, and the vagaries of God and nature, the rewards can be meaningful. For some Hollywood newcomers, there simply is no other way to get started in the business.

Friday evening, December 9. 9:15 P.M. Stage 8.

During a break in shooting "Eye of the Needle," Rick Kolbe walked across the street and into Stage 18 to look at the Ocampa enclave set. A few of Smutko's construction crew were working inside, and so the large roll-back door was wide open. The cold crisp December air filled the stage. Kolbe would be shooting there the following Tuesday, as part of the "Caretaker" reshoot, and wanted to see how construction was progressing.

The Ocampa underground city, a matte painting prepared by Illusion Arts, under the direction of Dan Curry, *Voyager's* visual effects producer. This painting was used in the pilot episode, "Caretaker."
STEPHEN EDWARD POE.

Roughly the same size as Stage 8, Stage 18 is normally used as a swing set stage for *Deep Space Nine*. Immediately inside the big door, however, are the standing sets for that show's *Defiant*-class starship, a sleek new ship introduced in *Deep Space Nine's* third season. Kolbe made his way though the ship, emerging into the main, open area of the stage.

Very much a work in progress, the Ocampa set was nevertheless beginning to take shape. Toward the rear of the stage was an enormous open area where men were building fake rock walls, to give the appearance of an underground cavern—the enclave. In the foreground, suspended from the ceiling, were high-tech-looking columns and structures with electrical wires dangling out of the sides. On the sides of the stage were large, unfinished walls with glassless windows. Two huge columnlike pieces—with more electrical wires protruding—hung from the ceiling down to within six feet of the floor. Large metal

rings encircled each. The floor was covered here and there with piles of dirt that had been brought in, to simulate a cavern floor.

Michael DeMeritt appeared on the stage and said they were ready for the next shot. Kolbe looked around for a moment, made a mental note to ask Richard James about the type of greens he planned to use behind the walls on either side of the set, and then walked with DeMeritt back across the street to Stage 8.

The "Caretaker" reshoot was a massive undertaking. Smutko's crews worked through the weekend, as did Jim Mees and his crew, Ed Charnock, and a sizeable contingent of others. By 6:00 A.M. Monday, a substantial portion of the Convention Center no longer looked as if it belonged on planet Earth. The day's shoot went off as scheduled. With all the work everyone had put into the preparations, the filming itself seemed almost anticlimactic.

Kolbe's instincts about the greens for the Ocampa enclave set proved accurate. When he walked Stage 18 again Monday evening with Richard James and Michael Mayer, he complained there was not enough coverage behind the walls. He wanted a taller, greener, lusher look. Mayer said he would have more greens brought in—he thought some eucalyptus would fill in the area nicely. The problem would be solved before Kolbe came in the next morning. And it was.

Tuesday's shoot in the Ocampa enclave started on schedule, with a set call of 7:30 A.M. As the day wore on, it became obvious that this was going to be a long day. Part of the problem was Kolbe's dissatisfaction with several master shots throughout the day. He didn't like the energy of some of the actors, the way they moved and interacted with the Ocampa aliens. The day got longer. Shooting went late into the evening, with the final shot wrapping near 11:00 P.M. With "Eye of the Needle" set to resume the next morning at 7:30, that meant a forced call for most of the cast and crew. There would be precious little sleep for them that night.

Besides all the work to do, there was that other life going on "out there" in the real world.

Christmas was coming. By mid-December, cast and crew were wondering if there would be a break over the holidays. The answer was "yes" for some, "no" for others. Al Smutko's construction crews would have to work straight through. The cast and shooting crew would get the week off between Christmas and New Year's. Most of those in the Cooper and Hart Buildings would also get a break. But not Dan Curry, or David Stipes, or Wendy Neuss. Or their PAs.

They, and a few others had to keep the postproduction effort moving on

"Caretaker." The completed show, final in every way, was due to be delivered to Paramount by January 10. It seemed almost impossible, but somehow they would have to do it. Dan told his wife, Ubolvan, and son, Devin, that Christmas day would be his only day at home. Wendy Neuss cut short the plans she and her boyfriend had made. Others had similar conversations with family and friends. The show must go on.

December 16. Stage 8. 6:30 P.M.

Day six of the seven-day shoot for "Eye of the Needle." In some ways it was a typical Friday. Shooting had started late and would run well into the night. It was Merri Howard's turn to stay late on the stage. Brad Yacobian had gone home early to do some Christmas shopping with his family.

Following the "Caretaker" reshoots on Monday and Tuesday, filming on "Eye of the Needle" had resumed, on schedule, at 7:30 A.M. Wednesday. Another long day. Wrap that evening was late enough to push the shooting call for Thursday morning back an hour, to 8:30. On top of the one-hour delay in starting, Kolbe shot even later into the evening on Thursday. By Friday morning they were rolling the first shot at 11:00 A.M., three-and-a-half hours later than normal.

About midafternoon a cortege of visitors arrived on Stage 9, where filming was taking place in the engineering set. The group was there under the auspices of the Make-A-Wish Foundation, escorting a ten-year-old boy from Scotland, who was dying from brain cancer. He was dressed in a Starfleet uniform, and obviously having the time of his life. He was accompanied by his younger brother, also in a Starfleet uniform, and his mother, who was dressed like Doctor Beverly Crusher, from *The Next Generation*.

Forget filming for a while. This was more important.

The young boy was ecstatic, walking around the sets, having his picture taken with various cast members. Unobtrusively, Bill Peets, Marvin Rush, and several other crew members slipped over to Stage 8, and lit the bridge. Ben Betts fed video to the monitors, and *Voyager* was suddenly at warp 6.

When everything was ready, the young boy was brought over to the bridge, and invited to sit in the chair, flanked by Captain Kathryn Janeway and Commander Chakotay. Cameras flashed as he sat there beaming. No one could have asked for better memories.

Now, in the early evening, the cast and crew were filming a scene in the transporter room. People were tired. The fatigue brought with it an air of casualness and informality. Tim Russ and Robert Beltran were blowing lines, cutting up, and making jokes with Bill

Tim Russ as chief security officer, Lieutenant Tuvok. DANNY FELD.

Peets and Charlie Russo. Wil Thoms and Randy Burgess were adding comments of their own. Even Adele Simmons, who usually takes everything rather seriously when she is on the set, was getting playful. In general it was a noisy, boisterous group on the set that evening.

Noise is always a problem. The ADs, and the first and second ADs, are constantly asking the crew to "hold it down," "quiet for rehearsal please," and similar admonitions. When Brad Yacobian is on the set, noise is not usually a problem. He is well known for a stern, almost unforgiving attitude about noise when the camera is rolling. (Actually, Brad is quite patient, but like anyone, he has his limits.)

Generally the calls for quiet on the stage are heeded. Everyone tries to respect the need for quiet so the director and the actors can keep their concentration on the scene being filmed. But sometimes these pleas fall on deaf ears. This Friday evening was one of those times. But no one was upset about it, least of all Kolbe. He knew people were tired, and needed a break from the tension.

Unexpectedly, Rick Berman walked onto the stage and stood at the door to the transporter room, just out of camera view. He rarely visited the sets, but there he was.

Suddenly this was a special occasion. Word spread quickly. In no time, many of the forty or so members of the shooting crew were crowding around the inside periphery of the set—being careful to stay out of the "live" area of the shot Kolbe had lined up. The transporter room, the area around all openings to the set, and the corridor leading to it soon became packed with onlookers. Kolbe briefly acknowledged Berman's presence, and continued with the filming. The actors continued being silly. Berman was smiling, enjoying the moment.

Adele Simmons turned to him and stated the obvious. "They look like they're having a good time." Rick adopted a mock serious expression and replied, "I don't pay them to have a good time." Then he rolled his eyes upwards, toward the ceiling.

Berman's arrival was just in time to see a crucial scene in the episode. The *Voyager* crew had found a wormhole and transported a Romulan captain through it. The Romulan captain stood on a transporter pad. Gathered in front of him were Janeway, Chakotay, Tuvok, and B'Elanna. They were excited about the prospect of beaming the entire crew through the wormhole, to the Romulan ship. They had been miraculously delivered from a life of certain exile, and were going home. The scene was a very dramatic moment in the episode.

In the shot Kolbe was rehearsing, Janeway welcomes the Romulan, makes the introductions, then gives the order for preparations to evacuate the ship. Tuvok says "wait," and in dialogue determines something is very wrong. The Romulan is from the past. Tuvok drops the awful news on Janeway and the others that the Romulan captain has somehow been beamed aboard ship through a wormhole that originates twenty years in the past. They, and the rest of *Voyager*'s crew, cannot transport through the wormhole because they would all arrive back in the Alpha Quadrant twenty years before *Voyager* left it.

The moment was tense, highly charged—partly because of the impact of the scene itself, and partly because Rick Berman was standing just off the set, watching. Everyone was acutely aware of his presence.

Speaking to Janeway but looking at the Romulan, Tuvok makes the awful pronouncement: "We have transported him from twenty years in the past—into our future." There is a moment or two of dreadful silence while Janeway and the others react to the news that their hopes are dashed; they cannot go home; they are still marooned in the Delta Quadrant. The camera continued to roll as Kolbe filmed the reactions. The set was quiet. As if on cue, Robert Beltran turned to Tim Russ and in a loud, questioning manner, innocently asked, "Does that mean we're fucked?"

A split second of silence, and the set erupted in laughter as everyone, including Berman, cracked up.

The incident illustrates an important point about the close-knit nature of the cast and crew. Everyone may be dead tired, but there is still room—and a need—for relief through humor. Things would be rather grim if no one could joke around at times.

Not long after the scene in the transporter room, Berman left the stage and walked outside. Parked in an open area between the rows of cast trailers, a van and driver waited, to take Berman back to his office in the Cooper Building. As he exited the stage, the driver immediately started the engine. Berman turned to a visitor and remarked, "That's the sound of power…when you walk out the door and you hear the engine start up." It is indeed, and no one doubts that Berman has it.

The cast trailers are "the big ones." As opposed to the very small ones (about fifteen feet) which earlier cast members were given at the start of production on *The Next Generation* back in 1987. At the time, Rick Berman's position was that each season the cast trailers get a little bigger…until finally they get the big ones. *Deep Space Nine* started the same way. According to Robbie McNeill, Berman "took a big risk and got us the big trailers right away. He started us off right."

Cast trailers are an important form of support, given the horrendous hours each actor has to put in every day. Unlike the cast, crew members do not get a break, but because they work behind the camera they do not need to look rested and refreshed. The actors do. During scene and lighting changes, cast members can retreat to the privacy of their own trailer. They can relax, change clothes, take a nap (even a short one), make phone calls, or simply escape the pace for a few minutes.

> Robert Duncan McNeill: It's great. My family can come here…the kids can play and watch videos. While they're lighting a scene, I can come in here and lie down, read my book, or do whatever it takes just to get myself rested and ready to go back in there at 2:00 A.M. and look like I have had some rest, and be alert enough to do the next scene. I think a lot of times people on the outside, they come here, they look at these trailers, and they think, "Oh, aren't you so lucky." They look at it as some kind of extra perk…"Isn't it luxurious," or something.
>
> I'm sure you could do this job without a trailer. I did this play last summer and we all shared one little dressing room back off the stairwell. You

adapt, and you do what you need to do. But as you spend the time here, especially with the hours that we keep here, you realize that the trailer certainly helps.

Tuesday, December 20. The scoring stage in the "M" building. 9:00 A.M.

Some twenty people have crowded into the large control room that overlooks the stage through a thirty-foot wall of smoked glass. The control room is dominated by two long, massive audio consoles, positioned one behind the other. Each is studded with buttons, switches, knobs, and dials. Four deeply upholstered executive chairs sit in front of each console, and are occupied by Paramount's chief scoring engineer Norman Dlugatch and his assistants. At the rear of the room the few guest chairs are already filled. Most people—including Rick Berman, Jeri Taylor, and Wendy Neuss—stand where they can, each trying to maintain a good viewing angle of the music stage.

There is electricity in the air, a sense of expectation and excitement, as if history is about to be made. In a way, it is. The assembled group is awaiting the arrival of famed composer Jerry Goldsmith, who this morning will conduct a fifty-piece orchestra, recording *Voyager*'s main title theme music. Goldsmith is a man larger than life in the Hollywood music business. An Oscar and Emmy-Award winner many times over, he is more than a heavyweight—he is in a class by himself.

The music stage is filled with musicians, all in their places, tuning instruments, practicing run-throughs, warming up while waiting for Goldsmith to arrive and take the podium. Overhead, thirty microphones hang suspended, strategically placed above the orchestra. Each microphone will record a separate track; all will be mixed into a final master stereo track.

Goldsmith arrives and ascends the podium. There is almost instant quiet. He is dressed casually in western boots, Levis, and a gray silk shirt over a black turtleneck. His white-streaked gray hair is pulled back in a long ponytail that drapes across a shoulder as he leans over the podium to speak with a musician friend. His presence on the stage is nothing less than commanding.

Goldsmith dons a set of headphones and gets right to work. With the ease of a master very much at home, he asks a few selected musicians to play the first few bars—woodwinds, brass, percussion. He listens intently, then asks for adjustments, both from the musicians and the engineers at the consoles in the control room.

They play through the entire piece—about three minutes. Goldsmith comes into

the control room and asks for a playback. As he listens to the music, he watches one of the large video monitors mounted along the wall above the plateglass window that overlooks the stage. The monitors display the dazzling opening animation and CGI sequence designed by Dan Curry. The effect is breathtaking. Goldsmith's music is magnificent. It has a sweep and majesty about it that fills the room and moves the emotions of every person there.

Goldsmith is not satisfied. He discusses changes with the engineers, then goes back to the podium for another take. Thirty seconds into the take he halts the orchestra and asks the woodwinds to make an adjustment. Take three. Again Goldsmith stops, this time to ask the trumpets to "tone it down at bar 24." Take four. Goldsmith comes back to the control room for another playback. He says the strings were late. He returns to the stage and does take five. He is still not happy with the woodwinds, stops the take, and asks the wood-winds to "pull it up a little."

Take six.

Again Goldsmith enters the control room to hear the playback, stops it midway through. He thinks a C-sharp is off. Back to the podium. It is now 11:45 A.M. Goldsmith asks for a single-ear headphone. Take seven. He wants to do it again. Take eight. Suddenly everything seems to fall in place. The music fills the control room with a grandeur that is unmistakably beyond superb. Goldsmith can tell. He smiles delightedly. Everyone in the control room is smiling with him. They know this is the one.

Jerry Goldsmith returns to the control room one last time to hear the playback, but he really doesn't need to. The playback confirms what he already knows—the main title theme has been recorded. Everyone congratulates Goldsmith, and each other. The maestro thanks the engineers, then returns to the podium to begin recording the music for the rest of the pilot episode.

While Goldsmith and the musicians were on the scoring stage, a block away, on Stage 8, Roxann was busy blowing out the dorsal phase emitters and venting a couple of LN2 exhaust conduits.

Time travel, phase variance matrix, coherent tetryon beams…these are standard concepts and terms in the *Star Trek* universe. To cast, crew, and fans, they are collectively known as technobabble. *Star Trek* has used these seemingly incomprehensible and unpronounceable terms since *The Original Series* first aired. The terms are in fact not meaningless. Some are legitimate, present-day scientific terms. Others are purely made up—what Rick Sternbach refers to as "bogus" twenty-fourth–century science—but based on extrapolations of known or accepted theoretical science.

The two types are not combined haphazardly. Like everything else in *Star Trek*, the words and phrases are carefully constructed, to convey as close to "usable, realistic" information as possible. This is an important issue. Not only does this approach help maintain scientific credibility and consistency, it also helps the actors understand that they are not mouthing gibberish. In most cases they are speaking lines filled with significant information, even if they personally do not comprehend what that information means. It is helpful for them to know that each word defines something out of the twenty-fourth century, and has to be delivered as if they knew what that definition was.

Some actors maintain that speaking technobabble is a lot like speaking lines in a Shakespearean play. As an actor, you have to study the words, until you understand that each one actually has meaning. You must make the words real to you, and then those words *become* real, which allows them to be part of normal dialogue—and sound normal when spoken. Perhaps this is the reason why stage-trained actors seem to have an easier time speaking *Star Trek* technobabble.

Today, technobabble is a fixture of every episode. Some say it is overused. There is always talk of cutting back its usage, but that never happens. It is like a weed that has somehow taken root and resists all efforts at extermination. People learn to live with it.

In the beginning, some of the cast had a bit of difficulty learning how to let these technological tongue twisters roll smoothly off the tongue like a well-used and familiar piece of hard candy. Most adapted quickly. Some guest stars, though, have considerable difficulty making it sound believable.

Rick Berman: The dialogue and the specifics in *Star Trek* scripts are very important. It's easy for these things to become hokey. It's easy for these things to become contradictory. It's easy to get the tech wrong. It's easy for the tech to be correct but not sound correct. Or sound correct but be confusing. It's easy for technobabble to sound great, but at other times you turn around and it just loses the audience.

Good or bad, authentic or not, in all likelihood, technobabble is here to stay. Sort of like a technological Virginia creeper.

Sometimes it is not the actors who have problems with their lines, it is the crew who have trouble with the equipment on the stage. A typical example occurred the week before Christmas, while shooting in the mess hall. LeVar Burton was directing the

episode, "Ex Post Facto." The scene was the final one before the show ends and the credits roll. Burton had lined up a shot in which Tuvok and Paris are talking. When all was ready, Arlene Fukai put the stage on the bell, Michael DeMeritt and a chorus of other voices yelled out, "Rolllliinnggg!" and Burton called, "Action!"

Outside the mess-hall windows, Wil Thoms started the motor that drives the moving starfield curtain. This is one of the large black curtains with all the zillions of sequins hand-sewn on it—one of those same ones that no doubt sent the hand-sewer-on-ers to a long rest in a padded room somewhere when they finally ran out of places to stitch on more sequins.

As the starfield curtain slowly rotated past the mess-hall windows, it was supposed to provide the illusion of the ship in flight. With this simulation of stars passing by, the impression of movement could be achieved without an expensive optical effect every time they shot a scene in the mess hall.

When it worked properly.

This day it did not. The camera was rolling when suddenly Marvin Rush stopped the shooting. Burton said, "Cut," with a touch of irritation in his voice. The day had started at 10:00 A.M. Everyone knew this would be a long day, and a late night. The next day, Thursday, was the last day of shooting before the Christmas hiatus. People were anxious to get out of there. The last thing anyone wanted was another delay. LeVar was puzzled. The take was going well. He asked Rush what was wrong.

Marvin complained about the starfield curtain. He had noticed a shimmer as the curtain moved. There was not supposed to be a shimmer. The curtain was supposed to move smoothly and uniformly along the overhead track near the ceiling of the stage. And the curtain itself was a washed-out gray. On film, the stars would not look like stars going by the windows. They would look like a gray shimmering mass.

Bill Peets was familiar with the problem. It had happened before. Too many times. He conferred with Marvin, then walked over to the curtain. He pointed to an area on the curtain and said, "Yeah. You can see the shimmer right here." Peets moved to the side, barked orders to lamp operators Ken Suzuki and Bob Eyslee, who quickly adjusted some of the lamps. With all the sequins, it was hard to light the curtain without having the whole thing turn gray. The curtain had become Peets's sequined albatross.

"Is that any better?"

"Yeah, that's better," Marvin replied. LeVar Burton set up the shot again. Bill Peets walked away from the starfield curtain muttering, "God, I hate that thing. $25,000 and it still doesn't work."

Any number of things can go wrong during filming and cause delays that, by the end of the day, can easily add an hour or more to the schedule. Monitors can fail, electronics can die, general equipment failures, all sorts of things. As Charlie Russo observed one evening, adding a mere three minutes to the preparations for each new shot, or setup, can have severe consequences. With thirty to thirty-five setups in an average day's shooting, the episode can quickly get dangerously behind, and over budget. Frequently, it is not a matter of three or four minutes' delay, per setup; it is more like six or seven.

Even makeup can cause serious delays. Roxann periodically has to stop and leave the set because of her Klingon appliance. She has to wear it for so many hours every day that the chemicals and the latex eventually begin to irritate her skin, which breaks out in a painful rash. The discomfort gets so bad at times that it brings tears to her eyes.

Ethan Phillips also suffers periodically from skin rash, for the same reasons. He is further plagued with an additional problem caused by sixteen-hour days and the special contact lenses he wears. As the day gets longer, he is reduced to putting drops in his eyes every ten minutes just to help him get through the next scene. By the time he gets out of makeup and drives off the lot, he is almost blind.

Acting is glamorous and romantic.

Occasionally, there are shooting delays stemming from totally unexpected sources. One such example occurred during the filming of "Death Wish," an episode in which John de Lancie guest starred as the godlike alien Q.

The crew was shooting a long master shot on the bridge late one Friday evening. Jim Conway was directing. Brad Yacobian was nervously pacing the set, as he usually does when the schedule gets behind. It was Brad's night to stay late on the stage. The scene was difficult and complex. The cast included Mulgrew, McNeill, Russ, Wang, Beltran, Dawson, De Lancie, and guest star Gerrit Graham.

Conway did several takes, but the actors were having a lot of trouble getting the scene the way he wanted it. Finally, everything seemed to be working. Conway appeared pleased with the way the master shot was progressing. They were just about finished with the scene when all of a sudden, off camera, somewhere near the side of the stage, there was a horrendous crashing cacophony of what sounded like dozens of pieces of scrap iron things falling onto the floor. The noise filled the entire cavernous stage.

Everyone froze. Mulgrew stopped in midsentence. People looked at each other. Conway looked around. Everything came to a disorganized halt.

The crashing stopped, there was a slight pause, then a single, smaller crash…the sound of tin. That distinctive noise a lone hubcap would make if it were spinning loosely on asphalt, slowly spiraling down to finally rest quietly flat on the street.

Silence.

Randy Burgess snickered. Charlie Russo snickered. David Bernard snickered. Jim Conway said, "Aw...cut it," and began laughing. An angry Jerry Fleck rushed off the set in the direction of the noise, determined to find out who the klutz was that had just spoiled Conway's master shot.

Suddenly the stage erupted in snickering and laughter as it quickly dawned on everyone: Brad Yacobian was nowhere to be seen. The noise had come from the craft service storeroom. Where the Ding-Dongs are kept. A minute later Fleck reappeared, grinning broadly. In a loud voice Jerry confirmed what everyone by this time suspected anyway: "It was Brad." The cast and crew roared. Of all the people to spoil a master shot, the last person anyone would expect to be the culprit would be Brad Yacobian. Done in by his legendary sweet tooth.

Late Thursday evening, December 22, LeVar Burton, the cast, and the shooting crew halted production on "Ex Post Facto," and left on Christmas hiatus. Over in the Cooper Building and elsewhere on the lot, other *Voyager* personnel also left. All would be back by Tuesday, January 3. But many, especially those in construction and postproduction, would get no break for Christmas. There was just too much left to do, to get ready for *Voyager*'s premiere.

The first week of January the five-act-to-four decision was reversed. All episodes would air with five acts. Additional commercial air time appeared to be the reason. There was a mad scramble to recut the first five episodes to reflect the new format. J.P. Farrell and his crew of editors again had their hands full for a while.

The fallout from the five-act format decision also affected Lolita Fatjo and Janet Nemecek—again—who had to make the script changes in "Ex Post Facto" and "Emanations"—the two episodes most affected in production and preproduction. The earlier scripts would have to be changed when time permitted, if ever. It was a case (as usual), of the hottest brushfire being the one that got the attention first. More long days. More long evenings.

Somehow "Caretaker" was finished on time, and delivered to Paramount on schedule. The studio held a big-bash, invitation-only screening in the new Paramount Theater on the lot. Dr. Sally Ride, America's first woman in space, was there, as an honored guest. Kate Mulgrew presented her with a special *Star Trek* communicator pin, making Dr. Ride an honorary member of Starfleet. "Caretaker" was screened to a packed, and rapt, audience. It was an auspicious launch, the best ever, according to many.

A week later, *Star Trek:Voyager* made its nationwide television debut.

MYTHOS

I was very ambivalent about the role. I didn't know much about *Star Trek*. They said she was

a Borg, and I didn't know what that meant. My agent said "Oh, those are the gray bald-headed

guys with the metal plates on their heads." Which was not the right way to describe this

character to make me leap at the opportunity.

Jeri Ryan
Seven of Nine

VOYAGER'S TWO-HOUR PREMIERE SET VIEWING-audience records all over the country. The new *Star Trek* series was off to an excellent start. But while viewers were delighted to have *Voyager*, they were not at all happy about when the program aired.

UPN had been highly successful in signing up stations in virtually every significant market. The problem was, many of these stations were independents that scheduled the series at widely varying time slots and on any day of the week. For much of *Voyager*'s first

season, this inconsistency in programming times confused, frustrated, and irritated viewers, and was the subject of considerable chatter on the Internet.

As the first season passed, the time-slot problem gradually went away. More cities scheduled *Voyager* for the same day and time each week, eventually giving viewers some sense of coherency to that segment of the *Star Trek* universe.

Aside from the time-slot problem, one of the first things fans fastened onto was Janeway's hair. Mulgrew's hairdo quickly became a favored target for on-line comments, with some fans claiming it was everything from a wormhole to a Kazon secret weapon.

Josée Normand tried valiantly to come up with a solution, but the problem refused to go away. In the third season, Josée created yet a new style that combined the hair up with the hair down. The style was attractive and suited Mulgrew very well. But it was not destined to last. In the fourth season still another new coif—shorter than its predecessor—appeared. Doubtless there would be others.

For her part, Kate had long since grown disgusted with the entire subject of hair, and would have given anything to have the matter settled once and for all. This was exactly the sort of distraction Paramount executives had sought to avoid in the first place, when they decided to reshoot some of the scenes in the pilot.

Perhaps what this really proves is that modern women who aspire to leadership must combine personal integrity with political cunning, noble vision with practical judgement, and courageous bravado with organizational patience. And even if a woman in power possesses all these qualities, we will still not be satisfied. We will always be able to nit-pick her hair.

Like any close-knit family, *Voyager*'s personnel were defensive about any form of criticism. Some, like Frank O'Hea, were unabashedly passionate in defending *Voyager* against any carping whatsoever. Frank came in to work one day, fuming and sputtering about an article in a local newspaper that had reviewed the previous night's episode. Frank had a clipping of the review and showed it to everyone he met.

He kept saying, "*Look* at this! *Look* at this! How *dare* they say these things?" The reviewer had made the comment that Janeway and the crew looked "stiff and formal" in the episode.

"What do they *mean*, 'stiff and formal'?" O'Hea hotly demanded, his Irish brogue more noticeable than usual. "Don't they *realize* what serious business it is, flying around out there in outer space?"

The launch of a new *Star Trek* series is a significant event. In the history of entertainment, both *Star Trek* and television have been powerful engines for social change. Year by year their influence seems to grow.

The franchise itself continues to evolve, expand…and change. One of the most significant changes occurred with the fourth season opener, "Scorpion, Part Two." In this

episode, a Borg named Seven of Nine is brought aboard *Voyager*, and under Janeway's guidance becomes a member of the crew. In the *Star Trek* universe, this is every bit as profound an event as the decision to bring a Klingon (Worf) onto the bridge of the *Enterprise* in *The Next Generation*. (Historically, the Klingons had been Starfleet's archenemy.)

Seven of Nine's origins grew out of a marathon conversation between Rick Berman and Brannon Braga in the Spring of 1997. While the basic idea came from Brannon, Rick Berman immediately took the concept to a higher level by suggesting the character be a female. He reasoned that this would create an entirely new type of character, with enormous potential for the series. It was a brilliant stroke, although initially many fans did not think so.

> Jeri Taylor: The idea of having a female Borg was one of those that came largely through spontaneous combustion. It started with Brannon, and quickly gained a great deal of support. We decided to make her a human female who had been assimilated while very young and raised by the Borg. So in essence, she lost her childhood. She has missed a great deal of her humanity.

Philosophically, Seven of Nine's presence aboard *Voyager* is an extension of a *Star Trek* canon—the idea that we are embracing our enemy. This is a precept that has always been espoused by *Star Trek*, and demonstrated countless times over the last three decades.

One more time, *Star Trek* is saying to viewers, "Just because someone looks and acts differently from you doesn't mean they are bad and wrong and should be killed. Everyone has worth. Everyone has value. It may take a bit of doing, and a lot of altering of attitudes, but sentient beings really can peacefully coexist well with each other."

Seven is also the outsider, a traditional *Star Trek* character, and the first female created in that role. She thus serves the same purpose as Spock and Data, making comments and observations about humans, and interacting with the captain in a way not possible by anyone else. Her relationship with Janeway is therefore very much in the tradition of Spock and Kirk, Data and Picard. As Janeway's foil, her very presence helps define and enhance the character of the captain—an aspect lacking in *Voyager* from the outset.

Having created Seven of Nine, the producers set about giving her a visual image. Her introduction to viewers would be as a fully assimilated Borg. Berman wanted to duplicate the Borg look created by Robert Blackman and Michael Westmore for *Star Trek: First Contact*. Over the next few episodes, Seven's Borg implants and body armor would be gradually removed as she was slowly humanized.

Under Berman's careful eye, Robert Blackman began sketching ideas for the cos-

tume Seven of Nine would wear after the initial transition. What emerged was a skintight bodysuit made of a stretch material similar to nylon Lycra. The justification for the design was that it was a dermal regeneration device, a technological means of allowing her human body to heal from all the scarring after the Borg armor and implants were removed. The notion is similar to the full-body wraps applied to severe burn victims.

Rationale or no, the design seemed dictated as much by a desire for increased ratings as anything else. There was great concern that *Voyager* was losing the eighteen to thirty-four-year-old male audience. On the right actress, a skintight bodysuit wouldn't hurt. Counterbalancing this concern was the staunch determination by the producers to avoid comparison to shows like *Baywatch*. To offset the costume's blatantly sexy appearance, the producers gave Seven of Nine a completely sexless personality. She is totally oblivious to the potential effect her presence could have on *Voyager*'s male crew members.

> Brannon Braga: She's got it all—she's got hormones, she's got feelings and emotions, everything human. But having been raised by wolves—Borg in this case—she has absolutely no socialization. She is without a compass.

It's a duality. A character that looks one way, but acts just the opposite. No other television series has continuously done this as successfully as *Star Trek*.

Casting happened rather quickly. One of the actors called in to read for the part was Jeri Ryan, who had just finished a stint on the short-lived series *Dark Skies*. She was aware of *Star Trek* ("I don't think anyone born in the latter half of the twentieth century is not aware of *Star Trek*"), but was not a fan, and had only seen snippets of *Voyager* episodes here and there. Jeri read for the part, but was not at all sure she wanted the role. She was nervous about being typecast as an alien (a common concern among actors), and worried that Seven of Nine would be rehumanized too quickly and then pushed into a series of shallow romantic encounters.

So when her agent called her and said the producers wanted a test deal, she ended up saying no. Fortunately for *Voyager*, Rick Berman was able to allay her concerns and win her over. That gave Blackman a body to fit the costume.

> Robert Blackman: The garment looks so simple. It's probably the hardest, most complicated garment we've ever made. Because it is structured in a way that it will shrink-wrap to the contours of her body. And that's hard to do, because materials tend to go naturally from one high point in a straight line to the next high point. I wanted it to be—within the laws of decency according

to network Standards and Practices—for it to be as if it were painted on. With a separate substructure underneath so that it wasn't so gratuitous that it revealed every minute detail of her anatomy.

The unique substructure Blackman refers to includes a special corset and, overall, gives a suggestion of some sort of external ribbed skeleton just underneath the suit…a hint perhaps of more Borg remaining than literally meets the eye. The result is not a simple jumpsuit. Ryan cannot get dressed by herself. Even with costumer Jamie Thomas's help, it still takes more than half an hour just to get her into the suit.

Blackman's approach was strongly reminiscent of the philosophy espoused by Bill Theiss for *The Original Series*: It isn't *what* you see, it's what you *think* you see. And it's also the suggestion of what you think you *might* see, if only you could manage to get just a little better look.

Jeri Ryan: It's all perception and it's all mystery. That's the best. I have no problem with showing shape. That's all we're showing. That doesn't bother me at all. I think that's a lot more appealing than flesh.

Michael Westmore meanwhile began making the appliances which would initially turn Ryan into a Borg, and then, later, into a recognizable human. The final design included a small star-shaped wheel next to her right ear, a "little mechanical gadget that goes around her left eye," and the appliance worn on her left hand.

Leaving these small prosthetics on her face and left hand was definitely a wise decision. To totally de-Borg Seven of Nine would negate the profound advantage inherent in the character. It would be like removing Spock's pointed ears in order to make him look more human.

Jeri Ryan: Rick Berman loved everything everybody did about this character. He tweaked it. He fixed minor things. But he loved the costume, the makeup, the hairstyle. He's tough, and he's a hard sell. And before he tells you he loves it he'll give you twenty-nine things to work on. But he loved it. Everyone did a phenomenal job in putting this character together. The final product was exactly what Rick envisioned when he and Brannon first created this character.

The developmental process was deliberately kept low-key, almost secretive. There were no on-camera film tests. Most meetings were limited to the producers, Blackman, Westmore, and Ryan. Despite these precautions, word leaked out, and it was not long

before the flak from dismayed fans began to roll in. They were not happy about what they had heard regarding the latest *Voyager* cast member. Unperturbed, the producers pressed on.

Seven of Nine made her debut at the start of *Voyager*'s fourth season, and quickly became enormously popular with viewers, in the same grand tradition as Spock and Data.

The new character's tremendous popularity is gratifying to everyone, most of all Jeri Ryan. Her heavy fan mail is predominantly from women, who all say basically the same thing: "We were prepared to hate your character, but in fact we love her." The reason seems obvious. Seven is intelligent, strong-willed, and independent. She thinks for herself, stands up to the captain, and is not afraid to speak out if she sees something happening that seems stupid or doesn't make sense to her.

Where else on television today can women viewers find a powerful role model like that?

Eventually viewers get beyond the visual image. It is just like the reaction to Data. Sooner or later viewers were no longer fascinated by the slicked-back hair, the amber eyes, and the gold skin. The intrigue of the look eventually fades. It is what is *inside* the character that matters. That has always been precisely the point of *Star Trek*'s characterizations. It is also what lies at the heart of *Star Trek*'s continuing appeal, and drives many of the series' changes.

Viewer response to Seven of Nine has been nothing short of phenomenal. Ratings have increased dramatically, which can only mean new viewers are turning to the series in record numbers. Months after Seven's introduction, *Voyager*'s popularity continued to surge. Her presence appears to have become the driving force behind what one producer calls "*Voyager*'s renaissance." Everyone feels it—from the sets, the stages, the lot, and from the viewing audience, there is a highly charged energy that is palpable, radiating a renewed dynamism around the series.

This resurgence of interest in *Voyager* reflects a key element in the enduring nature of the *Star Trek* universe: Viewers are hungry for characters and stories that speak to them on many levels. This is what makes *Star Trek* unique and has kept it so for more than three decades. At the heart of *Star Trek*'s universal appeal is the kind of stories it tells. *Star Trek* has always endeavored to tell stories that are meaningful, relevant, yet rooted in myth…the echoes of our distant origins and evolution as human beings. It resonates with our psyche even when we don't know the language being spoken.

In a broader sense, *Star Trek*'s enduring appeal probably reflects television's own influence worldwide. Television has become the global village McLuhan predicted, giving all of us a larger community and an electronic campfire around which we all sit and tell stories. For *Star Trek* viewers, these stories are the same stories, the same timeless themes voiced by our ancestors, now cloaked in twenty-fourth–century trappings.

Which is why *Star Trek* is universally recognized, and today seems to have assumed

near-mythological status not only in our culture but throughout the world. Brannon Braga, long a dark star in the *Star Trek* constellation (a sign on his office door reads "The Prince of Darkness"), concurs.

> Brannon Braga: *Star Trek* is mythos. It represents something positive that people need. It has persevered long enough that parents will pass down an interest in *Star Trek* to their children. The characters and the morality tales are so important and appealing and hopeful. We need mythologies. We need heroes to come back to again and again. In the American culture we don't have that. Except for *Star Trek*.

Mythologies help us understand our relationship to each other, and the world in which we live. They do this by providing role models to emulate.

> Victoria Murden: *Star Trek* reminds us that there are stories worth telling and faiths worth living by. *Star Trek* allows us to observe fictional characters as they struggle with issues of integrity, as they are forced to stand by their personal commitments, and as they give voice to the courage of their convictions. The characters need not be real for us to follow their examples.

Kate Mulgrew is also clear about the mythological proportions of *Star Trek*, and the archetypal role of Captain Janeway. The captain represents what the late Joseph Campbell talked about…the hero's journey. She is the leader, the teacher, the nurturer, the protector, and the one who sees the crew members safely home at journey's end.

> Kate Mulgrew: My son Ian is reading the *Odyssey*. So we were talking about it, and he said, "You know what this is, mom? This is what Janeway is. She is heroic. It's like in the *Odyssey*." And he's right. *Star Trek* is mythic storytelling on film. *Star Trek* isn't *about* the future. *Star Trek* *is* the future.

The *Star Trek* universe is not just a separate series of television shows and movies strung together. It is an entire body, an entire universe, an entire collective consciousness. Nothing like *Star Trek* has ever occurred before. Nor is anything like it apt to occur again anytime soon.

Which means we need to make certain that *Star Trek* continues to "boldly go." We need the mirror, in order to see where we are and where we could go.

STARFLIGHT

It's my job to try to tell stories uniquely, in the most surprising way possible. I'm not interested

in writing typical archetypal stories. It's classic Jungian philosophy that the shadow side has a

lot to offer. And frankly, it's a lot more interesting. So I don't deal in explicit archetypes.

But certainly I do try to put Jungian themes into the scripts. I do it all the time.

Brannon Braga
Co-Executive Producer

Friday evening, April 19, 1996. Stage 16. 10:30 P.M.

The last day of the last episode of the second season. Rick Kolbe is directing "Basics, Part II," which will open *Voyager*'s third season next Fall. It has been a very long day, and it is not over yet. The cast and crew are shooting in a gargantuan set constructed to simulate a rocky planet surface where the crew was marooned by the traitorous Seska and the Kazon.

That action took place in "Basics, Part I," which was slated to be the cliff-hanger episode ending the second season.

The alien planet set consumes more than half of Paramount's largest soundstage. Tons of dirt have been hauled in and piled in heaps around rocks and cave walls. The wooden floor is built up in several places and covered with more dirt. Here and there a few shrubs and scraggly-looking plants add a bit of green to the brown tones of the dirt floor and rock walls. The air is laden with dust particles, and people try not to shuffle when they walk.

High overhead in the catwalks, lamp operators Roger Bourse and Bob Eyslee wear face masks to protect their lungs against the dust particles that float in the air above the set. Heat rises, taking the dust with it. The masks help, but the men are coughing anyway.

The Chez Sandrine set sits on roughly a quarter of the remaining stage area, closed up and darkened. It is a "fold and hold" set, but because it is used fairly often, the set is held on the stage as a matter of convenience.

The remaining space around the alien-planet set is fairly crowded. The forty or so regular members of the shooting crew have been augmented by another twenty-five lighting, rigging, special effects, and camera personnel. Additional makeup, hairstylist, and wardrobe people have also been called in to handle the unusually large cast for this part of the shoot. Regular makeup persons Tina Hoffman, Greg Nelson, and Scott Wheeler have their hands full, as does Suzan Bagdadi, the department head hairstylist.

The expanded complement of *Voyager*'s cast, crew, and extras has been further swollen by some twenty more extras and stand-ins—most of whom are made up as indigenous aliens, with a few more Starfleet personnel for good measure. The aliens are humanoid, resembling cave dwellers out of Earth's prehistoric past. All in all, there are close to a hundred people on the stage.

Some have been on the job since their makeup call at 7:30 A.M. Fifteen hours straight, and it isn't over yet. People are so tired they are getting punchy.

Portable makeup and hairstyling tables, chairs, and mirrors have been brought in, and form a line along one exterior wall of Chez Sandrine. There are a few benches for the extras, and the ubiquitous director's chairs for the cast, all more or less clustered in an open area nearby. Many of the extras and a few crew members sprawl on the floor here, or lounge in several of the empty makeup chairs. Backpacks, coats, sweaters, and miscellaneous personal articles litter the floor, interspersed with the benches and chairs.

Along the rear wall of the stage, near the exit door, Jan Djanrelian presides over the craft service tables. Plenty of food, snacks, coffee, and assorted juices are still available for

everyone, but by now most people—even the extras—are so tired they no longer care about food. They just want to finish and go home.

Wil Thoms straddles a bench, facing Charlie Russo. Wil is telling Charlie about his latest run-in with "those little punks"—teenage gang members—who are trying to take over the neighborhood where Wil lives in the San Fernando Valley. Gang problems have been increasing the last few years, and so has Wil's antigang crusade.

Despite threats on his life and attacks on his property, Wil has been resolute in his activism. He has been successful in getting some of his neighbors to join his efforts, and as a result the street he lives on is safer and quieter than it once was.

"But those little punks don't give up," he tells Charlie. "They just moved to the next street over." Wil and his neighbors are now expanding their efforts to enlist the aid of the homeowners on the surrounding streets. "They have no right to interfere with our lives," he says emphatically. "No right."

On the set, Robert Beltran is doing a scene in which, as the Native American expert on such matters, he is supposed to start a fire. *Voyager*'s crew has no weapons or implements of any kind. The script calls for Chakotay to start the fire by using a small traditional bow-and-wooden drill to create friction against a dry piece of wood. The friction produces heat, which is used to kindle a small fire. A method dating back to the dawn of man, and a technique routinely taught to Boy Scouts.

Beltran cannot start the fire.

He works the bow furiously, like a Native American born to the technology. The wood will not even get warm. Kolbe shoots take after take. The wooden drill keeps breaking. The small bow slips off the drill. The drill slips off the wood base. Beltran is getting frustrated. Fatigued as they are, the cast and crew are beginning to giggle and make wisecracks. A crowd gathers at the sides of the set, to watch and to show encouragement and support. Alan Sims steps in to give advice on how to use the bow. It does not help. Tim Russ offers to do a mind-meld. Ian Christenberry waves a book of matches.

11:00 P.M.

Kolbe finally surrenders to the inevitable. "Cut. Okay, we'll print that. We'll show him doing that business with the bow, then we'll cut to smiling happy faces as everybody reacts to Chakotay's success, then we'll cut to the fire." In other words, they will fake it. Beltran gives the offending "fire-starting tools" to Alan Sims and walks off the set, relieved to be through with the scene. But he still takes some good-natured ribbing from L. Z. Ward, who

has come in from the chilly night air to get a cup of hot coffee. Hearing the laughter, L.Z. had gravitated to the edge of the set to see what was going on, and observed Beltran's battle with the bow.

Mike DeMeritt begins releasing a few of the extras as they finish their scenes. Before they leave, those in Starfleet uniforms must surrender their combadges in exchange for their pay vouchers. The assistant directors have had to resort to this control measure because too many combadges have been disappearing. A choice *Star Trek* icon, the badges fetch a high price on the fan merchandise market.

1:40 A.M.

There is a big round of applause, as Tim Russ and Robert Beltran complete their last scene, and can now be released. They say goodbye to everyone, and make their way to the stage door and leave. But it will be thirty to forty-five more minutes before they both can leave the lot. They head for the makeup trailer. Gil Mosko and Mark Shostrom are waiting to remove their makeup. For the two makeup artists, it will be hours more before they too can go home.

There is a brief break in the filming while Marvin Rush re-lights for the next shot. Roxann slowly drags herself to the edge of the set and stands, waiting for Kolbe's call for rehearsals. She looks bone weary, almost somnambulistic. Wil Thoms walks up behind her and starts rubbing her shoulders.

"You look like you're beat," he says, sympathetically.

"I am," she replies, with some effort.

Randy Burgess stood close at hand. "It's okay," he reassures her. "Your brain doesn't have to be in gear. As long as your eyes are open, they think you're paying attention."

That bit of comic relief brings a smile to Roxann's lips. As tired as she is, she laughs anyway.

David Sireika and Tom Moore begin removing equipment from around the perimeter of the set. Anything no longer needed is packed up. Before they are finished, every cable, light, stand, and piece of equipment will be hauled back to Stage 8, where it will be stored under lock and key.

Kate, Roxann, and Garrett are the only regular cast members now left on the stage. There is one scene left. The last remaining extras have been released. The stage is noticeably empty. Frank O'Hea still prowls the edges of the set, ready to add a touch-up of paint to any spot that needs it. Like the others here, he cannot leave until the last shot wraps.

2:10 A.M.

The last scene. Kolbe does not like the first take. They do it again. Alan Bernard is having trouble with the sound levels. They do the scene a third time. Bernard is still not happy with the sound. Take four. Everything works great. Kolbe shouts, "Good! Cut, please! Print it!"

Everyone left on stage breaks out in cheers and applause.

People start saying goodbye to each other. Marvin Rush, Doug Knapp, and Michael Stradling begin disassembling the camera and putting it away. The crew swiftly removes the rest of the equipment from the stage, their exhausted muscles now reenergized by the idea of leaving—and not coming back for a good long while. Kolbe calls out to everyone to drive carefully on the way home.

Arlene Fukai is already on the phone to Merri Howard, advising her that the last shot is done, and shooting has wrapped for the season. For this news Merri does not mind being awakened from a sound sleep. Amidst all the confusion, Cosmo Genovese still sits in his director's chair, carefully recording notes about the final scene. Finally he closes his book, puts on a sweater, and heads for the huge roll-back stage door, now open to permit easier removal of the equipment.

A last cluster of crew members hurry away through the door, into the darkness. Jan Djanrelian finishes cleaning up around the craft service tables, boxes up the leftovers, and disappears into the night.

2:55 A.M.

A stray cat streaks through the large side door, dashes along a wall, then darts between the alien rocks and vanishes from sight.

The stage is now deserted. Everyone has gone their separate ways. Ed Herrera rolls the big stage door shut with a loud kathump that echoes through the semidarkened interior. I make one last walk through the alien planet set. Here, there is an empty Seven-Up can sitting on a rock. There, a shovel and rake someone had used to smooth out the dirt floor. Over there, a solitary can of spray paint, absently left behind by a departing Frank O'Hea. Nearby, a *People Magazine* lay on a director's chair, open to an article someone had been reading. Now it was no longer important, and already forgotten.

Remnants of the second season.

I pushed open the heavy stage door and stepped out into the cold night air. There

was an instant flash of déjà vu. Thirty years earlier I had done exactly the same thing after the second-season wrap of *The Original Series*. The evening rain had stopped, the skies were clear, and the night air was crisp. I looked in the direction of Stages 8 and 9, but Herrera and Ward were nowhere in sight. I zipped up my jacket and walked south along Avenue L, towards the Melrose side of the lot, and my car.

As I walked along the empty street I couldn't help thinking about all the people who work in the company. I had grown close to so many. Each had dreams, aspirations, a life outside of work. These were real people living real lives in a real world. And yet they seemed somehow extraordinary to me.

I thought about Ed Herrera and his wife Terri, who wanted desperately to have a child, and had undergone a protracted period of expensive treatments and fertility clinic procedures. But it was worth it. Only days earlier, tests had confirmed Terri was now pregnant (with a girl, who would be named Allison Kate).

For some reason I felt like a proud family member, and their joy was also my joy. Now Ed could focus on his ambition to join the IATSE union, and become a grip. Perhaps one day he would be lucky enough to be a member of a *Star Trek* production crew. In the coming months he would be significantly assisted by Merri Howard.

I thought about Robbie McNeill and his wife, who had at last been able to buy a house of their own. And Kate Mulgrew, who got to keep hers. And Garrett Wang, flush with success at being cast as Harry Kim, rushing out and buying a white BMW. And Dan Curry, one of *Star Trek*'s unsung geniuses. A truly superb artist and sculptor in his own right, whose son, Devin, is also an incredibly talented artist and—at age thirteen—is already an eloquent, compassionate human being.

There was Jim Garrett, whose son, Dylan, is a gifted student in a school for exceptional children in Van Nuys and—like Dan's son, Devin—is an ardent *Star Trek* fan. And Dave and April Rossi, who had met during the first season, fell in love, and got married. On their honeymoon the couple went to Hawaii, and the Island of Kauai. When they arrived at their hotel they discovered that their room had been upgraded to a suite, compliments of Rick Berman, Merri Howard, and the other producers.

I recalled the morning I walked into the *Deep Space Nine* art department to talk with Jim Van Over. Jim and his "roommates" were having their morning coffee, and just as I entered the room, Denise Okuda pressed a button on a boombox. Frank Sinatra's voice suddenly filled the department with the "coffee song"—"...a politician's daughter / was accused of drinking water, / and was fined a great big fifty dollar bill /...they've got an awful lot of coffee in Brazil..." Denise, Doug Drexler, Jim Van Over, and Anthony

Fredrickson all started bouncing up and down, keeping time to the music. It looked for all the world like a scene straight out of the Muppets.

I thought about Michael and Denise Okuda, so passionately devoted to the maintenance, preservation, and support of the *Star Trek* universe. They had become like an extended personal family to me (and of course, Molly, Tranya, and the Fishes), and were among the first to make me aware that my first *Star Trek* book had, in fact, actually made a difference in people's lives.

I did not know that.

An intersection lay before me. Like the street I was walking along, it was deserted. Overhead, a police helicopter flew by, on the way to some early morning call. Down the street to my right, a lone bicyclist pedaled through an intersection of his own, headed through the darkness on an earthbound midnight mission only he knew where.

A few minutes later I emerged into the large parking area where I had left my car, some twenty hours earlier. The lot was virtually empty. My car sat alone on the far side, just south of the Roddenberry Building.

Suddenly I felt very cold. I told myself that probably it was the long, fatiguing hours, combined with the chilly night air. I opened the car door, sat behind the wheel and started the engine to warm the heater. As I sat there, my eyes wandered, resting at length on the Roddenberry Building. Effortlessly my mind transported me back in time, to another era, to a seemingly kinder, gentler world. One in which my friend was still very much alive, vibrant, creative, holding forth like a god in the universe he had created, enthusiastically embracing and consuming life—"burning brightly."

At night the Roddenberry Building has a vaguely Middle Eastern feel to it, the way it is landscaped with shrubs and trees. It is lit with lights placed in such a way as to illuminate the columns that extend from the ground upwards, toward the third floor. The effect is quite pleasing. The lighting draws the eye naturally along the columns, leading one's gaze to the top of the building. As I thought about Gene, my eyes followed the invitation of the lights, momentarily rested at the top, and then jolted me back to reality with the image above and behind the roof.

It was the Paramount water tower.

The structure was brightly bathed in white lights, emphasizing the blue Paramount Pictures logo against the white background of the enormous tank. From my vantage point I could not see the tower's giant legs. I could only see the tank, gigantic, like an alien spaceship hovering there, imperious, above the Roddenberry Building. The image was so sudden, and the impact so personal, that I felt a visceral shock.

The irony of the image was overwhelming.

Gene Roddenberry and the studio had been at odds with each other almost from the day Herb Solow gave the green light to do the first pilot for *The Original Series*. Adversaries if ever there were. Always, the studio had seemed to dominate his life. And now, sitting there in my car in that empty parking lot, looking up at the Roddenberry Building and the Paramount water tower in the background, I thought, there it was again. There it was, still. The tower, looming large over the building. Even in death, the one competing with the other.

The chilly night air sent a shiver through my body, momentarily bringing me back to the reality of the parking lot. Although I was tired and the hour was very late, for some reason I was reluctant to leave. I found my thoughts drawn back to Stage 16 earlier in the evening, and the shooting crew.

Much of the conversation among them had centered on what each person planned to do during hiatus. Most would get approximately six weeks in which they could relax, catch up on chores around the house, or perhaps go on a vacation with their family.

Arlene Fukai looked forward to the realization of a lifelong dream. In a few days she would be on her way to Japan, where she would meet relatives, and see her parents' homeland for the very first time. Others, like Randy Burgess, would try to pick up a few weeks extra work on a feature somewhere.

A surprisingly large number of crew members planned to forgo personal pleasure, in favor of a higher purpose.

Wil Thoms will go to Seattle where he will join his daughter, to volunteer his time teaching underprivileged kids how to water-ski. "Almost everybody in here [the cast and crew] is doing something in one way or another, helping people somehow." One year Wil rode his bicycle from the gate at Paramount all the way north to Seattle, to raise money to send asthmatic kids to summer camp at Lake Arrowhead. Three years later, at the end of *The Next Generation*'s final season, Thoms, fellow crew member Johnathan West, and one of the stand-ins, Mike Eccles, rode the reverse route to raise money for the Make-A-Wish Foundation. Marvin Rush and others will also do bicycle rides for charity.

Bill Peets will go scuba diving at Catalina Island's Avalon Bay. Not to fish, but to spend his time cleaning up trash at the bottom of the harbor, thrown overboard by unthinking boaters. "We should keep as much of the world as clean as possible," he insists.

Suzan Bagdadi will spend her time on hiatus doing volunteer work for the Rainforest Action Group, which is dedicated to saving the rain forest and helping the indigenous peoples in South America save their homelands from destruction. "We just can't be destroy-

ing Mother Earth this way. If each person would do their part, we could stop the destruction of our environment."

Remembering each of the crew talking about things like community service, helping needy kids, and environmental activism, I am struck by the seeming parallel between the high ideals of the *Star Trek* universe and the real-world actions of the extraordinary group of men and women who comprise *Star Trek's* cast and production company. These people do not give lip service to the "message" they film every week. They live it.

I closed the car door, started the engine, and drove slowly to the Bronson Gate. One last time I waved at the security guards, and drove off the lot, onto Melrose Avenue.

The clock on my dashboard read 3:27 A.M.

A P P E N D I X 1

Star Trek: Voyager Staff and Crew List

(Titles and tenure are as of the start of the Third Season)

PRODUCERS

EXECUTIVE PRODUCER	RICK BERMAN
ASST TO R. BERMAN	KRISTINE FERNANDES—Pilot, 1st, 2nd Season
	DAVE ROSSI—3rd Season
EXECUTIVE PRODUCER	MICHAEL PILLER—Pilot, 1st, 2nd Season
CREATIVE CONSULTANT	MICHAEL PILLER—3rd Season
ASST. TO M. PILLER	KIM FITZGERALD—Pilot Only
	SANDRA SENA—1st, 2nd Season
EXECUTIVE PRODUCER	JERI TAYLOR—Pilot, 1st, 2nd, 3rd Season
ASST. TO J. TAYLOR	ZAYRA CABOT—Pilot, 1st, 2nd Season
	SANDRA SENA—2nd, 3rd Season
SUPERVISING PRODUCER	DAVID LIVINGSTON—Pilot, 1st Season
ASST. TO D. LIVINGSTON	SCOTT BERRY—Pilot, 1st Season
PRODUCER	MERRI HOWARD—Pilot, 1st, 2nd, 3rd Season
ASST. TO M. HOWARD	DAVE ROSSI—Pilot, 1st, 2nd Season
	LAURIE McBRIDE—2nd Season
	MARIL DAVIS—3rd Season
SUPERVISING PRODUCER	PETER LAURITSON—Pilot, 1st, 2nd, 3rd Season

SUPERVISING PRODUCER	BRANNON BRAGA—Pilot, 1st, 2nd, 3rd Season
ASST. TO B. BRAGA	SANDRA SENA—Pilot
	KAREN RAGAN—1st, 2nd Season
	MICHAEL O'HALLORAN—3rd Season
PRODUCER	WENDY NEUSS—Pilot, 1st, 2nd, 3rd Season
PRODUCER	JOE MENOSKY—3rd Season
ASST. TO J. MENOSKY	CHRIS CULHANE—3rd Season
CO-PRODUCER	KEN BILLER—1st, 2nd, 3rd Season
ASST. TO K. BILLER	ROB DOHERTY—3rd Season
CO-PRODUCER	J. P. FARRELL—Pilot, 1st, 2nd, 3rd Season
STORY EDITOR	LISA KLINK—2nd, 3rd Season
ASSOCIATE PRODUCER	DAWN VELAZQUEZ—Pilot, 1st, 2nd, 3rd Season

PRODUCTION

LINE PRODUCER/UNIT PROD. MGR	BRAD YACOBIAN—Pilot, 1st, 2nd, 3rd Season
PRODUCTION COORDINATOR	DIANE OVERDIEK—Pilot, 1st, 2nd, 3rd Season
PRODUCTION ASSISTANT	ANDRZEJ KOZLOWSKI—Pilot, 1st Season
	BOB FOSTER—2nd Season
	DYLAN MORSS—3rd Season
PRODUCTION ASSISTANT	DEBORAH McCRAE-THOMAS—Pilot
	KAT BARRETT—1st Season
	JENNIFER RETTIG—2nd Season
	ELLEN HORNSTEIN—3rd Season
1ST ASSISTANT DIRECTOR	JERRY FLECK—Pilot, 1st, 2nd, 3rd Season
1ST ASSISTANT DIRECTOR	ADELE SIMMONS—Pilot, 1st, 2nd, 3rd Season
2ND ASSISTANT DIRECTOR	ARLENE FUKAI—Pilot, 1st, 2nd, 3rd, Season
2ND 2ND ASSISTANT DIRECTOR	MICHAEL DeMERITT—Pilot, 1st, 2nd, 3rd Season
DGA TRAINEE	KATHLEEN BARRETT—Pilot
	MICHAEL RISNER—1st Season
	TODD COVERT—2nd Season
	PIPPA LOENGARD—3rd Season
SCRIPT SUPERVISOR	COSMO GENOVESE—Pilot, 1st, 2nd, 3rd Season
PRODUCTION ACCOUNTANT	SUZI SHIMIZU—Pilot, 1st, 2nd, 3rd Season
ESTIMATOR/AUDITOR	CATHY HULING—Pilot, 1st Season
ASST. PROD. ACCOUNTANT	BARBARA CALLOWAY—2nd Season

	CATHY ROSEBERRY—3rd Season
ASST. PROD. ACCOUNTANT	MATT SINGER—2nd season
	MIKE SUNGA—3rd Season
SCIENCE CONSULTANT	ANDRE BORMANIS—Pilot, 1st, 2nd, 3rd Season

ART

PRODUCTION DESIGNER	RICHARD JAMES—Pilot, 1st, 2nd, 3rd Season
ART DIRECTOR	ANDY NESKOROMNY—Pilot
	MICHAEL MAYER—1st, 2nd Season
	LESLIE PARSONS—3rd Season
ASST. ART DIRECTOR	LOUISE DORTON—Pilot, 1st, 2nd, 3rd Season
SR. ILLUSTRATOR	RICK STERNBACH—Pilot, 1st, 2nd, 3rd Season
SR. ILLUSTRATOR	DAREN DOCHTERMAN—Pilot
SCENIC ART SUPERVISOR	MICHAEL OKUDA—Pilot, 1st, 2nd, 3rd Season
SCENIC ARTIST	WENDY DRAPANAS—Pilot, 1st, 2nd, 3rd Season
SCENIC ARTIST	JAMES VAN OVER—Pilot, 1st, 2nd, 3rd Season
SR. SET DESIGNER	GARY SPECKMAN—Pilot, 1st Season
SR. SET DESIGNER	JOHN CHICHESTER—Pilot, 2nd Season
SR. SET DESIGNER	MASAKO MASUDA—Pilot
SR. SET DESIGNER	COSMAS DEMETRIOU—Pilot
SR. SET DESIGNER	LOUISE DORTON—Pilot, 1st, 2nd Season
JR. "A" SET DESIGNER	GREG HOOPER—3rd Season
JR. "B" SET DESIGNER	GREG BERRY—3rd Season
SCENIC ARTIST ASSISTANT	JIM MAGDALENO—Pilot, 1st, 2nd Season
ART DEPT. PRODUCTION ASST.	TONY SEARS—Pilot, 1st, 2nd, 3rd Season

CONSTRUCTION

CONSTRUCTION COORDINATOR	AL SMUTKO—Pilot, 1st, 2nd, 3rd Season
CONSTRUCTION FOREPERSON	TOM PURSER—Pilot, 1st, 2nd, 3rd Season
LABOR FOREPERSON	RON VOSS—1st, 2nd, 3rd Season

SET DRESSING

SET DECORATOR	JIM MEES—Pilot, 1st Season
	LESLIE FRANKENHEIMER—2nd, 3rd Season
LEAD PERSON	FERNANDO SEPULVEDA—Pilot, 1st, 2nd Season
	GREG RENTA—3rd Season

SWING PERSON	DICK D'ANGELO—Pilot, 1st, 2nd, 3rd Season
SWING PERSON	BOB DE LA GARZA—Pilot, 1st Season
	MATT FURGINSON—2nd Season
	RONALD SICA—3rd Season
SWING PERSON	PAUL CLARK—Pilot
	RON RENTCH—1st Season
	LARRY BOYD—3rd Season
SET DRESSING PROD. ASST.	TRICIA SETTLE—Pilot, 1st, 2nd, Season
	GEORGIA MARGO-VOSS—3rd Season

PROPS

PROPERTY MASTER	ALAN SIMS—Pilot, 1st, 2nd, 3rd Season
SET PROPERTY MASTER	CHARLIE RUSSO—Pilot, 1st, 2nd, 3rd Season
ASST. PROPERTY	JOHN NESTEROWICZ—Pilot, 1st, 2nd, 3rd Season

CAMERA

DIRECTOR OF PHOTOGRAPHY	MARVIN RUSH—Pilot, 1st, 2nd, 3rd Season
CAMERA OPERATOR	JOE CHESS—Pilot, 1st Season
	DOUG KNAPP—2nd, 3rd Season
1ST ASSISTANT CAMERA	MARICELLA RAMIREZ—Pilot, 1st, 2nd Season
	CHRIS ISHII—3rd Season
2ND ASSISTANT CAMERA	MICHAEL STRADLING—Pilot, 1st Season
	SCOTT MIDDLETON—2nd, 3rd Season

SET LIGHTING

CHIEF LIGHTING TECHNICIAN	BILL PEETS—Pilot, 1st, 2nd, 3rd Season
ASST. CHIEF LIGHTING TECH'N	SCOTT McKNIGHT—Pilot, 1st, 2nd Season
	BOB EYSLEE—Pilot, 1st, 2nd, 3rd Season
RIGGING GAFFER	IAN CHRISTENBERRY—Pilot, 1st, 2nd, 3rd Season
LAMP OPERATOR	KEN SUZUKI—Pilot, 1st Season
	BRIAN COOPER—2nd, 3rd Season
LAMP OPERATOR	ROGER BOURSE—Pilot, 1st, 2nd, 3rd Season
LAMP OPERATOR	TONY MATERAZZI—3rd Season

GRIP

KEY GRIP	BOB SORDAL—Pilot, 1st Season
	RANDY BURGESS—2nd, 3rd Season

2ND COMPANY GRIP	RANDY BURGESS—Pilot, 1st Season
	DAVID SIREIKA—2nd, 3rd Season
DOLLY GRIP	DON HARTLEY—Pilot
	GERALD T. SZILLINSKY—1st Season
	GEORGE SANTO PIETRO—2nd, 3rd Season
GRIP	TOM MOORE—Pilot, 1st, 2nd Season
	TOM BOOKOUT—3rd Season
GRIP	PAT VITOLLA—Pilot, 1st, 2nd, 3rd Season

SPECIAL EFFECTS

SPECIAL EFFECTS	DICK BROWNFIELD—Pilot, 1st, 2nd, 3rd Season
ASST. SPECIAL EFFECTS	RICHARD CHRONISTER—Pilot, 1st, 2nd Season
ASST. SPECIAL EFFECTS	MARK STIMSON—Pilot, 1st, 2nd, 3rd Season
ASST. SPECIAL EFFECTS	WIL THOMS—Pilot, 1st, 2nd, 3rd Season
ASST. SPECIAL EFFECTS	AMANDA KARNES—2nd, 3rd Season
SPECIAL EFFECTS LABORER	GERALDINE CARLUCCI—Pilot, 1st Season
	RICK HESTER—2nd, 3rd Season

SOUND/VIDEO

SOUND MIXER	ALAN BERNARD—Pilot, 1st, 2nd, 3rd season
BOOM OPERATOR	GREG AGALSOFF—Pilot, 1st, 2nd, 3rd Season
UTILITY	DAVID BERNARD—Pilot, 1st, 2nd Season
	PAUL MILLER—3rd Season
VIDEO SUPERVISOR	DENISE OKUDA—Pilot, 1st, 2nd, 3rd Season
VIDEO	BENJAMIN BETTS—Pilot, 1st, 2nd, 3rd Season
VIDEO	LARRY MARKART—Pilot

PAINT

PAINT FOREPERSON	ED CHARNOCK—Pilot, 1st, 2nd Season
	GREG ANTONACCI—3rd Season
STANDBY PAINTER	FRANK O'HEA—Pilot, 1st, 2nd, 3rd Season

CRAFT SERVICE

CRAFT SERVICE	JON DJANRELIAN—Pilot, 1st, 2nd, 3rd Season

WARDROBE

COSTUME DESIGNER	BOB BLACKMAN—Pilot, 1st, 2nd, 3rd Season
SKETCH ARTIST	CHRISTINA HAATAINEN—Pilot
WARDROBE DEPT. FOREPERSON	CAROL KUNZ—Pilot, 1st, 2nd, 3rd Season
KEY COSTUMER—WARDROBE DEPT.	CAMILLE ARGUS—Pilot, 1st, 2nd Season
	SUZIE MONEY—Pilot, 3rd Season
KEY COSTUMER—WARDROBE DEPT.	KIM THOMPSON—Pilot, 1st Season
	KIM SHULL—2nd, 3rd Season
KEY COSTUMER—WARDROBE DEPT.	TOM SIEGEL—Pilot, 1st, 2nd, 3rd Season
KEY COSTUMER—SET	MATT HOFFMAN—Pilot, 1st, 2nd, 3rd Season
KEY COSTUMER—SET	JAMIE THOMAS—Pilot, 1st, 2nd, 3rd Season

MAKEUP

DEPT. HEAD MAKEUP	MICHAEL WESTMORE—Pilot, 1st, 2nd, 3rd Season
ASST. TO M WESTMORE	VALERIE CANAMAR—Pilot, 1st, 2nd, 3rd Season
MAKEUP ARTIST	TINA KALLIONGIS—Pilot, 1st, 2nd, 3rd Season
MAKEUP ARTIST	GREG NELSON—Pilot, 1st, 2nd, 3rd Season
MAKEUP ARTIST	SCOTT WHEELER—Pilot, 1st, 2nd, 3rd Season
MAKEUP ARTIST	MARK SHOSTROM—1st, 2nd, 3rd Season
MAKEUP ARTIST/LAB TECH.	GIL MOSKO—2nd Season

HAIR

DEPT. HEAD HAIR	JOSÉE NORMAND—Pilot, 1st, 3rd Season
	SUZAN BAGDADI—2nd Season
HAIRSTYLIST	PATRICIA MILLER—Pilot, 1st Season
HAIRSTYLIST	SHAWN McKAY—Pilot, 1st Season
HAIRSTYLIST	KAREN ASANO-MYERS—Pilot, 1st, 2nd, 3rd Season
HAIRSTYLIST	BARBARA MINSTER—2nd Season
HAIRSTYLIST	SUZAN BAGDADI—3rd Season
HAIRSTYLIST	CHARLOTTE GRAVENOR—3rd Season

TRANSPORTATION

TRANSPORTATION CAPTAIN	STEWART SATTERFIELD—Pilot, 1st, 2nd, 3rd Season
DRIVER (CONSTRUCTION)	BOB McLAUGHLIN—Pilot, 1st, 2nd, 3rd, Season
DRIVER	MARILYN BELL—Pilot, 1st, 2nd, 3rd Season

DRIVER	LARRY DUKES—3rd Season
DRIVER (SET DRESSING)	RAFAEL GONZALEZ—Pilot, 1st, 2nd, 3rd Season

SECURITY

SET SECURITY	L.Z. WARD—Pilot, 1st, 2nd, 3rd Season
SET SECURITY	ED HERRERA—Pilot, 1st, 2nd Season

STUNTS

STUNT COORDINATOR	DENNIS MADALONE—Pilot, 1st, 2nd, 3rd Season

LOCATIONS

LOCATION MANAGER	LISA WHITE—Pilot, 1st, 2nd, 3rd Season
LOCATION MANAGER	JOHN LOWE—Pilot

CASTING

SR. V.P., TALENT/CASTING	HELEN MOSSLER—Pilot, 1st, 2nd, 3rd Season
ASST. TO H. MOSSLER	RITA VANDERVAAL—Pilot, 1st, 2nd Season
	KRISTEN KOSINSKI—3rd Season
CASTING DIRECTOR	NAN DUTTON—Pilot
CASTING DIRECTOR	JUNIE LOWRY-JOHNSON—1st, 2nd, 3rd Season
CASTING DIRECTOR	RON SURMA—1st, 2nd, 3rd Season
CASTING ASSOCIATE	KATHRYN EISENSTEIN—Pilot
CASTING ASSISTANT	LIBBY GOLDSTEIN—Pilot, 1st Season
ATMOSPHERE CASTING	CENTRAL CASTING—1st, 2nd, 3rd Season
ATMOSPHERE CASTING SUP.	JENNIFER BENDER—1st, 2nd, 3rd Season

SCRIPTS

PREPRODUCTION/SCRIPT COORD.	LOLITA FATJO—Pilot, 1st, 2nd, 3rd Season
ASST. SCRIPT COORD/TYPIST	JANA WALLACE —- Pilot
	JANET NEMECEK—1st, 2nd, 3rd Season

PUBLICITY

PUBLICIST	BENDER, GOLDMAN & HELPER—Pilot, 1st, 2nd Season
PUBLICIST CONTACT	DIANE CASTRO—Pilot
PUBLICIST CONTACT	MICHELE FISCHER—1st, 2nd Season
PUBLICIST CONTACT	JOLYNN BACA—Pilot, 1st Season
PUBLICIST CONTACT	DEBORAH McCRAE-THOMAS—2nd Season

PARAMOUNT PUBLICIST CONTACT	DEBORAH McCRAE-THOMAS—3rd Season
ASST. TO D. McCRAE-THOMAS	JENNIFER FERALDO—3rd Season

MUSIC

COMPOSER	DENNIS McCARTHY—Pilot, 1st, 2nd, 3rd Season
COMPOSER	JAY CHATTAWAY—Pilot, 1st, 2nd, 3rd Season
COMPOSER	DAVID BELL—3rd Season
MUSIC EDITOR	GERRY SACKMAN—Pilot, 1st, 2nd, 3rd Season

EDITORIAL

SUPERVISING FILM EDITOR	J. P. FARRELL—Pilot, 1st, 2nd, 3rd Season
FILM EDITOR	DARYL BASKIN—Pilot, 1st, 2nd, 3rd Season
ASST FILM EDITOR	LISA DE MORAES—Pilot, 1st, 2nd, 3rd Season
FILM EDITOR	BOB LEDERMAN—Pilot, 1st, 2nd, 3rd Season
ASST FILM EDITOR	EUGENE WOOD—Pilot, 1st, 2nd Season
	DAVID KOEPPEL—3rd Season
FILM EDITOR	TOM BENKO—Pilot, 1st, 2nd, 3rd Season
ASST FILM EDITOR	JIM GARRETT—Pilot, 1st, 2nd Season
	JAQUES GRAVETT—3rd Season

POSTPRODUCTION

POSTPRODUCTION COORDINATOR	APRIL ROSSI—Pilot, 1st, 2nd, 3rd Season
VISUAL EFFECTS PRODUCER	DAN CURRY—Pilot, 1st, 2nd, 3rd Season
VISUAL EFFECTS SUPERVISOR	RONALD B. MOORE—Pilot, 1st, 2nd, 3rd Season
VISUAL EFFECTS SUPERVISOR	DAVID STIPES—Pilot, 1st, 2nd Season
VISUAL EFFECTS SUPERVISOR	BOB BAILEY—1st Season
VISUAL EFFECTS COORDINATOR	PHIL BARBERIO—Pilot, 1st Season
VISUAL EFFECTS COORDINATOR	MICHAEL BACKAUSKAS—Pilot, 1st Season
VISUAL EFFECTS COORDINATOR	JOE BAUER—Pilot, 1st, 2nd Season
	EUGENE WOOD—3rd Season
VISUAL EFFECTS ASSOCIATE	EDDIE WILLIAMS—Pilot, 1st, 2nd, 3rd Season
VISUAL EFFECTS ASSOCIATE	ERIC ALBA—Pilot, 1st Season
	CHERYL GLUCKSTERN—Pilot, 1st 2nd, 3rd Season
	DEXTER DELARA—2nd Season
	PETER LEFEBRE—3rd Season

VISUAL EFFECTS ASST. EDITOR	ART CODRON—Pilot, 1st, 2nd, 3rd Season
VISUAL EFFECTS ASST. EDITOR	LIZ CASTRO—1st, 2nd, 3rd Season

STAND-INS

SUE HENLEY—Pilot, 1st, 2nd, 3rd Season

JERRY QUINN—Pilot, 1st Season

CY KENNEDY—Pilot, 1st Season

LEMUEL PERRY—Pilot, 1st, 2nd, 3rd Season

JOHN TAMPOYA—Pilot, 1st, 2nd, 3rd Season

NORA LEONHARDT—Pilot, 1st Season

SIMON STOTLER—1st, 2nd, 3rd Season

JENNIFER SOMERS—Pilot, 1st, 2nd Season

ROBERT RASNER—Pilot

SUSAN LEWIS—2nd, 3rd Season

RICHARD SARSTEDT—2nd, 3rd Season

CARL DAVID—2nd, 3rd Season

JENNIFER RILEY—3rd Season

J.R. QUINONEZ—3rd Season

TREVOR JAMES—3rd Season

RECURRING ATMOSPHERE EXTRAS
(Listed by frequency of appearance)
Name in brackets is character name in series.

1. Tarik Ergin [Lt. Ayala]
2. Louis Ortiz [Dorado]
3. Brian D'Nofrio
4. Shepherd Ross [Murphy]
5. Kerry Hoyt
6. Cardine Gibson
7. Demaris Cordelia
8. Lydia Shifferaw
9. Holiday Freeman
10. Julie Jiang
11. Doug Wilson
12. Christine Delgado [Nicoletti]
13. Heather Ferguson
14. Heather Rattray
15. Noriko Suzuki
16. Lou Slaughter
17. Steve Carnahan [MacKenzie]
18. John Austin
19. Rad Milo
20. Joey Sakata
21. Deborah Stiles
22. Hallie Singleton
23. Joyce Lasley
24. Andrew English

A P P E N D I X 2

Transfers & New Assignments

Bob Bailey, left the company at the end of the first season.

Ken Biller, was promoted to co-producer, at the end of the second season, proving that despite his own
initial fears, he really is an excellent writer and a valuable asset to the company.

Brannon Braga, was promoted to co-executive producer for the fourth season.

Zayra Cabot, left the company during the second season, and now has a real life of her own.

Joe Chess, left *Voyager* at the end of the first season.

Kristine Fernandes Cox, left *Voyager* at the end of the second season and is currently an associate producer
on *Deep Space Nine*.

Leslie Frankenheimer, left the company at the end of the third season.

Jim Garrett, left the company at the end of the second season.

Chandler Hayes, joined the company during the fourth season as Paramount's senior publicist for media
relations.

Ed Herrera, left *Voyager* at the end of the second season, and now works as a grip for various productions
on the Paramount lot.

Lisa Klink, promoted to executive story editor at the end of the third season.

David Livingston, at the end of the second season David got his wish. He resigned his position with the
company to devote his creative energies full-time to directing.

Jennifer Lien, left the cast after the second episode of the fourth season. She was replaced by actress Jeri
Ryan, who plays the humanized Borg, Seven of Nine.

Deborah McCrae-Thomas, left the company at the start of the fourth season for a publicity post with CBS
television.

Scotty McKnight, left at the end of the second season, to work independently in television and film production. He still spends a great deal of time on the lot.

Jim Mees, left at the end of the first season, but he rejoined the *Voyager* production company at the start of the fourth season.

Joe Menosky, a former *TNG* staffer and frequent contributor to *Star Trek* since a move to Rome, returned from Italy to join the *Voyager* staff at the beginning of the third season.

Wendy Neuss, about halfway through *Voyager*'s fourth season, Wendy left the company to become head of Patrick Stewart's production company, Flying Freehold Productions.

Karen Ragan, left the company at the end of the second season, to be blissfully happy with her new husband.

Dave Rossi, at the end of the second season he became Rick Berman's PA. At the end of the third season Dave was promoted to Supervisor of *Star Trek* Projects.

Tony Sears, left the company at the end of the third season.

David Stipes, left *Voyager* at the end of the second season and now works on *Deep Space Nine.*

Bob Sordal, retired from the company at the end of the second season, is rumored to be enjoying life with his family and grandchildren.

Dawn Velazquez, was promoted to postproduction producer in the fourth season, when Wendy Neuss left.

Brad Yacobian, at the end of the second season Yacobian was promoted to producer.